FOURTH EDITION

Women Artists

in History

From Antiquity to the Present

Wendy Slatkin

California Polytechnic University
Pomona, California

Prentice
Hall

Upper Saddle River, New Jersey 07458

Library of Congress Cataloging-in-Publication Data

Slatkin, Wendy
 Women Artists in History : from antiquity to the present / Wendy Slatkin.—4th ed.
 p. cm.
 Includes bibliographical references and index.
 ISBN 0-13-027319-8
 1. Women artists—Biography. I. Title.
 N43 .S57 2001
 704'.042—dc21

 00-026345

This book is dedicated to the creativity of all women artists, past, present and future, and their scholars. Without their efforts there would be no book.

The credits begin on page 300, which is considered an extension of the copyright page.

Acquisitions editor: Bud Therien
Assistant editor: Marion Gottlieb
Editorial production/supervision
 and interior design: Judy Winthrop
Manufacturing buyer: Sherry Lewis
Cover design: Kiwi Design

© 2001, 1997, 1990, 1985, by Prentice-Hall, Inc.
A Division of Pearson Education
Upper Saddle River, New Jersey 07458

This book was set in 10/12 Palatino by Carlisle Communications and was printed and bound by R. R. Donnelley & Sons.
The cover was printed by Phoenix Color Corp.

Printed in the United States of America
10 9 8 7 6 5 4 3 2 1

ISBN 0-13-027319-8

Prentice-Hall International (UK) Limited, *London*
Prentice-Hall of Australia Pty. Limited, *Sydney*
Prentice-Hall Canada Inc., *Toronto*
Prentice-Hall Hispanoamericana, S.A., *Mexico*
Prentice Hall of India Private Limited, *New Delhi*
Prentice-Hall of Japan, Inc., *Tokyo*
Pearson Education Pte. Ltd., *Singapore*
Editora Prentice-Hall do Brasil, Ltda., *Rio de Janeiro*

Contents

PART III The Nineteenth Century

PART IV The Twentieth Century

Preface

Women Artists in History is a textbook targeted at college students in introductory-level courses focused on women artists and the contributions of women to visual culture, women's studies courses, and surveys of western art history. It is written in a style that is crafted to communicate complex ideas clearly and effectively for this targeted audience. Most students will bring little or no preexisting intellectual framework for comprehending this material. Therefore, whenever possible, I do not discuss a work of art without providing an accompanying illustration. I try to write clearly and succinctly in a manner that is similar to the way I teach, based on more than 25 years of teaching experience in such introductory-level courses. The topics discussed in each chapter have been selected to provide a foundation for these student readers. I hope that instructors of these courses will appreciate the text as a strategy for engaging their students and encouraging them to explore the fully published field, which is so rich and varied in methodologies.

This fourth edition of *Women Artists in History* provides this author with a welcome opportunity to build on the structure of the third edition and to incorporate a selection of the valuable scholarship published in the years since the last edition was written. In the third edition, detailed analyses of individual works of art, which had been objects of scholarly attention, provided the core structure of the text. This edition retains such focused discussions but incorporates some of the most compelling newly published scholarship. In this edition, readers will find each creator represented by one single illustration. This seemed to me to be the most effective way to balance the existing scholarship addressed in the third edition with the more recently published material.

The topics addressed in each chapter reflect the course of the current state of published research for each historical epoch. The issues vary because the material evidence of different times and places is so diverse. Therefore "feminist interventions into the histories of art," Griselda Pollock's well-known term for this scholarly practice, leads to an exploration of different types of issues for the five millennia of artistic production spanned by the scope of the text.[1] Feminists have suffered from the tyranny of meta-theories. We should not then seek to impose new methodological priorities for texts, course syllabi, or the research interests of our colleagues. I argue here for a flexible approach to the field of visual culture and art history. In this book I have tried to make selections from the broadest range

of the outstanding scholarship in the field, which necessarily reflects a variety of methodological approaches.

It is unarguable that the contributions of women to the visual cultures of their societies go far beyond the small handful of women who became "professional artists." Women have participated in the visual arts on many levels, including the activities of amateur creators and as patrons, critics, and viewers. Whenever possible, I have indicated the roles of such women, especially as patrons, in the appropriate chapters. Such discussions naturally parallel the available published scholarship.

Interpretations of representations of women are also an important area of investigation for scholars studying the construction of gender distinctions in specific historical epochs. Art historians must address issues of "imagery" in their areas of expertise to deconstruct the "natural" categories of "Man" and "Woman" and their implicit power hierarchies. Such intellectual efforts provide us with one of the only escape routes for future generations to reinvent new, more tolerant, and more flexible definitions of gender. This scholarship is extremely valuable and important work. In this text, discussions of the roles of images of women are included in nearly every chapter prior to the eighteenth century.

However, *Women Artists in History,* does prioritize the works of women creators. The concrete material existence of these works of art by women artists with names attached, whenever possible, is the most direct didactic method to ensure that the contributions of women to visual culture will not be marginalized, minimized, or summarily dismissed. It is unthinkable to permit the art made by women to retreat into the invisibility and anonymity that existed prior to the 1970s. Therefore I believe that there is a responsibility to educate each new generation of college students with the outstanding creations of women artists. Given the limited number of illustrations that can be included in this text, I have chosen to include as many works created by women as is possible and practical. To shift the focus of the text to discussion of images of women, or works of art commissioned by women patrons but created by male artists, would inevitably result in many fewer works by women creators appearing as illustrations in this book.

It is undeniable that the text has a Eurocentric emphasis. This resulted necessarily from two factors, the current state of the literature and the practical limitations of space. There is simply much more scholarship currently in print on the women artists of Europe and the United States than for the creators from other continents. Furthermore, there are the physical limitations on the length of this book. Adding brief and, necessarily cursory, chapters describing women artists from other continents would have forced me to substitute some of the text devoted to the much more detailed and theoretically complex material which I have included. In the conclusion, a summary of the state of research on issues for global women creators has been added. This does not reverse the balance, but it

does begin to point students in the directions of scholarship available on women artists of Asia, Africa, Latin America, Australia and New Zealand. As an introduction to this material, an essential part of the text is the updated bibliographies for each chapter. An annotated bibliography of general reference sources is also included. Students should be directed to these additional research materials, in English, which are published as books or essays, in refereed or peer reviewed publications.

Women Artists in History is like a "freeway" or "turnpike" for feminist art historical discourse. Each chapter is a major "exit" into much more detailed scholarly work. Each subheading within the chapters is a road leading to more specialized studies. It is my intent that students use this book as a beginning point, a road map, to help guide them through what has become a terrain of complex and extremely sophisticated intellectual inquiry.

ACKNOWLEDGMENTS

First, I acknowledge my debt to the sustained efforts of the scholars whose work is summarized in these pages. We are now benefiting from several generations of their expertise, that permits this text to become a very different book from the first edition, written in the early 1980s.

No text book is created without a committed team. At Prentice-Hall I have been fortunate to work with a group of professionals without whose efforts this fourth edition could not have been produced. I would like to thank my revision editor Susan Alkana, whose support and insights moved this edition along at a crucial stage. I also wish to acknowledge Judy Winthrop's Herculean efforts to keep this project on track and on schedule and who knew when to say yes and no. As always, I am grateful to Bud Therien who has sustained this text through four successive revisions, and to the efforts of his assistant, Marion Gottlieb and Wendy Yurash, who were both patient and efficient.

I am most appreciative of the input from the readers who provided valuable suggestions in the earliest stages of this revision.

The students in my classes have constantly been an inspiration to me. Realizing that many were born after 1980 is a sobering lesson to all and reminds us of the need for "reiteration" and remembering that each individual class of students needs to be educated with a fresh perspective.

I gratefully acknowledge all those institutions, libraries, museums, and individuals who granted permission to reproduce the photos included in the text.

I wish to thank my family, Randy, Josh and Sara, who have lived with this revision with patience, tolerance, and good humor. Finally, I would like to recognize the support of my mother and especially, my father, who did not live to see this text printed.

Introduction

Unlike most other introductory-level textbooks, *Women Artists in History* focuses on women artists and issues that directly affect women's opportunities to become artists. Works by male artists appear in this book only to increase our understanding of women artists. To a lesser extent, images of women and the roles of women as patron or viewer are also discussed. In contrast, most other art history textbooks are composed mainly of works created by male artists. In general surveys, works created by women make an appearance as minor "marginal" additions to the major trends in the visual arts, defined by works created by men. A small percentage of works by women creators might be included in these books as "token" additions to an "Art History" dominated by male geniuses. Therefore, there is still very much a need for texts such as this one, in which women artists are the primary focus of interest. By adjusting our focus toward the roles of women in their "visual cultures," we will discover new concepts, issues, insights, and works of art that differ from the group of well-known "masterpieces" found in most standard survey texts of art history.

Understanding the roles of women in art history is a complex and varied undertaking. In 1973 Linda Nochlin published an essay "Why Have There Been No Great Women Artists?"[1] Nochlin was responding to the attitude of the vast majority of the art historians who believed, then, that the study of women artists was not worthy of attention because there had been no "great" women artists whose works were of the "quality" which would merit scholarly attention. Since then, during the past 25 years, an enormous outpouring of convincing and compelling scholarship has been published. Every time period, nearly every creator, and absolutely every underlying principle on which the previous editions of this text were based

have been thoughtfully and frequently brilliantly argued by an international community of scholars. This, the fourth edition of *Women Artists in History*, has, like all previous editions, been revised to reflect the most recently published scholarly work, which supplies a wealth of new insights both in terms of factual data and interpretive strategies. Each time I have the opportunity to rework the book, I can do so on a much broader and more solid foundation of scholarship. Taken collectively, these texts on which the scholarship for this book is based constitute "a discourse," published mainly in English, as well as in other languages. This extensive discourse has greatly expanded our knowledge and understanding about women artists of the past and the conditions in which they worked.

"FEMINIST INTERVENTIONS IN THE HISTORIES OF ART"

This book is an introductory-level text designed for college students with little or no background in the material. Space limitations meant that much information, scholarship, and works of art could not be incorporated into the book. I have made selections in an effort to provide some insight into the processes of feminist art historical interpretations and the range of methodologies that can be effectively used to illuminate the contributions and concerns of one-half of the population of any given culture. Whenever there were active professional artists whose works have survived, I have tried to include a representative selection of such work in the text. If the emphasis were shifted away from the woman creator, the book would necessarily include more illustrations of works created by male artists. Since one of my goals is to introduce my readers to the creativity of women, I include and reproduce works made by women whenever possible.

INTERPRETATION AND ANALYSIS OF IMAGES OF WOMEN

Prior to the twentieth century, women artists remained a small percentage of practicing artists. Furthermore, many works by women have not survived or may not be identified as the work of a woman creator. Painting, sculpture, and architecture—collectively known as the "fine arts"—were male-dominated professions. Feminist scholars have recognized this reality and, therefore, they have not confined their investigations exclusively to works created by women artists. Griselda Pollock's excellent term "feminist interventions in the histories of art"[2] describes well these reappraisals and interpretive strategies within the field of inquiry of the visual arts. We now can take a much more varied approach to the range of available evidence in different periods than was possible when Nochlin first posed her famous question. Feminist scholars have examined images of women created by men in great detail to achieve a more complete understanding of the ways

in which gender was constructed in a given historical period. Below we define these terms more completely. In addition to research on works made by women, issues related to interpretations of images of women, created by men, is another major concern of feminist scholars.

WOMEN AS PATRONS

In certain times and places, women, usually from the elite classes of their society, made a strong impact on their visual culture by acting as patrons. In this text, we discuss the activity of women patrons in a few circumstances, for example, in Rome and during the Early Modern era. However, our small sampling of women patrons is just the "tip of the iceberg" in terms of assessing the impact of women on their visual cultures as commissioners or patrons of the visual arts. Exciting research is being done in this expanding field of inquiry.

WOMEN AS VIEWERS

All works of art were created with some group of viewers in mind. The intended audience for a work could be as private as the bedroom of the patron, or as public as the relief on the façade of a church. Each specific historical situation permits the viewing of the image in a specified context. Not all works are seen in all places. Until quite recently, in historical terms, there were no public museums. Therefore, the viewers of a given painting would have been a narrower segment of the society than the "public." Some scholars have analyzed images for the impact they might have exerted on the audience. Feminist scholars are interested in gender roles in terms of a viewer's position in "reading" works of art. It does matter whether men or women are doing the looking. Michael Ann Holly has described the "power of the gaze" quite succinctly. "The person who does the looking is the person with the power. No doubt about it: looking is power, but so, too, is the ability to make someone look."[3] Whether it is the artist who made the viewer "look" or the role of an audience in helping to produce certain types of art, it is important not to omit the role of the viewer in any discussion of the visual arts. However, even though this field has produced some of the most interesting scholarship available, it is not the sort of analysis that can be easily summarized in the given format of this text. Women as viewers play an important role in their visual culture, but it is a role that is quite difficult to clarify given the uncertainties of the gender issues, to be discussed below. Therefore, while this scholarship is included in the bibliographical entries, it is not emphasized with any regularity in this text. I encourage all readers to pursue the issues of the gendered nature of the audience in their further reading on this topic.

Both analyses of images of women or investigations into women patrons and viewers are strategies that carry persuasive validity, providing new insights into the active roles of women in visual culture. It is my position, writing in the millennial year 2000, to accept all such interventions into the discourses of art history as valuable. Feminist scholars have actively and convincingly engaged in a reexamination of virtually every fundamental premise within the scholar's own area of specialization. It is neither possible nor desirable to force "feminist art history" into a unified "school" or methodology. The works are too diverse, the ways in which they were created and defined in various periods too different, and the cultural matrix in which they were produced is so varied, that a single, unified methodological approach is inappropriate. Methodologies then must be varied to properly understand the material under consideration. This range of valid scholarly approaches is reflected in the variety of issues and methodological strategies employed in this text.

SOME DEFINITIONS

Women Artists in History is an introduction to this discourse, a starting point for a journey of discovery for the reader. This book is like a road map, for the more detailed and specialized research, indicated in the endnotes and bibliographies of each chapter. Maps are useful guides: They help you navigate through unfamiliar territory. But a map is never a substitute for a visit to the real place. The published scholarship, which can be only summarized here in a very concise manner, is like the actual town indicated by a small dot on the map. Furthermore, all maps use a set of symbols to guide the reader through the terrain. An understanding of the meaning of the map's code is essential if the map is to be of any use at all. If you cannot decipher the symbols used on the map, you may find yourself lost. Our map uses some concepts and terms that have been redefined by scholars in ways that are probably unfamiliar to most readers. The following terms appear frequently in this text and require some definitions, so that the reader does not set off on this journey without a set of basic theoretical tools for understanding this map of the discourse.

Woman/Women

Feminist philosophers have written influential texts that call into question anyone's ability to speak confidently about what it means to be a "woman" or to rely with assurance on an understanding of the collective noun "women." Denise Riley was one of the first philosophers to question whether one can truly define what it means to be a "woman" in any given time or place. She believes that the term "women" is not a singular unified entity, but rather "a volatile collectivity in which female persons can be very

differently positioned, so that the apparent continuity of the subject of 'women' isn't to be relied on."[4] Judith Butler in a widely read book, *Gender Trouble*, also questions the ways in which the term "women" can be used. By reducing all women living in any specific culture to a unified group, there is a tendency to overlook importance differences among women. Butler cautions her readers to question the reliability of lumping all female persons (or subjects) into a single noun, "women." Butler notes that the insistence upon the coherence and unity of the category of women has effectively refused the multiplicity of cultural, social and political intersections in which the concrete array of "women" are constructed.[5] It is quite evident that women can be very different depending on factors such as age, race, and class. Women of different generations, economic levels, and racial/ethnic backgrounds certainly have different perceptions of their roles as "women" in every cultural matrix under consideration in this text. Similarly, most scholars also resist the term "woman" as a generalized noun, defining some sort of archetypal figure. There is no reliable intellectual category of woman that is knowable. Many feminists view the use of the term "woman" with great suspicion since it has most often been employed by a patriarchal discourse which is perceived as trying to deny individual subjectivity to the actual female humans living in that culture. Butler and others have called into question the use of the terms "woman" and "women" with any sort of unproblematic understanding of what is actually being defined by that term.

The message these philosophers are communicating is the caution that should be exercised when speaking in general terms about "the women" of any specific culture. We know that in the United States, in the year 2000, it is quite impossible to speak confidently about "Women of the New Millennium." Each individual internalizes a gender identity, male or female, in unique ways that resist such generalizations. Therefore, how can we discuss with any confidence "the women of the Renaissance"? Can we really know what any given female living in Florence in the 1400s, for example, might have comprehended about herself as a woman?

Sex/Gender

It is a biological fact that humans are born with sexual anatomy that divides us into two different groups. "Sex," then, refers in most texts to this biological difference of anatomy. Butler, however, in her next published book after *Gender Trouble*, *Bodies that Matter*, questions whether the sex of an individual is as simple as the bodily differences between male and female anatomy. Butler defined "sex" and sexuality as being produced or constructed through behavior that is repeated often during an individual's life. Sex is not something with which we are born, already formed as a coherent aspect of our identities, but rather is a process of "performative acts" or "reiteration."

One's sexual identity is formulated through the lived experiences of one's life. Butler asserts that, in the process of living in a physical body, "sex is both produced and destabilized in the course of this reiteration."[6] Therefore, sexual identity changes as one's experiences change. Sex is not a concept that can be fixed and finalized but is variable depending on repeated actions. Therefore, even the seemingly factual matter of defining a person's sex is open to a series of interpretive "problems."

There is a scholarly consensus that it is more valid to discuss "gender" rather than "sex" when dealing with issues of relevance to women and the woman artist, which is our focus in this book. When we begin to think about what it means "to be a woman" or "to be a man," it is clear that these categories are not biologically given but rather are constructed, or put together from many stimuli in an individual's cultural environment. Scholars use the term "gender" to define the nature of sexual identities grounded in the society in which an individual lives. As Natalie Kampen has defined the term: "Gender is the social transformation of biological sex into cultural category."[7] Many feminists quote a famous phrase by Simone de Beauvoir in her pathbreaking study, *The Second Sex,* "One is not born a woman, but, rather, becomes one."[8]

As discussed in relation to "sex," then, each individual comes to identify his or her "gender" through social practices and discourses and through acts that are multiple and repeated throughout an individual's life. Such ideas have gained wide currency. By 1995, Mary Sheriff could confidently state "it is commonplace to say that we construct ourselves through the discourse and image of others and it is language that writes us and not we who write language."[9] Sheriff was referring to an understanding that many aspects of a person's gender are developed in response to input from the culture, both in terms of texts and images. Human identity is not fully developed outside of one's cultural institutions, of which language is, perhaps, the most significant, but in response to the stimuli present in any given environment. Butler, however, warns us again of understanding gender as a fixed, stable aspect of identity: Gender identity can be understood more productively as performative. . . . "Gender is always a doing, though not a doing by a subject who might be said to preexist the deed."[10] Both sex and gender are elements of identity that are fluid and changeable depending on circumstances and behaviors.

Representation and the Construction of Gender

If we understand that what subjects come to identify in themselves as "masculine" and "feminine" is governed to a great extent by the input from their society, then language and images play important roles in determining what it actually means "to be a woman" or "to be a man." All societies seem to have an ideal set of expectations of behaviors, values, emotional

responses, and so on that define the ideal Man or Woman. This set of beliefs may be termed "gender ideology." "Representations show people idealized forms of themselves, forms by which to recognize the categories to which their society assigns them and by which to mark their hopes and desires. It also shows people how they differ from one another both as individuals and as member of categories."[11]

In this book, because we are focused on the visual arts, we are most interested in the role of art, that is, visual "representations," for the process by which gendered identities are constructed from multiple stimuli, in any culture. Many scholars have addressed the problems of the interpretation of works of art which image the form of "woman" in an effort to deconstruct the ways in which these images relate to attitudes toward gender roles, and concepts of femininity or masculinity, in any given culture. Images both reflect and perpetuate such gender stereotypes and also serve to construct these roles in new ways. Some images also resist or provide different images from the prevailing gender ideology of their cultural matrix. It is tempting to look to the works of art by women to find "spaces" in representation where alternatives to the dominant gender ideology of the society are visualized. However, since women artists were professionals who worked for male patrons, predominantly, one must be cautious when asserting such alternative readings.

Patriarchy

Gender relations are always implicated in practical terms of power. This means that in most societies, for which we have evidence, men exercised power over women and elite men exercised power over everyone else. The term "patriarchy" refers, then, to societies in which men occupy the highest positions of political and economic power. All women and men of a lower class have less power. Although "power" never operates easily or simply, it does exist. Power relations can be asserted through economic, legal, or simply customary behaviors. Kampen notes that the power relationships under consideration always operate in terms of "age, status and ethnicity."[12] Power relationships are not absolutes, but rather exist in a matrix with other social categories. Patriarchy, then, refers to a complex system in which men and women are positioned differently from each other in a number of different ways related to access to wealth, knowledge, and personal autonomy.

Artist

Just as it is difficult to specify what it might mean to a given person to be a "woman," the concept of the "artist" has also been "deconstructed" or analyzed carefully by theorists. Philosophers such as Roland Barthes and Michel Foucault have questioned what it actually meant to be an "author"

or, for our purposes, an "artist." Is there a unified identity of "the artist" that is separate from all the other aspects of an individual's life? What parts of a biography help us understand the "artist" and what other facts belong outside that boundary? Can the "artist" as an coherent identity exist in a fully self-contained, neat package? As with the term "woman," the "artist" is an intellectual construct, "elaborately produce[d]."[13] Nearly all of art history, however, is organized around the category "artist" as if this were a clearly defined entity. One of the ways in which "the artist" is constructed is through the "monograph," a type of book that focuses on a single creator. A monograph tends to inscribe the individual is a tidy package, isolating him or her from the visual environment and creative matrix in which the person lived. To a certain extent, one could argue that "the artist" as a knowable entity is only found in the monograph. This is the issue that led Griselda Pollock to critique the disciple of art history noting that "archaic individualism [is] at the heart of art historical discourse, . . . a masculinist discourse party to the social construction of sexual difference."[14]

History

The third element in the title *Women Artists in History* presents us with yet another complex and difficult concept to define with precision. What did it mean for any human subject to be positioned "in history"? Even the concept of "history" itself is susceptible to deconstruction. One scholar of classical art, Amy Richlin, has written: "History is what groups write as they come to power."[15] There is no way that we can rely with assurance on certain factors in any time or place to be significant as "historical context." As Bal and Bryson asserted: "Context can always be extended; it is subject to the same process of mobility that is at work in the semiosis of the text or artwork that 'context' is supposed to delimit and control . . . it cannot be taken for granted that the evidence that makes up 'context' is going to be any simpler or more legible than the visual text upon which such evidence is to operate."[16] Therefore, we cannot firmly define exactly which ideas and issues in the society might prove to be directly relevant to the situation of the specific woman artist under consideration. It is not clearly determined which historical "facts" will lead to an informed interpretation of the situation of the "woman artist in history."

Canons and Canonicity

The "canon" of art history refers to a highly selective group of works that constitute the highest level of achievement in art. This canon is white, male, and Eurocentric. Even today, while there are a few "Great Women Artists," who are well known and regularly included in art historical texts, these

women are not "canonical," that is, they are not part of the small, elite group of artists who define "greatness." Pollock has been one influential feminist theorist who has warned against the inclusion of a few women into an otherwise unchanged art historical canon. Instead she called for a "paradigm shift," a wholly new way of thinking about art which is termed "visual culture." Such a paradigm shift will necessarily involve a "differencing of the canon." Those women artists now regularly included in survey texts are "notorious, sensational, commodifiable or token."[17] Perhaps, as Mary Sheriff has defined the term, the women artists included in most art history texts remain "exceptional," proving the rule that the majority of women artists are not worthy of consideration.[18]

SELECTION CRITERIA: ISSUES OF QUALITY

If the categories of "woman," "artist," and "history" are not easily clarified with any degree of intellectual certainty, what is left for the scholar to study? What does remain for art history as concrete evidence are the works of art themselves, the "visual texts" or the "objects." Therefore, various headings in each chapter of this book link the creator of the work with the title of the specific object, which is the focus of discussion. The information provided is selected for its relevance to an understanding of that specific work of art.

This leads us to another complex issue, the role of "quality" in the selection of the works of art included in this text. Since it is not possible to illustrate a work from every known woman artist, some selection process is necessary to determine which works of art will be discussed. Some scholars believe that criteria of excellence that evaluate the "quality" of the work are not relevant to the situation of the woman artist who was always active in a culture dominated by men.

It is true that issues of "quality" have been employed to effectively marginalize or eliminate altogether certain types of works simply because they were created by women. Christine Battersby has considered the concept of artistic "genius" from a feminist perspective. She has shown how the contemporary concept of the artistic "genius" originally developed in the Romantic era is an inherently gendered concept. "The genius can be *all sorts* of men; but he is always a 'Hero,' and never a heroine. He cannot be a woman. . . . The genius is male . . . the genius's power is modeled on that of God the Father. . . . Like god, the author possesses authority."[19] Battersby's study helps us understand why the notion of the "Great Woman Artist" was not developed until the late twentieth century. "What I am arguing is that the Romantic conception of genius is peculiarly harmful to women. Our present criteria for artistic excellence finds its origins in theories that specifically and explicitly denied women genius."[20]

Battersby's analysis is cogent and persuasive. However, I believe that it is not possible, or even desirable, to completely ignore or eliminate issues of "quality" in the selection process for this book. To do so would negate the struggles and efforts of so many of these creators. To become a "painter," a "sculptor," or (in the case of Julia Morgan) an "architect" involved for women in the periods since 1550 an acceptance of the "rules of the game." To enter the arena of painting was to challenge many of the fundamental assumptions on which the discourses of patriarchy were grounded. Since the Renaissance, art has been a profession. Women who entered this professional arena produced works that could only be judged by the criteria of excellence of its institutional matrix, whether it was the French Royal Academy of the eighteenth century or the New York art world of the 1940s and 1950s. There were no alternative systems of evaluation.

Quite obviously, men dominated these institutions and their critical discourses. Most artists were men, most patrons were men, and most writers of critical texts were men. The criteria of excellence were invented and perpetuated by men. When women chose to become artists, as defined by their specific culture, they accepted those standards, since there were no other options. The nineteenth-century campaigns to gain admission into the Royal Academy in London, or to the Ecole des Beaux-Arts in Paris, were efforts to improve women's training so they could compete with their male contemporaries using the same system of critical criteria. The difficulties inherent in this undertaking were great and frequently insurmountable.

Despite this, the evidence of the surviving body of works of art attributed to women creators documents the historical reality that women artists accepted the inequities and struggled to meet the criteria established by male artists. If these creators could recognize and accept the reality of male-defined standards for excellence, contemporary art historians must as well. Perhaps we should not wonder why so few women managed to meet those criteria, but rather how any women at all surmounted the immense difficulties of patriarchal society to create works that met such stringent critical standards.

The criteria employed in this book to select works by women for consideration may be grouped under the following categories:

1. *Stylistic or technical innovation.* A number of artists have developed methods of painting and sculpture that are different from any previous style. These artists usually are members of an avant-garde group. This category applies most frequently to artists living in the late nineteenth and the twentieth centuries, when stylistic innovation has been most valued. However, Rosalba Carriera, for example, was a technical innovator in the lower status categories of miniature painting and pastel portraiture during the eighteenth century.

2. *Compositional or iconographic originality.* Some artists have been singled out because they invented a new format, compositional arrangement, or structure for painting or sculpture. For example, the originality of Clara Peeters lies more in her compositions and the selected viewpoint of her still lives than in her method of paint application. A number of artists have invented new subjects, sometimes based specifically on their experiences as women. Other artists have developed new variations or layers of meaning for subjects regularly depicted by their male colleagues. Artemisia Gentileschi, Judith Leyster, Harriet Hosmer, and Käthe Kollwitz are examples of artists who have created new iconographies based on their personal identities as women.

3. *Iconography that resists gender stereotypes.* I am most interested in those works which question, challenge, and/or redefine the social and cultural construction of the category "woman." At certain times, women artists created images which "resist" the more widespread cultural categories of "gender." Whenever possible, priority has been given to images created by women in whom their interpretation can illuminate and provide alternatives to some aspect of the construction of gender issues for the culture.

4. *Influence on other artists.* One standard regularly applied by art historians to evaluate the contribution of an artist to the history of art is the extent to which that artist's imagery or technique influenced the works of other artists. Certain artists, such as Angelica Kauffmann, exerted a decisive and widespread influence on the art of their contemporaries.

5. *Recognition within the culture.* Many of the artists to be discussed were widely appreciated during their lifetimes. They received official and critical recognition and occupied positions of prominence in the contemporary culture. Rachel Ruysch, Elisabeth Vigée-Lebrun, and Rosa Bonheur are examples of artists whose careers belong in this category.

This text is intended to be a starting point for an understanding of this diverse, complex, and fascinating topic. It should lead the reader into many different types of inquiries, all of which can enrich one's understanding of the visual culture of any given historical moment. Women are always present as one-half of the population. To ignore the existence of this half of a society is no longer a legitimate scholarly position. Despite the small percentage of women included in most survey texts, I believe that the work of feminist scholars since the 1970s has changed the discipline of art history. It is my perception that there does exist a scholarly consensus, which now recognizes the importance of gender issues for art history inquiry. I encourage the reader to explore this discourse, using this text as a map. The journey will be an exciting, intellectual adventure.

1

Prehistory

THE NATURE OF THE EVIDENCE

The historical era is defined by the survival of the earliest written records in the third millennium B.C. The past 5,000 years are a relatively recent epoch in human history. Written documents emerge from civilizations in which both patriarchal institutions and a class structure with a ruling elite and slaves exist. Therefore, the archeological evidence from the thousands of years of social organizations that preceded the third millennium B.C. have provided a source of great attention for feminist scholars. Is there evidence of social groups in which men and women occupy similar positions of status in the community? Is there any evidence in prehistory of societies organized as "matriarchies," that is, societies in which women were more important than men? The fascination with prehistory for today's feminists reflects the need for alternative models for gender relationships in contemporary society.

ART OF THE UPPER PALEOLITHIC ERA

The surviving art works of this epoch fall into three categories: (1) cave paintings in France and Spain, (2) stone objects, decorated with designs, which most often have animal motifs, and (3) female statuettes.

Female Statuettes

For contemporary feminists, the most interesting groups of objects are the sculptured female figurines. Over 60 figures have been found over a wide

area of Europe, from southwestern France to eastern Russia. The oldest examples have been dated to the Upper Paleolithic era, and most appear to have been created within a relatively short time span of 2,000 years, that is, between 25,000 B.C. and 23,000 B.C. Most of these examples have been carved in stone or mammoth ivory, although a few are modeled from baked clay. As a group, they are quite small in scale, the largest being 22 cm tall.

- Upper Paleolithic Hunting and Gathering Societies, Statuette of a Woman from Willendorf

This figure, excavated at Willendorf, in Austria, has frequently been called the *"Venus" of Willendorf,* using the name of the Roman goddess of love and fertility. Obviously, naming such an image "Venus" is an anachronism. Roman civilization would only develop nearly 25,000 years later than the creation of this work, and the beliefs attached to "Venus" as a Roman deity were surely vastly different from concepts of female divinity in these societies.

The sculpture is characteristic of this group of Paleolithic figures in its treatment of female anatomy. The image is a nude human identifiable as a

Fig. 1–1. *Venus of Willendorf.*
c. 30,000–25,000 B.C. Limestone.
Height 4⅜ in. *(Naturhistorisches Museum, Vienna)*

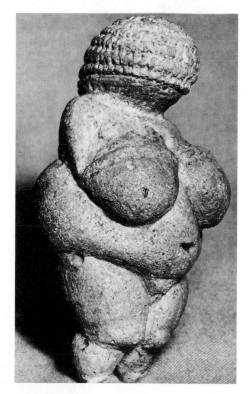

woman by the enlarged breasts, stomach, buttocks, and thighs. Like the other sculptures in this group, the figure is faceless and lacks feet. Tiny arms are incised across her massive abdomen.

In formulating an interpretation of the meaning of these objects, it is important to pay attention to the evidence of archeological excavations. Most such figurines have been found in houses or homesites. They are usually excavated as single objects, along with flint tools and other debris. Margaret Ehrenberg summarizes the interpretation of these statuettes into two categories. Some scholars have argued that these images are the representation of a "Mother Goddess" or fertility goddess. However, despite the appeal of such a concept, Ehrenberg argues against the assumption that these figures provide evidence of a universal religion based on a unified concept of a female goddess.[1] The societies in which these statuettes were created were composed of small-scale populations, which survived by gathering or foraging plant foods, whenever possible, and hunting animals. These men and women lived in very cold climates, on the edges of glacial ice sheets where foraging would have been difficult and meat would have been the mainstay of the diet. Religions based on personified deities are very unusual in such societies, which have been studied in recent times.

Ehrenberg argues convincingly for the second interpretation. These images served as aids in sympathetic magic to promote fertility in women of the community. She cites examples among North American Indian tribes such as the Zuni or West African tribes in which a model of the hoped-for child is carried until the woman gives birth. After the pregnancy or successful birth of the child, the figure could be discarded or retained and used as a doll.

However, it is not necessary to commit to a single unifying explanation or interpretation for all the figures. Since they have been excavated in such a broad geographical area, there were, quite possibly, a wide range of purposes for these fascinating images.

• Neolithic Agricultural Societies, Statuette from the Cyclades

Most of the surviving sculptures of the Neolithic period may be dated in a much more recent historical epoch, stretching from 5500 to 3000 B.C. Small-scale sculptures depicting women have been located throughout Europe and in southwest Asia. They are especially numerous in the Mediterranean islands from the Cyclades, in the east, to Majorca.

The figures from the Cyclades have been found mainly in graves, rather than in settlements like the Upper Paleolithic figures. Both male and female figures have been excavated. Like the older examples, such as the statuette from Willendorf (Fig. 1–1), a range of interpretations have been proposed to explain their significance. Compared with these older statuettes, the differences are quite distinct. These figures have all their body

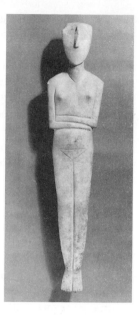

Fig. 1–2. Cycladic Figure from Amorgos. c. 3000 B.C. Marble.
Height 2 ft. 6¼ in. *(Ashmolean Museum, University of Oxford)*

parts, from head to feet. They are relatively flat, and arms are incised across the stomach. The enlargement of breasts, stomach, and buttocks visible in the Willendorf figure is no longer apparent. Instead, a highly simplified conceptual treatment of anatomy is used, one which provided inspiration to early-twentieth-century modernist sculptors such as Brancusi.

One especially significant difference is in the nature of the societies in which these images were made. By the time these works were created, agriculture was well established throughout the Mediterranean world. Our knowledge of contemporary communities in which agriculture is practiced reveals a number of consistent factors. When the plough is employed and animals are domesticated, the agricultural work is done mainly by men. In horticultural societies in which other tools such as hoes or digging sticks are used, women are mainly responsible for agricultural production.

Ehrenberg believes that women can be credited with the discovery of agriculture. Since women were most probably responsible for gathering plant foods, they would have developed specialized knowledge about the growth of plants. Eventually, the conscious planting and cultivation of grains would have led to two important consequences: a change from a nomadic to a sedentary living situation and an increase in population due to the improved and more dependable food sources. If women were cultivating the crops, it is possible that they would likely have been responsible

for inventing the necessary tools. Heavier, more solid containers, probably made from pottery, would have been desirable to store the increased food supply. The oldest examples of pottery have been found at sites in the same regions in which farming first appears in southwestern Asia. With this sedentary lifestyle and food supplies such as cereals appropriate to young children to supplement breast milk, women could have given birth to more children, leading to population increases.[2]

In contemporary times, there is a significant correlation between non-plough agriculture, matrilineal and matrilocal systems, and an enhanced status for women. By the time records were kept, the shift had been made in Egypt and the ancient Near East to plough agriculture, patrilocal residence, patrilineal descent and land ownership, and the domestication of animals. Ehrenberg concludes that when men took over most of the agricultural work, the social status of women declined.

Another theory traces the origins of male dominance to the development of patrilocality. When women moved into their husband's kin group, their labor could be effectively exploited for the creation of commodities for exchange. Female subordination then established the necessary labor force for the emergence of private property and the state.[3]

In the absence of concrete evidence, it is very difficult to determine the extent of women's participation in craft activity. We simply do not know whether women were responsible for the creation of fertility figurines, clay pots, or woven baskets. However, we can assume that women were responsible for the creation of cloth. Elizabeth Barber has accumulated a vast body of evidence documenting the production of textiles in the Neolithic and Bronze Ages. Based on her analysis of the data, she concludes that nearly all textile workers during these epochs were women.[4] Barber builds her case by associating the production of woven cloth for household use as a task consistent with child rearing, and thus appropriate to women.[5]

It is important to remember that the existence of these small sculptures does not necessarily tell us about the organization of society, the division of labor between the sexes, or the relative status of women and men in communities of the prehistoric past.

The survivals of these statuettes, as well as mythological references, have elicited many speculations about the existence in prehistoric culture of societies organized as matriarchies. There is no consensus among scholars that this was the case. On the contrary, "motherhood has often placed abstract *woman* on a pedestal, but it has at the same time left concrete *women* in the home and powerless. Reverence . . . does not necessarily result from, or lead to, the high status or power of the revered object that is symbolically presented."[6] Contemporary anthropologists generally discount any arguments for the widespread existence of matriarchies in prehistory.

That there are biological differences between men and women is clear and undeniable. But biology alone does not determine the roles, activities,

and status differences between men and women in any given culture. "The chief importance of biological sex in determining social roles is in providing a universal and obvious division around which other distinctions can be organized."[7] Although every society has some sort of division of tasks for men and women, the assignment of any particular task to one sex or the other varies enormously from culture to culture. Biologically determinist theories are an inadequate explanation for the success of male dominance in early civilizations.

Suggestions for Further Reading

BARBER, ELIZABETH, *Prehistoric Textiles: The Development of Cloth in the Neolithic and Bronze Ages* (Princeton, NJ: Princeton University Press, 1991).

BARBER, ELIZABETH, *Women's Work: The First 20,000 Years: Women, Cloth and Society in Early Times* (New York: Norton, 1994).

CONKEY, MARGARET W., and JOAN M. GERO (eds.), *Engendering Archaeology: Women and Prehistory* (Cambridge, MA: Basil Blackwell, 1991).

COONTZ, STEPHANIE, and PETA HENDERSON (eds.), *Women's Work, Men's Property: The Origins of Gender and Class* (London: Verso, 1986).

EHRENBERG, MARGARET, *Women in Prehistory* (Norman: University of Oklahoma Press, 1989).

GADON, ELINOR, *The Once and Future Goddess: A Symbol for Our Time* (San Francisco: Harper and Row, 1989).

GIMBUTAS, MARIJA, *The Civilization of the Goddess: The World of Old Europe* (San Francisco: HarperCollins, 1991).

JOHNSON, BUFFIE, *Lady of the Beasts: Ancient Images of the Goddess and Her Sacred Animals* (San Francisco: Harper and Row, 1988).

ORENSTEIN, GLORIA FEMAN, *The Reflowering of the Goddess* (New York: Pergamon, 1990).

REITER, RAYNA R. (ed.), *Toward an Anthropology of Women* (New York: Monthly Review Press, 1975).

2

The Ancient Near East

THE NATURE OF THE EVIDENCE

Archeological Evidence

By the third millennium B.C. the subordination of women in a patriarchal social structure was well under way. A leading scholar of this period, Julia Asher Grève, has discussed the existence of a small population of upper-class women in the ruling families, some of whom served as high priest-esses. There existed an equally small middle class of women with married status whose spouses were priests, or temple or palace administrators. The largest group was composed of women employed in the temples and palaces, the working women.[1]

Examinations of skeletons show an average life expectancy of 25 to 35 years, with death due to childbearing accounting for the shortened life spans of women.

Written Records

In the culture of the "fertile crescent" in the ancient Near East, political power became centralized in the hands of male military leaders, and hierar-chical class stratification of the society began. Women were excluded from decision making and became another form of private property. The marriage laws that controlled women's lives to a great extent document this process. Parents arranged marriages. The groom paid a "bride's price" to the parents of the bride. Daughters from poor families were sold into marriage or slavery to improve the family's financial situation. After marriage the husband became undisputed head of the family. He could

divorce his wife quite easily or sell or pawn her and his children to pay off his debts. While husbands could maintain concubines, a wife's adultery became a crime punishable by death. Children, like wives, were considered property of economic value.[2]

There is no evidence for female infanticide in Mesopotamia because the more children a man possessed, the greater his economic worth became. Abortion was considered a serious crime, and the society encouraged numerous births. A woman who was a mother had higher status and better legal rights than a woman who did not have children.

Because the main occupation of most women was the bearing and raising of children, the education of daughters focused on instruction in household tasks, which included weaving, needlework, and music making. However, women were not totally excluded from the economy.

Women do seem to have had equal rights in some legal and financial transactions.[3] Wives had the right to use their own dowry after their husband's death. Therefore, some upper-class women were active in business affairs. Such women were literate and signed documents and contracts in their own names. They could buy and sell slaves and other forms of property. Women could act as witnesses in court. A few women were priestesses living in convents and conducting a wide variety of business affairs independently of men.

Lower-class women and female slaves were active in many types of jobs and contributed to the economic development of their societies in the ancient Near East. Women were scribes, midwives, singers, tavern keepers, and even chemists (thirteenth century B.C.). Records from as early as the third millennium B.C. show that women were brewers, cooks, and agricultural workers, occupations associated with women into the eighteenth century A.D.

One significant occupation of women in Mesopotamia continued to be the making of textiles, a laborious and time-consuming activity which, as noted in Chapter 1, could be done in the home and was therefore well suited to women. The fibers of flax, cotton, or wool first had to be cleaned and prepared and spun into thread. Then the thread was woven into cloth. Clothing was often decorated with embroidery. All of these tasks were the exclusive concern of women. Female slaves who were skilled weavers were highly valued and in great demand in the ancient Near East by the upper classes, which purchased fine garments, beautifully decorated. Such items were also economically valuable commodities for export.

The professional activities of women in the Near East were largely confined to women of the artisan and slave classes, who were forced to work for survival. In royal families, women practiced spinning and weaving, as well as embroidery and basket plaiting. But aristocratic women (as will be discussed in the chapter on the Middle Ages) performed these tasks for the domestic needs of the household, not as professional skills.

Visual Evidence

In contrast with the contemporary surviving visual evidence from Egypt (see Chapter 3), the roles in which women appear in images known to us from the ancient Near East are relatively few. Irene Winter notes the very limited number of public roles performed by women in Mesopotamian art. She suggests that the "general invisibility" of women does indeed reflect greater distinctions between the public and private definitions of gender roles than, for example, in imperial Roman art (see Chapter 6). With the notable exception of the priestess, women do not occupy important public roles in the surviving visual examples. This is also consistent with the few roles in which women appear in the epic literature of Mesopotamia.[4]

Seated women are most commonly presented as praying. Nudity is rare. "Working women are shown in scenes depicting weaving, harvesting . . . creating dairy products and caring for animals."[5]

As in Crete, women made pottery. A cylinder seal from the early third millennium B.C. shows women potters making vessels in what appears to be a workshop.[6] Basket plaiting was another craft practiced by women of all classes.

PRIESTESSES

Asher Grève has cataloged the figures of clothed women in "cultic settings." Women are shown donating statues as votive offerings and carrying different emblems or symbols of the deities. Asher Grève believes that most of these images depict priestesses. Some of the seated figures found in cultic settings, such as temples, were most likely donated by women of high rank. This is suggested by the fact that some of these women are seated on elaborate stools symbolizing an elite status. Such statues, presented to the temple on important religious occasions such as the temple's inauguration, could serve a variety of purposes. Women are shown in three roles in images of religious ceremonies: (1) high and middle rank priestesses, (2) queens and princesses representing the ruling family, and (3) offering bearers in religious ceremonies.[7]

- *Disk of Enheduanna*

Irene Winter has analyzed the information we can glean from this image. An inscription identifies Enheduanna as the wife of Nanan and the daughter of Sargon. She was En-priestess of the cult worship of the moon-god Nanna/su'en at Ur during the reign of her father, Sargon of Akade. On the left, a nude male figure pours a libation. The central figure of a woman, identified as Enheduanna, is facing toward the cultic activity. Her upraised hand is a gesture of pious greeting. Her cap with a rolled brim is identified

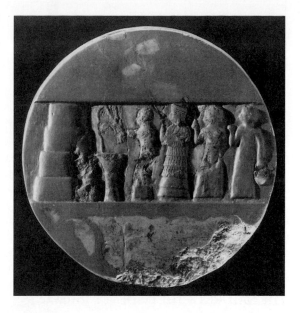

Fig. 2–1. *Calcite Disk of Enheduanna, Daughter of Sargon the Great.* *(University of Pennsylvania Museum, Philadelphia)*

with the headgear of priestesses. As En-priestess, she does not pour herself, but stands in worship while the male functionary performs the ritual act. Her head is the only one which touches the upper edge of the border, which is a sign of her importance.

Winter suggests that the stepped architectural form on the left is a symbol of the ziggurat of Nanna. From this and other evidence, Winter concludes that the office of En-priestess predates this disk. It is assumed that Enheduanna was "placed in the service of the moon-god precisely to consolidate the Akkadian dynasty's links with the traditional Sumerian past in the important cult and political center of Ur."[8] As daughter of Sargon, her Akkadian identity is important for the political consolidation of that dynasty. Her role as priestess, then, is a means of providing divine sanction for the legitimacy of the political rule of her family.

Suggestions for Further Reading

LERNER, GERDA, *The Creation of Patriarchy* (New York: Oxford University Press, 1986).

SEIBERT, ILSE, *Women in the Ancient Near East,* trans. Marianne Herzfeld (New York: Abner Schram, 1974).

3

Egypt

THE NATURE OF THE EVIDENCE IN IMAGES

Virtually all surviving images of women in Egyptian art occur in the context of temples, funerary monuments, and tomb art. Since all Egyptian art is idealizing, there are no portrait likenesses or deviations in anatomy from the standard, perfected types. There are two basic types for men, the slender youthful image as seen in the statue of Menkaure and Queen Khamerernebty II (Fig. 3–1), and an older, fuller figure with enlarged breasts and abdomen. Gay Robins identifies the second type with the successful official whose sedentary lifestyle and access to ample food permitted a weight gain as a mark of status. Women had only the single, slender image with no indications of the physical changes of childbearing.[1]

Skin color is a second convention that distinguishes men from women. Women's skin is usually a lighter yellowish-brown, while men's skin is a darker reddish-brown. This convention may have been a symbol for the realities of some women's lives. Since women's occupations were more frequently performed indoors, their skin may have been less colored by exposure to the sun. Light-colored skin, then, may have conveyed upper-class status since women living in wealthy families did not have to work outdoors at all. However, Robins warns that this is an artistic convention and not a reliable indicator of actual skin colors, which would most likely have varied widely in reality.[2]

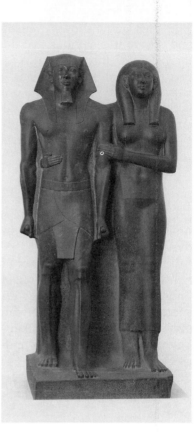

Fig. 3–1. *Pair Statue of Menkaure and His Queen.*
From Giza. Dynasty IV, 2599-1571 B.C. Schist.
Height (complete statue): 54½ in. *(Harvard
University-Museum of Fine Arts, Boston, Expedition.
Courtesy, Museum of Fine Arts, Boston)*

ROYAL WOMEN IN EGYPTIAN ART

• Pair Statue of Menkaure and Queen Khamerernebty II

The main role of Egypt's royal women was to complement the divine aspect of kingship through divine queenship. Both the "king's mother" and the "king's principal wife" played crucial roles in ritual. Based on analysis of headdresses and other insignia, Robins concludes that just as kingship was considered divine, there was also a concept of "divine queenship" spanning the entire history of Egyptian civilization.[3] However, there is evidence to dispute the position of some scholars that the pharaoh occupied the throne by marrying a female of the royal family. This "heiress" theory, according to Robins, simply cannot be supported by the surviving evidence since queens were frequently not of royal birth.

This statue shows a remarkably equal and balanced image of the king and queen. It is obvious that the queen is very important, even if she is not the "heiress" through which Menkaure achieved kingship. This sculpture reveals two other consistent elements in the gendered conventions of Egyptian royal imagery. The proportions of the queen are more slender, the definition of her musculature is less developed, and her legs are longer compared with the male figure. Furthermore, her extremely form-fitting clothing reveals the body beneath. By contrast, Menkaure's loincloth does conceal his genitals.

- Funerary Temple of Queen Hatshepsut at Dier el-Bahri

In many respects Hatshepsut (1504–1483 B.C.) was an exceptional and unusual woman who, benefitting from specific circumstances in the dynastic succession, emerged as a powerful leader on her own.

She was the daughter of Pharaoh Thutmose I. She apparently married her half-brother, Thutmose II, since she appears on a stele with the title of "principal wife" and "God's Wife" of Thutmose II. This is a case in which succession was contained within the royal family. Robins explains this practice as a way of mimicking the behavior of the gods. For example, in Egyptian mythology, Osiris and Isis were a brother and sister who married.

Fig. 3–2. Funerary Temple of Queen Hatshepsut, Dier el-Bahri. *(Foto Marburg/ Art Resource, NY)*

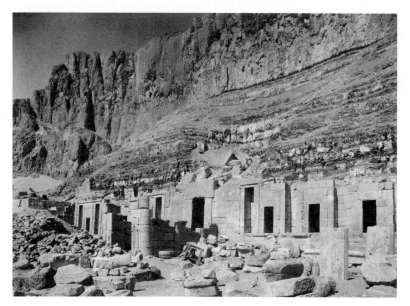

This distinguished the king from other mortal Egyptians, who did not marry their sisters.

The successor of Thutmose II was Thutmose III, who must have been a boy since his reign is recorded as lasting 54 years. Records also indicate that Thutmose III was not Hatshepsut's son.

For the first years of Thutmose III's reign, Hatshepsut served as regent, but when Thutmose III grew old enough to assume the rule independently, Hatshepsut did not relinquish power and step down as regent but, using the precedent of a co-regency, reigned as "king" jointly with Thutmose III. This joint "kingship" lasted from year 7 to year 22 in the reign of Thutmose III. At the beginning of the regency, Hatshepsut used the titles and insignia of "king's principal wife," although she preferred the title of "God's Wife." After year 7 in Thutmose's reign, she abandoned all references to her role as queen and adopted the full range of titles and insignia of a king, even appearing on monuments in the body type and costume of the king.

Hatshepsut had one daughter, Neferura, who is most frequently recorded as "God's Wife." The exceptional prominence of a daughter may be due to the unusual circumstances of her mother's rule. Hatshepsut needed her daughter to fulfill the ritual role normally played by a king's mother or king's principal wife. Hatshepsut, who defied tradition, is clearly exceptional; no other woman in the span of 3,000 years of Egyptian history assumed such power and for such a long period of time. In fact, only 4 of the 200 to 300 Egyptian rulers were female.

One measure of the success of her reign is her building activities. She supervised construction of the temple to Amun at Karnak. She ordered a pair of obelisks for this temple, an act that was strictly the prerogative of the king, and had herself depicted presenting offerings directly to the gods. Most important, she had the impressive mortuary temple at Dier el-Bahri constructed. In this temple, designed for her funerary cult rituals, reliefs illustrate the achievements of her reign. Prominently featured is the successful trading mission to the land of Punt in east Africa, which was a source of incense and other valuable goods. This temple is the only example of a large-scaled stone architectural monument built by a woman ruler. It is tangible evidence of the political power wielded by Hatshepsut as "king" of Egypt.

- Stele, Altar at Amarna

Amenhotep IV, who changed his name to "Akhenaten," is well known for a major shift from the polytheism of Egyptian religion to a monotheistic worship of the single god Aten, symbolized in the sun disk.

His "principal wife" Nefertiti was extremely important in his reign since "no other queen was ever shown so frequently on the monuments, in temples, tombs and statuary."[4] Her importance in the Aten religion is documented by her appearance in the temple at Karnak, presenting

Fig. 3–3. Stele, Altar at Amarna,
Nefertiti and Ahknaten.
(© Staatliche Museen zu Berlin,
Preußischer Kulturbesitz, Ägyptisches
Museum)

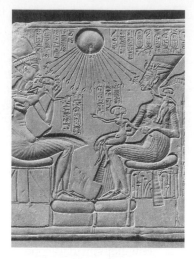

offerings directly to the god Aten. This relief was part of a household altar in the palace at Amarna. Nefertiti is depicted in the same scale and as an equal partner with Akhenaten. Both king and queen are seated below the symbol of the new god, forming a triad, such as the famous example of Menkaure between two goddesses. Other textual evidence shows that Nefertiti functioned as an intercessor, much like the Virgin Mary, between common people and the new male god, bridging the gap left by the abandonment of the traditional pantheon of goddesses.

The tall blue crown in the famous bust of Nefertiti (now in Berlin) was a unique royal insignia. Early in her reign, Nefertiti wore insignia commonly associated with queens. However, later on she was sometimes depicted wearing crowns identical to that of the king and in poses and situations borrowed, like Hatshepsut, from the king's iconography.

REPRESENTATIONS OF WOMEN IN TOMB PAINTINGS

One important function of tomb paintings was to provide a setting for the rebirth of the tomb owner in the next world. Representations of women in tomb paintings must be interpreted in this context.

- Scene from Tomb of Menna, *Spearing Fish and Hunting Birds*

This scene, common in tomb paintings from the Old Kingdom throughout the Eighteenth Dynasty, usually combines two motifs. The tomb owner hunts birds with a throwstick and spears two fish. The marsh setting carries associations with Hathor, the cow goddess, and the primordial swamp from which it was believed the mound of creation arose. The lotus,

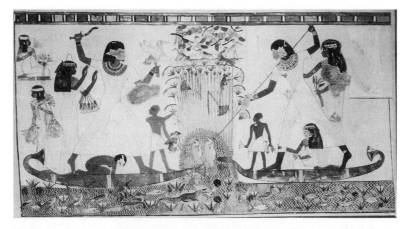

present here in abundance, was a common symbol of rebirth. Hunting the wild fowl symbolizes the ability of the tomb owner to establish order from the chaos of natural forces. Fowling was an activity associated with the god Osiris, who was resurrected after his murder by his sister, the goddess Isis. Isis would conceive a son with Osiris, the falcon god Horus. She gave birth to Horus in the marsh of Khemmis, where wild fowl abound.

The fish, the tilapia, was also a symbol of rebirth, associated with Hathor. It was believed to accompany and protect the sun god in his journey and is invoked in the text of *The Book of the Dead.*

Female members of the family appear prominently in these representations. Their presence may be interpreted not merely as a genre element but as crucial to the successful rebirth of the tomb owner and here function as "representative[s] of the female generative principle of the universe."[5]

• Tomb of Nebamun, Banquet Scene

Banquet scenes, which depict the deceased tomb owner and guests participating in a ritual meal, were common tomb decorations in the Eighteenth Dynasty.

As discussed in relation to the sculpture of Menkaure and Khamerernebty II (Fig. 3–1), the costumes of men and women were clearly differentiated in Egyptian artistic conventions. In the New Kingdom, during the Eighteenth Dynasty, the visual representations of female costumes began to change to pleated looser fitting drapery, which reflects the styles in actual dresses which have survived from this epoch. Linen cloth, worn loosely, would tend to conceal the body. The "sheath" dress, then, was an artistic convention and not a reflection of the daily realities of clothing. A costume

Fig. 3–5. Wall Painting, *"Scene from a banquet,"* Tomb of Nebanum. *(Copyright The British Museum, London)*

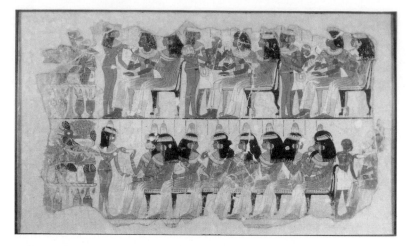

that obscures the form of the body beneath is visible in both these tomb paintings. While goddesses continued to be shown in the sheath dress, other images of women adopt this looser style.

This tomb painting is of further interest in that it contains three nude adolescent serving girls wearing only headdresses, jewelry, and a thin belt around the waist. The nakedness of young girls is very rare in Egyptian art and has no counterpart in male figures, who are never shown completely undressed. Small children of both sexes, however, were usually depicted without clothes. In other paintings and sculptures, nude adolescents wear an amulet associated with Bes, the deity entrusted with the protection of women in childbirth and newborn infants.

Robins relates the banquet scene of the image to the ritual meal eaten at the tomb at the time of burial and annually following the tomb owner's death. Since the ancient Egyptian verbs "to pour" and "to impregnate" were identical, she concludes that acts of pouring might be references to fertility, birth, and rebirth. The nudity of the girls is linked to such generative ideas, essential for the immortality of the tomb owner's soul. Robins concludes that such banquet scenes carry associations of sexuality relative to birth and rebirth. The presence of these serving girls would facilitate the rebirth of the deceased tomb owner.[6] Similar images also appear in the decoration of mirror handles, cosmetic containers, and ritual spoons.

Nudity in Egyptian art is linked to both sex and class. Only lower-class women appear in representations without clothes. Men and elite women are never depicted nude. However, as we have seen in the Queen's image in Figure 3–1, fertility of women is significant, so "the device of transparency was adopted to indicate the pubic area through the material of

the dress."[7] The symbols of fertility in this world are linked in both tomb paintings and funerary art to the desired rebirth in the next world.

Suggestions for Further Reading

CAMERON, AVERIL, and AMELIE KUHRT (eds.), *Images of Women in Antiquity* (London: Croom Helm, 1983).

LESKO, BARBARA (ed.), *Women's Earliest Records from Ancient Egypt and Western Asia* (Atlanta, GA: Scholar's Press, 1989).

MANNICHE, LISE, *Sexual Life in Ancient Egypt* (London: Routledge, 1987).

ROBINS, GAY, "Dress, Undress, and the Representation of Fertility and Potency in New Kingdom Egyptian Art," in Natalie Boymel Kampen (ed.), *Sexuality in Ancient Art* (New York: Cambridge University Press, 1996).

ROBINS, GAY, *Women in Ancient Egypt* (Cambridge, MA: Harvard University Press, 1993).

4

Crete

THE NATURE OF THE EVIDENCE

Surviving archeological remains on the island of Crete are more elaborate and better preserved than other early Bronze Age civilizations. This visual evidence is connected mainly with large architectural complexes, such as the palace at Knossos. Since the vast majority of evidence comes from palaces, sites of the wealthiest elite of the society, the frescoes would clearly reflect the values and interests of this particular class. It is highly speculative to pinpoint, from the surviving archeological remains, the exact functions and purposes of the different spaces, so it is unwise to rely too much on designations such as "Queen's bedroom" attributed to certain spaces by the original archeologist who supervised the excavation, Sir Arthur Evans. One aspect of the palaces that is undeniable, however, is their chosen physical location. Vincent Scully has convincingly argued that the selection of Minoan palace sites and their architectural orientation were dependent on the relationship of the surrounding landscape to the "body" of the Earth Mother. All Cretan palaces were located in an enclosing valley and oriented to a conical hill and double-peaked or cleft mountain in the distance. The closer cone was perceived as the body of the Great Mother Goddess. The horns of the more distant mountain created a profile evocative of a pair of horns, raised arms, the *mons Veneris* or a pair of breasts of the Great Goddess.[1] In the courtyard of Knossos, from which Mount Jouctas is visible, young men and women performed the famous bull dances, seizing the horns sacred to the goddess. Thus, locations of Cretan palaces were determined by their proximity to the center of life and the divine powers of the Earth Mother Goddess.

PALACE FRESCOES

Many of the walls of these palaces were decorated with frescoes, in which women are depicted more frequently than are men. Women are included as spectators in scenes of crowds observing an event, and sometimes women occupy the front row of seats. In a famous example, the "bull-leaping" scene, one of the figures is usually identified as a woman, based mainly on the lighter color of her skin.

It is believed that this culture may have demonstrated a relatively high status for women. Minoan women had access to all professions, including the manufacture of their famous pottery, which was distributed throughout the ancient world.

- Snake Goddess

Further evidence of the role of women in Crete can be found in small-scaled sculptures. A number of these statuettes, made of terra cotta or faience (a glass-like material), have been located on Crete. They share some consistent elements: The women wear long skirts but reveal their breasts, their arms are outstretched, and snakes are entwined about their arms.

Ehrenberg looks at the archeological context in which such figures were found to help interpret their meaning. They were excavated within the palaces in rooms with raised structures thought to be altars. They have also been found in caves on top of certain mountains. Furthermore, similar representations have been found in frescoes, sarcophagi, and other small-scale objects, in which the figure appears to be venerated by a group of people, mainly women. Ehrenberg accepts these images as either an effigy of a goddess or a priestess devoted to the worship of a goddess. She rejects their interpretation as images of the queen, perhaps in the role of priestess or goddess, due to differences between the dress and hairstyle of these sculptural figures and other visual evidence in depictions of ordinary people. These statuettes, therefore, document female participation as divinity and priestess in Minoan society.[2]

WAS CRETE A MATRIARCHY?

Despite the longings or wishful thinking of some scholars it would appear unwarranted to identify Crete as a matriarchy. Based on the archeological evidence, it is not valid to assume that Crete was ruled by a female leader or that women occupied a higher status than men. However, we can safely assume that upper-class women participated in a wide range of activities. It is likely that a female divinity was worshiped and women were predominant in the role of priestess in the cult worship of a Mother

Fig. 4–1. Snake Goddess, Palace at Knossos. c. 1600 B.C. Height 13½ in. (Archaeological Museum, Heraklion, Crete. Courtesy of Hirmer Verlag München)

Goddess. In fact, there is no solid evidence for identifying any culture in antiquity as a "matriarchy."

Suggestions for Further Reading

EHRENBERG, MARGARET, *Women in Prehistory* (Norman: University of Oklahoma Press, 1989).

SCULLY, VINCENT, *The Earth, the Temple and the Gods: Greek Sacred Architecture*, rev. ed. (New Haven, CT: Yale University Press, 1979).

5

Greece

THE NATURE OF THE EVIDENCE

A wide range of visual and textual documents are extant from Greek civilization, especially dating from the classical era of the fifth century B.C. From this wealth of sources, it has been possible for scholars to formulate a more complete picture of women's lives and the relations between men and women, mainly in Athens, than from earlier civilizations. The status of Greek women in the culture of the classical era (fifth century B.C.), especially in Athens, seems to have been very low, and this may be explained by a number of factors. Particularly among the upper classes, a sharp separation existed between the men's public world and the women's domestic one, a situation similar to that in modern capitalist cultures. While men were occupied with running the Athenian democracy and waging almost continual warfare, upper-class women rarely left their homes. There is a scholarly consensus that Athenian women "led sequestered lives indoors with only occasional trips to the fountain house to fetch water or to the gravesite to mourn the dead."[1] They remained in segregated quarters, often on the upper story of town houses. While boys were taught the arts of rhetoric and other intellectual pursuits, girls learned domestic crafts from their mothers. The age discrepancy between husband and wife and the gaps between the education of men and women further intensified the isolation between the sexes in Classical Athens.[2] As we know, women were excluded from any form of political participation in the city-state or *polis*. Women were ranked with those men who, accused of a serious crime, were deprived of political rights.[3]

The Athenian woman, daughter of a citizen, always had a dowry that was meant to remain intact when she married. The dowry provided her

with some degree of economic security. In the absence of sons, a daughter could legally inherit the family wealth, but the nearest male relative was supposed to marry the heiress. While women could acquire property through their dowries or by inheritance or gift, they had no legal rights. Women could not conduct business or sign contracts for major sums. Furthermore, because few women were literate, it was virtually impossible for women to conduct a business enterprise independently of men.

Greek women of all classes were occupied with the same types of work, mostly centered around the domestic needs of the family. Women cared for young children, nursed the sick, and prepared food. Wealthy women supervised slaves who did these tasks. Poorer women who could not afford to remain at home worked for wages at these jobs. There is evidence that some lower-class women sold retail goods in the marketplace.

Archeological evidence indicates that the Greeks practiced female infanticide and that males outnumbered females by at least two to one.[4] This smaller proportion of females surviving infancy extends from the Greek Dark Ages (1100–800 B.C.) through the classical and Hellenistic periods. By the Hellenistic era (fourth to first centuries B.C.), even fewer children of either sex were raised to maturity. A Greek girl who survived infancy was fed an inferior diet.

WOMEN AND WEAVING

- Amasis Painter, *Lekythos*

Throughout this period in the Greek world, one of the major tasks of women was the weaving of textiles and their decoration. Women of all classes contributed to the making of cloth. Wealthy women and slaves worked in their homes, while poorer women earned wages as wool workers in the cloth industry. Spindles used to spin flax or wool into thread have been found in graves from the Dark Ages, identifying these as burial places of females.

In the Homeric epics, many female figures, including Helen and Penelope, are occupied with spinning and weaving. Penelope, the wife of Odysseus, spends her days weaving a shroud for Laertes, Odysseus's father, and unraveling it at night to evade her suitors. This is her primary activity, and can serve as an example of the importance of weaving in the life of the Greek upper-class woman. In fact, textile manufacture was a primary occupation for women throughout the ancient world. As noted before, women of all classes in the ancient Near East made textiles. Phoenician women were famous for their fine cloths. In the excavations of Troy, many weaving tools have been found. Representations on Greek vases of women spinning or weaving far outnumber the pictures of other crafts. For example, the black-figured painting on this *lekythos* (Fig. 5–1) illustrates

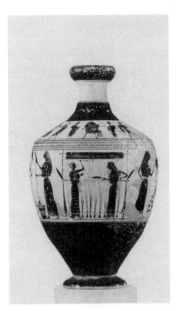

Fig. 5–1. Attributed to The Amasis Painter, *Lekythos.* Women working wool. Attic vase, c. 560 B.C. Height 6¾ in.

women occupied in a variety of tasks related to the making of cloth. On one side of the vase (not illustrated), women are shown cleaning the wool, and combing it into "long, fluffy, sausage shaped rolls for easy spinning." On the side illustrated here, women are actually weaving the wool on a warp-weighted loom. Of interest to us is the further identification of this scene as the weaving of the Panathenaic peplos, to be discussed below. As Barber notes "This interpretation is supported by the decoration of the shoulder (the upper curved portion of the vase, known as the neck) where eight female dancers and four youths approach a seated woman with a wreath who could well be an enthroned goddess."[5]

- Attic Red Figure Vase Painting, *Procession to the Nuptial Bed*

Athenian girls were married between the ages of 12 and 15; men were usually married at 30. Such young marriages forced women into early pregnancies, further threatening their survival. The shortage of women plus the practice of female infanticide also ensured that women would have multiple pregnancies. Many women did not survive the childbearing years, and women's life expectancy was five to ten years shorter than men's. One may conclude that only a fraction of the female population lived long enough to practice any profession without being pregnant or responsible for the care of small children.

The future of the bride was thus one of enforced isolation and multiple pregnancies of great danger to the woman's survival. In this context, this example of a wedding scene acquires new meaning. Wedding

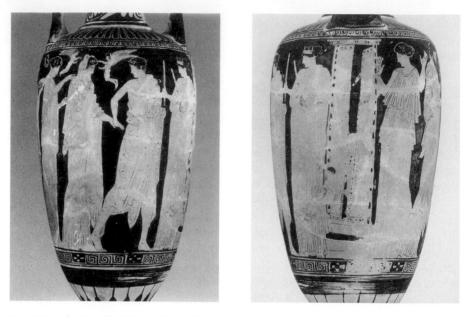

Fig. 5–2. Athenian Red Figure Vase Paintings, *Bridal Procession* and *Father and Son Bidding Farewell.* c. 430 B.C. Height 0.753 m. Diameter (of body): 0.18 m. *(Francis Bartlett Donation; Courtesy, Museum of Fine Arts, Boston)*

scenes depicted in the classical period are frequently on a ritual water jar, known as a *loutrophoros.* These vases were used to carry water for the bridal bath from a special spring. In this example, several figures of Eros are flying about the head of the bride and, according to Robert Sutton, adorning her with a wreath and a necklace. Another winged eros is zooming out from the bridal chamber. Sutton has noted that marriage to an Athenian woman was most important since this was the only way to produce legitimate children with full citizenship rights. Therefore, the acceptance of sexual relations between husband and wife carried political implications.[6] The romantic elements in this scene might have encouraged young women to accept the sexual elements of marriage, which were part of their social responsibilities in this culture.

• Domestic Scene

This vase illustrates the central roles of the upper-class married woman: bearing and caring for children and making textiles in a nonprofessional, domestic context. It is another example of the prominent association of textile manufacture with the activities and responsibilities of women, as has already been discussed.

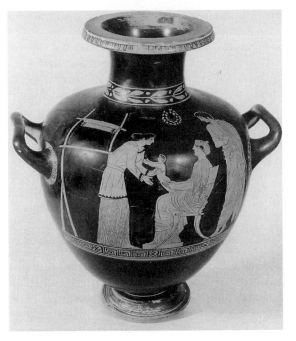

Fig. 5–3. Painter of the Polygnotan Circle, Domestic Scene. c. 430 B.C. Red-figure ceramic, 34.6 × 24.6 cm. *(Courtesy of the Arthur M. Sackler Museum, Harvard University Art Museums, bequest of David M. Robinson)*

The central figure is seated on a chair and is handing her baby to a female servant. She is flanked by an adolescent male (presumed by Dyfri Williams to be an eldest son) and a loom.[7] This vase was believed to have been found in a tomb and would therefore have been a gift for the deceased presented by a member of the family.

Women were not only responsible for the manufacture of cloth but also for its decoration. Embroidery was an exclusively female occupation in Greece. In the decoration of textiles, women were the tastemakers of antiquity. Here, they had an outlet for their visual creativity. In the 1930s Kate McK. Elderkin built a convincing case for the influence of textile patterns and decoration on the successive stylistic development of Greek pottery design.[8] She maintained that the geometric style, as seen in the Dipylon pottery vases of the eighth century B.C., was derived from the ornamental patterns found in Dorian wool fabrics. Not only the specific forms, but also the use of bands, are consistent with the weaving of wool fabrics. Ornamentation in bands is a noteworthy characteristic of Corinthian ware, such as the famous *François Vase*. In the later Archaic period, that is, the sixth century B.C., fashions changed and the less decorated linen *chiton* of the Ionians gained popularity. The painted decoration on pottery subsequently became less ornate, and the influence of weaving became less pronounced in this epoch.

Barber confirms this close relationship between pottery designs and the weaving patterns in Archaic Greece, arguing for the decisive impact of textile decoration on contemporary vase painting.[9] Athena was the patron goddess of both weavers and potters, connecting both of these activities with women. However, by the Classical era it was mostly men who made pottery. Some women did continue to practice this craft. A woman, shown decorating a vase on a Greek red-figured *hydria* from the fifth century B.C., is depicted in a workshop setting, documenting the participation of women in pottery manufacture.

- Peplos Scene from the Parthenon, East Frieze, *Women and the Panathenaia*

Extensive scholarship focused on the festival known as the "Panathenaia" has provided a much more complete picture of the role of women in this state-sponsored week-long celebration in honor of the goddess Athena, patron of the city of Athens. This festival occurred annually, but every four years it was "celebrated with special pomp, and referred to as the 'great' festival."[10] Given the general sequestred isolation of upper-class Anthenian women, the Panathenaia provided women with a rare opportunity to be seen in public. As Jenifer Neils notes: "Perhaps the greatest impact of the Panathenaia was felt by the women of Athens since it was a festival in which they played a major role."[11]

Women serviced the cult of Athena in several capacities. Women of the aristocratic class were involved in especially important ways in the rituals conducted for the worship of Athena. The priestess of Athena Polias was "an office held for life and passed through the female line of the aristocratic clan known as the Eteoboutadai . . . who claimed to be the direct descendants of the Athenian royal family."[12] The priestess supervised younger women and others active in the cultic rituals. One of the most important tasks of these young women was the weaving of a ritual robe known as the *peplos* for a statue of Athena, housed in the Erechtheion. Two young girls selected from among the noble families of Athens would spin the yarn for the cloth. Other women then assisted in the weaving and embroidering of this holy garment. The culmination of the Panathenaic procession was the presentation of this *peplos* to the statue of Athena, as depicted in this scene from the east frieze (Fig. 5–4). Young women also prepared offering cakes for sacrifice to Athena and served as basket bearers in the Panathenaic procession.

Barber has provided a detailed discussion of the appearance of the *peplos.* She believes that it was saffron colored, and decorated with a scene of the battle of the gods and the giants. She believes that this ritual dates back into the Bronze Age, when textiles were at the core of the Aegean economy and thus female producers had more economic importance than

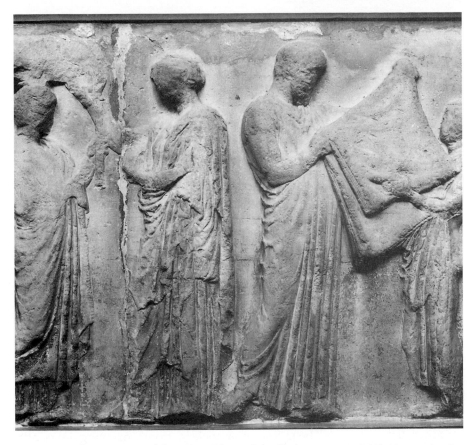

Fig. 5–4. *Peplos* Scene, Panel from East Frieze of the Parthenon. *(British Museum, London, Great Britain)*

in the Classical era of the Parthenon and the Athenian *polis* or city-state under consideration. She concludes that the weaving of the *peplos* was a central ritual for the women of Athens to the goddess Athena. "She was their particular patron goddess, and to her they rendered the most appropriate gift they could make, a saffron robe: a splendid piece of weaving celebrating Athena and thanking her for one of her most famous deeds, the destruction of the world-threatening giants." [13]

The *peplos* scene was positioned directly in the center of the east façade, in front of the main entrance to the cult chamber. Both Robin Osborne and Eva Stehle and Amy Day consider this scene from the point of view of the female spectator, who would be standing in front of the east doors of the Parthenon. Osborne stresses the sense of religious awe evoked by the vision of the huge statue, which would be visible right below the scene.[14] Stehle and Day note that the *peplos* is actually handed over to a

man: "A man intervenes between the women's production of the peplos and the gift of it to the goddess, and this intervention is singled out by the iconography as essential: a gift from the city as a whole is a gift from men, for human women may not/cannot represent the city." [15]

Osborne considers this portion of the frieze in the context of the other sculptural decorations of the Parthenon as an integrated program, which included the battle with the Amazons figured in the metopes. Although she does not draw any definite conclusions, she does read the entire sculptural program with the understanding that both men and women in Athens would have been "aware that the part which an individual played in Athenian life, both public and private, was determined in crucial ways by their gender." [16]

THE "HISTORY OF SEXUALITY" IN CLASSICAL ATHENS

For the culture of classical Athens, scholars have been able to study the earliest interpretations of the "history of sexuality." Such a concept is possible because a wide range of sexual behaviors is tolerated, permitted, and accepted in any given culture. As we discussed in the introduction, "sex" is to a great extent not a "natural" phenomenon, but rather behaviors enacted repeatedly by individuals, which vary in different societies. Sexuality, then, is a question of culture: "Sexuality is that complex of reactions, interpretations, definitions, prohibitions and norms that is created and maintained by a given culture in response to the fact of the two biological sexes."[17] If we accept this view of sex, then it follows logically that there can be a "history of sexuality" in which scholars attempt to reconstruct the attitudes toward sexual behavior of a society, from surviving texts and images.

CLASSICAL SCULPTURE AND NUDITY

The Adolescent Male

Michel Foucault is one of the most important scholars who has analyzed surviving written texts to study the history of sexuality in Greek and Roman culture. Foucault identifies the relationship between adult men and adolescent boys as the location or "site" of classical Athens's "problematizations" of sexual relations. There is nothing that "prevented or prohibited an adolescent from being the openly recognized sexual partner of a man . . . there is every indication that they [the Greek writers] were anxious about it." [18]

It is this philosophical and ethical background that should be brought to bear on the interpretation of the preponderance of ideal male nudes in the classical era. Works such as *The Kritios Boy* and the *Doryphoros* are famous examples of the nude adolescent male body presented as objects of

aesthetic pleasure in works of art created by male artists and targeted at the male viewer. As Foucault concludes: "The young man—between the end of childhood and the age when he attained manly status . . . his youth with its particular beauty (to which every man was believed to be naturally sensitive) . . . and the status that would be his . . . formed a 'strategic' point around which a complex game was required."[19] This definition of the adolescent male as an object of sexual attraction is paralleled in the history of art with the preponderance of male nudity observable in monumental sculpture.

The Female Nude

- Praxiteles, *Aphrodite of Knidos*

It is not until the fourth century B.C., outside of the culture of classical Athens, that the female nude first appears as an appropriate subject for

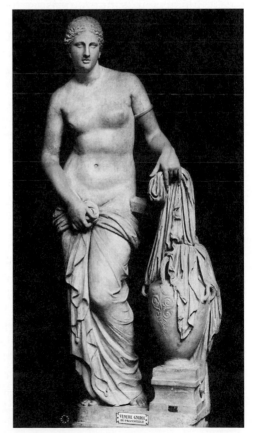

Fig. 5–5. *Aphrodite of Knidos*. Roman copy after an original of c. 330 B.C. by Praxiteles. Marble. Height 6 ft. 8 in. *(Vatican Museums, Vatican State; Alinari/Art Resource, NY)*

sculpture. That extremely special case can be pinpointed to the work of the sculptor Praxiteles, who created two cult statues of the goddess of love, Aphrodite. The citizens of the city of Kos selected the clothed version, while the nude sculpture was placed on the island of Knidos, in a circular temple so it could be appreciated from a full range of viewpoints. In this sculpture, existing only in later Roman copies such as this image, Aphrodite was depicted as a bather. Female nudity was believed to have "aphrodisiac" powers, that is, the ability to arouse sexual feelings in the viewer deriving from the power of the goddess of love. The myth of Pygmalion who fell in love with his sculpture is echoed in a story retold by Roman authors about this statue. A dark blemish on the statue was left by a youth who, locked in the temple overnight, supposedly had intercourse with the statue.[20]

WOMEN ARTISTS IN GREECE

Considering the severe restrictions on women's lives, their inability to move freely in society, conduct business, or acquire any type of nondomestic training, it is not surprising to find that no names of important artists have come down to us from the classical era. Only the poet Sappho (c. 600 B.C.) received high praise from the Greeks; Plato referred to her as the twelfth Muse. Significantly, she came not from Athens or Sparta but from Lesbos, an island whose culture incorporated a high regard for women.

While very few artists' names of either sex survive from antiquity, the earliest recorded names of women painters are found in Hellenistic texts. Unfortunately, none of the works of these artists has survived. In 228 B.C., Nealkes of Sicyon had his daughter trained as a painter.[21] Another Greek painter known by name alone was Eirene, daughter of Kratinos, who was famous for painting in the city of Eleusis. Eirene is singled out for special mention in Boccaccio's *Concerning Famous Women*.[22] Boccaccio's treatise, largely dependent on the Roman historian Pliny, is a very important Renaissance source, preserving for his era the names of notable women of antiquity. Boccaccio also mentions Thamyris, or Timarete. This artist's reputation was based on a painting of the goddess Diana, guarded at the sanctuary in Ephesus. It is, of course, possible that women were painters in earlier periods and that their names, like those of their male colleagues, have simply been lost in history. To my knowledge, no evidence of women sculptors or architects in the ancient world has survived.

Long before the appearance of women painters in literary records, women had been credited in legend with the invention of this art. In both Eastern and Western cultures, the origin of the art of painting is attributed to the observation of a shadow and the tracing of that outline. By the time Pliny recorded the legend, the inventor of painting was identified as a woman,

that is, the "Corinthian Maid." The Maid traced her lover's profile on a wall. Subsequently, her father, the potter Butades, built up the work into a sculpture. The Corinthian Maid is often called "Dibutade," the daughter of Butades. A variation of this legend is recorded by Athenagoras, a Christian Athenian of the second century A.D. The first artist is now called "Core."

The legend of the Corinthian Maid was first widely used as a subject for the visual arts during the era of romantic classicism, in the late eighteenth century A.D. One art historian, Robert Rosenblum, believes that the increased popularity of the story of Dibutade at that time is related to the prominence of contemporary artists such as Angelica Kauffman and Elisabeth Vigée-Lebrun.[23] The careers of these artists are discussed in Chapter 10.

The legend of Dibutade and the preservation of the names of these women painters from the past have immense importance for the history of women artists. Despite their limited number, these notable painters served as role models for women artists from the Renaissance through the nineteenth century. Eirene, Timarete, and the other women recorded by Pliny and included in Boccaccio's study were incorporated into many subsequent histories of women artists.[24] Even though their works were lost, their reputations remained alive, preserving the idea that women could become excellent painters.

Suggestions for Further Reading

AVERIL, CAMERON, and A. KUHRT (eds.), *Images of Women in Antiquity* (London: Croom Helm, 1983).

CANTARELLA, EVE, *Pandora's Daughters: The Role and Status of Women in Greece and Roman Antiquity* (Baltimore, MD: Johns Hopkins University Press, 1987).

FANTHAM, ELAINE, HELENE PEET FOLEY, NATALIE BOYMEL KAMPEN, SARAH B. POMEROY, and H. ALAN SHAPIRO, *Women in the Classical World: Image and Text* (New York: Oxford University Press, 1994).

FOUCAULT, MICHEL, *The Use of Pleasure: The History of Sexuality*, vol. 2, trans. Robert Hurley (New York: Random House, 1985).

HAWLEY, RICHARD, and BARBARA LEVICK (eds.), *Women in Antiquity: New Assessments* (New York: Routledge 1995).

JOHNS, CATHERINE, *Sex or Symbol? Erotic Images of Greece and Rome* (Austin: University of Texas Press, 1982).

KAMPEN, NATALIE BOYMEN (ed.), *Sexuality in Ancient Art* (New York: Cambridge University Press, 1996).

KEULS, EVA C., *The Reign of the Phallus* (New York: Harper and Row, 1985).

LEFKOWITZ, MARY, *Women's Life in Greece and Rome: A Sourcebook in Translation*, 2nd ed. (Baltimore, MD: Johns Hopkins University Press, 1992).

NEILS, JENIFER (ed.), *Goddess and Polis, The Panathenaia Festival in Ancient Athens* (Hanover, NH, and Princeton, NJ: Princeton University Press, 1992). Essays by E. J. W. Barber, "The Peplos of Athena," and Neils "The Panathenaia: An Introduction."

PERADOTTO, J. (ed.), *Women in the Ancient World* (Albany: State University of New York Press, 1984).

POMEROY, SARAH B., *Goddesses, Whores, Wives and Slaves: Women in Classical Antiquity* (New York: Schocken Books, 1975).

POMEROY, SARAH B., *Women's History and Ancient History* (Chapel Hill: University of North Carolina Press, 1991).

RABINOWITZ, NANCY SORKIN, and AMY RICHLIN (eds.), *Feminist Theory and the Classics* (London: Routledge, 1993).

RICHLIN, AMY (ed.), *Pornography and Representation in Greece and Rome* (New York: Oxford University Press, 1992).

WALLACE-HADRILL, A. (ed.), *Patronage in Ancient Society* (London: Routledge, 1989).

6

Rome

THE NATURE OF THE EVIDENCE

Feminist art historians studying the visual evidence in the Roman Empire have expanded our knowledge and understanding of the roles of Roman women, especially of the elite class. As more research is published, we are beginning to form a fuller picture of the roles that women could occupy in Rome. As Diana Kleiner notes, "unlike their earlier Greek counterparts, they [Roman women] played an active role in public and private life. Roman women could own property, inherit estates and run family businesses. . . . Roman women were not confined to their homes, as Greek women had been, but mingled freely in the marketplace, went to the theater or amphitheater, and bathed in public baths."[1] As scholars turn their attention to the participation of women in Roman society we are creating a fuller, more complete picture of the contributions of women in the political, economic, and cultural life of Rome. To achieve this goal, the roles of images of women are extremely important, as is the acknowledgment of the part that elite women played for the visual arts as patrons.

We know that lower-class women practiced a number of occupations. In Pompeii, there were women physicians and "commercial entrepreneurs," as well as prostitutes, waitresses, and tradeswomen. Slaves worked as domestics and, as already noted, in the clothing industry. "Freed women and female slaves worked as fishmongers, barley-sellers, silk weavers, lime burners, clothes-menders . . . as midwives and nurses . . . stenographers, singers, and actresses, among other professions."[2]

Spinning and weaving continued to be a major preoccupation of women of all classes: "The old-fashioned Roman bride wreathed the doorposts of her new home with wool. When Augustus wished to instill

respect for old-fashioned virtues among the sophisticated women of his household, he set them to work in wool and wore their homespun results. Many women of the lower classes, slave and freed, were also employed in working wool both at home and in small-scale industrial establishments where working-class men joined women as weavers and weighers of balls of wool to be apportioned to weavers. Spinning, however, continued to be solely women's work."[3]

Iaia of Kyzikos (known as Marcia to Boccaccio) is the only name of a Roman woman artist that has been preserved. According to Roman historian, Pliny, "She painted chiefly portraits of women. . . . No artist worked more rapidly than she did, and her pictures have such merit that they sold for higher prices than those of Sopolis and Dionysios, well-known contemporary painters. . . ."[4]

Considering the wide variety of occupations practiced by Roman women, there may well have been other women painters whose names have not come down through the centuries. At any rate, the fact that Pliny recorded for posterity the names of a handful of women painters is a mark of the increased respect the Romans had for women of talent.

IMAGES OF WOMEN ON HISTORICAL RELIEFS

• Family of Emperor Group on *Ara Pacis*

Diana Kleiner addresses the question of the unusually prominent appearance of women and children in the processional friezes of the *Ara Pacis*.[5] Unlike the Parthenon frieze, which is clearly a visual prototype, family groups form an important part of the procession. Following Augustus, there are three groups of men, women, and children on the south side of the monument and two additional groups with children on the north side. Such prominent displays of family groups are unprecedented in earlier republican art forms, although prototypes in Greek funerary stelae do exist.

The display of family groups in public sculpture should be understood in the context of Augustus's policies as documented in a series of laws intended to strengthen and preserve the nuclear family of the upper-class patricians. The *lex Julia de adulteriis* brought adultery under court jurisdiction and out of the private sphere, reinforcing marriage bonds. Another law, the *lex Julia de maritandis ordinibut,* as well as other legal measures, removed existing restrictions on marriage and was intended to stimulate the raising of children. Many social policies favored married men with large numbers of children. For example, in the case of a tie for an electoral office, the man with the most children would be declared the winner. Celibacy and childlessness, both of men and of women, were penalized financially in the existing tax structure.

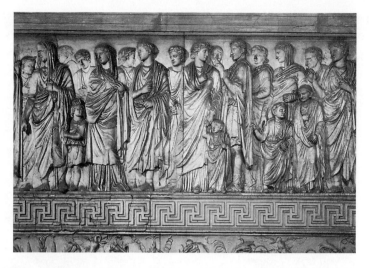

Fig. 6–1. Family of Emperor Group on *Ara Pacis*.　　*(Museum of the Ara Pacis. Rome, Italy)*

The legendary Cornelia, who lived in the second century B.C., provided a cultural ideal for women as mothers. Cornelia was considered a paragon of virtues: "She possessed an excellent Greek education, was a master of rhetoric such as no other woman was and corresponded with philosophers, scientists and distinguished men of affairs."[6] Through her sons, the Gracchi (their father was the tribune Tiberius Sempronius Gracchus), she exerted political influence as well. Cornelia was a model figure not only for subsequent generations of Roman matrons but also for later centuries. (See Kauffman's *Cornelia Pointing to Her Children as Her Treasures*, Fig. 10–2.)

As in Sparta, the prolonged absence of men on military campaigns and the administration of a far-flung empire gave upper-class women greater autonomy. As Natalie Kampen notes, the highly visible appearance of women on the *Ara Pacis* occurs precisely when the political regime was "most uncertain about issues of reproduction, legitimacy and dynastic succession" at the very beginnings of the Roman Empire.[7]

- Relief on Column of Trajan, Provincial Town

In this portion of the Column of Trajan, the Emperor is traveling through the regions already under Roman control. Women and children form a prominent portion of the audience of townspeople observing a sacrifice. As Kampen indicates, "the presence of women and children signified the whole 'community' and implies a happy future as well as the benefits of *romanitas* to both public and private realms."[8] Therefore, the

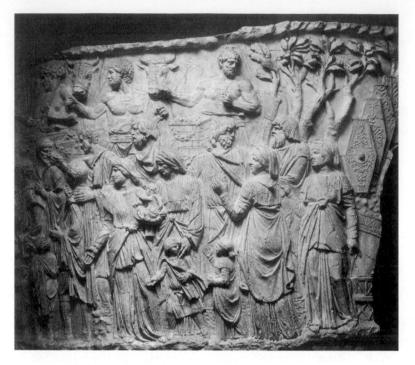

Fig. 6–2. Relief on Column of Trajan, Provincial Town. c. 110 A.D. *(Courtesy Deutsches Archäologisches Institut, Rome)*

appearance of women on public monuments indicates that the political actions of the Emperor and the Roman state will have an impact on the domestic privatized world of the family as well as on *all* individuals living under Roman rule. The well-being of both the family and the state are perceived as mutually interdependent in the Roman Empire.

ELITE WOMEN PATRONS

Livia

Again we are indebted to the research of Diana Kleiner for more information on the role of Livia, wife of Augustus, as a patron of the arts. Most art history texts include a photo of the beautiful landscape painting which decorated Livia's villa, a country retreat known as "Primaporta." "The villa was decorated between 30 and 25 B.C.E. with one of the finest landscape paintings ever conceived, apparently painted by Studius, one of the most famous landscape painters of his day."[9] Livia's selection of this artist shows her ability to recognize artistic quality. The well-known statue of Augustus in military armor was also found in Livia's villa. However, Livia's

patronage activities went well beyond the construction of domestic environments however elaborate. Livia commissioned a series of public buildings, including the Porticus Liviae, a recreational space for the Roman people, surrounded by gardens. She built the Shrines of Patrician and Plebeian Chastity and the Temple of Divine Augustus.

Livia assumed a distinctly public persona and used her wealth in a public and ultimately political manner. Her example stimulated other wealthy Roman women to sponsor public structures in other towns. Ultimately the activities of Plancia Magna may be traced back to the example set by Livia in the earliest period of the Roman Empire.

Plancia Magna

Plancia Magna was an extremely wealthy and prominent citizen of a city called Perge, now located in modern Turkey, which was then in the eastern portion of the Roman Empire. She subsidized an elaborate monumental city gate and triumphal arch with a nearby "display wall" just south of the city gate. Mary T. Boatwright has reconstructed the complex building program that can be attributed to the lavish patronage of this leading citizen of Perge. In fact, from the surviving inscription it can be determined that Plancia Magna was the *demiourgos*, the leading magistrate of the city, the priestess of Artemis, and "the first and only priestess of the Mother of the Gods."[10] In one statue, Plancia Magna is depicted with her head covered with the outer cloak, or *himation*, in a reference to her functions as priestess. Her crown, or *diadem*, was ornamented with four busts of Roman emperors, identifying her priestess function with the imperial cult religion.

This statue was part of an extensive complex consisting of a large, horseshoe-shaped courtyard decorated with statues of Olympian gods and the city's mythological and historical founders. Plancia Magna's father and brother, identified through their relationship with her, are also represented. This was quite unusual, since women were most commonly identified through their relationships to their male relatives, especially their fathers, rather than the other way around.

Plancia Magna also had a huge triple arch constructed, which served as a transitional structure between the courtyard and the city streets. The arch carried a prominent inscription in which Plancia Magna dedicated the arch to her city. The arch was decorated with statues of members of the imperial family including many female members, such as the Emperor Trajan's sister, the mother of Hadrian's wife. Boatwright speculates that the number of imperial women on the arch was motivated by Plancia Magna's own gender. She was associating herself with the female members of the imperial family to acquire status and recognition in Rome. The sculpture and the marble revetement all added to the cost and magnificence of this gift to her city.

Plancia Magna's public patronage is exceptional but not unique. She is one of many women who played an active role in their communities. There were other benefactresses whose buildings have disappeared but whose generosity is documented in coins and inscriptions. The role of priestess, which Plancia Magna occupied, was a highly prestigious and very public office. Ramsay Macmullen notes that one of the largest buildings in Pompeii's forum was presented by a woman named Eumachia. Macmullen concludes that "women as benefactors should be imagined playing their part personally and visibly, out in the open."[11]

Inscriptions on coins provide us with additional evidence of the importance of the role of high priestess, occupied by Plancia Magna. Most often, Macmullen believes, the title was held by the wife of the high priest. For example, Menodora, living in a city in Pamphylia, was a member of the aristocracy. Her father and grandfather had been high priests before her, and she was a very wealthy individual who funded a temple and distributed money publicly to town senators. Women most probably did appear regularly in public, but were unlikely to speak in public.

FUNERARY SCULPTURE: WOMEN AS GODDESSES

• Roman Matron Depicted as Venus

This sculpture is a fascinating example of a type of portrait sculpture in which the realistic head of a real woman is combined with the idealized body of a goddess, in this case, a nude Venus of the "Capitoline Aphrodite" type. Although this statue has been identified as Marcia Furnilla, the second wife of the emperor Titus, Eve d'Ambra questions this identification. D'Ambra believes that this statue depicts an anonymous matron, and dates the work, based on hairstyle, to 90–100 A.D. It does seem certain that the statue was intended for a tomb. D'Ambra is interested in the juxtaposition of the mature face with the youthful idealized body of Venus. She interprets this to be "a belief in the resilience of the maternal body. . . . The typical Roman matron expected to be married at least twice. . . . The rejuvenating nude portrait with its Venus imagery was appropriate for matrons whose bodies were renewed and whose social horizons were extended through several marriages."[12] Regardless of the exact identity of this figure, all such images may be traced to a tradition of depicting women in Imperial families as Venus.[13]

DOMESTIC ARCHITECTURE: ARISTOCRATIC ROMAN VILLAS

A number of scholars have studied the archeological remains of homes of upper-class, wealthy families living in Roman cities throughout the empire. "A roman's house was a complex which incorporated both private spaces

Fig. 6–3. Marcia Furnilla, *Roman Matron as Venus.* (*Courtesy of Ny Carlsberg Glyptotek, Copenhagen. Photo: Jo Selsing.*)

for the family and public rooms, in which the men conducted business affairs. The *domus* contained not only the private living quarters of the owner but also public rooms and gardens that served as the center of the owner's life of negotium, his civil and political activity. Both the architecture and decor of the town house were orchestrated to create appropriate settings in which the owner, his dependents and his adherents acted out their socially ordained roles."[14]

The research of Yvon Thébert and Andrew Wallace-Hadrill, among others, has clarified and expanded our understanding of the ways in which interior spaces of upper-class Roman villas mediated between the concepts of the public world of the city or empire and the private world of the family. The Roman household was the site of a wide range of social activities. The master of the house would receive any number of strangers into the house on a daily basis to conduct business affairs. Thébert tells us that political life was concentrated in the home of Caesar as much as in the Senate. Therefore, the impact of these spaces for women of this class who did not circulate as freely in the other politicized spaces of the city is significant.

Typically, Roman villas had a main entrance, which was the transition from the street to the interior. The vestibule was a large space where visitors

would be seen, under the observation of a slave who served as guard. Meals united the family. Men, women, and children ate together. Women and children also regularly attended banquets. The dining room, then, "played a key role in domestic socializing."[15]

Wallace-Hadrill has considered the gendered nature of spaces in the Roman house and concludes that "what may be historically distinctive about Roman domestic society is that man and woman do not inhabit worlds apart. For example, a loom was symbolically positioned in the atrium in the center of the Roman domus. The loom "symbolized the desired qualities of the good materfamilias . . . the woman's virtues of industry."[16]

Private tutors educated upper-class girls, but the early age of marriage limited the extent of their education. However, as was also true of the Renaissance, education and other accomplishments were considered positive attributes for women. Because women were not so completely isolated from male company as in classical Athens, a woman was expected to be able to converse intelligently with men. Large numbers of upper-class women were interested in literature, and a few were even authors and poets. Numerous orations honoring women have survived, indicating a public approval of notable women.

The bedroom, the *cubiculum*, was a strictly private space. Bedrooms were not open to strangers, although private homes did have guest bedrooms. The privacy of the *cubiculum* is nowhere more apparent than in the nature of the erotic paintings that were regularly placed there. Molly Myerowitz has discussed these images.[17] Most of the surviving works are from Pompeii and were located in the bedrooms of Roman villas of the wealthiest people. Their intended audience was the married couples of the upper classes. Most of these images depict anonymous, idealized hetero-sexual couples involved in explicit positions of sexual intercourse.

Myerowitz interprets the presence of these scenes in the bedroom as a sort of mirror in which the real-life sexual partners could see an idealized reflection of their own behavior. She relates such an interpretation to literary texts, such as Ovid's *Ars Amatoria* (The Art of Love) in which women are instructed to manipulate their bodies for the visual effects on their male partners. This context emerges, however, from the literary evidence on the social attitudes surrounding sexual relations. The images themselves are remarkably free of the types of voyeuristic poses encountered in the post-Renaissance world. They also present men and women in nonviolent and nonhierarchical depictions of sexuality.

It is tantalizing to interpret these images further in the context of Foucault's reading of Pliny and other Roman texts in which the relationship between married couples may be seen as "detach[ed] . . . from the status-determined authority of the husband . . . and take on the character of a

singular relation having its own force, its difficulties, obligations, benefits, and pleasures . . . [Roman texts] . . . show that marriage was interrogated as a mode . . . of relation between two partners . . . this role was involved in a complex interplay of affective reciprocity and reciprocal dependence."[18]

This was a favorable situation for Roman women since marriage and motherhood continued to be the main occupation of Roman matrons. The exposure of girl infants and early death in childbearing resulted in fewer women than men in Roman society.[19] During both the Republican era and the Empire, virtually all upper-class women were married. In fact, Augustus made marriage almost compulsory. Girls were married early, between the ages of 12 and 15. Motherhood conveyed great status, as well as economic benefits, on women. Unmarried women forfeited their inheritances, and childless women lost half of their inheritances.

Although, legally, women could not control any money or transact business on their own, in practice, as we have noted in connection with Livia and other Roman "matrons," women did control and bequeath their wealth. The growing bureaucracy of the Empire served to protect the rights of wives and children. A wife's dowry had to be returned intact if her husband repudiated the marriage. Thus, the Roman woman, entirely powerless within the public structure, could exercise very considerable power in private life as a result of the wealth and property that she might accumulate by herself or through her family.[20]

THE BYZANTINE EMPIRE

- Mosaic of Empress Theodora, San Vitale, Ravenna

This image of the Empress Theodora, wife of Justinian, is among the most famous visual images of a woman from the Byzantine Empire. It is one of a pair of dedicatory mosaics in the apse of San Vitale in Ravenna, and the only certain portrait of Theodora that has survived.[21] It is important, therefore, to understand the ways in which the images of Emperor and Empress are similar as well as their differences. Both Justinian and Theodora are in the center of their compositions, which are of equal scale. However Justinian's image has an indeterminate setting, and he is escorted by other important males, such as the Bishop of Ravenna, Maximian. Theodora's mosaic setting is in an interior, and she appears to be passing through the space of the mosaic into yet another region screened by the curtain on the left. Justinian's crown is less ornate and imposing, while Theodora's headdress expands her physical height so she is taller than the ladies of the court and the two men in her entourage. She is wearing a purple cloak, the *paludamentum*, identified as a symbol of the imperial family. The embroidered image of the three Magi relates to the chalice she

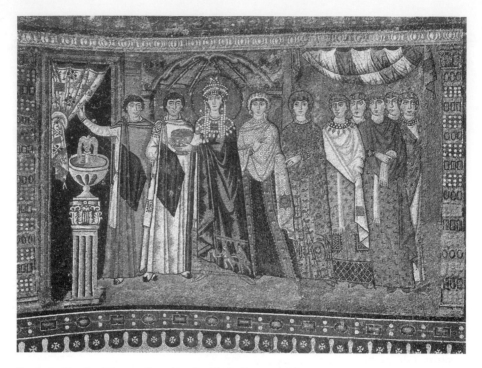

Fig. 6–4. Mosaic of Empress Theodora, San Vitale, Ravenna. 6th century. *(Alinari/Art Resource, NY)*

bears as a gift to the new church. This image was dedicated one year before Theodora's death in 548 and would be contemporary with Procopius's account of her in *The Secret History.*[22]

The problems with accepting Procopius's narrative concerning Theodora in this account as secure historical evidence have been clearly defined by Averil Cameron. Procopius's text was distorted by his political desire to discredit Justinian. All "facts" about Theodora are therefore called into question.[23] However, the very visible presence of Theodora in San Vitale is unprecedented and must relate to certain conditions of the time. Cameron does note that court ceremonies were giving the empress a greater ritual role, one in which other women of the court participated.[24] This is surely one element explaining this image.

Theodora was an actress and a prostitute prior to her marriage to Justinian (c. 524) and her elevation to the position of Empress. Procopius tells us that Theodora founded a Convent of Repentance for reformed prostitutes and helped women in distress. Theodora was an active supporter of a religious sect known as Monophysitism. The members of this group regarded Theodora as their champion and protectress. The Monophysites were grateful for her support and welcomed her as a reformed and penitent

sinner, perhaps on the model of Mary Magdalen. Cameron sees these acts as well within the traditional roles of a "great lady," rather than as "feminist" interventions to improve women's status.[25]

It should be remembered that Theodora never ruled independently. She led a private life as queen of a traditional court, and any power she did achieve was exerted from behind the scenes, not in a public manner.

The life of Theodora does, however, document the large degree of upward mobility for certain women in the elite society of Constantinople. Theodora had one daughter, born illegitimately during her days as an actress. Theodora's daughter married into the family of the Emperor Anastasius. The marriage produced three sons, Theodora's grandsons, all of whom married into the most wealthy and highest circles of Byzantine society. "The marriage alliances of Theodora's descendants conveyed wealth, position and lineage."[26] It is reasonable to view Theodora, at the least, as an intelligent woman who vastly improved her own life and those of her descendants through her marriage to Justinian.

Suggestions for Further Reading

AVERIL, CAMERON, and A. KUHRT (eds.), *Images of Women in Antiquity* (London: Croom Helm, 1983).

CANTARELLA, EVE, *Pandora's Daughters: The Role and Status of Women in Greece and Roman Antiquity* (Baltimore, MD: Johns Hopkins University Press, 1987).

CLARK, GILLIAN, *Women in Late Antiquity: Pagan and Christian Life Styles* (Oxford: Clarendon Press, 1993).

D'AMBRA, EVE, *Private Lives, Imperial Virtues: The Frieze of the Forum Transitorium in Rome* (Princeton, NJ: Princeton University Press, 1993)

D'AMBRA, EVE (ed.), *Roman Art in Context: An Anthology* (Englewood Cliffs, NJ: Prentice Hall, 1993).

FANTHAM, ELAINE, HELENE PEET FOLEY, NATALIE BOYMEL KAMPEN, SARAH B. POMEROY, and H. ALAN SHAPIRO, *Women in the Classical World: Image and Text* (New York: Oxford University Press, 1994).

FOUCAULT, MICHEL, "The Care of the Self," in *The History of Sexuality*, vol. 3, trans. Robert Hurley (New York: Random House, 1986).

GARDNER, J. F., *Women in Roman Law and Society*, 2nd ed. (Bloomington: Indiana University Press, 1990).

GAZDA, ELAINE K., *Roman Art in the Private Sphere: New Perspectives on the Architecture and Decor of the Domus, Villa, and Insula* (Ann Arbor: University of Michigan Press, 1991).

JOHNS, CATHERINE, *Sex or Symbol? Erotic Images of Greece and Rome* (Austin: University of Texas Press, 1982).

KEULS, EVA C., *The Reign of the Phallus* (New York: Harper and Row, 1985).

KLEINER, DIANA E. E., and SUSAN B. MATHESON (eds.), *I Claudia: Women in Ancient Rome* (New Haven, CT: Yale University Art Gallery , 1996).

LEFKOWITZ, MARY, *Women's Life in Greece and Rome: A Sourcebook in Translation*, 2nd ed. (Baltimore, MD: Johns Hopkins University Press, 1992).

PERADOTTO, J. (ed.), *Women in the Ancient World* (Albany: State University of New York Press, 1984).

POMEROY, SARAH B., *Goddesses, Whores, Wives and Slaves: Women in Classical Antiquity* (New York: Schocken Books, 1975).

POMEROY, SARAH B. (ed.), *Women's History and Ancient History* (Chapel Hill: University of North Carolina Press, 1991).

RABINOWITZ, NANCY SORKIN, and AMY RICHLIN (eds.), *Feminist Theory and the Classics* (London: Routledge, 1993).

RICHLIN, AMY (ed.), *Pornography and Representation in Greece and Rome* (New York: Oxford University Press, 1992).

WALLACE-HADRILL, ANDREW, *Houses and Society in Pompeii and Herculaneum* (Princeton, NJ: Princeton University Press, 1994).

7

The Medieval World

WOMEN MYSTICS AND MANUSCRIPT ILLUMINATORS

The range, variety, and power of women in the religious life of the Middle Ages has been the object of extensive scholarly attention. A clearer picture of the special characteristics of female religious life and mysticism in the later Middle Ages can thus be formulated from the scholarship published during the past decade or so, than was previously possible.

The role of convents or nunneries in the cultural life of upper-class women during the Middle Ages was crucial. Only women from the upper classes could become nuns, since a dowry was required before a woman was permitted to join a convent. Furthermore, unmarried women of the lower classes were economically productive, and their labor was useful for the family unit. The nunneries provided a socially accepted refuge for women whose only other alternative was marriage. The convent schools trained boys and girls of the upper classes. Convents also served as boarding houses for wealthy wives and widows who, for whatever reason, could no longer reside in their castles. Even though the contemplative life of a nun was an available option for only a small percentage of the female population, nunneries fulfilled an important purpose for upper-class women. Freed from male domination, some women could exercise leadership skills, powers of organization, and management of a complex estate. Especially in the early Middle Ages, between 500 and 700 A.D., nunneries not only preserved learning and maintained culture but often exercised power through their land holdings.

Prior to the end of the thirteenth century, the production and illumination of sacred books was solely confined to monasteries and convents. For the history of art, this is the most important role of these institutions. The

nunnery was the only place in that society where women could be trained as painters. Consequently, women painters of the Middle Ages came from the upper classes. A limited number of women manuscript illuminators who were nuns are known from the tenth to the sixteenth centuries. Only a signature or self-portrait can authenticate the attribution of a manuscript illumination to a woman, and many medieval artists did not sign their works. It is possible that many other women artists are simply unnamed and therefore unknown.

The first major convent scriptoria, or book-making workshops, coincided with the revived interest in manuscript creation and preservation under the reign of Charlemagne. Charlemagne's sister Gisela directed the first Carolingian convent scriptorium located at Chelles, northeast of Paris. Although one cannot firmly attribute a set of illuminations to women painters at the Chelles convent (which was part of a double institution of monastery and convent), other related manuscripts are signed by women. Also, there are literary references to illuminators who were nuns in England and Flanders in the eighth and ninth centuries.

After the Gregorian reform movement of the late eleventh century, the formerly widespread practice of the double monastery, one for men and one for women, was abolished. Convents were thus excluded from the institutional hierarchy of the Church. There was no female monastic order, despite the efforts of a few men, most notably Pope Innocent III, who wished to keep the women's religious movement within the Church organization. The existing orders, such as the Franciscans, Dominicans, and Cistercians, were not receptive to the integration of nuns into their administrative domain. It is not surprising, then, given this unwillingness on the part of the established Church hierarchy to accept the administration of pious women, that women formed independent, semireligious, unofficial communities. Beginning in the twelfth century, pious women known as Beguines gathered together to live in chastity and poverty. Most of these women were from the upper class, both married and single, and renounced all worldly goods to pursue a penitential life and perform charitable acts. Significant numbers of women were also attracted to heretical sects that provided a wider role for women in their orders. The Waldensians and Carthars, for example, permitted women to preach and act as priests. The Albigensians also concerned themselves more directly with the position of women in society.

Despite these institutional obstacles, the population of convents grew rapidly in the thirteenth century. The "Poor Clares" discussed on page 60 developed in this period. Furthermore by 1250, there were 500 convents in Germany. The large number of German nunneries accounts for the fact that most known female manuscript illuminators of the later Middle Ages were German nuns. A self-portrait identifies Claricia as the illuminator of a

manuscript made in Augsburg, Germany, in the twelfth century. In a clever way, Claricia painted herself swinging from the body of the initial "Q." Another illuminator named Guda inserted her own image in a manuscript from Frankfurt also dating from the twelfth century. While Guda is in a nun's habit, Claricia appears in ordinary clothes. Claricia might have been an upper-class woman who was sent to a convent for schooling—a common practice. "It becomes clearer and clearer as the Middle Ages move on that miniature painting was regarded as an appropriate occupation and a becoming accomplishment for a lady."[1] The future recommendation of Castiglione in the sixteenth century, advising women of the courts to acquire painting skills, is merely a continuation of a widespread practice in the Middle Ages and not the initiation of a new set of expectations for women of the upper classes.

- Illumination from St. Hildegarde of Bingen, *Scivias*

Nunneries permitted women to pursue lives dedicated to spiritual contemplation, which was highly respected in the society of the Middle

Fig. 7–1. Illumination from St. Hildegarde of Bingen, *Scivias*. *(© 1978 Brepols Publishers Corpus Christianorum Continuatio Mediaevalis 43–43A: Hildegardis, Scivias)*

Ages, so dominated by religious concerns. In fact, the most learned women of the Middle Ages, those who made significant contributions to their culture, were nuns. The power of abbesses, rivaled only by queens, was equal to that of abbotts and even bishops.

St. Hildegarde of Bingen (1098–1179) was the abbess of a convent in Germany. She is generally regarded as one of the greatest mystics of the Middle Ages. From her position as head of a convent she became quite famous in her epoch and corresponded with the most noted contemporary religious and political figures. Although not a painter herself, St. Hildegarde was believed to be responsible for the innovative design of the imagery that illustrated her visions, the *Scivias* (Fig. 7–1).

This image illustrates one of Hildegarde's visions in which "the figure of woman" (Hildegarde's phrase) is shown receiving a dowry of Christ's blood. Below the cross stands an altar with the chalice of the Eucharist and representations of events in Christ's early life. Hildegarde heard the words "Eat and drink the body and blood of my Son to abolish the prevarication of Eve and receive your true inheritance."[2] One noted scholar of medieval female mysticism, Caroline Bynum, underscores the centrality of the image of "woman" for female mystical writers. Hildegarde also wrote "And man truly signified the divinity of the Son of God, and woman his humanity."[3] Hildegarde argued that since Christ's body was formed by Mary, it was female flesh that restored the world. This lent women an elevated status in mystical thought.

- The Visual Culture of the Poor Clares: Pacino di Bonaguida, *Tree of Life*, c. 1310

Jeryldene Wood has written a valuable study of the role of the visual arts for the community of sequestered nuns in early modern Italy, known as the Clarisse or Poor Clares. The nuns were inspired by the piety of Saint Clare, a follower and contemporary of Saint Francis of Assisi. Clare renounced her aristocratic wealth and privileges and, over the objections of her family, chose a religious vocation. By 1216, Clare and a small group of religious women were living in claustration, independent and completely isolated from their society. Wood notes that the separation of the Clarisse from the Franciscan order may be traced to "strongly ingrained ecclesiastical prejudices toward women. In the thirteenth century, women—even holy women—still carried the stigma of Eve; they were considered defective or, worse, seductive. "[4]

The absence of works of art in their first residence, San Damiano in Assisi, can be explained by the extreme poverty of the group. However, the cult of Saint Clare grew so rapidly that, by 1253, there was a need for a larger complex, built to house the remains of Saint Clare. This church, Santa

Fig 7–2. *Tree of Life,* c.1310. Pacino di
Bonaguida, *(Courtesy of L'Albero Della
Vita. Alinari.67243. Firenze: Accademia)*

Chiara, still stands today in Assisi and is related to the much more famous
Church of St. Francesco.

Another group of Poor Clares, led by Clare's sister Agnes, was estab-
lished in Florence around 1219. It was for this community that Pacino di
Bonaguida created the remarkable panel, *Tree of Life,* around 1310. Wood
believes that this image was commissioned for the second complex of the
Clarisse, near the Porta Romana, and provides evidence, by its very
existence, of the growing financial security of the community. Its complexity
and scale seem to indicate that it was originally positioned on the high altar
of the church. Wood bases her interpretation of this fascinating image on the
text of Saint Bonaventure, and analyzes the image in light of the spiritual
exercises advocated for the Clarisse, which involved visualization, leading to
empathy and ultimately to an understanding and contemplation of abstract
principles. This image is an important aid and stimulus to piety.[5] Wood's
exegesis of this panel is complex, detailed, and convincing. She concludes
that the visible image of the body of Christ on the altar carried associations
with the Eucharist, the symbolic consummation of Christ's body during the
ritual of the mass. "The Poor Clares serve at the holy banquet while on
earth in the hope of becoming 'celestial' guests in eternity. They are 'nailed

to the Cross' through self-denial, restraint and suffering."[6] Convents of the Poor Clares were established throughout Italy and Europe in subsequent centuries.

The importance of imagery for this order of nuns is further reinforced by Saint Catherine Vigri, the abbess of the Clarisse convent in Bologna, during the mid-fifteenth century or Quattrocento. Catherine was not formally canonized until 1712, but a cult developed around her body soon after her death, in 1463. Saint Catherine recorded her visions in texts, like Hildegard of Bingen. What is more unusual and more significant for the history of art is that St. Catherine created paintings, mainly of the Madonna and Child. She also created images of the infant and boy Jesus. Wood concludes that Catherine "hoped to inspire devotion to the Incarnation among her nuns by encouraging them to identify with the Virgin as if they too were his mother."[7] These works of art were treasured and cared for, confirming the significance of aesthetic objects for the spiritual goals of the nuns. Creating a painting, like other activities, was a devotional act, a metaphor for divine creation and for the inexplicable nature of vision, miracles, and other spiritual mysteries. "The shining gold and vibrant colors of paintings heightened the beholder's sensory awareness and, in doing so, evoked what is otherwise indescribable."[8]

Wood's valuable study helps us reconstruct the role of works of art for the spiritual life of the Clarisse (the Poor Clares) in early modern Italy. Furthermore, such scholarship brings our attention to the importance of religious women to the society of the Renaissance, an aspect of this culture totally ignored in most art histories of the period.

Nuns as Artists

- ### The Convent of St. Walburg: *The Heart as a House*

Jeffrey Hamburger's detailed study of a series of single-page drawings from a convent in the region of Franconia, in Germany, has provided valuable insights into the role played by images in the spiritual life of nuns. Hamburger is interested not only in an iconographical analysis of the individual images, but also in defining the ways in which these images were used within the religious practices of the convent. He concludes that the drawings, created around 1500, served as instruments of instruction and framed an experience of prayer. These drawings were integral to religious exercises that, in turn, were linked to the convent's liturgical and devotional life. They testify to the vital place of images for "the full spectrum of the abbey's religious observances: from meditation, consecration, and the celebration of the sacraments to the cult of saints and the integration of prayer and work."[9]

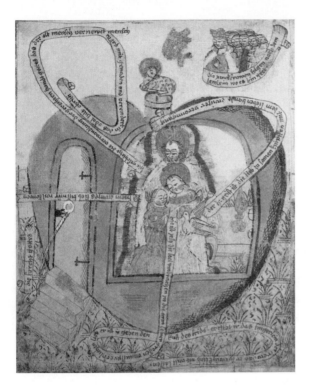

Fig. 7–3. Convent St. Walburg,
The Heart as a House.
Staatsbibliothek zu Berlin.
(*Courtesy of Staatsbibliohek zu
Berlin-Preußsischer Kulturbesitz,
Handschriftenabteilung 417.*)

The drawing reproduced here depicts the heart as a house, "closed to the world, within which the soul rests secure in the embrace of the Trinity."[10] The heart is an enclosing structure, a symbol of the convent itself. Four steps lead to a closed door, which is closed off from the outer world. A small dog, attached to the doorknocker, is identified as "the fear of God." Through the window of the heart/house the nun in the center sits on an altar, surrounded by the three persons of the Trinity: God, the Father, the Son, and the dove of the Holy Spirit. Hamburger notes that "comparable images of spiritual intimacy are extremely rare and appear to occur exclusively in manuscripts made both by and for women."[11] This image is designed to communicate the ideal of a mystical union of the nun with divinity achieved through prayer. Her soul is joined with Christ in a mutual embrace. The inscriptions, which radiate out from the center, would have encouraged the viewer to rotate the image in her hands. These inscriptions encourage the mystical union of the nun's soul with Christ through the reception of the Host, the Eucharist in which the body and blood of Jesus were ingested. The nun

set within the circle of the Trinity places the viewer at the very heart of Christian mystical ideas.

The importance of the experience of the mass and Eucharist is emphasized by the fact that the scene takes place on an altar. Since actual communion may have occurred only infrequently, Hamburger suggests that the experience of viewing the drawing provided the nuns with "a substitute for sacramental presence. . . . In the absence of Communion or even access to the altar, the drawing could make present what the nuns would have missed most: communion with Christ understood simultaneously as mystical and corporeal."[12]

The Motif of the "Lactating Madonna"

The significance of the nun's union with Christ as manifested though eating and drinking in the sacramental ritual of the mass is connected with another motif that appears in the visual arts, the "Lactating Madonna." Caroline Bynum notes that the cult of the Virgin's milk was one of the most extensive in medieval Europe.[13] There were many paintings which depicted the "Lactating Madonna" in the visual arts. The motif has sources in the Egyptian Goddess Isis breast feeding Horus, and in Roman antiquity in the allegorical figure of Caritas or "Charity," who was always depicted nursing a child. During the Middle Ages, this image was extended to the allegorical figure of the Church or "Eclesia."

Medieval writers believed that breast milk was the transformed blood of the mother. Christian theologians drew the analogy between God who feeds humanity with his blood in the Eucharist and the human mother who feeds her children. Miraculous lactations, exuding fluids after death, and visions by women mystics of nursing the Christ child, are recorded as early as the second century. "The extreme interest in physicality and the close association of woman with body and food that characterized late medieval culture seem to lie behind not only women's eucharistic piety and food asceticism but also the startling number of women's miracles that involve bodily change."[14] Caroline Bynum and Margaret Miles, historians of this period, both develop persuasive arguments that demonstrate the medieval association of women's bodies with food.

Secular Manuscript Illuminators

- *Marcia, Self-Portrait from a Mirror*

This image depicts a woman artist, identified as Marcia, painting her self-portrait using a mirror. Marcia was one of the outstanding women recorded by Boccaccio in his text, *De Claris Mulieribus (Concerning Famous*

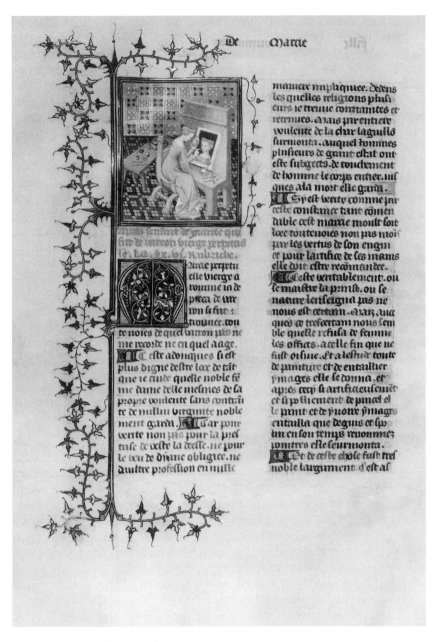

Fig. 7–4. *Marcia, Self-Portrait from a Mirror.*
From Boccaccio, *Concerning Famous Women.*
(Bibliothéque Nationale de France)

Women). Boccaccio revived a tradition in which men write in defense of women by noting outstanding women of the past, the "women worthies." Although the gender of the artist who painted this miniature is unknown, we do know that women were active as secular manuscript illuminators, outside the nunneries, in the later Middle Ages.

In northern Europe, unlike Italy, the art of illuminating manuscripts did not occupy a secondary place to large-scale fresco painting. This form of painting was highly valued and actively supported by the leading art patrons of the era.

As early as the thirteenth century, commercial book illustrators, as opposed to monks and nuns, ran businesses in the cities of Europe. While never very numerous, women painters and sculptors did exist by the late thirteenth and early fourteenth centuries, as documented by tax records. Etienne Boileau's *Livre des Métiers* (1270) refers to a guild of female book illuminators and binders.[15]

Susan Groag Bell has analyzed the impact on medieval culture of women's widespread ownership of books, especially those not written in Latin.[16] Women were not regularly given instruction in Latin, then the universal language of the Church and the universities. Latin was taught mainly to boys, not girls. Therefore, women patrons were instigators in commissioning vernacular translations of Latin texts. Based on surviving evidence, such as bequests, Bell concludes that women of the upper classes inherited books frequently. Most of the Duc de Berry's famous collection of manuscripts came into the hands of women after 1416. By the fourteenth century there are records of women who amassed libraries, and women collected, in the late fifteenth century, printed books as well as handwritten texts. Many of the books owned by women were devotional in nature, a book of hours being the most common.

Books served other purposes for women in medieval society. Women were expected to involve themselves with the literary and moral upbringing of their children, especially daughters. When women had the opportunity and financial means to commission a book, they could exert a powerful influence on the contents of the volume. When noblewomen married, they often moved to an entirely new country. They became a "cultural ambassador" when they brought their manuscripts with them. This served to disseminate stylistic elements around Europe. Bell suggests that a close analysis of devotional literature and the contents of these books may reveal aspects of the relationships between mothers and daughters. A daughter of the noble classes was often married at a young age and forced to live far away from her parents. It is tempting to suppose that this version of Boccaccio's text was commissioned by an aristocratic mother to fortify the spirits and strengthen the courage of just such a young bride, removed from her family.

• *Christine de Pisan at Work*

In 1405 an extraordinary woman author, Christine de Pisan, wrote the first defense of women that was actually written by a woman. This text, *The City of Women*, thus initiates, as Joan Kelly has documented, a 400-year-long debate in innumerable texts known collectively as the "Querelle des Femmes."[17] Kelly refers to Christine de Pisan as "the first feminist," meaning that she was the first writer who understood gender roles as a cultural, not primarily a biological, issue. Widowed at the age of 25, Christine de Pisan was able to support herself, her children, and her widowed mother through the income derived from her writing of over thirty texts.

A scene depicts a crucial moment in the text. The author describes how she was oppressed by the massive literature on women's nature, which found all women "abominable," and "the vessel . . . of all evil and all vices." In a vision, three allegorical figures, Reason, Righteousness, and Justice, appear to inspire Christine de Pisan to challenge these misogynistic dogmas. Kelly refers to this episode as a "passage of consciousness" which stimulates the writing of her unprecedented defense of women.

These arguments would be repeated over and over in the next 400 years. Gerda Lerner, in *The Creation of Feminist Consciousness*, theorizes that the lengthy period in which such arguments were repeated by women writers was characterized by "a lack of continuity and the absence of collective memory on the part of women thinkers."[18] Lerner emphasizes the disadvantages of women intellectuals who were isolated and lacked communities, which inhibited the growth of a collective feminist consciousness.

Of special importance to the subject of women artists, Christine de Pisan praises the illuminations of a contemporary artist, Anastaise, in *The City of Women:*

> . . . with regard to painting at the present time I know a woman called Anastaise, who is so skillful and experienced in painting the borders of manuscripts and the backgrounds of miniatures that no one can cite a craftsman in the city of Paris, the center of the best illuminators on earth, who in these endeavors surpasses her in any way. . . . And this I know by my own experience, for she has produced some things for me which are held to be outstanding among the ornamental borders of the great masters.[19]

It would seem that Anastaise specialized in the less prestigious aspects of manuscript painting, that is, backgrounds and borders. Yet her skills were clearly impressive enough for Christine de Pisan to extol, thereby leaving a record of her existence for posterity.

Surviving records document the existence of another woman artist, Bourgot, who was actively employed by the most important patrons of her

era in the decoration of manuscripts. Bourgot was the daughter of the painter Jean Le Noir.[20] Le Noir and Bourgot executed a book of hours for Yolande de Flandres, an important and active patron of the era around 1353. This "delicious and delicate" manuscript continued the inventive traditions of Jean Pucelle, but "infused it with a more sturdy expressionism."[21] They moved to Paris where they worked for the King of France, Charles V. Le Noir received payments from Jean, Duc de Berry, in 1372 and 1375. The list of their sophisticated patrons testifies to the skills and reputations of Le Noir and Bourgot.

By the fifteenth century, women would appear to be even more active in the art of book painting. The records of the painters' guild in Bruges, which, atypically, did admit women as members, reveal that 12 percent of the guild members were female in 1454, and that the proportion had increased to 25 percent by the 1480s. As Anne Sutherland Harris suggests, such extensive participation in this field is an essential background for the emergence of Flemish miniature painters in the sixteenth century.[22]

From this account it is clear that both in convents and commercial enterprises, women formed a small but not insignificant percentage of the artists active as manuscript illuminators. While it is impossible to identify the precise contributions of these craftswomen, their existence can be either inferred from general custom in the society or documented when guild records included women and have been studied by modern historians.

MEDIEVAL EMBROIDERY

As we have discussed in preceding chapters, the association between women and the decoration of textiles with embroidery can be traced back to the ancient world. This time-consuming activity is usually associated with women of the upper classes who had the leisure to devote to the art. During the Middle Ages, many women were taught to embroider, and they used this skill to fashion some of the most significant but fragile works of their epoch. In many of the homes of noblewomen, embroidery was not a casual pastime but a serious occupation, an organized domestic activity.

Prior to the development of the town economies of the twelfth and thirteenth centuries, embroidery was made in convents and in the homes of noblewomen. In Carolingian convents, teams of women produced fine fabrics used for vestments or as export commodities to be sent to Byzantium in exchange for gold. Women's work thus produced one of the few marketable export items of the economy.

Many convents were occupied with the creation of elaborate embroideries used for priests' vestments or as an offering to a saint. These objects were frequently encrusted with pearls and other jewels and often sewn with gold and silver thread. The earliest reference to a woman embroiderer

is St. Etheldreda, Abbess of Ely, who lived in the seventh century. She "offered to St. Cuthbert a stole and maniple, a fine and magnificent embroidery of gold and precious stones, worked, it is said, with her own hands, for she was a skillful craftswoman in gold embroidery."[23]

Convent schools taught the arts of needlework to the daughters of the landed nobility as part of their premarital education. This factor, combined with the transmission of techniques informally from generation to generation, did not merely preserve the art but helped to stimulate its practice. Noblewomen prided themselves on the skill of their needlework, lavished on clothing as well as on the decoration of church vestments. The stole and maniple worked by order of Queen Aelfflaed, wife of Edward the Elder (c. 910), have been preserved in Durham Cathedral. The work demonstrates the extreme finesse and technical excellence of the art of embroidery at this time.

In addition to the use of embroidery to decorate religious garments, we know of at least one tapestry that illustrated a narrative of the deeds of a nobleman. Around 991, a woman named Aedelfleda presented the church at Ely with a hanging embroidery illustrating the achievements of her husband. This work, although now lost, may have inspired Odo, Bishop of Bayeux, to commission the most famous embroidered work of the Middle Ages, the *Bayeux Tapestry*.

- *Bayeux Tapestry*

The *Bayeux Tapestry* is a unique surviving masterpiece of the medieval art of needlework. Made around 1070, it depicts events surrounding the invasion of England by William the Conqueror in the year 1066. The narrative is a moral tale of the downfall of Harold, who broke his oath, sworn at Bayeux. Whether the historical account of the Norman Conquest documented in the *Bayeux Tapestry* should be considered reliable history is less important than the fact that the tapestry was almost certainly executed by teams of women, following the cartoons of a single designer of undetermined sex. Worked in brightly dyed wool on linen, the *Bayeux Tapestry* is 230 feet long. The elaborate detail, lively movement of men and animals, and sophisticated composition prove that it is a work of highest quality.

The energy and activity of the narrative in the *Bayeux Tapestry* is shown in this banquet scene (Fig. 7–5). Roasted poultry on skewers is taken off the fires and placed on a sideboard. The horn informs the company that dinner is served. Bishop Odo, seated in the center of the semicircular table, says grace; William the Conqueror is seated at his right. The scene uses green, red, and yellow thread that retains some of its original brilliance. The precision of the needlework demonstrates the exceptional technical capabilities of the workers. The decorative borders, enlivened with composite animals, provide additional scope for inventive designs.

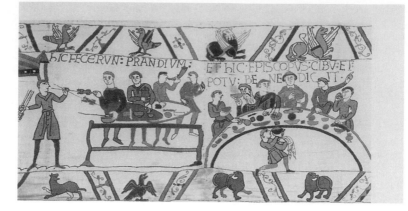

Fig. 7–5. *Bayeux Tapestry,* detail, c. 1073–1083. Wool embroidery on linen. Height 20 in. *(Town Hall, Bayeux, France)*

As Roszika Parker has noted, in the Victorian era it was believed that Queen Mathilda, the wife of William the Conqueror, was the sole creator of the embroidery. Mathilda was portrayed by the Victorians as an exemplar of "wifely excellence."[24] Victorians were attached to this fiction of the individual aristocratic noblewoman as sole creator of the Bayeux Tapestry because of the survival of such images in medieval texts of courtly love. "The Victorian lady found a reassuring representation of her own curious power and powerlessness in the medieval lady of courtly love."[25]

Opus Anglicanum

- ### Syon Cope

As early as the eleventh century, some lower-class women earned their living practicing the art of embroidery. By 1250 professional women embroiderers in England had an international reputation, and their creations were in great demand. The popes frequently ordered embroidered vestments from English workshops. Royalty, clerics, and wealthy persons all over Europe wanted to own examples of the now renowned *opus Anglicanum,* the term used to refer to works of embroidery created at this time in England. Around 1240, Mabel of Bury St. Edmonds was an important creator. In the early fourteenth century, Rose of Burford received a commission from Queen Isabella of Spain to decorate a vestment intended as a gift to the Pope.

After 1250 the demand for examples of *opus Anglicanum* was so great that there was a shift from production by individuals in scattered homes to

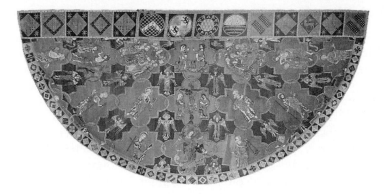

Fig. 7–6. *Syon Cope.* Gold, silver, and silk thread on linen. *(© The Trustees of the Victoria and Albert Museum, London)*

an organized commercial activity in the towns. With this shift the names of more men appear in connection with this art, although they may have been acting more as intermediaries. We do know that by the thirteenth century, a master craftsman such as a goldsmith was considered perfectly competent to supply a design for an embroidered vestment, although the actual fabrication of the garment may well have remained in the hands of women. At first, men may have restricted their role to supervision and management of female workers. "Modern scholars note a general decline in the quality of embroidery being produced by the fourteenth century but without commenting on the growing role of men in this hitherto female craft. By the fifteenth century, we hear of traveling teams of embroiderers, a situation incompatible with extensive female participation."[26] Whether one should attribute this diminished excellence to the greater participation of men or the changing methods of production remains undetermined.

One of the most famous examples of *opus Anglicanum* is the *Syon Cope* (Fig. 7–6), once the property of the Bridgettine Nuns of Syon Convent, located outside London. Originally a chausable, which was reshaped into its present semicircular form, the cope is a complex composition of interlaced barbed quatrefoils. The heraldic shields of the border are a later addition, and not part of its original design. The work illustrates scenes from the life of Christ and the Virgin, St. Michael slaying the dragon, and the twelve apostles. Seraphim, angels, and two priests fill the interstices of the quatrefoils. Most of the robes of the holy figures inside the quatrefoils are sewn in gold thread. A wide range of colored silk threads enlivens the work. The background colors alternate between salmon inside the panels and green as background in between.[27] The *Syon Cope* is one example of the delicacy, precision, and magnificence characteristic of the best examples of *opus Anglicanum.*

URBAN WORKING WOMEN: 1200–1600

Opus Anglicanum must be understood in the context of women's work in the later Middle Ages. Martha Howell has studied the women workers in the German cities of Cologne and Leiden during the later Middle Ages.[28] She has developed a theoretical framework that helps to clarify the role of women workers in medieval embroidery. Howell asserts that when work was organized in a "family production unit," women had access to high-status jobs. This is consistent with the prominence of wives and widows of merchants such as Rose of Burford, who came from a wool merchant family and continued running the business as a widow. Howell found evidence of the strong presence of women in Cologne's commercial world as long as business and work were organized around "family production units."

Wives and daughters most often worked in the family's commercial enterprise. Many wives, not directly active in their husband's trade, would handle the retail end of the business. Because there was a surplus of women, unmarried women were forced to support themselves and often worked for wages or ran their own businesses. "Under English common law, the unmarried woman or widow, the *femme sole*—was, as far as all private, as distinct from public rights and duties are concerned, on a par with men."[29] In certain cases when women were conducting businesses of their own, even a married woman could be treated as a *femme sole* in England.

A number of women workers were employed in the manufacture and sale of food and beverages. The bread-making and brewing industries were dominated by women. Women often sold food in markets and were innkeepers. These types of employment continued the traditional identification of women with food preparation for the family.

Of greatest interest for the history of art is the wide range of craft and artisan activities practiced by women in medieval towns. In Paris by the late thirteenth century, women were working at 108 occupations of the most diverse kinds. Women were shoemakers, tailors, barbers, jewelers, goldsmiths, bookbinders, painters, and many other skilled artisans. Five of the 110 craft guilds that existed in Paris restricted membership to women only.

Another important female occupation during the Middle Ages and continuing into the seventeenth century was midwifery. However, while midwives could practice family medicine and obstetrics, they were not permitted to become professional physicians.[30]

A large number of women were occupied in the rapidly expanding textile industry. In fact, the making of wool, linen, and silk cloths was one of the major occupations of women until the eighteenth century and the Industrial Revolution. Women performed nearly all the work in the preliminary processes of cloth making, such as combing and carding the fibers, and spinning the yarn. Women holding distaff and spindle, the tools of the

trade, appear frequently in the marginalia of medieval manuscripts. In England, the Netherlands, northern France, and Italy many women worked at these tasks. The term "spinster," that is, one who spins, originally identified a person's occupation. By the seventeenth century, the term had acquired the additional meaning of "an unmarried woman," indicating the virtually total identification of spinning with women. Weaving was also a female occupation in the thirteenth century, but by the sixteenth century this craft was taken over by the all male weavers' guilds.

In addition to the wool trades, women dominated the silk-making industry in France. The women who spun the thread and made the silk cloth were paid notoriously low wages. The manufacture of silk belts and alms purses was the responsibility of women's guilds. Until the fourteenth century, dressmaking and embroidery were also female-dominated activities.

Women and Guilds

While women were very active in a wide range of crafts throughout the Middle Ages, their relationship to the guilds varied widely. Guilds were powerful trade organizations that limited membership in the professions and established regulations controlling the products.

In Paris, women could become independent members of a guild as early as the thirteenth century and were subject to the same regulations as men. Crafts monopolized by women were organized in the same way as crafts with greater male participation.

In the fourteenth century women were often members of German guilds. However, by the fifteenth century women began to be excluded more and more from membership in Italian and German guilds.

In England women were almost never admitted as full members to a guild, and there were no guilds for the female-dominated industries. Exceptions were made for widows, who were regularly admitted as full members of their husbands' guilds. Some widows carried on their husbands' businesses, documenting their active partnership in the trade.

Maryanne Kowalski and Judith Bennett conclude: Most medieval townswomen worked in a wide variety of low-skilled, low-status, low-paid occupations that never formed into guilds.[31] Even the most skilled trades and crafts in which women were active rarely formed guilds on the continent and never in London. The women's guilds in Rouen, Paris, and Cologne were highly exceptional instances of skilled women who organized and regulated their crafts.[32] In the case of London silkworkers, who did not organize their craft into a guild, men eventually took over the work and used the guild structure to protect their economic position and exclude women. This background is extremely important for understanding the difficulties of women in subsequent periods to become professional artists.

Howell believes that restrictions in women's access to high-status work occurred with the shift to "market production."[33] In these different systems, labor became more specialized, and access to training became more important. Guilds were the main organizations that controlled training and access to the expertise needed to create goods for "market production." This is generally identified with the beginnings of "capitalism."

Merry Wiesner, in her study of German cities, identifies the period of the mid-fourteenth century as the time when guild ordinances begin to control, limit, and restrict the activities of the female members of the household workshop, especially the master's widows.[34] Wiesner discusses the attitudes of the journeymen who were the most vocal opponents of work by women. Although it was in the economic self-interest for the journeymen to have widows continue to run the shop. Wiesner infers that journeymen were frustrated when their opportunities to become masters were restricted. They could raise their status and position only by differentiating their work in the shop from "women's work."[35]

Wiesner uses two crafts, goldsmithing and textile production, to analyze the changing patterns of women's work. In Nuremberg, women continued to work independently as "gold spinners," making gold thread used in fancy embroidery such as the *opus Anglicanum*. This was so unusual that Wiesner concludes it was a craft especially suited to women. It could be done at home, with little workspace and few tools. Cloth production shows a different picture. Beginning in the fourteenth century, the guilds controlled the production of cloth. Women were "gradually excluded from most weavers', drapers', tailors', and cloth cutters' guilds in most cities."[36] The earliest phases of the process (carding and spinning) and the production of cheap cloth were left to unorganized women workers.

Clothmaking was not the only occupation taken over by men in the fourteenth and fifteenth centuries. Men were invading many other trades that had been traditionally exercised by women, for example, wholesale brewing. At this time occupational designations, with a few exceptions, such as the food and clothing trades, were male. By the sixteenth century, women were forbidden to become apprentices or to take the examinations that might have enabled them to become journeymen or masters.

Natalie Zemon Davis has studied the role of women in the production of crafts in the French city of Lyon, during the sixteenth century. Her conclusions provide insight into the ways in which women's work was organized. She finds that women had "weak work identity and high identity as a member of a family and neighborhood . . . the female adapted her skills and work energies to the stages of her life cycle."[37] Davis believes that this flexibility was an important component of the craft economy of the period. While women continued to work "however and whenever they could,"[38] they were accepting of the conventions which identified the husband as "The Artisan." This would have had clear financial advantages in the trades controlled by

guilds. Independent women were concentrated in textile and clothing trades and provisioning trades, such as bakers and innkeepers.

The progressive exclusion of women from full membership in professional organizations continued into the sixteenth century. "By 1600 women had disappeared almost completely from professional life."[39] In the seventeenth and eighteenth centuries, new commercial organizations that were replacing the guilds were almost exclusively male dominated. Throughout most of Europe, women could not function on a professional basis independently of male relatives during the Renaissance era.

Given this discriminatory situation, it is not surprising to learn that the absolute number of women who were professional artists is very small in comparison with the number of male artists. In the sixteenth century, only thirty-five women are known to have been artists.

Suggestions for Further Reading

General Sources on Women

GIES, FRANCES, and JOSEPH GIES, *Women in the Middle Ages* (New York: Crowell, 1978).

GROSSINGER, CHRISTA, *Picturing Women in Late Medieval and Renaissance Art* (New York: Manchester University Press, 1997).

HAVICE, CHRISTINE, "Women and the Production of Art in the Middle Ages: The Significance of Context," in Natalie Harris Bluestone (ed.), *Double Vision: Perspectives on Gender and the Visual Arts* (London; Cranbury, NJ: Associated University Presses, 1995).

LABALME, PATRICIA (ed.), *Beyond Their Sex: Learned Women of the European Past* (New York: New York University Press, 1980).

LABARGE, MARGARET W., *A Small Sound of the Trumpet: Women in Medieval Life* (Boston: Beacon Press, 1986).

MOREWEDGE, ROSEMARIE THEE (ed.), *The Role of Women in the Middle Ages* (Albany: State University of New York Press, 1975).

POWER, EILEEN, in M. M. Postan (ed.), *Medieval Women* (London: Cambridge University Press, 1975).

STUARD, SUSAN MOSHER (ed.), *Women in Medieval Society* (Philadelphia: University of Pennsylvania Press, 1977).

On Female Mysticism and Religious Life

BYNUM, CAROLINE WALKER, *Holy Feast and Holy Fast: The Religious Significance of Food to Medieval Women* (Berkeley: University of California Press, 1987).

BYNUM, CAROLINE WALKER, *Jesus as Mother: Studies in the Spirituality of the High Middle Ages* (Berkeley: University of California Press, 1982).

MILES, MARGARET, *Image as Insight: Visual Understanding in Western Christianity and Secular Culture* (Boston: Beacon Press, 1985).

MILES, MARGARET, "The Virgin's One Bare Breast: Nudity, Gender and Religious Meaning in Tuscan Early Renaissance Culture," in Norma Broude and Mary D. Garrard (eds.), *The Expanding Discourse: Feminism and Art History* (New York: HarperCollins, 1992).

NEWMAN, BARBARA, *Sister of Wisdom: St. Hildegarde's Theology of the Feminine* (Berkeley: University of California Press, 1987).

WOOD, JERYLDENE M., *Women, Art, and Spirituality: The Poor Clares of Early Modern Italy* (New York: Cambridge University Press, 1996).

Christine de Pisan and the Querelle des Femmes

DESMOND, MARILYNN (ed.), *Christine de Pisan and the Categories of Difference* (Minneapolis: University of Minnesota Press, 1998).

JORDAN, CONSTANCE, *Renaissance Feminism: Literary Texts and Political Models* (Ithaca, NY: Cornell University Press, 1990).

KELLY, JOAN, "Early Feminist Theory and the Querelle des Femmes: 1400–1789," *Signs*, 8 (1982), pp. 4–28.

LERNER, GERDA, *The Creation of Feminist Consciousness: From the Middle Ages to Eighteen-Seventy* (New York: Oxford University Press, 1993).

Medieval Embroidery

WILSON, DAVID M., *The Bayeux Tapestry* (New York: Knopf, 1985).

PARKER, ROSZIKA, *The Subversive Stitch: Embroidery and the Making of the Feminine* (London: Routledge, 1984).

Urban Working Women

HANAWALT, BARBARA A. (ed.), *Women and Work in Preindustrial Europe* (Bloomington: Indiana University Press, 1986).

HOWELL, MARTHA, *Women Production and Patriarchy in Late Medieval Cities* (New Brunswick, NJ: Rutgers University Press, 1986).

KOWALSKI, MARYANN, and JUDITH M. BENNETT, "Crafts, Guilds and Women in the Middle Ages: Fifty Years after Marian K. Dale," *Signs*, 14 (1989), pp. 474–488.

WIESNER, MERRY E., *Working Women in Renaissance Germany* (New Brunswick, NJ: Rutgers University Press, 1986).

Women Artists

CARR, ANNEMARIE WEYL, "Women Artists in the Middle Ages," *Feminist Art Journal*, V (1976).

HAMBURGER, JEFFREY F. *Nuns as Artists: The Visual Culture of a Medieval Convent* (Berkeley: University of California Press, 1997).

MINER, DOROTHY, *Anastaise and Her Sisters* (Baltimore, MD: Walters Art Gallery, 1974).

8

Italy: 1450–1600

THE ABSENCE OF WOMEN ARTISTS IN QUATTROCENTO FLORENCE

The patterns of urban working women, discussed in Chapter 7, help to explain the virtual absence of professional women artists in Florence during the fifteenth century. Florence was one of the most industrialized cities in Europe during this period. Women are largely absent from the records of the wool industry after 1350, as well as from most other work situations. Judith Brown documents this shift in the labor force from female weavers to German male weavers.[1] The well-documented power of the Florentine guilds would have been an additional factor restricting women's opportunities to become artists.

Most artists in the early Renaissance came from an artisan or working-class background and were members of guilds. Predictably, one can infer from the artists' guild regulations in Italy that women were hardly ever active. Furthermore, by the fifteenth century, the study of the human body, especially the male nude (from corpses and live models), was an essential component of the artist's training. It was absolutely impossible for women to acquire such training. Artists were also expected to travel to art centers to study contemporary production. Such freedom of movement was also beyond the capabilities of most women.

Brown proposes that the reentry of women into the labor force in Florence only occurred after the 1530s when the Medici dukes had established their political control and restricted the power of the guilds. Women found work in the textile industry then, as men shifted employment to luxury crafts such as ceramics, books, jewelry, and furniture intended for export to the European aristocracy.

While women were being actively excluded from the labor force in the fourteenth and fifteenth centuries, an ideology of domestic confinement was developing. This "Cult of Domesticity" was initiated during the early Renaissance among the aristocracy. Brown notes that by the early seventeenth century, the vast majority of women weavers worked in the home and had children. In 1610 one visitor to the city noted: "In Florence women are more enclosed than in any other part of Italy; they see the world only from the small openings in their windows."[2] By 1600, then, this gender ideology had permeated throughout all social classes of Florentine society.

QUATTROCENTO ARISTOCRACY IN FLORENCE

The Profile Portrait

- Domenico Ghirlandaio, *Giovanna Tornabuoni, née Albizzi*

Patricia Simons has studied profile portraits of women from the fifteenth century.[3] This work is an example of a type of image which dominated the production of portraits of aristocratic women beginning in

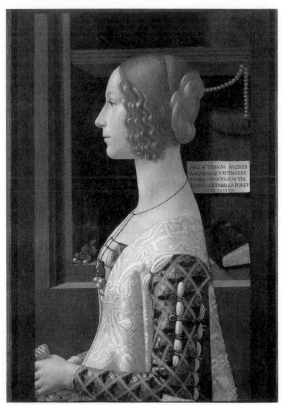

Fig. 8–1. Domenico Ghirlandaio, *Portrait of Giovanna Tornabuoni, née Albizzi*. 1488. Mixed media on panel, 77 × 49 cm.
(Fundación Coleccion Thyssen-Bornemisza, Madrid)

the 1440s. These images present women as objects of "the male gaze." They are painted by male artists for male patrons and are addressed, like virtually all art from this period, to male viewers. As a rule, aristocratic Renaissance women were not permitted to be seen in public.

The scope of activities demanded and expected of the upper-class woman of the Renaissance was more narrowly restricted to the roles of wife and mother than it had been for the noblewoman under feudalism. "All the advances of Renaissance Italy, its proto-capitalist economy, its states, and its humanistic culture, worked to mold the noblewoman into an aesthetic object; decorous, chaste, and doubly dependent—on her husband as well as the prince."[4]

For most women of all classes, marriage and motherhood were expected roles. For upper-class women, the only other available option was the seclusion of the convent. Marriages were always arranged by parents and continued to be primarily an economic contract or an alliance between two families of the same class status. A daughter's chastity was an absolute necessity and a very high priority of the culture. Daughters were strictly supervised to ensure their virginity. Divorce was virtually unknown.

Women's legal rights throughout this era remained very limited. In general, husbands administered matters and made decisions. Women were not only excluded from holding public office, but also from participation in legal matters and law courts. For example, a law in Florence passed in 1415 forbade a married woman from drawing up her own will or disposing of her dowry to the detriment of her husband and children.[5] In Florence, women "could not adopt children, go bail for any body, act as guardian or representative of any person of minor age, except of their own children, and even for these they were not allowed to appoint a guardian."[6]

Almost all Renaissance treatises on women viewed them strictly as wives, regardless of class status. The most important virtue of the wife was obedience to the will of her husband. After obedience, chastity was an essential virtue. In a wife chastity signified sexual fidelity to her husband, and this was sometimes enforced by the "chastity belt." In addition, silence, discretion, love of her husband, and modesty are frequently cited as ideal qualities for the Renaissance woman. The gentle, passive aspects of her nature were extolled and cultivated; the more aggressive aspects of her character were repressed.

The list of virtues makes it clear that the upper-class woman in the Renaissance was subjugated emotionally to a greater extent than the noble-women of the Middle Ages, who retained control over property and often ran the estate in the absence of husbands. One of the most important activities of the female members of the upper classes continued to be the spinning of wool and flax, although professional weavers organized in guilds actually made the cloth. Needlework was also deemed one of the most appropriate activities for women.

The education and training of the upper-class girl in the Renaissance was focused exclusively on her destined role of wife and the skills needed to maintain a household. Therefore, her education aimed primarily at

> . . . suppressing all individuality, fostering both fear of offense and complete dependence upon the will of her husband for all her comforts, and contentedness to live within the orbit of the house. . . . Nothing must be allowed in the training of her mind that would encourage or enable her to compete on even ground with men. This general assumption is implicit in everything that was said on the training and education of women. Extremely limited goals were set for their education even by their most ardent supporters, in the restriction on subjects and books, and most of all in the almost total absence of reference to the professions.[7]

While the Renaissance man received an education in a wide variety of subjects, Renaissance women were taught only those skills that would make them competent housewives, except for instruction in religious principles, which would encourage docility and obedience.

The sitter in this portrait, Giovanna Tornabuoni, died while pregnant, in 1488. The work was commissioned by her husband, Lorenzo Tornabuoni, whose initial "L" is embroidered on her garment. Her expensive clothes and prominently displayed jewelry were part of the aristocratic custom of loading the bride with a "portable dowry." This practice of conspicuous consumption served as a symbol of the husband's rank and status. Within this "display culture," as Simons characterizes it, the profile painting of a wife is a "representation of an ordered, chaste and decorous piece of property."[8] This specific image was hung in the Tornabuoni family palace. "Forever framed in a state of idealized preservation, she is constructed as a female exemplar for Tornabuoni viewers and others they wished to impress with the *ornamento*."[9]

DOMESTIC ARCHITECTURE

The Renaissance Palace

There is no more obvious example of the Quattrocento aristocratic taste for conspicuous consumption than the building of palaces. As Richard Goldthwaite has documented, a significant change in attitudes about private spending took place in Florence. Prior to the fifteenth century, Florentines operated under strong restraints against spending money too visibly. After 1400, however, such restraints were lifted, and Alberti, for example, believed that the accumulation of possessions was necessary for the happiness of the family.[10]

Prior to 1350, urban residences of the wealthy class of Florence did not constitute a distinctive architectural form. The ground floor often housed a

retail shop. The second story had an open *loggia* or balcony where the family could "assemble on ceremonial occasions."[11] These structures were also defined by a tower that served as protection when needed. What Goldthwaite manages to ignore in his otherwise excellent study, *The Building of Renaissance Florence,* are the specific implications of these architectural changes for the women of the household. The open loggia would have provided a place in which women could communicate, albeit from a height, with the larger social life of the streets.

The change in design of the new Renaissance palaces of the fifteenth century, such as the Palazzo Medici or the Palazzo Strozzi to cite the two most famous architectural examples, was dramatic. Unlike the Roman villa, the Renaissance palace is exclusively a residential property and not a place of business. For example, the Medici bank and cloth shop where the family's business dealt directly with the public was located elsewhere. The open loggia onto the street was eliminated and replaced by a completely enclosed internal courtyard, arcaded and architecturally embellished. These enormous buildings housed, generally, a nuclear family.

The new palaces provided vastly greater areas of living space than had existed in the earlier buildings. These empty spaces demanded to be filled. As Goldthwaite notes: "The more space *he* had to fill up, the more *he* consumed, and the more conspicuous *his* consumption became, the greater was the social distance *he* put between *himself* and the ranks of ordinary *men* . . . A distance that *his* ancestors *probably* did not know even though they may have been every bit as wealthy."[12] I have emphasized the male pronouns in this statement to underscore the male perspective of this scholar.

What Goldthwaite does *not* discuss is the impact of this increased isolation and social stratification on the women of the household, confined in these huge structures. The design of the Renaissance *palazzo* would have effectively served as prisons, isolating the women inhabitants from the life of the community.

• Sandro Botticelli, *La Primavera*

This famous painting was commissioned for the wedding of Lorenzo de Pierfrancesco de' Medici to Semiramide d'Appiani. It was hung in the home of this couple, in a room adjacent to their bedroom. Lilian Zirpolo has interpreted the iconography of this painting in the context of the prevailing rituals connected with marriage and the discourses on the ideal wife in this period.[13] The Graces represent the behavior and ideals appropriate to a Renaissance bride. They symbolize purity and chastity, and exhibit restrained movements and lack of emotionality. On the right, the rape of Cloris, who is then transformed into Flora, would instruct the new bride on the need for her sexual submission to her husband to ensure order, stability, and future children to continue the Medici clan. Flora's stomach is enlarged

Fig. 8–2. Sandro Botticelli, *La Primavera*. c. 1477–1480. Tempera on panel.
Approx. 6 ft. 8 in. × 10 ft. 4 in. *(Uffizi, Florence, Italy; Alinari/Art Resource, NY)*

to emphasize her fertility, and her face reveals contentment as opposed to Cloris's distress. This would serve as a model for the desired response of the bride. The centrality of Venus would have underscored the importance of procreation for the Renaissance marriage. Her enlarged stomach shows Venus as a goddess of fertility. Fertility is emphasized, as well, by the lush, fruitful garden setting.

Italian women of this aristocratic class were married at age 16 or 17, as opposed to most women in northern Europe who did not marry until 25 or 26. Italian noblewomen could expect to have three more children than would women living in northern Europe. Since they played virtually no economic role in their society, other than the transfer of property in the dowry (as discussed in the profile portraits), their reproductive capacities were enhanced in the gender ideology of the culture.[14]

WOMEN ARTISTS, 1525–1600: THE RENAISSANCE "VIRTUOSA"

• Properzia De'Rossi, *The Chastity of Joseph* (or *The Temptation of Joseph by the Wife of Potiphar*), c. 1526

Properzia De'Rossi was a sculptor and this very unusual choice of medium earned her the designation of "virtuosa" in the early critical texts. De'Rossi was the only woman included in the first edition of Vasari's famous book, *The Lives of the Painters, Sculptors and Architects*. Even in the

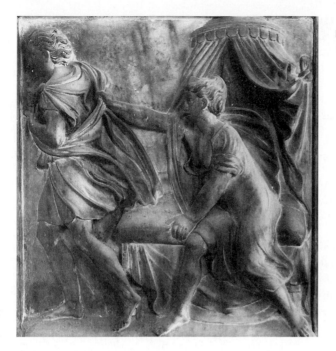

Fig. 8–3. Properzia de'
Rossi, *The Chastity of Joseph*
(or *The Temptation of Joseph
by the Wife of Potiphar*), c.
1526. *(Bologna, Basilica.
Photograph di S. Petrenio.
Formella di Marmo.)*

second edition, published in 1568, De'Rossi was singled out with her own biographical entry. Fredericka Jacobs has supplied us with a detailed analysis of this text. Jacobs notes that De'Rossi is not related to artists, but rather is identified as a "victim of a form of melancholia described best as lovesickness. De'Rossi is not remarkable for demonstrating that woman can rise above the condition of her sex but for proving that she cannot."[15] Rossi was born around 1490 to a father who was a native of Bologna. Little is known about her training. In August 1524, she was employed carving a relief for the Church of San Petronio in Bologna. The *Chastity of Joseph* was carved as part of this decorative project. In addition to the relief, she also carved miniature reliefs into peach stones, several of which have survived.

Court records exist that name Properzia in two lawsuits, one in which she and her lover Antonio Galeazzo Malvasia threw a tree trunk and 24 feet of vines into the garden of her neighbor. On a separate occasion, she scratched the face of a painter, Miola, and was charged with assault and battery. She died of the plague in 1530. Both Jacobs and Nancy Finlay provide interesting analytical readings of a series of texts written about this artist. Finlay analyzes six female writers who have addressed the issue of Properzia De'Rossi ranging from a nineteenth-century Bolognese aristocrat to a contemporary scholar.[16] Jacobs limits her analysis to critics both male

and female from Vasari to Laura Ragg, an Englishwomen who was the author of *The Women Artists of Bologna*, published in 1907. The dearth of secure information about Properzia De'Rossi would be a caution to those who might want to interpret the relief as a reflection of the life and personality of the sculptor. We are left with a single fact that is perhaps remarkable enough: the existence of a woman who was a competent professional sculptor active in the early sixteenth century.

• Sofonisba Anguissola, *The Chess Game*

This extraordinary painting documents the talents of a serious and accomplished woman artist, a true "virtuosa," Sofonisba Anguissola (1532/35–1625). To understand how such a woman could develop these painting skills, we must look to the social background of Anguissola, not in the guild-controlled realm of work but in the context of the humanist thought of the epoch, which began to impact women of the aristocracy. It is in this cultural context that Sofonisba Anguissola achieved her status as "the first Italian woman to become an international celebrity as an artist and the first for whom a substantial body of works is known."[17]

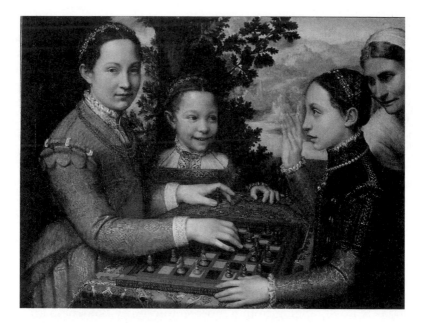

Fig. 8–4. Sofonisba Anguissola, *The Chess Game*. Canvas, 72 × 97 cm. (© Photography by Erich Lessing)

Beginning in the fifteenth century, a few humanist scholars influenced the education of a small group of noblewomen, at first in the courts of Italy, then spreading through Europe. Some Italian women emerged as scholars in this period and as authors of a wide range of texts. Women wrote in most of the genres of literature of the time: letters, orations, dialogues, treatises, and poems.[18] Margaret King cites, in particular, women from the fifteenth century such as Laura Cereta and Isotta Nogarola, who achieved fame for their learning as Sofonisba Anguissola achieved fame for her painting skills. Like Sofonisba they came from elite families. Just as Sofonisba had to learn to paint from the male artist Bernardino Campi, so the women humanists were educated by men, often members of their families.

These ideals were incorporated into a "Christian humanism" in England, France, and the Netherlands, spread by intellectuals like Erasmus and Thomas More. According to the humanists, women should receive the same education as their male counterparts. Like the Renaissance men, women should study Latin, classical literature, philosophy, and history, as well as geometry, arithmetic, and astrology. This model was eventually adopted for the upper-class women of the towns as well as for the ladies at court. By the sixteenth century, under the influence of humanism, schools for girls that taught minimal literacy were widespread in northern Europe. Some women, educated in the humanist tradition, wrote lively defenses of their sex, which, as noted earlier, became known as the *Querelle des Femmes.*

These humanist ideals also affected the training of artists. Artists were expected to possess a knowledge of science, mathematics, and perspective, as well as the practical skills acquired in an apprenticeship.

The noblewoman's education was impacted by the publication of Baldesare Castiglione's *The Courtier* in 1528. This book became an enormously influential treatise not only for the education of women but also for the definition of ideal modes of conduct for upper-class men and women. Castiglione grants to the noblewoman all the virtues and potential for perfection of the male courtier. Her education is equivalent to that of men. Most significantly for the history of art, all the arts practiced at court—music, writing, drawing, and painting—are seen as positive attributes for women.

These arts are not viewed as professional skills to be executed for money, but rather as appropriate accomplishments for a refined and properly educated noblewoman. Castiglione's ideas affected many women in the upper classes, the stratum of society from which some of the most important women artists of the sixteenth century, like Sofonisba Anguissola, emerged.

Anguissola was raised in an exceptional environment that allowed her to develop her creative talents. The oldest of six daughters, she was born

into a noble family in the provincial northern Italian city of Cremona. Following the advice popularized by Castiglione in *The Courtier,* her family made sure to provide their daughter with instruction in painting and music, as befitted a woman of her class. In addition to lessons in painting, Anguissola was taught to play the spinet, and in several self-portraits she shows herself playing this keyboard instrument. One can imagine that her father, Amilcare, faced with the financial burden of providing dowries for six daughters, was highly motivated to cultivate their talents. In fact, the three oldest sisters all received instruction in painting. Endowed with the fortunate circumstances of her class background and birth, Sofonisba Anguissola was in an unusually favorable position to develop her talents beyond the level of accomplished amateur to that of professional painter.

Anguissola painted more self-portraits than any other artist between Dürer and Rembrandt. These works were especially desirable. One patron wrote to her father:

> There is nothing that I desire more than the image of the artist herself, so that in a single work I can exhibit two marvels, one the work, the other the artist.[19]

Sofonisba first studied with Bernardino Campi (1522–1591), a well-known artist active in the 1540s in Sofonisba's native town of Cremona, in northern Italy. Following Campi's departure for Milan in 1549, Anguissola painted an interesting double portrait, *Bernardino Campi Painting Sofonisba Anguissola* (c. 1549, Pinacoteca Nazionale, Siena). Jacobs believes that Anguissola probably used a portrait or self-portrait of Campi, already in existence. Therefore, Sofonisba's act of appropriation was a conscious declaration of her progression from copying (*rittrarre*) to imitating (*imitare*). She authoritatively refashioned her source in accordance with her tastes and intent. This demanded *invenzione,* which imparts *grazia.* Therefore this image verifies Vasari's assertion that her works exhibit "greater grace than those by other women" because, according to Vasari, "those who do not possess *grande invenzione* are always poor in *grazia.*"[20] This painting constitutes an unusual homage to her teacher. Sofonisba had good reason to be grateful to Campi. The training she received from him, as recorded by the skillful double portrait, was unprecedented for a woman, especially from her class. Elena, Sofonisba's sister, however, gave up her career to become a nun. The third and fourth sisters, Lucia and Europa, also became painters, although very few works can be securely attributed to them.

Jacobs has analyzed in detail the texts written about Italian women artists of the sixteenth century to comprehend the ways in which women artists were perceived in the society. Jacobs's discussion is focused around the difficulty of defining the term *"virtuosa."* This title was a restricted one of praise and was used for less than one-quarter of the nearly forty women

artists active in Italy during the sixteenth century.[21] She concludes that a *virtuosa* is a "talented, attractive and properly behaved woman. Her artistic ability, like her musical accomplishment and *bellezza* (beauty) is merely one more ladylike quality making her a *'gemma, un ornamento.'*"[21] As opposed to the use of the term for Properzia De'Rossi, in the case of Sofonisba Anguissola, Vasari uses the term "virtuosa" to signify her exceptional talent. Vasari credits this artist with abilities normally reserved for male artists. However, as we will also see for "The Exceptional Woman," Vigée-Lebrun, Anguissola's excellence . . . "depends on whether she can rise above the condition of her sex and act (or paint) like a man. Therefore a *virtuosa* could be understood as a woman endowed with masculine abilities."[22]

Sofonisba Anguissola studied with another Cremonese artist, Bernardino Gatti (c. 1495–1576), for about three more years. However, the opportunities to develop her skills in Cremona were limited. In 1554 she traveled to Rome. Vasari mentions that Tomasso Cavalieri, a friend of Michelangelo's, sent one of her drawings to Duke Cosimo de' Medici of Florence in 1562. Documents exist which confirm that Sofonisba was in direct contact with the most important living artist of the time, Michelangelo.[23]

From surviving letters, it is known that Sofonisba sent Michelangelo a drawing she had made of a smiling girl, and asked for the master's criticism and advice. Michelangelo admired the work, but challenged her to depict the more difficult subject of a crying boy. In response to this challenge, Anguissola created a drawing that cleverly juxtaposes the two subjects. This work, *Boy Pinched by a Crayfish*, demonstrates Anguissola's ability to represent a range of emotions. The features of the boy were based on those of her young brother (the seventh sibling in the family). This drawing was presented to the duke of Florence, Cosimo de' Medici, and had widespread influence. It was seen by other artists, including Vasari, and copies were made of it. Anguissola's drawing may have inspired Caravaggio's *Boy Bitten by a Lizard*.[24]

Despite this contact with the renowned Michelangelo, the main influence on Anguissola's painting style derives from the local environment of Cremona. Surrounded by Milan, Brescia, and Parma, Cremona's painters were exposed to several strands of "verist" or naturalist styles prevalent in these art centers. Artists from this region of northern Italy retained an almost Flemish taste for the precise description of nonidealized forms, in religious painting as well as in portraiture. The stylization of Mannerism, so dominant in central Italy, never completely overwhelmed this local tradition. Thus, Sofonisba's talents for realistic description and anecdote seen in her drawing of the crying boy reflect the style of her native city. By 1555 the artist was back in Cremona.

Paintings from the first period of Anguissola's career, prior to 1559, are mostly portraits of her family. One of the most interesting of these

works, *The Chess Game* (Fig. 8–4), is an inventive composition for a group portrait. The image depicts the artist's sisters, grouped around a chess board, as if they are in the middle of the game. Lucia, the oldest sister on the left, is holding the important piece, the black queen. Minerva is on the right and the youngest, the fifth-born Europa, who would also become a painter, is shown smiling. This painting may be the first "conversation piece," a type of group portrait that would gain wide popularity in subsequent centuries.[25]

In 1559 Anguissola was invited to join the court of King Philip II of Spain. The governor of Milan had mentioned Anguissola to the duke of Alba, an emissary of the Spanish court. Anguissola's position as one of Spain's court portraitists fits into a pattern of artistic links between Spain and Italy in the mid-sixteenth century. There was a tradition of importing foreign artists to Spain as well as of sending native Spanish artists to Italy for training. Titian had been appointed as official court portraitist to King Charles V in 1533. In 1567 Philip II hired six Italian artists to work as fresco decorators on the huge palace–mausoleum–monastery complex, the Escorial. The most famous artist working in Spain at this time, El Greco, was trained in Italy. From the 1560s through the eighteenth century many Italian artists worked on royal projects for the Spanish monarchy.

Anguissola remained at the Spanish court through the 1560s. She painted several portraits of Queen Isabella, one of which was sent to Pope Pius IV. In 1569 she married a Sicilian nobleman, Fabrizio de Moncada, with a dowry that had been provided in the queen's will. King Philip of Spain gave her in marriage and presented her with numerous gifts. Through her talents as a painter, Anguissola achieved both fame and fortune, and other aspiring women artists emulated her example.

Anguissola's renown rests primarily on her pioneering position as the first professional woman painter from Italy. Aside from her artistic talents, which were exceptional, she altered the conventions of portrait painting. As we have seen in *The Chess Game,* she injected an innovative liveliness and range of emotion into her intimate portraits of members of her family. Her art anticipates the more overt emotional content of much Baroque imagery.

• Lavinia Fontana, *The Visit of the Queen of Sheba*

Compared to Sofonisba Anguissola, Lavinia Fontana (1552–1614), as the daughter of an artist, acquired her training in a manner that was much more characteristic for women artists of future centuries. Her father, Prospero Fontana, was one of the leading painters of Bologna. "Lavinia Fontana is the first woman to have had what might be called a normal successful artistic career. Although many of her works are lost or disputed, she still has the largest surviving body of work by any woman artist active before 1700."[26] Many of her works consist of large scaled multifigured religious paintings,

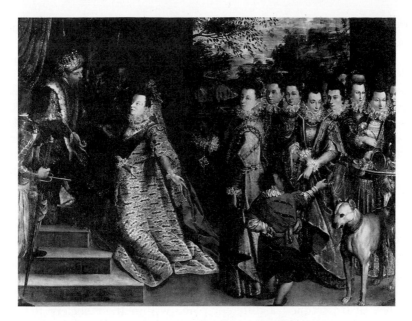

Fig. 8–5. Lavinia Fontana, *The Visit of the Queen of Sheba.* c. 1600. (*Courtesy of the National Gallery of Ireland*)

executed on commission as altarpieces. She also painted many commissioned portraits, a practice that was quite exceptional for a woman artist.

Her early portrait style may have been influenced by that of Sofonisba Anguissola, "whom Lavinia knew and admired."[27] By the 1570s her fame as a portraitist was well established. According to Eleanor Tufts, this painting is, in fact, a group portrait of the Gonzaga family, the Duke and Duchess of Mantua, who were famous and generous art patrons. The Duke, Vincenzo I (1562–1612), and the Duchess, Leonora de' Medici, could have sat for this work on their way to Florence for the wedding of Marie de' Medici in 1600.[28] Tufts connects the appropriateness of depicting this noble couple as Solomon and Sheba to one of their treasures, an onyx vessel believed to come from the temple of Solomon. Holbein had used this analogy in a miniature for a gift from Henry VIII to one of his wives. A literary source is found in Tasso's 1582 discourse on Feminine Virtue, which the poet dedicated to Vincenzo's mother. In that work, the woman who does not seek love from unbridled desire is likened to Sheba coming to Solomon.

Entrusting Lavinia Fontana with such a major commission testifies to her reputation among cognoscenti of her period. This group portrait dates from the period of 1595 to 1600 when she was at the height of her artistic powers. The work combines naturalistic observation of the heads in the portrait likenesses

with the Flemish precision of the costume textures. The work exhibits all the conventions demanded by court portraiture of the period.

Lavinia Fontana received an important commission from Cardinal Girollamo Bernerio in May 1599, for the chapel in Santa Sabina decorated by Federico Zuccari. The *Vision of Saint Hyacinth* was selected to illustrate an episode from the life of a recently canonized saint. Fontana followed this work to Rome and is known to have been living in Rome by 1604. She painted another large altarpiece, the *Martyrdom of Saint Stephen*, in the palace of Cardinal d'Este for the basilica of San Paolo Fuori Le Mure. (This work was destroyed in a fire in 1823.) During the last decade of her life she continued to be in great demand as a portraitist. She survived eleven pregnancies and died in 1614 at the age of 62.

THE ROLE OF WOMEN PATRONS

During the past decades, the contributions of women to the visual arts as patrons of specific works or as collectors of art have received broader interest among scholars. While these women usually belonged to an elite class they also occupied a different place within their society than their male counterparts. In general, women became more active as commissioners of works, "matrons," only after they had borne children or were widowed. When these women gained control of their financial resources, they were then in a position to promote artistic projects. Although motivation for subsidizing works of arts varied, it seems that, at least in the Early Modern period (c. 1300–1750), many projects were "linked to the continuity and promotion of the dynasty of the family."[29] We find that while women did amass personal collections of clothing, or jewelry or other luxury items, many of the patrons studied so far by scholars were actively involved in large architectural projects. Some built family residences or sponsored the construction of churches, convents, schools, or other public buildings. In these cases, women initiated the project, hired the architect, instructed workers on site and raised the necessary funds to complete the projects. As scholars continue to explore the roles of women in the formation of all types of art, the extent of this "matronage" will surely emerge in a more complete form than is currently available in the literature. In a recently published selection of scholarly essays a number of women patrons are discussed.[30] I briefly summarize the roles of two of these "matrons" as examples of the variety and importance of the roles of patron for the history of art.

Isabella d'Este Gonzaga (1474–1539)

The reputation of Isabella d'Este is based on her vast collection of works of art, which ranged from classical sculpture to antique coins to paintings by contemporary artists, such as Leonardo, Perugino, and Mantegna. She was born into the nobility, as a child of the Duke Ercole d'Este, who ruled the

region of Ferrara, and his wife, Eleonora of Aragon. From the time she arrived in Mantua, in 1490 as the wife of its Duke, Francesco II, until her death, in 1539, she was an active ruler. During this period she amassed a vast art collection. Over 20,000 letters survive that provide extensive documentation of her negotiations with artists and her methods of purchasing antiquities. In one letter she herself described her desire for antiquities as "insatiable." She was also responsible for the construction and decoration of two spaces in which her diverse collection could be properly exhibited: the Studiolo and a Grotta, which were "filled with paintings and books (as often as not of a non-religious nature), as well as antique coins, cameos, intaglios, and bronze and marble statuary."[31] Her collection housed in these spaces in the Palazzo Ducale in Mantua remained intact even after her death, preserved by her grandson. The fame of her collection has continued into the present era and, in fact, it is Isabella d'Este, rather than her husband or male heirs, who is the most famous ruler of this city, due in large part to the fame of her collections.

Catherine de' Medici (1519–1589)

The role of Catherine de' Medici as "matron" has been studied for over 15 years by Sheila ffolliott, whose efforts have expanded our knowledge and understanding of this queen's contributions to the visual culture of her era.[32] In 1533, Catherine de' Medici married the Duc d'Orleans, who became the king of France, Henri II, in 1547. In 1560, following the death of both her husband and first son, Francis II, she became regent of France and exerted considerable power for the remainder of her life. In a recent article, ffolliott analyzed the text of Nicholas Houel, written in 1586, which lays out a model for the activities of queens as patrons of the arts. For Houel, the queen's main responsibility lay in supporting charitable institutions, such as churches, monasteries, and hospitals. Queens were also to prod their husbands into encouraging such charitable acts and only the commissioning of their own tomb was viewed as an appropriately queenly activity. ffolliott argues that Catherine went far beyond such prescriptive restrictions, as defined by Houel's "gendered ideal." In this capacity, she planned the "Valois Chapel" the first independent structure for royal tombs, which provided for her own tomb as well as that of her husband and children to perpetuate the Valois dynasty. She also ordered the construction of a separate residence for herself near the Louvre, the Palace of the Tuileries, another house, the Hotel de la Reine, and homes for her children. She enlarged the chateau of Chenonceux, which had belonged to Henri's mistress, Diane de Poitiers. She supervised the construction of garden spaces in the Tuileries, in which rituals were enacted that carried political symbolism. Catherine de' Medici was a powerful ruler who appropriated the visual arts for her own strategic and political ends in a way that surpassed the customary expectations even for such prominent noblewomen as the queens of France.

Suggestions for Further Reading

BROUDE, NORMA, and MARY D. GARRARD, *The Expanding Discourse: Feminism and Art History* (New York: HarperCollins, 1992).

FERGUSON, MARGARET, M. QUILLIGANS, and N. VICKERS (eds.), *Rewriting the Renaissance: The Discourse of Difference in Early Modern Europe* (Chicago: University of Chicago Press, 1986).

FINLAY, NANCY, "The Female Gaze: Women's Interpretations of the Life and Work of Properzia de'Rossi, Renaissance Sculptor," in Natalie Harris Bluestone (ed)., *Double Vision: Perspectives on Gender and the Visual Arts* (London; Cranbury, NJ: Associated University Presses, 1995).

GOLDTHWAITE, RICHARD A., *The Building of Renaissance Florence: An Economic and Social History* (Baltimore, MD: Johns Hopkins University Press, 1980).

HERLIHY, DAVID, and CHRISTIANE KLAPISCHE-ZUBER, *The Tuscans and Their Families: A Study of the Florentine Castasto of 1427* (New Haven, CT: Yale University Press, 1985).

JACOBS, FREDRIKA, *Defining the Renaissance Virtuosa: Women Artists and the Language of Art History and Criticism* (New York: Cambridge University Press, 1997).

KELSO, RUTH, *Doctrine for the Lady of the Renaissance* (Urbana: University of Illinois Press, 1956).

LABALME, PATRICIA (ed.), *Beyond Their Sex: Learned Women of the European Past* (New York: New York University Press, 1984).

Anguissola

FERINO-PAGDEN, SYLVIA, *Sofonisba Anguissola: A Renaissance Woman* (Washington, DC: National Museum of Women in the Arts, 1995).

PERLINGHIERI, SONDRA ILYA, *Sofonisba Anguissola: The First Great Woman Artist of the Renaissance* (New York: Rizzoli, 1992).

Fontana

FORTUNATI, VERA, *Lavinia Fontana of Bologna, 1552–1614* (Washington, DC: National Museum of Women in the Arts, 1998).

The Age of Correggio and the Carracci: Emilian Painting of the 16th and 17th Centuries (Washington, DC: National Gallery of Art, 1986).

Women Patrons

KING, CATHERINE, *Renaissance Women Patrons: Wives and Widows in Italy, c. 1300–1550* (Manchester and New York, Manchester University Press, 1998).

LAWRENCE, CYNTHIA (ed.), *Women and Art in Early Modern Europe: Patrons, Collectors, and Connoisseurs* (University Park: Pennsylvania State University Press, 1997).

MARTINEAU, JANE and DAVID CHAMBERS (eds.), *Splendours of the Gonzaga* (London, Victoria and Albert Museum, 1981).

9

Europe: 1600–1700

Women artists remained isolated and exceptional in their professions in Europe during the seventeenth century. While a few very talented women managed to conduct successful careers, most artists and patrons were male. Therefore women artists functioned in institutional contexts that were dominated by male standards and expectations. Despite this, it is tempting to try to find spaces in which a proto-feminist sensibility emerges in their works. In the works illustrated in this chapter, however, with the exception of Leyster, there is very little compelling evidence for such an interpretation. The chapter concludes with a discussion of some images of women in Dutch genre paintings that provides insights into the gender ideology of this cultural matrix.

- Artemisia Gentileschi, *Judith Decapitating Holofernes*

Artemisia Gentileschi (1593–c. 1652) developed a forceful personal style that placed her among the leading artists of her generation who worked in the style of Caravaggio. She traveled a great deal and helped spread the Caravaggesque mode throughout Italy. The dispersal of her paintings further extended her influence.

Like Lavinia Fontana, Artemisia was the daughter of an artist, Orazio Gentileschi. Artemisia, therefore, had the advantage of being raised in an environment where she could acquire the basic technical skills necessary for a professional artist. Because Orazio was among the first artists to adapt Caravaggio's style in the first decade of the seventeenth century, it is not surprising that Artemisia would also develop a Caravaggesque style. One of her earliest paintings, *Judith with Her Maidservant* (Pitti Palace), was copied from her father's version of this theme as a learning exercise.

Fig. 9–1. Artemisia Gentileschi,
Judith Decapitating Holofernes.
1615–20. Oil on canvas, 46¾ ×
37¼ in. *(Pitti Palace, Florence)*

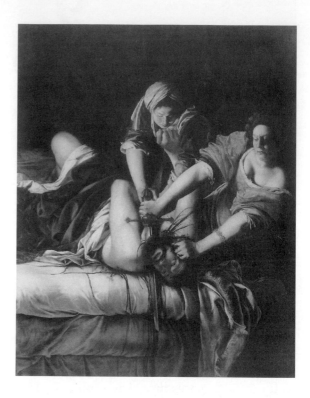

Orazio must have recognized his limitations as a teacher for his talented daughter because he arranged for her to study perspective with Agostino Tassi, a successful artist and collaborator who was receiving major commissions for fresco decorations of Roman palaces. Tassi seduced and forcefully raped Artemisia and then continued to have sexual relations with her, promising to marry her.[1] When it became clear that Tassi, a disreputable character with a prior criminal record, had no intentions of marrying Artemisia and restoring her honor and respectability, Orazio sued Tassi. The trial took place in 1612 and lasted several months. R. Ward Bissell, a leading scholar of this artist, believes that Orazio's motivation for bringing suit was related to his own sense of betrayal. "Orazio Gentileschi also construed Tassi's assault on his daughter to be a serious assault upon him as well."[2] Bissell characterizes Orazio, given the moral code of honor in seventeenth-century Rome, to be "compelled to press charges."[3] Artemisia was tortured on the witness stand with thumbscrews, a seventeenth-century lie detector. Tassi was imprisoned for eight months, but the case was ultimately dismissed, leaving Artemisia publicly humiliated.

Shortly after the trial, Artemisia married a Florentine and went to live in Florence. There was little Caravaggist painting in that city and

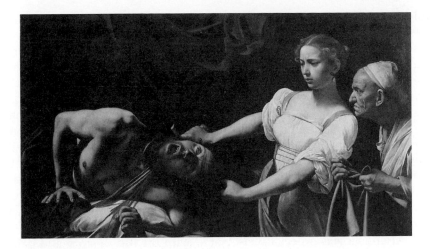

Fig. 9–2. Caravaggio, *Judith and Holofernes.* c. 1598. 144 × 195 cm. *(Galleria Nazionale D'Arte Antica, Palazzo Barberini, Rome)*

Gentileschi's presence stimulated Florentine artists to investigate the new expressive possibilities of Caravaggism.

One of her most impressive paintings from the Florentine period of her career is the dramatically baroque composition *Judith Decapitating Holofernes* (Fig. 9–1). Judith, the Old Testament heroine, stole into the enemy camp of the Israelites, murdered the tyrant Holofernes, and then escaped with his head. This story was a popular subject among the Caravaggists because it provided a biblical anecdote that could serve as a genre theme of violence or suspense. Since this work is fully characteristic of Gentileschi's mature, Caravaggesque style I have chosen this image rather than the admittedly juvenile Susanna for inclusion in this text.

When one compares Gentileschi's *Judith Decapitating Holofernes* with Caravaggio's version of the theme (Fig. 9–2), one can see both the extent of Gentileschi's assimilation of Caravaggio's style and the differences that reveal her own vigorous sense of drama and originality. Like Caravaggio, Gentileschi positions large-scale figures in the foreground and uses highlighted forms that emerge from a dark background. The women in both works are not idealized and details are realistic. Both artists have selected the gory moment of decapitation; however, Gentileschi designed a composition that is much more dynamic and energetic. In Caravaggio's painting, the figures are positioned across the picture surface. Gentileschi's composition places the figures in depth and is much more compact, and therefore more dramatic. Caravaggio's old maidservant is peripheral to the action while Gentileschi's maid actively participates in the murder, holding

Holofernes down. In Gentileschi's painting, the arms of all three figures intersect in the center of the canvas, fixing the viewer's attention inescapably on the grisly act. The position of Caravaggio's rather pretty, elegant Judith seems frozen; she is not exerting physical force to cut off the tyrant's head. By contrast, one can acutely sense the intensity of the physical effort that Gentileschi's Judith and her maid bring to this act. The powerful, monumental, and robust anatomy of Gentileschi's women makes this decapitation seem much more convincing than Caravaggio's version.

One notable characteristic of Gentileschi's talent is her excellent knowledge of female anatomy. Perhaps being raised in the home of an avant-garde painter, she had the opportunity to study the female nude in private, using a servant or even her own body as a model. Her knowledge of male anatomy was understandably less sophisticated. The drapery covering Holofernes's torso masks this weakness.

Artemisia was especially fascinated with the Judith story and painted at least six different versions of it. However, Bissell cautions the modern viewer to be wary of ascribing modern, feminist intentions to this selection of subject. Bissell summarizes his perspective in the following manner: "As I interpret the evidence, Artemisia Gentileschi was endowed with special gifts of insight and artistic skill, and, choosing thoughtfully from among the interpretive options available to her and adopting a naturalistic style, she produced an art that makes penetrating observations about humankind by way of women of monumental stature and independent mind. This dedication to speaking truth might be called a mission, but it is not a mission restricted to women or driven perforce by a proto-feminist ideology."[4]

In 1621 Gentileschi returned to Rome where she found the situation of the Caravaggists considerably different than when she had left the city almost a decade earlier. The Bolognese followers of Carracci were winning most major commissions, and Artemisia Gentileschi was now one of the few major Caravaggist painters living in Rome.

Unwilling to abandon her personal style of Caravaggism to accommodate the changing tastes of Roman patrons, Gentileschi traveled to Naples in 1630. Except for a brief visit to London to assist her ailing father on a commission, she lived in Naples for the rest of her life. The selection of Naples as her next residence was logical because more artists worked in a Caravaggist style there for a longer period of time than in any other Italian city. In fact, between 1600 and 1630, Caravaggism was the only advanced painting style practiced in Naples. However, this situation was to change during the 1630s when the influence of the Bolognese school, especially the art of Guido Reni, became increasingly important, even in Naples. Accepting the inevitable, Gentileschi now adapted her style to the more brightly illuminated, idealized mode of the Carracci followers. In the process she lost some of the intensity of her personal style. Scholars generally agree that the works created in her original Caravaggist mode are her finest paintings.

Bissell consistently reminds the contemporary feminist of the demands of patronage pressures on this artist. Artemisia Gentileschi was painting for male patrons and so, whatever her own understanding of her "identity as a woman" might be, she was still a professional artist who had to sell her paintings in order to eat. The importance of pleasing the patron is documented in some of the surviving letters written by Gentileschi. In a letter from 1649 to one of her patrons, Don Antonio Ruffo, she writes:

> Most Illustrious Sir and My Master,
> By God's will, Your Most Illustrious Lordship has received the painting and I believe that by now you must have seen it. I fear that before you saw the painting you must have thought me arrogant and presumptuous. But I hope to God that after seeing it, you will agree that I was not totally out of line. In fact, if it were not for Your Most Illustrious Lordship, of whom I am so affectionate a servant, I would not have been induced to give it for one hundred and sixty, because everywhere else I have been I was paid one hundred *scudi* per figure. And this was in Florence, as well as Venice and Rome, and even in Naples when there was more money. Whether this is due to [my] merit or luck, Your Most Illustrious Lordship, a discriminating nobleman with all of the worldly virtues, will [be the best] judge. You think me pitiful, because a woman's name raises doubts until her work is seen. Please forgive me, for God's sake, if I gave you reason to think me greedy. As for the rest, I will not trouble you any more.[5]

Such letters clearly reflect the financial pressure of her situation as a professional artist earning her own living in this era.

The sheer formal beauty and power of many of Gentileschi's paintings serve to rank her with the best artists of her generation. Never a mere imitator of Caravaggio, she adapted some of that artist's devices to forge an original style of strength and beauty. Her inventive adaptations of existing subjects are another aspect of her originality. She harnessed her formal energies to the expression of a personal iconography, expressing her identity as a woman and as an artist.

WOMEN ARTISTS IN HOLLAND

Holland secured its independence from Spain in 1581 and by the seventeenth century was the major maritime power of Europe, with a far-flung colonial empire. Because Holland was a Protestant country, the Church was not an active arts patron as it remained to some extent in neighboring Catholic Flanders. However, the Dutch middle class was wealthy and purchased paintings on a regular basis. This provided a strong incentive for Dutch artists to paint the kinds of works that would appeal to the merchants of the middle class—their only source of patronage.

Because these works of art were intended to adorn the burghers' homes, the vast majority of Dutch paintings are small in scale, suitable for

hanging in private houses. With the exception of portraits, paintings were sold on the open market, creating a competitive situation that kept prices low. In this context, painters developed precise areas of specialization, such as still life painting, flower arrangements, landscapes, seascapes, and genre paintings, in an effort to secure a steady market. The unifying factor in all of these categories was a dependence on precisely observed natural phenomena. Dutch art is characterized stylistically by its realism. Painting schools were flourishing in Utrecht, Haarlem, Amsterdam, Leiden, Delft, and other cities in Holland.

The competitive art market created an opportunity for a few talented women to emerge. Artists could paint what they liked and when they liked, rather than painting only when commissioned, and artists could accept as many pupils as they wished. Although the guilds were the primary artists' organizations, there were considerably fewer restrictions on who could become an artist in Holland than in other parts of Europe. Furthermore, with the development of the new painting specialties, there was no need to study the nude; in fact, there are very few nudes in Dutch art.

The careers of the artists discussed next in this chapter demonstrate the level of excellence that can be achieved by women artists when the expectations for women in their culture do not conflict with a measure of equality of opportunity and access to training.

WOMEN ARTISTS AND STILL LIFE PAINTING

Still life and flower painting did not require knowledge of anatomy or extensive travel to Italy to study the High Renaissance masters. Throughout Europe, women were in the forefront of still life painting in the early 1600s. Only a still life attributed to Caravaggio is known to predate the works of Fede Galizia in Italy. In France, Louise Moillon painted a series of impressive still lifes, and four women painters of still lifes were elected to the French Academy during the seventeenth century. Contemporaneously, Josefa de Obidos was a noted painter of still lifes in Portugal. However, the most noteworthy women still life painters were Flemish and Dutch, since these schools were the most active and suffered least from the French Academy's low esteem for this genre.

Painters incorporated into their works the new floral species that were brought back to Europe from the voyages of discovery around the globe. The East and West India Companies were expanding the Dutch colonial empire at this time. The introduction and cultivation of exotic species, not native to Europe, further stimulated contemporary interest in flower painting. As the prosperity of the merchant class increased, there was widespread interest in gardening and the cultivation of flowers, including new and familiar types. All of these factors combined to create an especially strong interest in the Netherlands for paintings of flowers.

Another way to account for the widespread interest in flowers is that these fragile objects, which bloom and die so quickly, are universal symbols of life's transience. Whether combined with other objects, associated with the vanity of earthly existence, or standing alone, flowers express in a gentle, beautiful manner the connotations of imminent mortality.

- Clara Peeters, *Still Life with Flowers, a Goblet, Dried Fruit and Pretzels*

Recent scholarship has thrown into question the reliability of almost every known fact about the life and career of Clara Peeters, one of the "first generation" of still life painters. As Pamela Hibbs Decateau has discussed, the two documents which refer to a "Clara Peeters," a baptismal record of 1594 and a marriage record in 1639, may not even refer to our artist.[6] E. de Jongh also noted the absence of documents to secure Peeters's birth and death dates and to verify the location of her work activity.[7] Even the presumed location of her early life in Antwerp cannot be verified by any guild records, although, as has been noted in connection with earlier practices, women were not usually guild members and many artists never joined a guild.

What can be verified is the existence of a unified group of thirty-one works that can be attributed to Peeters either through a monogram signature or very close stylistic affinities to those signed works.

Fig. 9–3 Clara Peeters, *Still Life with Flowers, a Goblet, Dried Fruit and Pretzels*. 1611. Oil on panel, 19 1/16 × 25 5/16 in. *(Prado Museum, Madrid)*

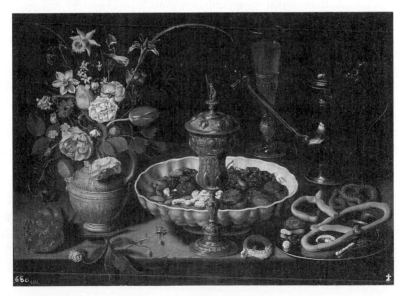

We do not know how Peeters acquired her skills. It is possible that she studied with Osias Beert, fourteen years her senior, who was a noted still life painter in Antwerp. Her works relate to those of Beert in the combination of different types of objects: flowers, fruits, tall decorative metal goblets, and flat dishes of fruits. Peeters, however, uses a lower viewpoint than Beert or other Flemish colleagues. With this lowered viewpoint, she employs more accurate perspective to situate the objects firmly in space. The illusion of the arrangement is thus enhanced. Compositions also differ from those of her immediate contemporaries in that she groups her objects closer together, permitting a certain amount of overlapping. These elements anticipated the subsequent development of the banquet pieces of artists such as Pieter Claesz and Willem Claesz Heda.

Peeters's innovations are evident in *Still Life with Flowers, a Goblet, Dried Fruit and Pretzels* (Fig. 9–3). This painting is part of a series of four complex works, each focused around a different theme: a fish piece, a game piece, a dinner arrangement, and the work illustrated here. This painting is typical of every known work by Peeters in its use of a simple stone ledge set against a dark background. An elaborate goblet defines the center of the composition. The low dish filled with dried fruits and nuts underscores the central focus. A plate of pretzels, a pewter pitcher, and a glass counterbalance the vase of flowers on the left. The placement of these objects results in a balanced composition that is not symmetrical or monotonous. Each object is rendered in a precise style that conveys clearly the diverse textures of the objects.

The inclusion of a vase of flowers in this complex work was consistent with Dutch tastes for flower paintings. Flower painters regularly juxtaposed blossoms that could never bloom simultaneously in nature. Each flower was studied individually. Assembling these studies in the studio, the painter created imaginary bouquets. By 1600 the cultivation of flowers as a commodity had become an important component of the Dutch economy. A highly speculative market developed and huge sums were paid for rare tulip bulbs. Prices became so inflated that the market crashed in the 1630s. (The term "tulipomania" is still used today to designate a highly speculative commodity market.)

It is easy to see, then, that when Clara Peeters included bouquets of flowers in her still life pictures, she was both demonstrating her versatility and increasing the marketability of her canvases.

Decateau concludes that Peeters was a very successful artist. Her influence on her contemporaries in Flanders, Holland, and Germany is one way to assess her importance. Another measure of her success may be traced though the locations of her paintings. This work is one of four related paintings of the same scale, all of which are today in the Prado Museum in Madrid. "Since all four are rather large, in the collection of royal

art and contain sumptuous objects, one is tempted to speculate that this series was a royal commission."8 Decateau, however, is a cautious scholar and reminds us that we have no proof of this, since the earliest record of these works in the collection of the kings of Spain is dated 1734, more than 100 years after their execution. Decateau concludes that "It is obvious that Peeters was not a minor, untrained artist, but one who significantly affected the evolution of still-life painting in the Netherlands and Germany."9

The emergence of Clara Peeters early in the seventeenth century anticipates the extremely successful careers of other Dutch women still life painters later in the century, artists such as Maria Van Oosterwyck and Rachel Ruysch.

- Rachel Ruysch, *Flower Still Life*

Rachel Ruysch (1666–1750) and Jan van Huysum were the two most prominent and successful painters specializing in flower pictures in the late seventeenth and early eighteenth centuries. Ruysch's complex paintings of flowers, fruits, and fauna were widely admired during her lifetime, and her

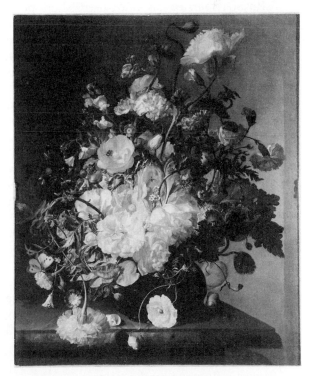

Fig. 9–4. Rachel Ruysch, *Flower Still Life.* *(Courtesy of The Toledo Museum of Art, Toledo, Ohio. Gift of Edward Drummond Libbey 1956.57.)*

reputation has not diminished since her death. One indication of the esteem in which her talent was held were the high prices her contemporaries regularly paid for her paintings. Ruysch sold her works for 750 to 1,250 guilders as compared with Rembrandt, who rarely received more than 500 guilders for his canvases.

Ruysch was born into a highly distinguished family, which encouraged her talents. Her father, an eminent professor of anatomy and botany in Amsterdam, had an extensive collection that Rachel could study up close and draw on for her compositions. In fact, the lizards and insects she included in some of her paintings might very well have been observed among the specimens in her father's collection. Her mother was the daughter of the noted architect Pieter Post, who designed the royal residence near The Hague. Given this stimulating intellectual and artistic milieu, Rachel's talents were bound to thrive.

Ruysch studied painting with the finest contemporary still life painter in Amsterdam, Willem van Aelst. An innovator in flower compositions, Aelst's arrangements were very open and asymmetrical. Like Aelst, Ruysch favored a baroque, diagonal composition, quite different from the compact and symmetrical arrangements of Peeters and other early seventeenth-century flower painters.

Ruysch married an undistinguished portrait painter named Jurien Pool in 1693. They were married over fifty years, and Rachel bore ten children. Despite this large family and the burdens of domestic responsibilities, about a hundred authenticated works are attributed to her. The family moved to The Hague in 1701, and during the next years Ruysch developed an international reputation. From 1708 to 1716 she was court painter to the Elector Palatine, Johan Wilhelm von Pfalz, whose court was located in Düsseldorf. During these years most of her paintings were kept in the Elector's collection. One of her most brilliant and complex works, *Fruit, Flowers, and Insects,* was presented to the Grand Duke of Tuscany, another mark of the extremely high esteem in which her art was held.

The painting illustrated here demonstrates the power and precision characteristic of her paintings. A precise, linear rendering of each blossom creates a marvelously illusionistic (trompe l'oeil) effect. The depicted space remains quite shallow and the viewer's attention rests firmly on the objects in the foreground; there is no escape back into deep space. Each flower is botanically accurate, demonstrating Ruysch's close study of natural phenomena. Nevertheless, the painting is a wholly artificial construction, since these flowers could never be found juxtaposed in this manner in nature. Ruysch's choice of colors, delicate brushwork, and precise description of object textures are aspects of her highly appreciated technique. Ruysch also bathed her compositions in an enveloping atmosphere that heightened the illusionism of her works. E. De Jongh notes that this type of image was influenced by the painter Otto Marseus van Schrieck (deceased in 1678), whose works Ruysch might have known through van Aelst.[10]

On a symbolic level, Ruysch's paintings, like those of many of her contemporaries, are *vanitas* images. The ripening fruit, grain, and blossoming flowers all retain their symbolic associations with the transience of earthly existence, the passing vanities of the temporal world. However, these somber symbolic associations do not interfere with the purely sensual pleasure one can take in the accuracy and variety of the depicted objects.

Ruysch's position in the history of art is clear and secure. She was the last of the great Flemish and Dutch flower painters. Towering over her contemporaries, she enjoyed a highly productive and successful career. Her works are never monotonous. She maintained a consistently high level of excellence in paintings that reveal a range of dynamic compositional formulas. Using a wide variety of plants, insects, fruits, and so forth, she created monumental paintings of widely recognized and enduring quality.

WOMEN IN DOMESTIC SETTINGS: ISSUES OF INTERPRETATION

Images of Domestic Virtue

- Judith Leyster, *The Proposition* or *Man Offering Money to a Young Woman*

Recent scholarship has provided more interpretive strategies for analyzing images of women in Dutch genre paintings, as well as a much more complete understanding of the career and circumstances of the artist Judith Leyster. An interpretation of these "images of domestic virtue" has been developed by Wayne Franits. To understand Leyster's *Proposition*, it is useful to discuss the broader category of image, first, and then the work by Leyster, who was one of the few women artists active in mid-seventeenth-century Holland.

Franits has studied a wide variety of Dutch genre paintings, which depict women in domestic interiors. He believes that these images do not simply recreate a "slice of life" but participate in the construction of a gender ideology, as discussed in the introduction to this book. Women depicted in Dutch genre paintings are not simply ordinary people but are meant to represent ideal behaviors, as "paragons of virtue." Franits concludes: "These pictures do represent plausible realities, but these realities were fundamentally structured by a culture that privileged males. They therefore resonate with an entire system of values, ideals, and even prejudices, all of which reflect common attitudes toward women at this time."[11]

One category of such genre paintings is the maiden occupied with needlework, as illustrated in Leyster's image. Needlework appears in many images as a symbol of the virtue of "diligence." This quality was deemed most important for the ideal maiden and housewife. Diligence, or industriousness, is the opposite of sloth or laziness. Such virtues as "docility, purity, industriousness, and domesticity"[12] were especially important for daughters who were embarking on the ritual of courtship.[13]

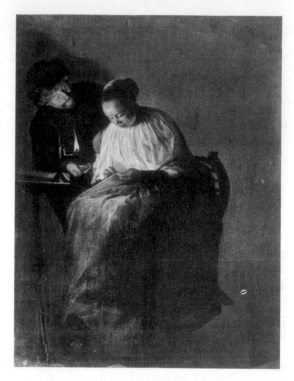

Fig. 9–5. Judith Leyster,
*The Proposition.*1631. Oil
on panel, 11¹¹⁄₁₆ × 9½ in.
(Mauritshuis—The Hague)

Leyster's fascinating genre painting has been the focus of much scholarly attention because its interpretation resists clear-cut and unequivocal meaning. The painting depicts a man in a fur hat, leaning over a woman who is sewing. He is offering her gold coins, possibly as payment for her sexual favors. The bare interior focuses the viewer's attention on this scene, which is illuminated by a single candle. One point that seems certain is that Leyster is presenting an image of "domestic virtue" as defined by Franits. The woman in *The Proposition* is resisting or simply ignoring the advances of the older man. Hofrichter first drew attention to this image and, as indicated in the title by which it is most well known, interpreted it as a "proposition." However, there is no doubt that this image differs dramatically from other "propositions," which are clearly brothel scenes.

When one compares Leyster's *The Proposition* with more typical examples of the motif, such as Dirck van Baburen's *The Procuress,* a wholly different content is immediately apparent. The woman in Baburen's image is obviously a willing prostitute exchanging her favors for the gold coin offered by the male customer. A low-cut dress reveals her physical attributes to the viewer. The musical instrument, especially the lute, is a familiar prop in themes of prostitution since music is always associated with Venus and lovemaking. The old procuress holds out her hand, waiting for payment for the prostitute's services. The mood is clearly jovial and animated.

By contrast, the modestly dressed woman in Leyster's image fixedly concentrates on her sewing. Her feet rest on a footwarmer, further emphasizing the immobility of her pose. As Hofrichter notes, "She is not entertaining the man, nor is she drinking, smoking, singing, or wearing a provocative gown. Leyster's work may be considered a critical response to those of her predecessors and stands apart in iconography even from the copies or variants of it."[14] From her simple dress one may deduce that the seamstress is possibly a domestic servant, therefore she is not of the same class as the maidens discussed by Franits.

Other scholars have proposed that the man's intentions are more honorable. He may actually be trying to encourage the woman to marry him, using the money as a form of persuasion for courtship and marriage. The woman is concentrating on her sewing and avoiding his advances. The fact that this encounter takes place at night, by candlelight, may refer to the emblem by Jakob Cats, "No pearl should be bought at night/no lover should be sought by candlelight."[15] Other images in which a younger woman resists the sexual advances of an older man do exist but as the recent catalog demonstrates, no example can match the powerful image presented by Leyster. The psychological tension of the scene is unique for the period.

The restrained, quiet mood of *The Proposition* may have influenced the next generation of genre painters, including Vermeer and Metsu. In several works, Metsu explores the theme of a sensitive woman victimized by a coarser man, while Vermeer became a master in the intimate domestic scene in which men interrupt women at their work. Both themes are anticipated in Leyster's painting.

Like Sofonisba Anguissola, Leyster was not born into a family of artists. Her parents were both involved initially in the local textile industry in Haarlem. In 1618 her father purchased a brewery; however, this business venture was ultimately disastrous and in 1624 he was forced to declare bankruptcy. It is quite probable that Leyster first studied painting with one of the leading portrait painters in Haarlem, Frans Pietersz de Grebber. de Grebber's daughter Maria was also in the studio. However, there are no strong traces of de Grebber's style in any of Leyster's known paintings. In Leyster's earliest paintings, as well as in this image, it is the influence of Frans Hals that is most pronounced. There are no documents that link Leyster with Hals or his household, however.

In 1633, when Leyster was about 24, she became a member of the painter's guild, the Guild of St. Luke in Haarlem. This membership enabled her to establish an independent studio, and she accepted pupils to supplement her income. Due to the highly competitive portrait market, in Haarlem she concentrated on genre pictures. Her works, therefore, aim at a different market of collectors, mostly merchants who were Flemish refugees.[16] In 1636, she married portrait painter, Jan Miense Molenaer, and the couple left Haarlem for the larger art market of Amsterdam. While only

one image can be securely attributed to Leyster after her marriage, one suspects that she did not stop working. Although she did bear three children, it seems highly unlikely that she would simply exit herself from the "family production unit" of the Leyster/Molenaer household.

Judith Leyster's works demonstrate her ability to combine influences from the Utrecht Caravaggists with her local Haarlem traditions, epitomized by the art of Hals into a personal style of variety, beauty, and iconographic originality. Leyster's technique is quite precise and linear. While she does use visible brush strokes in her lace cuffs and skirt, she generally does not allow the texture of the paint to intrude on the description of the variety of textures included in her image. Twentieth-century tastes, trained by exposure to Impressionism and subsequent avant-garde art movements, tend to place a higher value on the spontaneous, sketchlike style of her contemporary, Franz Hals. However, Leyster's technique would have been at least equally valued in her own time. In fact, the popularity and skill of an artist was measured in large part by the technical ability to depict a wide range of objects and textures.

The "Love-Sick Maiden" in Genre Paintings

- Jan Steen, *The Doctor's Visit,* c. 1663–1656

Steen's work is a characteristic example of a specialized type of genre painting analyzed in detail by Laurinda Dixon. The interpretation of these images requires an understanding of medical views of the era. Dixon notes that these paintings were created chiefly in the Dutch city of Leiden, home of a university, which was a center for the study of women's illnesses. Therefore, local doctors served as a group of patrons for this specific type of genre image.

She believes that these paintings are illustrations of symptoms of the illness known as "furor uterinus." Women who were "afflicted" with this ailment suffered from difficulty in breathing, rapid heart palpitations, which can cause women to faint, obstructions of the throat, swollen feet, and a deathlike pallor. Medical authorities believed that the main cause of this "illness" was sexual deprivation.[17] Within the cultural ideology of Dutch society, "matrimony was the most expedient cure, and doctors urged all single women still young enough to bear children to marry without delay."[18]

Dixon therefore interprets *The Doctor's Visit* as an illustration of the symptom of furor uterinus, lack of appetite or anorexia. A solicitous doctor is attending to the listless young woman. The laughing young man, on the right, presents her with a herring and two onions. Herring and other fish were regularly prescribed as a remedy for fevers and onions were prescribed to induce menstruation. In a related work, a similarly laughing

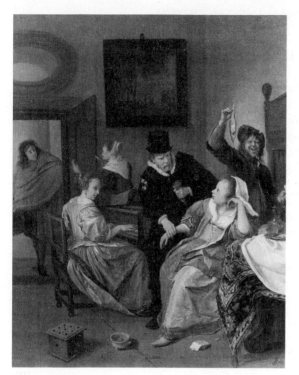

Fig. 9–6 Jan Steen, *The Doctor's Visit.* (*Courtesy of Johnson Collection, Philadelphia Museum of Art #8779 J510.*)

figure is holding the herring hanging from a raised hand and two onions referring to male genitalia. Because sexual activity was the main cure for the illness, this would be an appropriate visual pun. In fact, the doctor's efforts seem to go beyond bedside solicitations since the image also includes a young man arriving at the sickroom door. "Doctors were even authorized to arrange fulfillment by uniting lovers if all else failed."[19] The objects in the foreground, the string and footwarmer, were common remedies for reviving women from a faint, one of the symptoms of the "illness."

Dixon concludes that these images confirm the collusion of the medical establishment with dominant Protestant attitudes toward marriage. "Paintings of ailing women suffering from abstinence-induced illness reinforced the Protestant message against celibacy by instilling the fear of sickness and debility in female viewers. Marriage and family became the best choice not only for the common good but also for each individual woman's health and happiness."[20] Here we find another instance of art not merely reflecting real life, passively, but rather participating actively in a didactic manner to sustain the dominant patriarchal gender ideology of the culture.

ANNA MARIA VAN SCHURMAN AND THE DUTCH
QUERELLE DES FEMMES

Leyster's career was quite unusual. Most other women painters acquired their skills through family connections. Also, the majority of the other known Dutch women artists were amateurs and did not establish themselves as independent professional artists. Among these amateurs was Anna Maria van Schurman. Van Schurman was quite famous in her lifetime. Her art was confined to small-scale miniature portraits and genre paintings. These forms were not generally practiced by professional artists, but confined to amateurs. Katlijne van der Stighelen has analyzed van Schurman's artistic production. She concluded that van Schurman's acceptance in 1643 into the Utrecht painters' guild "does not in any way prove that she was in fact a practicing artist. . . . Her guild membership should be regarded as a sort of honorary degree."[21]

Apparently van Schurman received her artistic training under Magdalena van de Passe, daughter of a famous engraver in her hometown of Utrecht. Such training was consistent with the education advocated by the sixteenth-century humanists for upper-class girls, as discussed in relation to Sofonisba Anguissola. What does seem to be remarkable is the range of techniques van Schurman practiced in miniature portraiture. She produced portraits in oils, gouache, pencil, and pastels, and she carved in boxwood and ivory. She was also proficient in the technique of engraving with the engraver's tool, the burin.

This artistic activity appears to have lessened after the 1640s when she began to focus her efforts on writing scholarly treatises in Latin. Van Schurman is best known today for her essay, first published in Latin in 1641, and translated into English as "The Learned Maid or Whether a Maid May Also Be a Scholar" (1659). This text is a significant contribution to the literature of the *Querelle des Femmes,* in which she argues eloquently for the intellectual capabilities of women when provided with equal access to education. As Laurinda Dixon notes, this essay was part of a series of responses to the body of misogynist texts published in the seventeenth century. Dixon believes this discourse was, in part, a response to the successful political power exercised by women, such as Elizabeth I of England and Catherine de' Medici, whose art patronage was discussed in Chapter 8.[22]

Simon Schama argues that only in Holland could such an intellectually bold feminist statement be made in the 1650s. Compared with Catholic and Puritan societies, Dutch women lived with a greater degree of freedom and equality with men. Schama identifies an ideology of affection, which stood at the core of marriage. Love and companionship were the expected goals of marriage.

While excluded from political offices, women managed to assert their presence in public life in charitable institutions. From the Middle Ages, Dutch women retained certain rights over their property before and after

marriage and were allowed to bequeath and inherit property rights. They could go to court to protect their property against irresponsible husbands. Since Dutch women could form commercial contracts, they "had all the formal qualifications needed for active commercial or business dealings."[23] Apparently many women were active in business, although mainly in the context of the "family production unit." Given this cultural context, it is perhaps less surprising to find outstanding women painters such as Leyster and Ruysch in Holland.

Suggestions for Further Reading

Artemisia Gentileschi

BISSELL, R. WARD, *Artemisia Gentileschi and the Authority of Art* (University Park: Pennsylvania State University Press, 1999).

GARRARD, MARY D., *Artemisia Gentileschi: The Image of the Female Hero in Italian Baroque Art* (Princeton, NJ: Princeton University Press, 1989).

Still Life: Clara Peeters and Rachel Ruysch

DE JONGH, E., *Still Life in the Age of Rembrandt* (Auckland, New Zealand: Auckland City Art Gallery, 1982).

DECATEAU, PAMELA HIBBS, *Clara Peeters (1594–c. 1640) and the Development of Still-Life Painting in Northern Europe* (Luca Verlag, 1992).

GRANT, MAURICE H., *Rachel Ruysch: 1664–1750* (Leigh-on-Sea, Essex: F. Lewis, 1956).

MITCHELL, PETER, *European Flower Painters* (London: Adam and Charles Black, 1973).

SERRAO, VITOR, et al., *The Sacred and the Profane: Josefa de Obidos of Portugal* (Washington, DC: National Museum of Women in the Arts, 1997).

Judith Leyster and Genre Painting: Images of Women

DIXON, LAURINDA S., *Women and Illness in Pre-Enlightenment Art and Medicine* (Ithaca and London: Cornell University Press, 1995).

FRANITS, WAYNE E., *Paragons of Virtue: Women and Domesticity in Seventeenth Century Dutch Art* (Cambridge and New York: Cambridge University Press, 1993).

HOFRICHTER, FRIMA FOX, *Judith Leyster: A Woman Painter in Holland's Golden Age* (Doornspijk, The Netherlands: Davaco, 1989).

SCHAMA, SIMON, *The Embarrassment of Riches: An Interpretation of Dutch Culture in the Golden Age* (Berkeley: University of California Press, 1988).

WELU, JAMES A., and PIETER BIESBOER, *Judith Leyster: A Dutch Master and Her World* (Worcester Art Museum, Yale University Press, 1993).

Anna Maria Van Schurman

DE BAAR, MIRJAM (ed.), *Choosing the Better Part: Anna Maria van Schurman (1607–1678)*, trans. by Lynne Richards (Dordrecht and Boston: Kluwer Academic Publishers, 1996).

10

Europe:
1700 – 1800

ROCOCO PORTRAITURE

It was impossible for women artists to acquire training or develop a market for their works in seventeenth-century France. As opposed to the situation in Holland, where the Dutch middle classes were avid consumers of paintings, virtually all commissions in France during this period came from the monarchy. There was little diversity or scope for personal styles. Louis XIV believed that the arts, like the sciences, industries, and other activities, should serve the glory of France and her king. Through a reorganization of the Academy in 1663, the fine arts were brought under the direct control of the state bureaucracy. Early in Louis's reign, he decided to create a magnificent setting for himself and his court at Versailles. Most of the efforts of French artists of this era were directed toward the embellishment of this enormous palace. Only male painters were permitted to receive the training necessary to create the large-scale history paintings that decorated the walls and ceilings at Versailles. Control over artists was easily maintained because all artists working for the king had to be members of the academy.

Given the inflexibility of this system of education and patronage, it is not surprising to find no women artists of major significance in France during the seventeenth century. Denied access to the training essential for a professional artist, the highly structured, state-controlled art world of Louis XIV effectively prevented any women from achieving excellence. Because there was no real market for other types of paintings, few artists specialized in those genres popular in Holland, such as flower painting, still life, and small-scale portraiture, types of art in which women often excelled.

The decentralization and loosening of state control over the arts that occurred in France following the death of Louis XIV, in the period known as

110

the "Rococo," created a more favorable environment for women artists. However, women artists continued to function under highly discriminatory conditions throughout the eighteenth century. They were denied access to the major art academies, where their male colleagues studied the anatomy of the male nude and acquired training in the composition of multifigured history paintings. Therefore, it is not surprising that only one of the six artists included in this chapter, Angelica Kauffman, was able to build a career around the exhibition of history paintings as well as portraiture. Three artists discussed in this chapter, Rosalba Carriera, Elisabeth Vigée-Lebrun, and Adélaïde Labille-Guiard, were outstanding specialists in portraiture. Mary Moser and Anne Vallayer-Coster were most famous as flower painters. Also not surprisingly, four of these artists were daughters of artists and first learned to paint at home. Rosalba Carriera, a Venetian, did not suffer severely from a lack of proper training, since she worked in two media, pastel portraiture and miniature painting on ivory, in which she invented the techniques. The fifth artist, Labille-Guiard, learned to paint by apprenticing herself to a series of masters who specialized in miniature painting, pastel portraiture, and the technique of oil paint.

Despite the difficulties and obstacles, these women artists managed to achieve tremendous success and recognition for their achievements. All six painters received the highest levels of rewards for their talents in their respective cultures.

- Rosalba Carriera, *Portrait of Louis XV*

Carriera (1675–1752) rose from very humble origins to become one of the most successful artists of her epoch. She was born in Venice; her father was a clerk and her mother, a lacemaker. Harris suggests that she began her career by learning the art of lace making and when this industry declined, shifted to the decoration of ivory snuffboxes.[1] These inexpensive items were produced in mass quantities for the tourist trade. From this initiation, Carriera became familiar with painting on ivory in a small scale, and she began to create miniature portraits.

As a miniature painter, Carriera possessed great skill in rendering detail and in applying the paint in a range of thicknesses. Her active brushwork revolutionized the style of miniature painting and certainly contributed to her success. Miniature painting has suffered from low esteem in the history of art, despite the fact that miniaturization requires an especially precise technical control. Because they are small, miniatures are often seen as inherently less "significant" than large-scale paintings. Clearly, painting in miniature is a difficult task to perform because the small size of the image forces the artist to exercise extraordinary manual control. The eyestrain that this work inevitably involved may well have contributed to Carriera's loss of sight in 1746. She spent the last years of her life blind and in seclusion, suffering from periods of depression.

Fig. 10–1. Rosalba Carriera, *Louis XV as a Boy.* 1720. Pastel on paper, 19 × 14 in. *(Forsyth Wickes Collection; Courtesy, Museum of Fine Arts, Boston)*

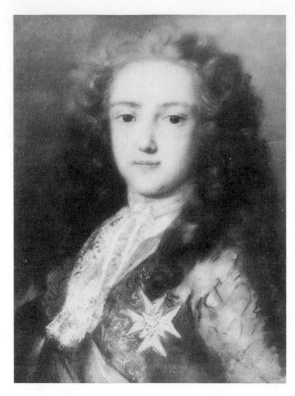

Although Carriera's first professional successes were in the medium of miniature painting, she achieved international recognition for her pastel portraits. Colored chalks, known as pastels, had been invented in the late fifteenth century, yet no artist before Carriera had explored their formal possibilities. Employing pastels in an unprecedented way, she skillfully created a naturalistic range of textures.

As early as 1716, Carriera had met Pierre Crozat, a wealthy banker and one of the most important art patrons in Paris.[2] Crozat had assisted Watteau in building his career. Crozat's home was the center of early Rococo activities in Paris. Crozat met Carriera on a trip to Venice in 1716 and in the spring of 1720, at his invitation, Carriera traveled to Paris. Her surviving diary records a constant sequence of sitters and social commitments.

One of her first portraits created in Paris was of the young French king, Louis XV (Fig. 10–1). The pastel portrait was greeted with widespread admiration. This image reveals a detailed, highly finished, and almost oil-paint-like treatment of the face combined with a more spontaneous technique in the jacket, cravat, and hair. In these sections, one can actually see the individual marks of the chalk. This precision, combined with a freedom of touch not achievable in oils, amazed her audience in Paris. In

recognition of her achievements, she was invited to become a member of the French Royal Academy—a great honor for any artist, and an unprecedented one for a foreign woman. Despite her warm reception in France, Carriera decided to return to her native Venice in 1721, where she lived with her mother and sisters.

As a portrait artist, Carriera's talents were widely appreciated by an international clientele. Europe's aristocracy demanded portraits by her hand. The king of Denmark and many members of England's upper classes were among her patrons, while Augustus III, Elector of Saxony and King of Poland, collected more than 150 of her works.

Carriera possessed a refined color sense. She often used bright, fresh colors for a brilliant, luminous effect. This specific aspect of her style relates her art to that of her Venetian contemporary, Tiepolo. Tiepolo also worked for foreign patrons, but unlike Carriera, Tiepolo regularly executed large-scale mural decorations.

A special flair of Carriera's was her ability to make a flattering image of her sitter without losing his or her individual likeness. This ability was essential for an eighteenth-century portraitist, when a portrait often served the purpose that a photograph does today. The duke of Modena, aware of Carriera's success in Paris, commissioned the artist to paint portraits of his three marriageable daughters. These portraits were circulated to attract eligible suitors who could form advantageous political alliances with the duke.[3] Clearly, a flattering image was not merely a matter of vanity but, as in this case, a political strategy as well.

Carriera's extensive correspondence is an excellent source for reconstructing the course of her career and the scope of her patronage. Fortunately, her letters and many letters from her patrons have survived. Carriera's travels, necessitating separations from her family, also stimulated correspondence. In addition, a few brief essays concerning issues of interest to the artist have also survived in her papers.

In her surviving documents, Carriera even made a contribution to the *Querelle des Femmes*. In her text, Carriera recognizes and rejects the defense of women based on the argument of the "women worthies." She places the reasons for the differences between the sexes squarely on the gender constructions of her culture, especially in the opportunities for education.[4]

That Carriera was a Venetian is not simply an accident of birth. Patricia Labalme suggests that women in Venice lived in a culture in which they had learned to challenge gender restrictions.[5] Women of the aristocracy retained rights over their dowries, which often were substantial fortunes. Lucrezia Marinelli wrote on "The Nobility and Excellence of Women," published in Venice in 1600. Another Venetian woman, Elena Lucrezia Cornar Piscopia, was the first woman to be awarded a doctorate from the University of Padua, in 1678. This took place despite the objections of the bishop of Padua. Although the degree of philosophy was substituted

for theology, the ceremony, attended by a great crowd, did take place. Labalme asserts that in Venice, despite enormous constraints and inequities, Venetian women retained power through family connections, resisted sumptuary laws, insisting on the privilege of wearing jewelry and other forms of family wealth, occasionally found the courage to resist the ideology of misogyny to write in defense of women, and acquired an unprecedented level of knowledge.[6]

Carriera's name resounded through the eighteenth century, and she paved the way, as a role model if not as a direct influence, for other portrait painters. Masters of pastel portraiture, such as Maurice Quentin de la Tour and Jean-Baptiste Perroneau, are among the inheritors of her invention. Contemporaries of Vigée-Lebrun and Labille-Guiard regularly compared these artists, active later in the eighteenth century, with Carriera. Theresa Concordia Mengs, Suzanne Giroust-Roslin, and Labille-Guiard's pupil, Gabrielle Capet, are among the many women who followed Carriera's example to become successful pastel portraitists in the eighteenth century.

WOMEN ACADEMICIANS IN ENGLAND

- Angelica Kauffman, *Cornelia Pointing to Her Children as Her Treasures*

Like many other artists discussed in this and preceding chapters, Angelica Kauffman (1741–1807) was the daughter of a painter. Born in Switzerland, she received her early training from her Tyrolean father. During her childhood, the Kauffmans traveled about in Switzerland, Austria, and northern Italy, executing commissions for religious murals and portraits. Angelica's precocious talents were recognized and encouraged from an early age.

Kauffman was also a talented musician. According to her biographer, Giovanni de Rossi, the artist felt that she had to choose between a career in music and one in painting, while still in her teens. Her commitment to painting is given visual form in a well-known image, the *Artist Hesitating Between the Arts of Music and Painting,* painted over thirty years later when Kauffman had established a European reputation. Kauffman adapted the iconography of the story "Hercules at the Crossroads Between Fame and Luxury" to illustrate an episode in her own youth when she had contemplated embarking on a career as an opera singer. As Wendy Wassyng Roworth notes, "Music" stands for sensual pleasure, "Painting" for Virtue. The necessity for such a choice connects Kauffman with what was usually a masculine decision of commitment to a single art form and a professional career track. Other women artists, such as Sofonisba Anguissola, painted self-portraits as musicians, but their musical skills are amateur ones, an appropriate feminine accomplishment of aristocratic women. Kauffman

distinguishes herself from this tradition with the self-discipline of a conscious choice.[7]

This decision carried immense implications for Kauffman's life. In 1762 Angelica and her father arrived in Florence, and the following year they settled in Rome. Kauffman had the fortuitous opportunity to make contact with all the leading figures of the Neoclassical movement at a very early phase in its development. Under the influence of Winckelmann, Mengs, and Hamilton, Kauffman developed a sophisticated Neoclassical style that placed her in the forefront of this movement.

In 1766, Angelica Kauffman arrived in London where she quickly established herself as one of the leading artists of the English school. She became friendly with Sir Joshua Reynolds, and when the Royal Academy was founded in 1769, she and Mary Moser, discussed below, were the only two women members. At this time, the vast majority of paintings produced in England were portraits commissioned by the aristocracy. Although she was forced to paint portraits to earn a steady income, Kauffman was one of the few artists working in England and one of the few women artists of any period who produced a steady stream of paintings with themes derived from classical and medieval history. Between 1766 and 1781, she contributed significantly to the widespread vogue for Neoclassicism in England.

Unfortunately, her professional successes were not matched by domestic happiness. In 1767 she married a man she believed to be a Swedish count but who turned out to be an imposter. After the scoundrel's death, she married a painter, Antonio Zucchi, who remained forever loyal and supportive of his more famous wife's career. In 1781, following their marriage, the couple returned to Italy. Refusing an offer to become resident court painter to the king of Naples, Kauffman settled in Rome in 1782. Some of her best paintings were created during these years.

As Roworth notes: "What distinguished Kauffman from most artists active in England during the eighteenth century, and from virtually all woman artists before the twentieth century, was her ambition to achieve standing as a history painter. Much of her success in England must also be attributed to this choice to become not just an artist, but specifically a history painter."[8]

In addition to the recognition she received for her history paintings, Kauffman's portraits were widely admired, and she attracted many patrons among the English aristocracy. Her talents were held in such high esteem by her peers that she was asked to contribute to the decoration of the new residence of the Royal Academy in 1778.

Cornelia Pointing to Her Children as Her Treasures (Fig. 10–2) is one of the history paintings from Kauffman's mature Roman period. Cornelia was a real matron in ancient Rome whose reputation as a paragon of virtue had come down through history. This painting illustrates a didactic anecdote in which a materialistic Roman woman, seated at the right, shows off a

necklace, while Cornelia displays her three children as her "jewels." The stylized faces of the women, the severely simplified costumes, and the austere architecture are all characteristic of Kauffman's Neoclassical style. The rich, glowing colors of the robes and the warm tonality of the light show her assimilation of the stylistic achievements of the Venetian school.

Cornelia is contemporary with Jacques Louis David's Oath of the Horatii. A comparison between these two works reveals certain stylistic and compositional similarities as well as thematic differences. Both Kauffman and David arrange their figures in a simple, shallow space like a stage in a theater. Both use idealized classical figure types with legible gestures so the viewer can read the narrative. While both paintings depict an example of moral virtue, the virtues expressed are totally different in content. Cornelia is the admirable Roman matron who prizes her children above all worldly goods and devotes her life to raising them to serve the state. David focuses on the sacrifices of war, with emphasis clearly placed on the virile sons energetically dedicating their lives to defend the Roman Republic. While Kauffman has selected her didactic message to illustrate the behavior of a female role model, David's painting illustrates a male world of military heroism and patriotism. The women in the Oath of the Horatii are wilted, weak, limp, and tearful. They are clearly excluded from the male sphere and their role is confined to passive mourning.

Fig. 10–2. Angelica Kauffman, *Cornelia Pointing to Her Children as Her Treasures.* 1785. Oil on canvas, 40 × 50 in. *(Virginia Museum of Fine Arts, Richmond, VA. Purchase: Williams Fund, 1975)*

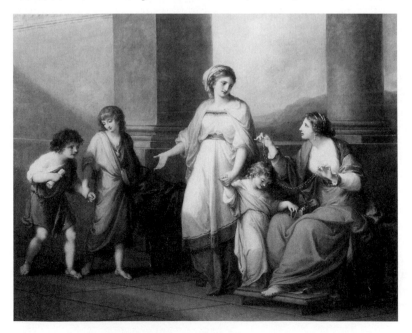

Cornelia was executed for George Bowles, an Englishman who owned fifty of Kauffman's works.[9] It was first exhibited at the Royal Academy in 1786 and received rather negative responses from English critics.[10] Despite this, versions were painted for Prince Poniatowsky, nephew of the king of Poland, and for Queen Caroline of Naples.

Kauffman's achievement places her in the forefront of Neoclassicism, as one of its original exponents and disseminators. By the 1760s she was creating convincing history paintings in a Neoclassical idiom, anticipating David's paintings of the 1780s. She was one of the most highly respected artists of her era. Some measure of the admiration and esteem she earned during her lifetime may be appreciated when one learns that all the members of the Roman Academy of St. Luke marched in her funeral procession. The funeral ceremonies were modeled after the services conducted for Raphael.

- Mary Moser, *Room at Frogmore*

Marcia Pointon's important study of aspects of the visual culture in England between 1650 and 1800 includes a discussion of the issues surrounding flower painting in the late eighteenth century. She also discusses the careers of women artists other than Kaufmann, who were active during this period in England. She includes a discussion of the art of Mary Moser and the specific commission from Queen Charlotte for the panels decorating a room in the royal residence, Frogmore House, Windsor.

Moser (1744–1819) was the only daughter of a painter in enamels. Her father was well known and was appointed drawing master to George III. Moser had been a member of the Society of Arts, which included a number of different types of arts professionals, but she withdrew from that organization once the Royal Academy was founded, in 1768. Pointon sees this as "symptomatic of Moser's own personal ambition for recognition according to the criteria of academic idealism. . . ."[11] Pointon argues against dismissing flower painting as an inferior genre and one without intellectual meaning. The taste for flower painting is supported by the development of the science of botany. Aristocratic women, including members of the royal family, were serious botanists in this era. Moser gave drawing lessons to Queen Charlotte and the princesses. The fascination with flower painting was linked to Dutch traditions, as exemplified by Ruysch. Expensive books of botanical illustrations were collected by the English aristocracy. This is consistent with the efforts of the noted botanical illustrator Maria Sibylla Meriam and her remarkable publication on the insects of South America, *Metamorphosis Insectorum Surinamsium*, published in 1705.

At Frogmore, Moser painted a decorative ensemble, which combined easel paintings and painting onto wooden panels, positioned on the walls. This decorative ensemble was executed in the mid-1790s. Frogmore was the Queen's favorite residence at which a series of elegant fetes were held. On the panel illustrated here, there are a number of symbols of the Order of the

Garter, underscoring allegiance to the monarchy. Flowers surrounding the urn symbolize the United Kingdom of England, Scotland, and Ireland. This is a reaffirmation of loyalty during the era of the French Revolution. Pointon relates these decorations to the concurrent taste among aristocratic women for flowered patterned silk dresses. Positioned on the south side of the residence, this room is consistent with other forms of royal entertainments held at Frogmore. Pointon argues for a reconsideration of the status and significance of flower paintings.[12] She believes that the dismissive attitude toward flower painting is derived from the popularity of this genre in the nineteenth century, with women of strictly amateur status. This has colored our appreciation for the skill, expertise, and scientific knowledge essential for the prominent artists who specialized in this genre, such as Moser.

FRENCH STILL LIFE PAINTING

* Anne Vallayer-Coster, *The White Soup Bowl*

Anne Vallayer-Coster (1744–1818) was one of the most talented, versatile, and productive still life painters of the late eighteenth century. Within this genre she painted a wide variety of works, ranging from simple groups of humble kitchen objects to elaborate compositions of exotic things, as well as hunting trophies and arrangements of fruits. She was especially renowned for her paintings of bouquets of flowers.

Vallayer-Coster's technical skills were widely recognized and appreciated by her contemporaries. She was elected to the Royal Academy in 1770. The following year, in 1771, the influential critic Diderot wrote that no other artist possessed an equal force of color and assurance. Among her patrons were the Marquis de Marigny, Minister of Fine Arts under Louis XV, the Comte d'Angiviller, who held the same position under Louis XVI, and Marie Antoinette. Through royal decree, she was permitted to live in one of the apartments reserved for artists, a mark of special esteem that had also been accorded to Chardin, her more famous colleague who also specialized in still life painting. The official rewards and successes enjoyed by Vallayer-Coster during her lifetime attest to both the quality of her art and the esteem in which naturalistic still life painting was held.

Anne Vallayer was born into a family of artisan-craftsmen. Her father was a goldsmith who worked for the Gobelins tapestry factory. Eventually, he established an independent shop, which his wife ran after his death. Thus, Vallayer was raised in an environment that cultivated and encouraged her talents. We do not know how she acquired her painting skills, but she was an accomplished artist by her early twenties.

Vallayer's successful professional career enabled her to raise her social status. In 1781, at the relatively late age of 37, she married a wealthy lawyer and member of parliament, Jean Pierre Silvestre Coster, a

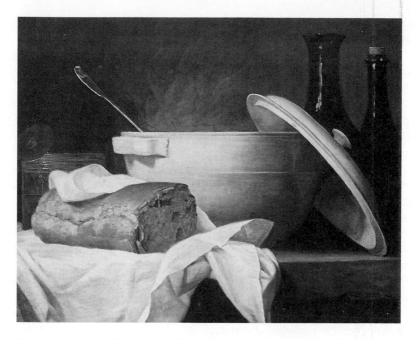

Fig. 10–3. Anne Vallayer-Coster, *The White Soup Bowl*. 1771. Oil on canvas, 19¹¹⁄₁₆ × 24 ½ in. *(Courtesy of the Library of Congress)*

match that represented a definite advance in class status for the daughter of a goldsmith.

Although Diderot was appreciative of Vallayer-Coster's talents, he was the first writer to compare her works with those of Chardin, and to some extent her reputation has suffered from this comparison ever since. One cannot deny that there are similarities in subjects and compositions between some of the still lifes of the two. However, one would find such constants in the works of almost any other eighteenth-century French still life painter. They are only the most general characteristics of national and period style in this category of painting. This does not indicate that Vallayer-Coster was less talented or less innovative than Chardin.

Vallayer-Coster painted a number of works depicting simple objects set on a stone ledge, like this remarkable painting, *The White Soup Bowl*, one of her most sensitive and beautiful still lifes of this type. This painting is a study in shades of white. The artist precisely and sensitively describes the different tones and textures of the porcelain bowl, the linen cloth, and the translucent steam rising from the soup. The composition is deceptively simple. There is a subtle play of horizontal, vertical, and diagonal linear accents that achieves a satisfying balance. The economy of the arrangement is consistent with the restrained color scheme. *The White Soup Bowl* displays

a technical ability of extreme control and finesse. The convincing depiction of something as intangible and evanescent as steam is quite remarkable, yet as a whole the image conveys tangibility and immediacy. The soup is steaming and soon someone will come to lift the ladle and serve the broth and bread to hungry people.

Vallayer-Coster's talents were not limited solely to the realm of still life painting. She also painted miniatures, portraits, and arrangements of fruits and flowers. Her paintings of flowers received widespread recognition and success, continuing the tradition of Peeters and Ruysch. Her flower compositions vibrate with color and freedom of touch, more characteristic of the nineteenth century than of the eighteenth. Both in flower paintings and still lifes, her precision and taste for reproducing exact detail served her purposes well. These talents were less appreciated in the realm of portraiture where, as noted in connection with Carriera's success in this field, the artist was expected to beautify the sitter's appearance.

Anne Vallayer-Coster was one of the leading French still life painters of her generation. She was a versatile artist with a sophisticated sense of composition and sensitivity to color combinations. Her paintings, like those of Chardin, are a realistic alternative to the erotic fantasies of the late Rococo painters, such as Boucher and Fragonard.

PRE-REVOLUTIONARY ARISTOCRATIC PORTRAITURE

• Elisabeth Vigée-Lebrun, *Marie Antoinette and Her Children*

Elisabeth Vigée-Lebrun (1755–1842) was among the most talented and successful aristocratic portrait painters of the late eighteenth and early nineteenth centuries. As official portraitist for Marie Antoinette, the queen of France, Vigée-Lebrun achieved one of the highest positions for an artist in her society. After the French Revolution, as she traveled around Europe, she continued to experience a series of international triumphs. Her output was prodigious: She produced about 800 paintings during her lifetime. Like Carriera, to whom she was frequently compared by her contemporaries, Vigée-Lebrun had the capacity both to reflect and to formulate the esthetic tastes of her aristocratic clientele.

The daughter of a pastel portrait painter, Vigée-Lebrun recalled in her memoirs, that her father and his colleagues gave her instruction and encouraged her talents. She also studied the paintings in the Louvre, especially Rubens's Marie de' Medici cycle. In this active, supportive environment, her talents developed precociously. When she was 20, she commanded higher prices for her portraits than any of her contemporaries. She was elected to the French Royal Academy in 1783, simultaneously with Adélaïde Labille-Guiard. These were the last two women to be admitted to

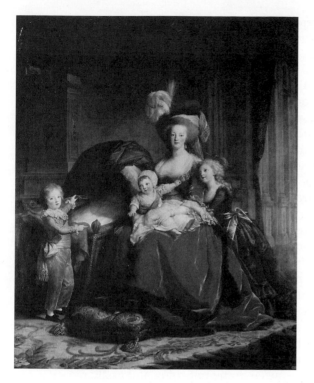

the prestigious institution before its 1790 dissolution during the revolution.
Mary Sheriff's perceptive and important study of Vigée-Lebrun provides
new insights into the process whereby Vigée-Lebrun and Labille-Guiard
were admitted into the academy in 1783. Sheriff notes that "a look at the
Academy records suggests that it was never eager to admit women and
always did so as 'exceptions.' Indeed, in addition to the order admitting
Vigée-Lebrun, the Academy's director, d'Angiviller, persuaded the king to
give a second order. The first ensured the acceptance of one woman, the
second ensured the exclusion of many . . . he also asked for a law 'limiting
to four the number of women who can, in the future, be admitted into the
Academy.' "[13] Sheriff notes further that "Fears over admitting women, and
thus making the Academy a heterogeneous, mixed body, surfaces not just
in the official resolutions, but in every acceptance of a woman. This was
the case even though women were admitted infrequently and comprised a
very small proportion of the membership. Indeed, during its history the
Academy admitted more than 450 artists and of that number no more than
15 one third of one percent were women."[14]

In 1778 Vigée-Lebrun was summoned to court to paint her first
portrait of Marie Antoinette. Thus began a relationship that would

dominate the career and reputation of the artist. An ardent royalist until her death at the age of 87, Vigée-Lebrun was called on to create the official image of the queen. The painting that best exemplifies Vigée-Lebrun's role as political propagandist is the monumental and complex *Marie Antoinette and Her Children* (Fig. 10–4).[15] This work was commissioned directly from the funds of the state to defuse the violent attacks on the queen's moral character then circulating in France. It was painted only two years before the cataclysm of the French Revolution, the imprisonment of the royal family, and their subsequent execution. This official image was designed as an aggressive, if ultimately ineffective, counterattack to the political opponents of the monarchy.

Lynn Hunt has studied the erotic and pornographic literature focused on Marie Antoinette during these years. The queen was accused of all sorts of sexual improprieties and misconduct, including promiscuity and homosexual liaisons. She was also accused of poisoning the heir to the throne. Of direct relevance to this painting is the slander identifying the queen as a "bad mother." During the period of imprisonment of the royal family, the queen was accused of sexual activities with the 8-year-old Louis-Charles, resulting in an injury to one of his testicles. Although the accusation would occur a few years after this painting, the nature of Marie Antoinette as a mother was at the core of the popular rage targeted against her during the pre-Revolutionary period in the 1780s.[16]

Vigée-Lebrun placed the queen in the imposing and easily recognizable setting of the Salon de la Paix at Versailles. The famous Hall of Mirrors is visible on the left side of the painting. The royal crown on top of the cabinet on the right is the ultimate symbol of the power and authority of the kings. The figure of the queen herself dominates the composition. Her features have been ennobled and beautified; the enormous hat and full, voluminous skirts create an impression of superhuman monumentality. Her luxuriant costume, the immense blue velvet robe, and the hat convey the grandeur of the French monarchy. Vigée-Lebrun wanted her painting to express not only the sanctity of divine right monarchy but also the bourgeois, Enlightenment concept of "Maternal Love."[17] The triangular composition is derived from High Renaissance images of the Madonna and Child by Leonardo and Raphael. Like Kauffman's *Cornelia Pointing to Her Children as Her Treasures* (see Fig. 10–2), Marie Antoinette displays her children as her jewels. The dauphin stands on the right, slightly apart from the group, as is only appropriate for the future king of France (although events were to alter the dynastic succession). The eldest daughter gazes up at the queen with filial adoration. The empty cradle to which the young dauphin points originally contained the queen's fourth child, an infant girl, who died two months before the painting was to be exhibited at the salon opening. On that day, August 25, 1787, anti-monarchist feelings were running so high that Vigée-Lebrun refused to display the painting for fear that it might be damaged.

Her close association with the queen made it dangerous for Vigée-Lebrun to remain in France after the imprisonment of the royal family. In 1789 she traveled first to Italy, then Vienna, eventually arriving in St. Petersburg, Russia. There, no political revolution had dispersed the aristocratic clientele on whom she depended for commissions.

Vigée-Lebrun was permitted to return to Paris in 1802, in response to a petition signed by 255 fellow artists, but the era in which she had risen to fame had passed into history. She lived another forty years, sadly out of place in Napoleonic France and neglected during the subsequent Bourbon restoration. Unlike David and Labille-Guiard, who adapted their talents to the successive governments of France, Vigée-Lebrun was both emotionally and professionally attached to the monarchy. While the portrait of *Marie Antoinette and Her Children* found a sympathetic audience during the restoration of the Bourbons at the salon of 1817, its creator never regained the preeminent position she had held before Marie Antoinette was guillotined.

Vigée-Lebrun's career is of great historical interest because she was one of the foremost painters of her era. High prices, prestigious commissions, and critical attention document her position in the society of the *ancien régime*. However, Sheriff argues convincingly that the situation of this artist was tolerated as "exceptional" and "whose achievement required a dispensation from and strengthening of the laws that regulated other women." Calling Vigée-Lebrun "The Exceptional Women," Sheriff reminds us that the success of one single individual was permitted and tolerated in this culture only by the exclusion of many more women artists.[18]

- Adélaïde Labille-Guiard, *Self-Portrait with Two Pupils*

Although she was six years older than Vigée-Lebrun, Labille-Guiard's (1747–1803) public career is contemporaneous. Unlike Vigée-Lebrun, the daughter of a painter, Labille-Guiard was born into a *petit-bourgeois* family with no obvious connections to the arts.[19] Her skills were developed over a period of many years, and it was only in 1780, when the artist was over 30, that she exhibited her first oil paintings. Following the example set by Carriera, she learned the art of miniature painting during her adolescence from François-Elie Vincent. She then studied pastel technique with the preeminent pastel portraitist of the age, Maurice Quentin de La Tour. She only developed her skills in oil painting later, from François-André Vincent, her miniature teacher's oldest son and her future husband. She married Louis-Nicolas Guiard in 1769, lived with him for about ten years, and divorced him in 1792.

Although she had mastered the full range of techniques for portraiture by 1780, she struggled to develop a clientele. Between 1780 and 1783 she executed an uncommissioned series of portraits of preeminent academicians, such as Vien, the teacher of David. This tactic proved to be an

Fig. 10–5. Adélaïde Labille-Guiard, *Self-Portrait with Two Pupils, Mademosielle Marie Gabrielle Capet (1761–1818) and Mademoiselle Garreaux de Rosemond (died 1788).* Oil on canvas, 83 × 59 ½ in. *(The Metropolitan Museum of Art, Gift of Julia A. Berwind, 1953. All rights reserved, The Metropolitan Museum of Art. 53.225.5)*

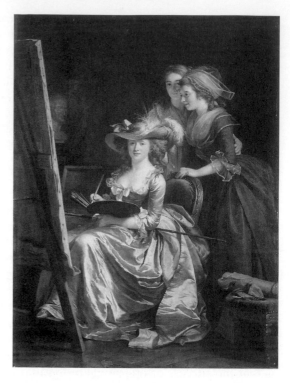

effective political lobbying technique to establish her abilities. She was admitted to the academy in 1783, simultaneously with Vigée-Lebrun.

Labille-Guiard is remarkable not only for her successful career, but also for her concern and active interest in the education of women artists. After 1780, she accepted into her studio a small group of young women whom she trained. Several of her pupils continued to pursue active professional careers as portraitists. Her *Self-Portrait with Two Pupils, Mlle. Marie-Gabrielle Capet and Mlle. Garreaux de Rosemond* (Fig. 10–5), exhibited at the Salon of 1785, includes two of her most capable students. Contemporary critics noted the appearance of these, as yet unknown, women artists. This painting constitutes a public introduction of the aspiring painters.

Labille-Guiard has presented herself in the costume and coiffure of the aristocracy. Documents survive indicating that, despite her salon success of that year, she was experiencing financial difficulties. Therefore, one must interpret this proud image as a form of self-advertisement, an appeal to potential aristocratic patrons on their own terms, rather than as documentation of the artist's actual social status. This painting is characteristic of Labille-Guiard's taste for muted color harmonies, as opposed to the more highly saturated colors often used by Vigée-Lebrun. Also unlike Vigée-Lebrun, who favored very simplified costumes and hair arrangements,

Labille-Guiard took pleasure in delineating precisely all details of the fashionable styles of her time.

According to the authoritative study of the artist, this painting was widely praised by the critical press of the day and helped to establish her reputation as a master painter in oils. The same year this work was exhibited she was awarded a substantial stipend from the king, although she was denied a studio in the Louvre due to the presence of her young female pupils. The following year she received major commissions from the royal family and worked on portraits of the "Mesdames," the aunts of the king. Her full-length *Portrait of Mme. Adélaïde* was hung as a pendant to Vigée-Lebrun's *Marie Antoinette and Her Children* (see Fig. 10–4) in the Salon of 1787. Such obvious proximity encouraged critics to compare the two artists and helped establish a "rivalry" which continued to exist, at least as a critical premise, for the remaining years of the *ancien régime*.

Unlike Vigée-Lebrun, Labille-Guiard did not leave France during the years of the Revolution. With the obvious disintegration of her clientele, her resourceful ability to develop patronage again surfaced, and in the Salon of 1791, she exhibited fourteen portraits of deputies, representatives of the new political elite of France, including Robespierre and Talleyrand. As in her campaign for admission to the academy, she was again successful in courting a new clientele. She received the same commission from the Constitutional Assembly as Jacques Louis David, *The King Showing the Constitution to the Prince.* Subsequent political events prevented the funding of these paintings, and neither was executed.

Labille-Guiard shrewdly used the political upheavals of the Revolution to lobby for an improved position for women artists. In September 1790, she addressed the Academy and argued for lifting the quota of four women academicians. In another motion she pressed for an honorary distinction to recognize women, since they could not assume positions as professors or officeholders. She was unsuccessful in effecting these reforms. The following year, Talleyrand presented her proposal for a school for impoverished girls to learn art skills suitable for careers in the art industries. Such a school was eventually established in 1805. Her ability to weather the political storms of her day is documented in her finally receiving a studio in the Louvre in 1795 and the large number of portraits she exhibited in 1798.

Both Vigée-Lebrun and Labille-Guiard were widely admired by their contemporaries and recognized for their talents by their peers in the academy. These ambitious artists outshone those male colleagues who also specialized in portraiture. One may surmise from both artists' determination to achieve excellence that, had the opportunity existed, they would gladly have competed in the realm of history painting as well. Their confinement to portraiture was determined not by talent or ability but by their gender in the state-controlled art establishment of the French *ancien régime*.

WOMEN SALONNIÈRES AND THE ENLIGHTENMENT

That the two most prominent portrait painters were women is not accidental but can be seen as related to the dominant role of women in the cultural world of the eighteenth century *ancien régime*. Roseanne Runte has discussed the extensive roles of women in this epoch centered in the salons: "It is not an exaggeration to say that literary and artistic fame and fortune depended on the judgement of women."[20] Women exercised influence in political ways, helping to elect writers to the academy. They provided financial aid, both as private benefactors and in dispersals of funds from the royal treasury. Mmes. De Pompadour and du Barry and Marie Antoinette were responsible, collectively, for 258 pensions paid to writers and visual artists. Aristocratic women provided sources of inspiration for both literary and visual artistic production both directly and indirectly as muses and as models. This cultural milieu was characterized in the 1830s by Vigée-Lebrun in this way:

> It is so difficult today to explain the urbane charm, the easy grace, in short all those pleasing manners which, forty years ago, were the delight of Parisian society. The sort of gallantry I am describing has totally disappeared. Women reigned supreme then; the Revolution dethroned them.

Suggestions for Further Reading

Women in Early Modern Europe

DAVIS, NATALIE ZEMON, *Society and Culture in Early Modern France* (Stanford, CA: Stanford University Press, 1975).

TILLY, LOUISE A., and JOAN W. SCOTT, *Women, Work and Family* (New York: Holt, Rinehart and Winston, 1978).

Women in Eighteenth-Century France

HUNT, LYNN (ed.), *Eroticism and the Body Politic* (Baltimore, MD: Johns Hopkins University Press, 1991).

SPENCER, SAMIA I. (ed.), *French Women and the Age of Enlightenment* (Bloomington: Indiana University Press, 1984).

Rosalba Carriera

COLDING, TORBEN HOLCH, *Aspects of Miniature Painting: Its Origins and Development* (Copenhagen: Ejnar Munksgaard, 1953).

SANI, BERNARDINA, *Rosalba Carriera: Lettere, Diari Frammenti* (Florence: Leo S. Olschki, Editore, 1985). (Italian)

Angelica Kauffman

Angelika Kauffman und ihre Zeitgenossen (Bregenz: Vorarlberger Landesmuseum, 1968). (German)

ROWORTH, WENDY WASSYNG (ed.), *Angelica Kauffman: A Continental Artist in Georgian England* (Brighton: The Royal Pavilion Art Gallery and Museums, and London: Reaktion Books, 1992).

ROWORTH, WENDY WASSYNG, "Anatomy Is Destiny: Regarding the Body in the Art of Angelica Kauffman" in Gill Perry and Michael Rossington (eds.), *Femininity and Masculinity in Eighteenth Century Art and Culture* (Manchester and New York: Manchester University Press, 1994).

Mary Moser
POINTON, MARCIA R., *Strategies for Showing: Women, Possession and Representation in English Visual Culture, 1665–1800* (Oxford and New York: Oxford University Press, 1997).

Anne Vallayer-Coster
ROLAND-MICHEL, MARIANNE, *Anne Vallayer-Coster* (Paris: C.I.L., 1970). (French)

Elisabeth Vigée-Lebrun
The Memoirs of Elisabeth Vigée-Le Brun, trans. SIAN EVANS (Bloomington: Indiana University Press, 1989).

BAILLIO, JOSEPH, *Elisabeth Louise Vigée-Lebrun: 1755–1842* (Fort Worth, TX: Kimbell Art Museum, 1982).

SHERIFF, MARY D., *The Exceptional Woman: Elisabeth Vigée-Lebrun and the Cultural Politics of Art* (Chicago and London: University of Chicago Press, 1996).

Adélaïde Labille-Guiard
PASSEZ, ANNE-MARIE, *Biographie et Catalogue Raisonné des Oeuvres de Mme. Labille-Guiard* (Paris: Arts et Métiers Graphiques, 1973). (French)

11

France:
1800 – 1870

INSTITUTIONAL CHANGES IN ART EDUCATION

The French Revolution extended legal rights and privileges to many more men than had previously enjoyed them, but it left women largely unaffected. Women remained perpetual legal minors. Despite this, women did make some gains toward improved rights during these upheavals. Marriage was deemed a civil contract. Women won legal protection for their property and inheritance rights. A leading champion of equality of education for women was the Marquis de Condorcet. Inspired by the American Declaration of Independence, Condorcet demanded increased educational and social opportunities for women as well as civil equality. In fact, the National Convention passed laws in 1794 and 1795 providing free and compulsory education for girls as well as boys. Unfortunately, the instability of the time prevented the implementation of these plans.[1]

The Napoleonic Code of 1804 reversed any gains women may have achieved. The code strengthened the patriarchal authority of the husband and father, inspired by the Roman model of the *pater familias*. The right to divorce was abolished in 1815, not to be reinstated until 1884. When a French woman married, she forfeited virtually all of her legal rights.

In addition to legal and civil discrimination, women were also prevented from developing other options in their lives by the restrictions imposed on their educational and professional training. Lower-class women received virtually no education. In France, only after 1850 were towns required to provide primary education for girls. Middle- and upper-class women received a rudimentary education either in convent schools or with tutors in the home. As in the Renaissance, a woman's education tended to reinforce her predetermined life roles as wife and mother, rather

than providing practical skills that might lead to financial self-sufficiency. Instruction in drawing and watercolor painting was part of this bourgeois curriculum because "art" was considered an appropriate hobby for women, if forbidden as a professional career.

Slowly, during the second half of the nineteenth century, a few women entered European universities. In France the first woman enrolled in medical school in 1868; the law faculty admitted its first woman in 1884. University education remained a potential option for only a tiny percentage of women throughout this period.

The general tendency for women to be excluded from professional careers of all types explains the low absolute numbers of professional women artists at the beginning of the nineteenth century. However, during the course of the century, and despite institutional obstacles, more and more women (as well as men) became practicing artists. In the French Salon of 1801, 28 women participated. By 1835, 178 women, consisting of 22.2 percent of artists exhibiting at the salon, were women.

More women turned to art due to increased access to training in public and private schools and artists' studios during the first half of the nineteenth century, although women's art education still remained discriminatory. The implementation of Labille-Guiard's idea (see Chapter 10 p. 126) occurred in 1805, when the first free drawing school for women was founded in Paris. In 1849, after the death of her father, Rosa Bonheur assumed the directorship of this school.

We are indebted to the research of Gen Doy for more information on the women artists active during the first half of the nineteenth century. As Doy notes, many women of the elite were taught basic art skills and practiced drawing and watercolor as amateurs. In fact, some facility in drawing was considered highly appropriate for upper-class women in this era. Doy notes that "What is crucial at this period is to differentiate between the gifted amateur woman and the professional woman artist, and this was probably the key issue for women artists themselves. Exhibiting at the salon was an important step, and exhibiting under one's own name indicated a definite attempt to be taken seriously as an artist."[2] Few women practiced landscape painting. Genre and portraiture were perceived as more appropriate women's themes.[3]

- Angelique Mongez, *The Oath of the Seven Against Thebes*

In this historical/cultural framework, the case of Angelique Mongez (1775–1855) is fascinating, yet isolated. Like so many other important male artists, in the early nineteenth century, Mme. Mongez was trained by Jacques-Louis David—and she was not alone. David accepted a number of female pupils as early as 1787 and was still teaching female pupils while in exile, in Brussels, during the Restoration (1815–1830).

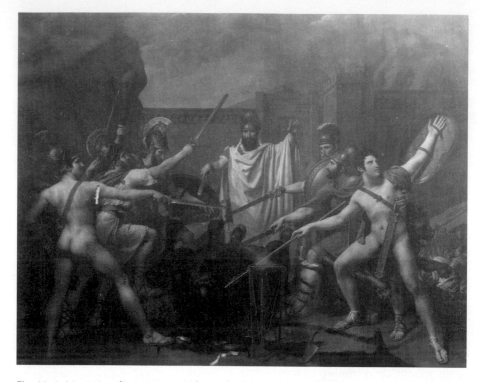

Fig. 11–1 Mme. Angelique Mongez, *The Oath of the Seven Against Thebes.* *(Courtesy of Musée des Beaux-Arts, Angers.)*

Angelique Mongez was the sister of David's business advisor, and her husband Antoine (1747–1835) was an archeologist, who became director of the government mint, under Napoleon, in 1804. Mme Mongez exhibited her first work at the Salon of 1802. She was awarded a first class medal for her next submission *Alexander Mourning the Wife of Darius* in 1804, establishing herself clearly as a history painter. She continued to exhibit regularly at the salon until the submission of this painting, *The Oath of the Seven Against Thebes* (signed and dated 1826, exhibited in 1827–1828). Her final salon submission was in 1854.

Despite the institutional obstacles, such as her ineligibility to study at the Ecole des Beaux-Arts, compete for the prestigious Prix de Rome, and attain membership in the Academy, she is proof that a woman could successfully tackle the most ambitious type of painting. Her invisibility in the art historical literature is an omission that can now be rectified.

This painting displays quite prominently two male nudes and brings us to the issue of access to the male nude for women. There is some evidence

that women were drawing from both male and female nudes in this period, either in mixed classes or in the privacy of their own homes.[4] In this case, at least, Mongez as a dedicated pupil of David must have studied the male nude, since she had the technical ability to execute a large scaled history painting, inspired by an episode from Homeric legend, and organized around the male nude. Mongez is creating an ambitious painting in the Davidian manner, such as the *Intervention of the Sabine Women* of 1799. As Doy notes:

> Mme. Mongez's very existence indicates that we need to re-evaluate some of the received ideas about the invisibility of women artists during this period, their exclusion from history painting, the prohibition of women artists from studying the male nude and the general hostility of male reviewers. However, we still need to bear in mind the discriminatory difficulties faced by women at this time and the fact that the nineteenth-century perception of Mme. Mongez as pretty exceptional was, unfortunately, an accurate one."[5]

WOMEN PATRONS IN THE NAPOLEONIC ERA: CAROLINE MURAT AND INGRES'S *LA GRANDE ODALISQUE*

It is not widely known that one of Ingres's most famous and frequently reproduced paintings, *La Grande Odalisque,* was commissioned by Napoleon's youngest sister, Caroline, wife of Joachim Murat. Between 1808 and 1815 the couple ruled Naples. Queen Caroline commissioned this work in 1814, probably as a gift for her husband. Carol Ockham's study of this work leads to new understandings of the role of women as patrons and as viewers of the female nude.[6] Ockham notes that this was not the only image of a nude commissioned by the Bonaparte sisters. Pauline Borghese, Caroline's older sister, had created a stir in Rome when she commissioned her nude self-portrait, the *Venus Victrix,* from the Neoclassical sculptor, Antonio Canova.

These are only two of the most famous examples of such elegant and "graceful" mythological images, commissioned by women. The issue of a specifically "feminine taste" during the period of the Napoleonic Empire, among aristocratic women patrons, leads Ockham to propose that these works provided an opportunity for women viewers to experience sensual pleasure. This is a historically specific example of the role of women patrons and viewers to directly impact the visual arts. It restores some component of female agency and control into the history of the nude. This situation contrasts directly with the assumption that images of the female nude could only provide visual pleasure to men. The role of these women as patrons forces us to question the gendered stereotype that presumes that men were the only viewers of such pictures.[7]

IMAGES OF "THE WOMAN OF IDEAS" IN THE JULY MONARCHY: 1830–1848

Janis Bergman-Carton has studied the appearance of caricatures of a specific type of intellectual woman, which she terms "the woman of ideas" during the era of the July Monarchy. Bergman-Carton uses this category to refer to women active in the fields of literature and politics, such as Georges Sand. She finds that certain themes, such as the emasculation of husbands, maternal irresponsibility, and sexual promiscuity are found repeatedly in these images.[8] When intellectual women could operate in the public domain of mass media, and thus gain access to the texts of French culture which participate in the definitions of gender roles, they became emblems of political threat.[9] This can explain the extreme level of ridicule to which the "trope" was subjected by a wide range of artists, even the politically radical Daumier. Studies of these negative images of women are valuable strategies for understanding the ways in which the visual arts can contribute to a construction of gender that discourages women from pursuing such careers and encourages them to confine themselves to the privatized roles of wife and mother.

REALISM

* Rosa Bonheur, *The Horse Fair*

Rosa Bonheur (1822–1899) was one of the most famous and popular French painters of her epoch. She devoted her entire career to painting animals, both domesticated and wild, in outdoor settings. Her style was based on a complete dedication to precise observation and the thorough study of animal anatomy characteristic of Realism. Many Romantic artists, such as Eugène Delacroix, Antoine-Louis Barye, and George Stubbs, chose to depict violent attacks of predatory animals when they selected subjects from the animal realm. Bonheur, by contrast, avoided bloody encounters between animals, preferring more peaceful situations that she could observe directly. Her innovative animal subjects, depicted with naturalism of detail, were greatly appreciated by her contemporaries. Numerous engravings done after her compositions were circulated in Europe and America, ensuring her widespread popularity and fame. One indication of this success is her absence from the salons. After 1853 she did not exhibit her paintings in those large exhibitions. She was able to maintain her financial independence from the proceeds of private sales and the income produced from engravings of her compositions.

Bonheur has the distinction of being the first woman artist to be honored with the highest award of the French government, the Cross of the Legion of Honor. The empress of France presented the medal to Bonheur in her studio in 1865.

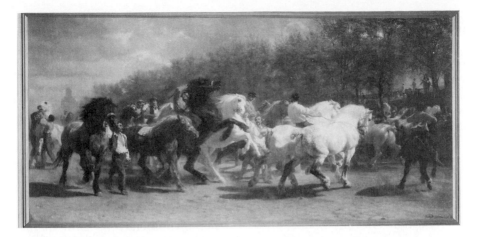

Fig. 11–2. Rosa Bonheur, *The Horse Fair*. OIl on canvas, 96¼ × 199½ in. *(The Metropolitan Museum of Art; Gift of Cornelius Vanderbilt, 1887. All rights reserved, The Metropolitan Museum of Art, 87.25)*

Born in Bordeaux, Bonheur received her initial training, along with the other children of the family, from her father. All four Bonheur siblings became competent *animaliers*, that is, artists who specialized in animal subjects. She is the first woman artist in the nineteenth century whose upbringing was directly affected by the beliefs of the utopian philosophical movement known as St. Simonianism. Bonheur's father, Raymond, was an active member of the St. Simonians, who believed that both women and artists had special roles to play in the creation of the future perfect society. The St. Simonians prayed to "God, Father and Mother of us all."

While women gained a much higher status in this ideal, utopian community, it was assumed that the leaders of the group would be male. One can understand Raymond Bonheur's attraction to St. Simonianism since male artists were given an important leadership role: "It was taught that the religious side of the sect would be directed by the man of the most artistic nature, who would be the supreme priest."[10] Armed from childhood with a belief in the innate superiority and religious mission of both women and artists to transform society, Bonheur developed her talents to the fullest extent possible. Her dedication to her art was total and unequivocal.

Bonheur regularly proclaimed the superiority of the female sex. Late in her life, she told her biographer:

Why would I not be proud to be a woman? My father . . . told me many times that the mission of women was to elevate the human race, to be the Messiah of future centuries. I owe to these doctrines the great and proud ambition I maintain for the sex to which I have the honor to belong. . . . I am certain that to us belongs the future.[11]

The deep emotional attachments of her life were only with other women. Bonheur never married, but lived for over forty years with a female companion, Natalie Micas. However, while Bonheur idealized women, she regularly wore male clothing, usually identified with the masculine point of view, and often referred to herself in masculine terms, such as "brother."[12] As Albert Boime has so perceptively noted, Bonheur's beliefs and lifestyle were an expression of revolt against the rigid polarizations of gender roles in her society. In place of the stereotypical male and female roles defined by her culture, she substituted a belief in an ideal androgyne, symbolizing a mystical union of the sexes. This revolt against social mores was paired with political views that were quite conservative. Bonheur's subjects were more acceptable to the Second Empire than the more overtly leftist political images of Courbet or Millet.

On many levels, Bonheur rejected her own society in favor of the animal kingdom, which she valued higher than that developed by mankind. Bonheur did not perceive a clear-cut separation between the animal and the human realms. She believed in metempsychosis, the migration of souls into animal forms. Thus, she could easily identify with animals and even referred to herself, on occasion, as an animal. Like the blurring of sexually defined characteristics, the blurring of distinctions between the animal and human worlds formed a fundamental part of her intellectual makeup.

Although Bonheur acquired the rudimentary principles of painting from her father, the true basis on which she built her images came from her studies of animals. A Realist urge toward accuracy is clearly apparent in Bonheur's masterpiece *The Horse Fair* (Fig. 11–2). This large painting (over sixteen feet wide) won immediate critical and popular acclaim for its creator, firmly establishing her reputation. It attracted large crowds when it was displayed in France, England, and America. Widely reproduced in engravings, this work became one of the most famous paintings of the nineteenth century. Bonheur said that *The Horse Fair* was originally inspired by the frieze of horsemen on the Parthenon. The even distribution of the horses across the picture surface and the processional movement from left to right do recall the Parthenon frieze. One can even see an echo of a Parthenon horseman in the man with an upraised arm, riding the rearing black horse in the center of the composition. However, instead of the classical restraint, simplicity, and slowly measured pace of the Parthenon frieze, Bonheur has presented an image of forceful energy, in which men and horses strain against one another. Bonheur also endows her image with the same romantic spirit and energy that Gericault gave both his horse and rider in *Mounted Officer of the Imperial Guard* (1812).

In actuality, *The Horse Fair* was the result of a conscientious study of horses at a market that was located on the outskirts of Paris. Both the realism of details, the large scale, and the unified composition contribute to

the powerful impression the work makes on the viewer. Bonheur has designed an unprecedented scene of great excitement, vividly portrayed, which places the viewer in the midst of the action as the horses are displayed in a circle. Her belief in the superiority of animals is evident in this composition by the dominant role played by the horses. In comparison, the humans look puny and insignificant.

James M. Saslow has identified the figure in the exact center of the composition, the only figure looking out at the viewer, as a self-representation of Bonheur in masculine guise. He builds a convincing case for understanding Bonheur's cross-dressing as "an attempt to claim male prerogatives and create an androgynous and proto-lesbian visual identity."[13]

Bonheur regularly worked in trousers and a loose smock throughout her life. Wearing male clothes or "transvestitism" was illegal and Bonheur needed to obtain repeated police permits to continue to wear pants, not just for the immediate necessity of frequenting the slaughterhouses for the preliminary studies for this painting. When control of dress falls into the realm of legal issues, we can see a clear example of the Second Empire's efforts to control and regulate deviant gender behavior. Social control operated through a number of channels including the popular press, in which a highly unflattering caricature of the artist appeared in 1899.[14] When we contrast Bonheur's image in *The Horse Fair* with equestrian portraits of Queen Victoria riding sidesaddle in elegant and obvious "feminine" costume, we can begin to appreciate the masculinized image Bonheur projects of herself in this work. Yet the presence of the self-portrait is overwhelmed here and in Bonheur's entire career by the depiction of animals.

As Whitney Chadwick notes, Bonheur's work was very popular in England. When Bonheur traveled to England with *The Horse Fair* in 1856, a private viewing of the painting was arranged for Queen Victoria. The work was engraved and widely distributed in that country. English patrons were Bonheur's strongest financial supporters, and Great Britain is the country in which she enjoyed her greatest fame in the 1860s and 1870s.

Chadwick builds a convincing case for understanding *The Horse Fair* in the context of the public debate on animal rights and vivisection. There was a close identification between women and animals in Victorian culture. Anna Sewell's *Black Beauty*, published in 1877, is one example of this comparison between the plight of animals and women. "*Black Beauty* is, in fact, a feminist tract deploring the cruel oppression of all creatures, especially women and the working class."[15] The practices of the new medical science of gynecology in which women's bodies were placed under the control of "medical science" was paralleled by the use of animals in vivisection experiments.[16] Chadwick notes the use of terms identified with horses, utilized both in the language of Victorian pornography, and also in gynecology. For example, the use of the term "stirrups" for the footrest on gynecological examination tables is still common today.[17]

After 1860, Bonheur lived with Natalie Micas in relative isolation near Fontainebleau, where she continuously studied the natural beauty of the forest and surrounding farms. On the extensive grounds of her chateau, she kept a personal menagerie to permit her to observe a variety of animals. Bonheur remained faithful to her form of Realism throughout her life, keeping her vision fresh and direct in all her works. Her intense powers of observation and her humility before the wonders of nature impressed her contemporaries, who frequently compared her art to the Dutch painters of the seventeenth century who set the standards for realistic description.

Suggestions for Further Reading

Angelique Mongez

DOY, GEN, *Women and Visual Culture in 19th Century France: 1800–1852* (London and New York: Leicester University Press, 1998).

Patrons and Images

BERGMAN-CARTON, JANIS, *The Woman of Ideas in French Art, 1830–1848* (New Haven, CT: Yale University Press, 1995).

OCKHAM, CAROL, *Ingres's Eroticized Bodies: Retracing the Serpentine Line* (New Haven, CT: Yale University Press, 1995).

Rosa Bonheur

ASHTON, DORE, and DENISE BROWNE HARE, *Rosa Bonheur: A Life and Legend* (New York: Viking, 1981).

BOIME, ALBERT, "The Case of Rosa Bonheur: Why Should a Woman Want to Be More Like a Man?" *Art History,* 4 (December 1981).

CHADWICK, WHITNEY, "The Fine Art of Gentling: Horses, Women and Rosa Bonheur in Victorian England," in Kathleen Adler and Marcia Pointon (eds.), *The Body Imaged: The Human Form and Visual Culture Since the Renaissance* (Cambridge: Cambridge University Press, 1993).

SASLOW, JAMES M., "Disagreeably Hidden: Construction and Constriction of the Lesbian Body in Rosa Bonheur's *Horse Fair*," in Broude and Garrard (eds.), *The Expanding Discourse, Feminism and Art History* (New York: HarperCollins, 1992).

STANTON, THEODORE, *Reminiscences of Rosa Bonheur* (London, 1910; reprinted by Hacker Art Books, 1976).

VAN SLYKE, GRETCHEN (ed. and trans.), *Rosa Bonheur: The Artist's (Auto)biography* (Ann Arbor: University of Michigan Press, 1997).

WEISBERG, GABRIEL, *et al., Rosa Bonheur: All Nature's Children* (New York: Dahesh Museum, 1998).

12

The United States:
1830 – 1900

In antebellum culture in the United States, prior to the 1860s, women were largely absent from the cultural arena as both patrons and artists. Women were not involved in any major art institutions, such as galleries, academies, or art unions, which were dominated by men. However, there were a few exceptions to the absence of women in formative positions in the art institutions of the period. For example, Sarah Worthington King Peter opened the first school of design for women in 1848 in Philadelphia and another school in Cincinnati.[1]

The prevailing cultural ideology of the epoch, the "Cult of True Womanhood," isolated and limited women's art activity to the category of decorations intended for the home. Professional women artists suffered from the association of women's activities with amateur, household pastimes, predominantly needlework.

During the first half of the nineteenth century, women in the United States who aspired to become professional artists had limited opportunities to acquire skills through apprenticeship to male artists. In a cultural structure similar to that in Holland, both Sarah Miriam Peale and Lilly Martin Spencer, the first two women painters discussed in this chapter, learned their craft in these more informal ways. These two painters became outstanding practitioners of the arts of portraiture and domestic genre scenes, respectively, in the era prior to the Civil War.

"Women artists often labored in professional isolation, shielded and encouraged by their fathers, brothers and husbands . . . but denied many of the collegial connections these men enjoyed."[2] This generalization is most appropriate for the painters Sarah Miriam Peale and Lilly Martin Spencer. Peale was born into a family of artists and Spencer's husband ran the household, although Lilly's paintings were the only source of income for the family.

Kathleen McCarthy has described the ways in which women artists were isolated from any existing female support networks. "Relegated to the periphery of men's professional networks by popular prejudices and the invisibility of their working lives, women artists were equally estranged from female support networks by virtue of their secular, unconventional careers."[3]

PORTRAITURE AND GENRE PAINTING

• Sarah Miriam Peale, *Portrait of Congressman Henry A. Wise*

Like Artemisia Gentileschi, Angelica Kauffman, and other women artists discussed in preceding chapters, Sarah Miriam Peale (1800–1885), the daughter of an artist, was in a highly favorable position to develop expertise and talent as a professional portrait painter in Victorian America. Born into a family of outstanding artists, she was among the few women of her era to build her career on the execution of full-sized portraits. The daughter of James Peale, a miniature painter, and niece of the noted artist Charles Wilson Peale, Sarah Miriam acquired training in painting both at

Fig. 12–1. Sarah Miriam Peale, *Henry A. Wise.* c. 1842. Oil on canvas, 29½ × 24½ in. *(Virginia Museum of Fine Arts, Richmond, VA. Gift of the Duchess of Richelieu in memory of James M. Wise and Julia Wise. Photograph © Virginia Museum of Fine Arts)*

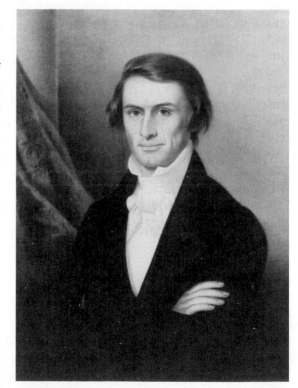

home and in the studios of her cousins. Her two sisters, Anna Claypoole and Margaretta Angelica, were also noted artists.

Born in Philadelphia, Sarah Miriam first learned the techniques of painting miniatures on ivory from her father. By 1825 she had moved to Baltimore where her cousins Rembrandt and Rubens Peale operated a museum modeled after that of their father, Charles Wilson Peale, in Philadelphia. Sarah Miriam had already learned more sophisticated painting techniques for flesh tones and fabric textures from Rembrandt. For more than twenty years she lived and worked in Baltimore, creating more than 100 full-scale portraits of the socially prominent of that city and the elected representatives of the nation living in nearby Washington, D.C. The *Portrait of Congressman Henry A. Wise* (Fig. 12–1) falls into the latter category. Peale painted this work when Wise was a Democratic congressman from Virginia. He would later be elected governor of the state in the years prior to the Civil War, and eventually served as a general in the Confederate army.[4]

This portrait is a characteristic example of Peale's commissioned works. The isolated sitter is presented half-length, in three-quarter position, confronting the viewer directly. Peale's style is linear, precise, and realistic. The detailed and well-modeled face, set off against the brilliant white shirt and cravat, and the unmodeled black suit forces the viewer inescapably to focus on the features of this handsome man. The barely indicated column on the left, swagged with a dark red drapery, enlivens the otherwise bare background, while the drapery establishes an echoing diagonal to the sitter's left shoulder.

In Baltimore, Peale had a very large clientele, but also direct competitors in the portrait market, such as Thomas Sully and John Vanderlyn. Perhaps this explains her eventual relocation to St. Louis in 1847. The city must have appealed to her, because she remained there for thirty years, returning to Philadelphia to live out her remaining years with her two sisters. A few still life paintings as well as portraits have survived from her years in St. Louis.

Sarah Miriam Peale capitalized on her birthright to develop her talents in order to pursue a long, productive, and one may assume prosperous career as a professional portrait painter in nineteenth-century America. She was the most accomplished and outstanding woman artist in this field during her era.

• Lilly Martin Spencer, *War Spirit at Home*

Lilly Martin Spencer (1822–1902) was one of America's most important genre painters in the years before and after the Civil War. In the extensive catalog, published in 1973, for a major exhibition of the artist's works organized at the National Collection of Fine Arts, she is characterized as "this country's most noted mid-nineteenth-century female artist."[5]

Spencer's parents were born in France and arrived in the United States with their young daughter in 1830. Her parents were liberal thinkers, probably affected by French utopian intellectual movements, and were to be active supporters of reform movements ranging from abolitionism to women's suffrage. After settling in Ohio, Lilly and her siblings were raised on a farm and educated at home. Her talent for art emerged in her teens, and, accompanied by her father, she traveled to Cincinnati in 1841 to acquire some training in painting. Cincinnati was in these years a thriving, wealthy port city, which supported many portrait painters and an active cultural life. Lilly Martin lived in this city for seven years, studied with several portrait painters, and married Benjamin Rush Spencer. Her marriage was productive and prolific. Seven children survived, and more pregnancies were endured by Lilly. Benjamin would eventually abandon any independent career activities to facilitate his wife's production of works of art. He assumed most of the domestic responsibilities of their household.

Lilly was able to develop her talents to the extent that she exhibited still life and genre paintings at the newly established Western Art Union in Cincinnati. However, chronic poverty plagued the couple. After selling a work to a New York collector and exhibiting a work at the prestigious National Academy of Design, the Spencers decided to move to New York in 1848, seeking the wider opportunities and broader patronage base of the large city. The artist arrived in New York when enthusiasm for Düsseldorf-school genre painting was at its height. Characterized by defined outlines, crisp details, and bright colors, Spencer worked to acquire a personal style of similar precision and realism.[6] Her subjects reflect the tastes for genre of the largely middle-class patronage of the era, which supported the successful careers of such male genre painters as William Sidney Mount. After developing her skills further, her genre paintings met with wide critical approval. *Peeling Onions* (1852) shows her newly acquired expertise in combining a kitchen genre scene with a realistically rendered still life. Another famous painting, *Fi! Fo! Fum!*, used her own family as subject for an intimate domestic moment of storytelling. During the 1850s and 1860s Spencer exhibited her works along the Eastern Seaboard and gained popularity through the distribution of hand-colored lithographs based on her compositions, printed in France. By 1858, the year the couple moved to a home in Newark, New Jersey, Lilly Martin Spencer had established herself as one of the leading domestic genre painters in America. Yet the family, still growing in size, continued to experience financial pressures. The lower cost of living in Newark was surely the main motivation for the move, and the Spencers even planted a vegetable garden for a source of food in lean times.

McCarthy notes that the Spencer household was constantly in debt and Lilly was often searching for commissions. In 1856, she had not sold a painting or received a portrait commission for over seven months.[7] In 1860,

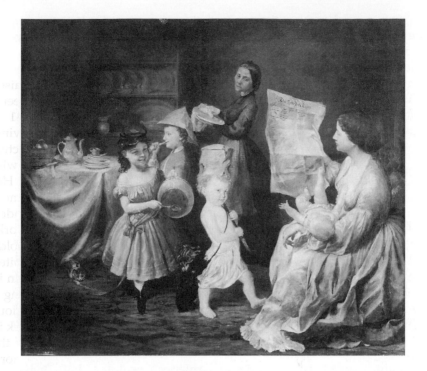

Fig. 12–2. Lilly Martin Spencer, *War Spirit at Home.* 1866. Oil on canvas, 30 × 32¾ in.
(*Collection of the Newark Museum. Purchase 1944 Wallace M. Scudder Bequest Fund*)

she was reduced to coloring photographs, a menial task. By contrast, William Sidney Mount never suffered from poverty. He roamed the countryside for subjects, socialized with a circle of professional male colleagues, and was supported financially by male patrons.

In the immediate aftermath of the Civil War, Spencer created several major compositions reflecting this traumatic national experience. *War Spirit at Home* (Fig. 12–2) provides the viewer with an image of the domestic life of women and children during the war. This painting depicts a fatherless household celebrating Grant's 1863 victory at Vicksburg, as recorded in the *New York Times,* displayed by the mother, a self-portrait, on the far right of the composition. The lighthearted energy of the children, ignorant of the realities of the conflict, is contrasted with the sober expressions of the mother and servant. The obvious absence of the father leads one to project a scenario in which the strength and determination of the women's sphere is a complement to the heroism of the soldiers on the battlefield. The sharply focused light, painterly rendering of the mother's dress, and dramatic foreshortening of the infant are all noteworthy formal elements of this image. Spencer's ability to invent a convincing domestic genre subject on such a serious issue as the Civil War demonstrates her talent for thematic innovation.

Following the war, artistic tastes began to change. The artist attempted to accommodate the new patronage demands and worked on an over-life-sized allegory, *Truth Unveiling Falsehood* (1869). It remained unsold throughout her life, and there is no evidence that it improved her financial situation. This change of direction marks the end of the most fruitful period of the artist's career. Lilly Martin Spencer lived until the age of 80 and died after a morning spent painting an image of a family reunion, convened to celebrate the 100th birthday of her aunt.

NEOCLASSICAL SCULPTURE

• Harriet Hosmer, *Zenobia in Chains*

When Horatio Greenough left America and traveled to Italy in 1825, he initiated the exodus that created the first significant American school of sculpture. Prior to this time, Americans who created three-dimensional objects were largely craftsmen, although Patience Lovell Wright (1725–1786) had been active as a maker of wax images in the eighteenth century. In addition to Greenough, Thomas Crawford and Hiram Powers are the most important Neoclassical sculptors of the second quarter of the nineteenth century. Powers's *The Greek Slave* (see Fig. 12–4) became the most famous sculpture produced by an American in the nineteenth century.

Italy retained its attraction for American sculptors both male and female during the third quarter of the nineteenth century. In addition to Randolph Rogers, William Wetmore Story, and William Henry Rinehart, a number of women sculptors established studios in Rome during the 1850s. Harriet Hosmer (1830–1908) and Edmonia Lewis are among the artists of the "White Marmorean Flock." This group set a historical precedent for the ability of women to become successful professional sculptors. Henry James coined the name the "White Marmorean Flock" in 1903, and this disparaging phrase has remained attached to these artists ever since. As Jane Mayo Roos convincingly argues, the implication of the appellation is that these women are "tiny, anonymous, hapless creatures who traveled *en masse* and whose accomplishments were diminutive in scale."[8]

Harriet Hosmer had begun her training in America. She studied anatomy at the Saint Louis Medical College, following the same course as Hiram Powers. She was one of the first American women to settle in Rome, arriving in 1852. In the 1850s and 1860s, Louisa Lander, Emma Stebbins, Anne Whitney, and Edmonia Lewis established neighboring sculpture studios in Italy.

On her arrival in Rome, Hosmer continued her studies with the English sculptor John Gibson. During her first year abroad she wrote to her best friend and biographer Cornelia Carr:

Don't ask me if I was ever happy before, don't ask me if I am happy now, but ask me if my constant state of mind is felicitous, beatific, and I will reply "Yes." It never entered into my head that anybody could be so content on this earth, as I am here. I wouldn't live anywhere else but in Rome, if you would give me the Gates of Paradise and all the Apostles thrown in. I can learn more and do more here, in one year, than I could in America in ten. America is a grand and glorious country in some respects, but this is a better place for an artist.[9]

Female sculptors were attracted to Rome for the same reasons as their male colleagues: the access to the famed statues of antiquity and the abundance of fine marble and of skilled artisans to work it. Furthermore, they also found in Rome an international community of artists who respected their unusual choice of profession. In Italy members of the "Flock" were released from the cultural restrictions imposed on women by Victorian American society. This freedom, combined with inexpensive living costs, made Rome especially attractive to these American sculptors.

Fig. 12–3. Harriet Hosmer, *Zenobia in Chains.* 1859. Marble. Height 49 in. *(Wadsworth Atheneum, Hartford. Gift of Mrs. Josephine M. J. Dodge)*

Fig. 12–4. Hiram Powers, *The Greek Slave.* Marble. Height 65½ in. *(Collection of the Newark Museum. Gift of Franklin Murphy, Jr., 1926. Photo by Armen)*

Hosmer's most famous statue is *Zenobia in Chains* (Fig. 12–3), which presents the queen of Palmyra, who was marched in chains through the streets of Rome, following the defeat of her army in 272 A.D. Hosmer does not depict Zenobia as the powerful warrior who, according to the historian Gibbon, conquered Egypt and parts of Asia Minor, but rather as a noble captive who accepts her defeat with dignity and reserve. Like Cornelia, Zenobia was a woman of outstanding talents and abilities whose reputation survived through history and made her a female role model from the classical past.

Hosmer's conception of Zenobia is dependent on the written account of this legendary figure by Anna Jameson, a noted English authority on art and a vocal advocate of women's rights. Hosmer apparently consulted with Jameson during the genesis of the statue. Thus Hosmer's *Zenobia* was clearly and self-consciously developed as a role model of courage and wisdom for contemporary women, challenging prevailing Victorian ideals of femininity. The original statue was monumentally scaled, seven feet tall. The drapery was derived from the authoritative classical model of the Golden Age *Athena Giustinini* and the crown inspired by the *Barberini Juno*.[10]

A comparison of Hosmer's *Zenobia* with Powers's *The Greek Slave* (Fig. 12–4) reveals important differences in attitude toward the portrayal of the female image that existed between two artists of the same Neoclassical movement, one a man, the other a woman. Powers made *The Greek Slave*'s nudity acceptable to prudish Victorian American society by the literary references surrounding the work. On one level, the figure was meant to evoke pity rather than lust, since she has been captured by the Turks during the Greek War of Independence. She is naked because she is about to be sold into slavery. But this motif was merely a respectable pretext because the statue is clearly designed to titillate the Victorian male viewer, and the chains emphasize the captive's passivity and vulnerability. By contrast, Zenobia, although chained, is clothed and retains her dignity and integrity as a woman. In this work, Hosmer provided an alternative to the sexual objectification of women so evident in *The Greek Slave* and chose, instead, to depict an individual woman of antiquity, worthy of deep respect and admiration on several levels.

- Edmonia Lewis, *Old Indian Arrowmaker and His Daughter*

One of the most interesting artists in this group was Edmonia Lewis (1843–c. 1911), who was half African-American and half Native American. The subjects of her sculpture reflect her mixed racial heritage. In 1867, as a monument to the recent emancipation of the American slaves, Lewis created a two-figure group, *Forever Free*. The white marble sculpture presents a black woman kneeling in a gesture of prayer beside a standing black man who displays his broken chains.

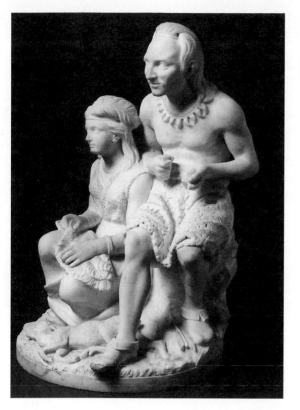

Fig. 12–5. Edmonia Lewis, *Old Indian Arrowmaker and His Daughter*. 1872. *(George Washington Carver Museum, Tuskegee Institute)*

Lewis was raised as a Chippewa Indian. *Old Indian Arrowmaker and His Daughter* (Fig. 12–5) is one example of her ability to create sculptural images of Native Americans of great dignity and symbolic force. This work contains some very realistic details. Object textures of the fur garments are articulated, and the Old Arrowmaker has a sharply defined face with prominent cheekbones. He holds a flint and stone, while his daughter plaits a mat. This work is one of several created by Lewis that were directly inspired by Longfellow's famous poem "The Song of Hiawatha," and thus we can identify the daughter as Minnehaha. The slain deer could be the one killed by Hiawatha, implying his presence. In this sculpture Lewis has developed an original and expressive symbol of the transmission and preservation of unique cultural values from one generation to the next.[11]

The achievements of the sculptors of the "White Marmorean Flock" were widely recognized in their era, and many of these women received commissions for monumental works to be placed outdoors. Although in retrospect, their works may seem stylistically conservative, this should not affect our appreciation of the historical position and achievement of these artists. Their statues were highly regarded in their day and were extremely

popular. The works of the "Flock" embodied an idealism and optimism that reflected American aspirations and expectations of the mid-nineteenth century. The critical success and widespread recognition of this group is significant not only historically but also because it set a precedent for the many important women sculptors of the twentieth century.

The largest collection of Neoclassical sculpture ever assembled was exhibited at the Philadelphia Centennial Exposition in 1876 (discussed in Chapter 14). By this date, however, Neoclassicism was no longer a viable stylistic mode for American sculptors. Post–Civil War America, disillusioned with earlier ideals of America as the new Eden and absorbed in rapid industrialization, could no longer sustain a movement in sculpture that focused so resolutely on past models.

Suggestions for Further Reading

General Works

McCARTHY, KATHLEEN D., *Women's Culture: American Philanthropy and Art, 1830–1930* (Chicago: University of Chicago Press, 1991).

RUBENSTEIN, CHARLOTTE STREIFFER, *American Women Artists: From Early Indian Times to the Present* (Boston: G. K. Hall, 1982).

RUBENSTEIN, CHARLOTTE S., *American Women Sculptors* (Boston: G. K. Hall, 1990).

TUFTS, ELEANOR (ed.), *American Women Artists: 1830–1930* (Washington, DC: The National Museum of Women in the Arts, 1987).

Lilly Martin Spencer

BOLTON-SMITH, ROBIN, and WILLIAM TRUETTNER, *Lilly Martin Spencer: The Joys of Sentiment* (Washington, DC: Smithsonian Institution Press, 1973).

Neoclassical Sculpture

CARR, CORNELIA (ed.), *Harriet Hosmer, Letters and Memories* (New York, Moffat, Yard and Co., 1912).

CIKOVSKY, NICOLAI, *The White Marmorean Flock: 19th Century American Women Neoclassical Sculptors* (Poughkeepsie, NY: Vassar College Art Gallery, 1972).

GERDTS, WILLIAM H., *American Neoclassical Sculpture: The Marble Resurrection* (New York: Viking Press, 1973).

LEACH, JOSEPH, "Harriet Hosmer: Feminist in Bronze and Marble," *Feminist Art Journal* (Summer 1976).

ROOS, JANE MAYO, "Another Look at Henry James and the 'White Marmorean Flock'," *Woman's Art Journal*, 4 (Summer 1983).

SHERWOOD, DOLLY, *Harriet Hosmer, American Sculptor, 1830–1908* (Columbia: University of Missouri Press, 1991).

WALLER, SUSAN, "The Artist, the Writer, and the Queen: Hosmer, Jameson, and Zenobia," *Woman's Art Journal*, 4 (Summer 1983).

13

Victorian England:
1850 – 1890

THE DEVELOPMENT OF A FEMINIST CONSCIOUSNESS

- Emily Mary Osborn, *Nameless and Friendless*

During the second half of the nineteenth century there was an enormous increase in the number of practicing professional women artists in England. In 1841 fewer than 300 women identified themselves as artists in the census; by 1871 there were 1,000 women artists. The middle third of the century saw this growing body of women artists become more vocal and visible. As Deborah Cherry notes, "Women artists' claims for public recognition collided with hegemonic definitions of bourgeois femininity as dependent and domestic, while their bids for professional status contested emergent codes of masculine professionalism."[1] In 1856 the Society of Female Artists was established.

The following year, in 1857, Emily Osborn (1834–c. 1909) exhibited *Nameless and Friendless* at the summer exhibition of the Royal Academy. In this painting, the woman artist stands in the center. Her clothing, a simple black dress and plaid shawl, identify her as belonging to the middle classes. She has entered a picture shop, a commercial place of work, to engage in an economic transaction. This activity was not compatible with the ideology of bourgeois femininity, which polarized masculine and feminine identities and spheres. Like the contemporary "Cult of True Womanhood" in America, gender roles were very sharply differentiated in Victorian England. While men were involved in paid, professional work and ran the world of industry, business, and government, women's lives were viewed as centered around the home, domesticity, family, and financial dependence on men.

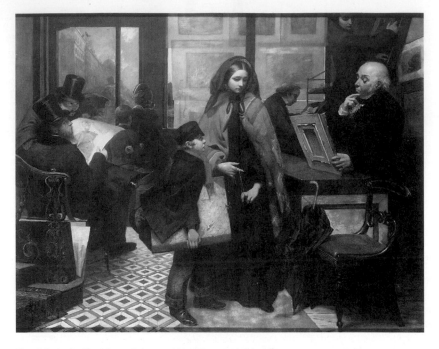

Fig. 13–1. Emily Mary Osborn, *Nameless and Friendless.* *(Courtauld Institute of Art, Photographic survey of Private Collections)*

Osborn appeals to her viewers by portraying this woman artist as a "distressed gentlewoman," a character familiar to her audience, since it had already been disseminated in other texts of the epoch. The distressed gentlewoman was a needy lady—a respectable, middle-class woman forced to earn money for survival, due to the death of a male provider. Osborn helped the Victorian viewers to "read" this image by supplying a quote from Proverbs 10:15 for the exhibition catalog: "The rich man's wealth is his strong city." The black dress, then, is a symbol of mourning, and the lack of a wedding band would have helped viewers understand that this woman is unmarried, and now an orphan. She has traveled some distance through the rainy weather to sell her work.

Cherry identifies the story behind this image with a complex of meanings that have to do with issues of "looking" and "being looked at." The young artist avoids the gaze of both the owner of the picture shop and the viewer. The avoidance of a forthright stare was another sign of respectable femininity. The forthright gaze, as in Manet's *Olympia*, is the sign of the prostitute. This "distressed gentlewoman" is, however, the object of attention of both men on the far left, who have interrupted their viewing of a print of a ballerina. The ballet dancer was an obvious sexual object in

this period, due to the exposure of her arms and limbs and her performance in public. Just as the men stare at her, the dealer looks critically and unenthusiastically at the painting he holds, which we presume to be the artist's work.

Sexual difference, then, is apparent in the different nature of "the gaze." Men are looking. Women, whether real or as images, are looked at and sexually consumed, as the leers of the "gentlemen" in the top hats indicate. Linda Nochlin notes that the empty chair in the right foreground and the standing position of the young woman further indicate her loss of status in this situation: " . . . had she been a wealthy lady client rather than a nameless and friendless woman painter, she would naturally have been sitting down rather than standing up."[2]

However, this is a painting by a woman artist. Emily Osborn was encouraged to paint by her mother, who herself had aspirations to become a professional artist. Over the objections of her father, a clergyman, Osborn's mother was her first art teacher. Osborn remained unmarried but lived with a woman, whom she characterized as her "great friend, Miss Dunn."[3]

Lady Chetwynd purchased this work in 1857. Queen Victoria purchased another work by Osborn, and the commission for a portrait of Lady Sturgis enabled Osborn to acquire her own studio. The financial support of other women was crucial for Osborn's career and testifies to the existence of networks of "matronage" for the financial support of women artists. A few years later, in 1860, Osborn addressed the plight of the governess in another painting, which, like Charlotte Bronte's novel *Jane Eyre*, elicited sympathy for this category of "distressed gentlewoman," which was one of the few paid occupations for respectable, middle-class women.

WOMEN ARTISTS AND THE PRE-RAPHAELITE MOVEMENT

• Elizabeth Siddall, *Pippa Passes*

The standard histories of the Pre-Raphaelite movement are focused on the formation of the all-male brotherhood (PRB) led by Dante Gabriel Rossetti in 1848. Women are present in these accounts as the subjects of the male artist's visions, as images, models, or as muses of inspiration. However, as Jan Marsh and Pamela Gerrish Nunn have documented, women artists were present in numbers at all stages of the movement from 1850 to 1900.[4] Women managed to create Pre-Raphaelite works despite the fact that their access to training was not equivalent to those of men. " . . . young women with pictorial talents began, like young men, with lessons from a drawing teacher. Men then progressed via private art schools, to free tuition at the Royal Academy schools, the recognised training-ground. Women were not admitted, so continued with private tuition, foreign study,

Fig. 13–2. Elizabeth Siddall, *Pippa Passes.* *(Courtesy of The Visitors of the Ashmolean Museum, Oxford.)*

or ladies' classes in government-funded art schools, including the Female School of Art in London."[5]

Pollock and Cherry have addressed the complexities of understanding the life and work of Elizabeth Siddall (1829–1862) in a fascinating essay, "Woman as Sign in Pre-Raphaelite Literature."[6] From their research, a few basic facts about the life of Elizabeth Siddall can be established with some degree of certainty. Born in July 1829, one year after Rossetti, she died at age 32, in 1862. She came from a working-class family—her father worked in the cutlery and ironmongering trades in Sheffield and London. Two of her sisters worked in the clothing trades, as did so many other working-class women of this era. Siddall was introduced to the PRB as a model. She studied with Rossetti, informally from 1852 to 1854, the year she drew *Pippa Passes.*

Siddall's relationship with Rossetti is consistent with the patterns of other male artists in the Pre-Raphaelite circle. These men sought out working-class women as models, lovers, and wives, "desiring them for their difference,"[7] perhaps as a form of rebellion consistent with their avant-garde artistic practices. Siddall did make art, however, as documented by this drawing and, in fact, she produced over 100 works. "There is evidence that Siddall was caught up in the cult of art as expressive genius unfettered

by formal training which was proclaimed by Rossetti and Ruskin."[8] Siddall's first works were illustrations. She developed a series of illustrations of Sir Walter Scott's poems, including *Clerk Saunders,* to be published in a book edited by William Allingham.

This drawing illustrates a scene from a poem by Browning. This is one of her earliest finished drawings and was sold to the influential art critic John Ruskin, in 1855. The theme of the contrast between a working-class woman and the "fallen" woman or prostitute is consistent with other works by male Pre-Raphaelites of the same year, such as Hunt's *Awakening Conscience* and Rossetti's *Found.*[9] Marsh and Gerrish Nunn emphasize that the awkwardness of proportions and perspective in Siddall's images are consistent with the "deliberate Primitivism" of "Pre-Raphaelitism" in this period.[10] These formal elements should not be interpreted as "incompetence" based on academic standards of realism or "accuracy."

Siddall's relationship with Rossetti was difficult and discontinuous. In 1858 their engagement was broken when Rossetti refused to honor his promises of marriage. Marsh and Gerrish Nunn believe that it was following this rupture, in the spring of 1858, that Siddall became addicted to laudanum, an opiate drug. In 1860 Rossetti, who believed Siddall was dying, did marry her. She became pregnant, but her baby daughter was stillborn in May 1861. In February 1862 "she died of a massive overdose of laudanum, which the coroner judged accidental."[11]

Marsh and Gerrish Nunn conclude: "Her display of drawings to Mr. Deverell, . . . her work as a model to the PRB (possibly her only access to the studio), her choice of Rossetti as instructor, her acceptance of Ruskin's allowance, her participation in the Russell Place Exhibition, and her attendance at Sheffield Art School should all be interpreted as the actions of an artist aspiring to professional status."[12]

VICTORIAN PHOTOGRAPHY

• Julia Margaret Cameron, *April 1865, The Whisper of the Muse*

Because photography was not regarded as an art in the late nineteenth and early twentieth centuries, the field was open to everyone without restrictions. Anyone who wanted to could make photographs, and no official schools controlled the dissemination of the technical knowledge necessary to practice photography. This made it possible for a number of women to achieve the first rank of excellence in the new medium. Women photographers, like women active in the fine arts, have created impressive images of a wide variety of subjects in many different photographic styles. As in the fine arts, women photographers were active participants in many avant-garde groups. The Englishwoman Julia Margaret Cameron (1815–1879) was one of the most famous photographers of the nineteenth century.

Julia Pattle was born in Calcutta, India. Her father was a wealthy

Fig. 13–3. Julie Margaret Cameron, *The Whisper of the Muse.*
(Courtesy of J. Paul Getty Museum.)

merchant in the East India Company. After being educated in France and England, Julia returned to Calcutta at age 19. A few years later she met Charles Hay Cameron, an upper-class Englishman, and they were married in 1838. Cameron, twenty years older than Julia, was an eminent jurist who codified the Indian statutes. In 1848 the couple returned to England, and in 1860 they settled on the fairly isolated Isle of Wight. Julia Cameron took up photography at the age of 48 as a diversion because her six children were grown and her husband was frequently away on business. Although she had no formal training and her knowledge of photography came from popular manuals and trial and error, she attacked the new medium with characteristic energy and enthusiasm.

In her time, Cameron was best known for her romantic, unfocused portraits. The Camerons were part of Britain's social and intellectual elite, friendly with many of the most notable Englishmen of the era, who often visited the family on the Isle of Wight. Among her illustrious sitters were the painters George Watts and William Holman Hunt, the poets Alfred, Lord Tennyson and Robert Browning, and the scientist Charles Darwin. She also used family members as sitters.

She often created images that are allegorical or adapted from medieval

themes, like the subjects of Pre-Raphaelite paintings. Marsh and Gerrish Nunn consider Cameron to be "without doubt the most celebrated Pre-Raphaelite photographer."[13] This image is a concrete documentation of her relationship with Watts who posed for the central figure. He is flanked by two children, who personify muses. Watts, himself a famous artist, is here "communing with the muses who bestow creativity and who inspire the highest form of art."[14] In this work Cameron is responding to contemporary ideals of art, espoused by Watts and others, and still prevalent from the times of Reynolds, which perceived portraiture to be a less exalted form of art than ideal, "history" paintings. She is using the medium of photography, which was still not considered to be an "art form," to create compositions that could challenge the most exalted types of painted images. An extensive literature has been published on Cameron, in recognition of her original achievement in photography.

THE ROYAL ACADEMY AND ISSUES OF PROFESSIONALISM

- Elizabeth Thompson Butler, *The Roll Call*

Elizabeth Thompson (1846–1933) was born into a family that nurtured her talents. Her mother was a landscape painter and her father personally tutored his two daughters. They lived abroad for much of their youth. Thompson's sister, the poet, essayist, and critic Alice Meynell, became famous in her own right. In 1866, at age 19, Elizabeth Thompson began her studies at the Female School of Arts in South Kensington, where she remained until 1870.

This artist was influenced by the contemporary French military paintings of artists such as Alphonse de Neuville, Edouard Detaille, and J. L. E. Meissonier, whose works Butler had seen in the Parisian Salon of 1870. *The Roll Call* is a realistic, detailed image, a close-up view of the Crimean War from the point of view of the soldier. This subject was radically innovative. For the first time in British painting, a realistic, serious image from a past war is combined with the sensitive portrayal of individuals typical of Victorian genre paintings.[15]

Matthew Lalumia has convincingly argued that *The Roll Call* must be understood within the reformist climate of the early 1870s, specifically the "Cardwell Reforms" enacted following the election of the Gladstone ministry in 1868. In a series of bills, practices in effect in the British army for 200 years were abolished. The legislation introduced a merit system for promotions, reduced the enlistment period, and improved barracks life.[16]

The phenomenal success of *The Roll Call* (Fig. 13–4), exhibited in 1874, catapulted Butler to fame. She was nominated as an Associate of the Royal Academy in 1879, but failed to be elected to full membership by a narrow margin. Unlike many other Victorian women artists, whose paintings often addressed the female world as defined by Victorian discourses, Butler's

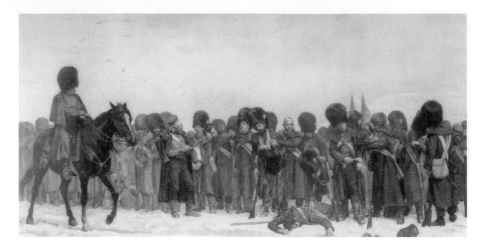

Fig. 13–4. Elizabeth Thompson Butler, *The Roll Call: Calling the Roll after an Engagement, Crimea.* *(The Royal Collection © 1995 Her Majesty Queen Elizabeth II)*

ambition and urge for professionalism eschewed traditional female subjects for themes of war. That her sympathies were not with the generals, but the foot soldiers, is not surprising given her own highly marginalized position as a professional woman artist. Her success, perhaps, can also be attributed to her rejection of "women's subjects." However, her exclusion from admission to the Royal Academy merely underscores the enormous difficulties encountered by even the most brilliant, ambitious, and talented woman artist in the face of the masculine-dominated art institutions of Victorian England.

Thompson's submission to the next Salon of 1875, *Quatre Bras,* enjoyed almost as extensive a reception. In fact, her successes encouraged a number of male artists to try to exploit the new market that Thompson's imagery had defined. Her preparation for *Quatre Bras,* recorded in her diary, emphasizes her attention to detail and desire for authenticity. The painting was hung in a dark central room, the "Black Hole" of the Royal Academy galleries. Despite this, Thompson writes: "They make a pet of me at the Academy." Usherwood suggests that the poor hanging of *Quatre Bras* was due to the fear that further concessions toward women artists, in particular Thompson's election to the Academy, might be expected. Although she lost her bid for election by only a few votes, the artist never stood for reelection. By the 1880s, the liberal, reformist climate and the women's movement itself had lost the zeal and momentum of the 1870s. Thompson's success within the Academy itself was a case of "tokenism" that failed to make any permanent changes in the bastion of patriarchal privilege that was the Royal Academy in Victorian England.[17]

After her marriage to William Butler in 1879, several factors influenced the course of her career: her change of name, her transient life as an officer's wife obliged to follow her husband to far-flung geographic locales,

and the bearing and raising of six children. These circumstances interfered with her ability to paint as a professional. The artist also adopted many of Butler's liberal political views. However justified it may seem to us today, his mistrust of the motives of imperialist colonial policies was not popular in the conservative political climate of the 1880s. Because Lady Butler selected topics consistent with her husband's unorthodox political positions, her reputation suffered.[18]

Suggestions for Further Reading
General Works
CASTERAS, SUSAN, *Images of Victorian Womanhood in English Art* (Rutherford, NJ: Associate University Presses, 1987).

CHERRY, DEBORAH, *Painting Women: Victorian Women Artists* (London: Routledge, 1993).

GERRISH NUNN, PAMELA, *Victorian Women Artists* (London: The Women's Press, 1987).

GILLETT, PAULA, *Worlds of Art: Painters in Victorian Society* (New Brunswick, NJ: Rutgers University Press, 1990).

MARSH, JAN, and PAMELA GERRISH NUNN, *Pre-Raphaelite Women Artists* (exhibition catalog for Manchester City Art Galleries) (London: Thames and Hudson, 1998).

MARSH, JAN, and PAMELA GERRISH NUNN, *Women Artists and the Pre-Raphaelite Movement* (London: Virago, 1989).

ORR, CLARISSA CAMPBELL (ed.), *Women in the Victorian Art World* (Manchester and New York: Manchester University Press, 1995).

Julia Margaret Cameron
The Cameron Collection/Julia Margaret Cameron, introduction by Colin Ford (New York: Van Nostrand Reinhold, 1975).

GERNSHEIM, HELMUT, *Julia Margaret Cameron: Her Life and Photographic Work* (Millerton, NY: Aperture, 1975).

HAMILTON, VIOLET, *Annals of My Glass House* (Seattle and London: Scripps College in association with University of Washington Press, 1996).

LUKITSH, JOANNE, *Julia Margaret Cameron: Her Work and Career* (Rochester, NY: International Museum of Photography at George Eastman House, 1986).

WEAVER, MIKE, *Whisper of the Muse: The Overstone Album and Other Photographs by Julia Margaret Cameron* (Malibu, CA: J. Paul Getty Museum, 1986).

Elizabeth Thompson Butler
LALUMIA, MATTHEW, "Lady Elizabeth Thompson Butler in the 1870s," *Women's Art Journal* (Spring/Summer 1983), pp. 9–14.

USHERWOOD, PAUL, "Elizabeth Thompson Butler: The Consequences of Marriage," *Women's Art Journal* (Spring/Summer 1988), pp. 30–34.

USHERWOOD, PAUL, and JENNY SPENCER-SMITH, *Lady Butler (1846–1933): Battle Artist* (London: National Army Museum, 1987).

14

The Late Nineteenth Century: Europe and the United States

1870 – 1900

WOMEN ARTISTS AND THE AVANT GARDE IN FRANCE

The period from 1870 to 1900 witnessed the rapid growth in absolute numbers of women who pursued serious professional careers as artists. Opportunities for women to study art in Paris expanded under the Third Republic. By 1879, there were twenty schools in Paris solely designed to train women for positions in the art industries, although such jobs were scarce and underpaid. During the 1870s there was a separate women's class at alternative schools such as the Académie Julian in Paris, where women worked with a model. In 1896 the most prestigious art academy of France, the Ecole des Beaux-Arts, officially admitted women, thus removing the most obvious institutional barrier to equality of artistic training. This feminist victory was achieved only after seven years of sustained political pressure by the Union des Femmes Peintres et Sculpteurs, the first professional organization of women artists in France, whose activities are discussed later in this chapter. By 1878, 762 women were exhibiting in the Paris Salon.[1] By 1900 thousands of women all over Europe were regularly displaying their works in official exhibitions.

IMPRESSIONISM

- Berthe Morisot, *Woman at Her Toilet*

Berthe Morisot (1841–1895) was one of the founding members of the avant-garde group known as the Impressionists. Like the other members of the group, Morisot devoted her career to the creation of images that depict, with elegance and spontaneity, intimate scenes from daily life. Often using

156

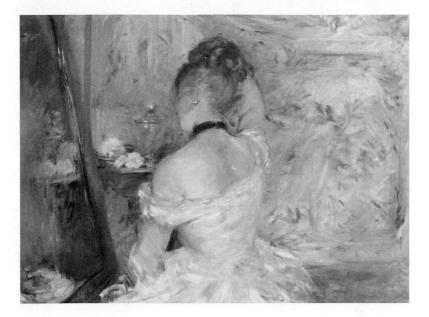

Fig. 14–1. Berthe Morisot, *Lady at Her Toilet.* c. 1875. Oil on canvas, 60.3 ×
80.4 cm. *(Photograph © 1995, The Art Institute of Chicago. All Rights Reserved. Stickney
Fund, 1924.127)*

her family as models, Morisot's paintings permit the viewer to enter a
closed domestic realm populated mainly by women and children.

Morisot's art is characterized by delicate brushwork and elegant
colors, juxtaposed in subtle harmonies. These "feminine" qualities of her
paintings were regularly noted by critics evaluating her works but are
actually stylistic elements also found in the paintings of her male Impres-
sionist colleagues. Both technically and thematically, Morisot belongs with
the Impressionists. Her exhibition strategy was the same as that of Renoir,
Monet, Degas, or Pisarro, because she also avoided the official salon and
submitted her works only to the private group shows held between 1874
and 1886.

There was little in her background to predispose her to the life of a
dedicated avant-garde artist. Morisot was born in Bourges into an upper-
middle-class family. When she was 7, the family moved to Paris. She and
her sister, Edma, were given drawing lessons at an early age. Both sisters
showed greater dedication to their art than was expected from or appro-
priate for women of their class. One of their teachers, Joseph Alexandre
Guichard, warned Mme. Morisot:

> Considering the characters of your daughters, my teaching will not endow
> them with minor drawing room accomplishments; they will become painters.

> Do you realize what this means? In the upper class milieu to which you
> belong, this will be revolutionary. I might almost say catastrophic. Are you
> sure that you will not come to curse the day when art, having gained
> admission to your home, now so respectable and peaceful, will become the
> sole arbiter of the fate of two of your children?[2]

In 1861 the Morisot sisters met Camille Corot, who became their mentor for
the next five years. Berthe Morisot's early paintings reveal Corot's influence
in the rendition of effects of early morning light and in the closely toned
color harmonies in her landscapes.

In one of her few surviving landscapes from the 1860s, *Thatched
Cottage in Normandy* (1865), Morisot had moved far beyond Corot's
technique to create what could be defined as the most sophisticated use of
paint to indicate grass and foliage of any of her Impressionist colleagues.
The work exhibits a remarkable versatility in handling paint as light and
texture that will only be achieved by Monet, for example, later in the 1870s
at Argenteuil.[3]

In 1868 Morisot met Edouard Manet and, through him, most of the
members of the Impressionist group. Morisot encouraged Manet to take up
painting outdoors. In 1874 she married his younger brother Eugène Manet.
Although Edma stopped painting after her marriage, Berthe pursued her
career throughout her lifetime, with only a brief interruption for the birth of
her daughter.

Woman at Her Toilette is one of a series of images by Morisot focused on
an anonymous female in the privacy of her boudoir. Charles Stuckey relates
this work to a painting by Manet of a similar subject.[4] This work documents
Morisot's ambition to conquer all the subjects of contemporary life explored
in the art of her male colleagues, despite the inherent difficulties of identi-
fying with the female figure as an object of aesthetic or sexual attraction, a
gendered response more appropriate to a male artist and/or viewer.

Both Pollock and Higonnet address the complexities of the woman
artist of the avant garde confronting the female nude. Pollock is interested
in the class relationship between nude model and female artist and notes
that the nudity of these women defines them as working class, probably
domestic servants.[5] Higonnet discusses the ways in which women artists
were positioned differently in the act of painting the female nude:

> If she [the woman artist] painted a female nude she would be painting a kind
> of reflection of her own body. She would therefore have to transform desire
> into being desired and enjoy pleasure by giving pleasure. For a woman who
> wanted to do the looking—and no one, arguably, needs to look more actively
> than an artist—identifying with a masculine point of view meant being two
> contradictory things at once: the one who looks and the one who is looked at.
> To paint a successful nude demanded that a woman artist paint a version of
> her own body and offer it completely to masculine viewers.[6]

In a collection of interesting essays concerning the imagery of the nude body, male and female, in this era, Tamar Garb also discusses Morisot's image in the context of contemporary depictions of women applying make-up, by male artists such as Seurat. Garb interprets this motif as an allegory of the act of painting "in which the woman artist seems to embrace woman's role by depicting a suitably feminine subject at the same time as subverting it by refusing its terms of reference."[7] Those "terms of reference" are the objectifying possessive act of the male gaze/nude as object of the gaze, which dominated so much of this imagery. Despite the bold stare of Manet's *Olympia,* most images of female nudes remained objects for scopophilia, erotic desire for male viewers. When women artists painted the nude, they were differently positioned than their male colleagues.

Neither Cassatt nor Morisot attempted the male nude. This was a theme outside their world. To their generation "the nude" meant "the female nude." Women artists would have lacked any technical training to study male anatomy with live male models, as well as the logistics to paint them. As the Stephens image shows (Fig. 14–5), even in Eakins's class at the Pennsylvania Academy of Fine Arts, the most "advanced" art school, women were only permitted to study the female nude.

Stylistically, this canvas is very sophisticated. It is filled with a flood of active brush strokes of high-valued, closely related tones revealing Morisot's superb, mature technique. Local color and specific object textures are subordinated to the energy of visible paint. Whether articulating the two-dimensional surfaces of mirror and wall or the three-dimensional figure, Morisot's paint dominates in a manner similar to the gestural force of the Abstract Expressionists of the post–World War II era.

As a full-fledged member of the Impressionist group, Berthe Morisot occupies a secure position in the history of art. United by common interests with the Impressionists, Morisot developed a personal style of originality, fluidity, and delicacy. Along with her male colleagues and Cassatt, Morisot and the others in the Impressionist group valued the private women's world of home and family and created pleasantly delightful images of beauty and elegance.

• Mary Cassatt, *Woman and Child Driving*

Like Berthe Morisot, Mary Cassatt (1844–1926) was an active and loyal member of the Impressionist group. Born in Pittsburgh into an upper-middle-class family similar in status to Morisot's, Cassatt also possessed the personal strength and force of her convictions to pursue a career as an avant-garde painter, eschewing official recognition and juried competitions. Stimulated by the exciting environment of Paris, Cassatt became, in the

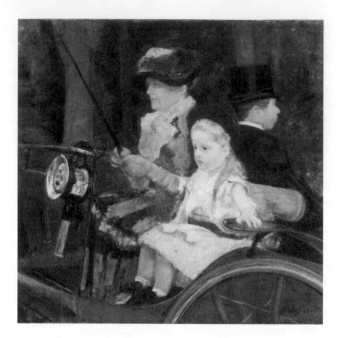

Fig. 14–2. Mary Cassatt, *Woman and Child Driving,* 1881.
(Courtesy of Philadelphia Museum of Art #8779 W21.1.)

view of many scholars, the best American artist, male or female, of her generation.

Cassatt overrode her family's initial resistance to her early decision to become an artist. In 1861 she entered the Pennsylvania Academy of Fine Arts, one of the first art academies in the world to open its doors to women. After four years of study there, she recognized the limitations that America imposed on artists. Like the women of the "White Marmorean Flock" and many male artists of her generation, she traveled to Europe in the late 1860s to study the old masters. After 1872 she settled permanently in Paris and pursued her artistic training. Her sister Lydia and her parents joined her in 1877. Although she became most famous for her paintings of mothers and children, Cassatt never married. She continued to paint until the age of 70 when her eyesight began to fail. Her achievement was recognized, relatively late in her life, by the award of the medal of the French Legion of Honor in 1904.

Cassatt possessed a brilliant instinct for determining what the history of art has deemed most important in the confusingly active world of late nineteenth-century Paris. She told her biographer that by the late 1870s, when Degas invited her to participate in the Impressionist exhibitions, "I

had already recognized who were my true masters. I admired Manet, Courbet and Degas. I hated conventional art. I began to live."[8] Cassatt learned from these artists without losing her individuality and personal style.

By the late 1870s and 1880s, Cassatt's works reflect the influence of Impressionism. *Woman and Child Driving*, painted in 1881, depicts the artist's sister Lydia and Odile Fevre, Degas' niece, competently moving through the public spaces of the Parisian parks. The young male "chauffeur" is displaced to the rear of the carriage, a passive passenger. This image is highly exceptional in the art created by Americans in this era. Bailey van Hook's excellent analysis of the ideal imagery employed extensively by contemporary male artists underscores the differences between Cassatt's responsible and capable driver and the paintings of idealized, and frequently nude, young women that dominated the canvases of American male artists. As van Hook notes: "Many of Mary Cassatt's paintings were the antithesis of all the tendencies that I have outlined. . . . Women are not decorative, they are given more importance than the objects that surround them; they are granted a three-dimensional space in which to act and then dominate that space. . . . They have a presence and authority not found in other contemporary paintings."[9]

Griselda Pollock has mapped out the physical spaces of masculinity and femininity in late-nineteenth-century Paris to elucidate the relationship between the territory of modernism and the dominant position of male painter and spectator in that formulation. Both this image of a woman driving in public and the theme of women at the opera fascinated Cassatt precisely because these motifs occur where the private spaces of femininity, such as balconies and interiors, intersect with public spaces. Cassatt was sensitive both as an upper-middle-class woman and as an artist to the boundaries of these spaces and the places where they can be bridged. Pollock defines this issue as "problematic of women out in public being vulnerable to a compromising gaze." The act of being looked at was a factor of risk for the middle-class woman in this epoch.[10] This image exists, therefore, on a "frontier of the spaces of femininity," the place of demarcation between the public/private dichotomy so crucial to women of the bourgeoisie living in urban environments such as Paris in the nineteenth century.

Mary Cassatt possessed both superb technical skills and great talent. Her dedication and devotion to the highest standards for her art helped her overcome the "handicap" of being a woman. As an American in Paris, at a time when Paris was the center of the art world, she absorbed the best innovations in her contemporary world of painting. Cassatt developed an independent style based on precise draftsmanship, refined color sensibility, and a gift for creative compositions.

Fig. 14–3. Marie Bashkirtseff, *The Meeting.* *(Musée d'Orsay, © photo R.M.N.)*

• Marie Bashkirtseff, *The Meeting*

Born into a family of minor Russian nobility, Marie Bashkirtseff spent much of her youth in France, first in Nice, then Paris. This émigré status was, no doubt, due to her parents' separation when she was 11. Precociously bright, she had taught herself Greek and Latin by the age of 13. A career as a singer was contemplated, but the idea was abandoned with the onset of tuberculosis, the disease that would eventually kill her at the age of 26. In 1877 she decided to become an artist, entering the Académie Julian. At that time, the segregated class at Julian's provided the most complete training in the visual arts available to women, though inferior to the training available to men at the Ecole des Beaux-Arts. Between 1877 and her death in 1884, Bashkirtseff created several hundred paintings, drawings, and pastels. She exhibited paintings at the Salons of 1880, 1881, and 1883. In 1884 she received a medal for her most famous painting, *The Meeting* (Fig. 14–3). Bashkirtseff aligned herself with the Naturalist school led by Jules

Bastien-Lepage. The similarities in theme and technique between *The Meeting* and Bastien-Lepage's work were obvious even to Bashkirtseff's contemporaries.[11] However, the painting does demonstrate her ability to organize a large-scale, multifigured composition of a psychologically engaged group, realistically delineated. Like that of Bastien-Lepage, her style treads a middle ground between a more detailed, linear, conservative academic style and the looser, more visible painterly surfaces of Impressionists like Morisot and Monet.

As early as the summer of 1882, Bashkirtseff expressed interest in using subjects derived from the working-class street life in urban Paris. In the lives of these young boys, Bashkirtseff perceived "a liveliness and freedom from the artifices which she as a woman of the upper class experienced as restrictions on her life."[12] Her impatience and frustrations about her lack of autonomy and independence are clearly expressed in her journal entry, dated January 2, 1879:

> What I long for is the freedom of going about alone, of coming and going, of sitting on the seats in the Tuileries, and especially in the Luxembourg, of stopping and looking at the artistic shops, of entering the churches and museums, of walking about the old streets at night; that's what I long for; and that's the freedom without which one can't become a real artist. Do you imagine I can get much good from what I see, chaperoned as I am, and when, in order to go to the Louvre, I must wait for my carriage, my lady companion, or my family?
>
> Curse it all, it is this that makes me gnash my teeth to think I am a woman![13]

The Meeting was purchased by the French government and reproduced in engravings and lithographs. Two paintings by the artist were shown posthumously at the Salon of 1885. That year the Union des Femmes Peintres et Sculpteurs, the major organization of professional female artists in France, mounted an extensive retrospective of her works, which included over 200 paintings, drawings, and pastels, and five pieces of sculpture.

Bashkirtseff's fame resides largely in the posthumous publication of her journal. Her eighty-four handwritten notebooks were edited by her mother and first published in France in 1887. Her ambition and self-absorption represented an entirely new phenomenon to appear in print in her epoch. The diary was widely read and created a sensation. Upon its translation and publication in English, in 1890, one reviewer, Marion Hepworth Dixon, wrote: "It is this Journal with which the world is now ringing, and which it is hardly too much to say is likely to carry the fame of Marie Bashkirtseff over the face of the civilized globe."[14]

EXPANDING OPPORTUNITIES FOR ART EDUCATION: PARIS, GLASGOW, PHILADELPHIA

The Union des Femmes Peintres et Sculpteurs (UFPS) and the Admission of Women to the Ecole des Beaux-Arts

In 1881, led by a powerful sculptor, Mme. Leon Bertaux, a group of French women came together to form the first professional organization of women artists in France. They called themselves the Union des Femmes Peintres et Sculpteurs (UFPS). From 41 founding members the organization grew to 450 members by 1896. This group led the campaign to admit women into France's most prestigious art school, the Ecole des Beaux-Arts in Paris. Tamar Garb has detailed the sustained political pressure needed to achieve this victory in her book, *Sisters of the Brush.*[15]

The UFPS annual salons were large exhibitions, which document the existence of a sizable population of women artists and the discriminatory conditions that existed regarding the exhibition of their works. In the 1896 UFPS salon, 295 women showed nearly 1,000 works. As Garb notes, quality was not the main criterion for including works in these exhibitions, since they existed as well to bring the awareness of women's art to public attention. Critics judged works by their "capacity to express an essential femininity, to encapsulate Woman."[16] Issues of quality were subsumed under other concerns of the "woman question." This contemporary discourse affected the critics' responses more than political affiliations. Portraits were the most plentiful genre of painting at the UFPS salons, followed by flower studies, landscapes, still lives, genre scenes, and animal scenes. Paintings tended to be fairly small scale, and history paintings were largely absent. Furthermore, most of the two-dimensional works were drawings, watercolors, and pastels. The predominance of these media was "used repeatedly as concrete evidence of women's propensity and skill in certain types of art and as tangible demonstration of their unsuitability for others."[17]

The art education available to women was a prime concern of the UFPS. After seven years of sustained political lobbying, this organization, now led by Virginie Demont-Breton, achieved an important victory, the admission of women in 1896 to France's most prestigious art academy, the Ecole des Beaux-Arts. The UFPS did uphold the gender ideology, which defined women's "nature" as that of wife and mother. The leadership of the UFPS perceived the creation of art as compatible with women's family responsibilities. Feminists, from a broad range of political positions, could champion the rights of women artists.

Mme. Bertaux was inspired by an idealistic mission to use the art of women for the redemption of a decadent France. According to Garb, "The

flowering of an *art féminin* was . . . a Utopian vision which entailed the valourising of women's talent and the flowering of a feminine culture long stifled by men's selfish monopolisation of resources and arrogant self-aggrandisement."[18]

"Glasgow Girls": The Glasgow Institute of the Fine Arts

• Poster for the Glasgow Institute of the Fine Arts, c. 1896

The key role of facilities for training women artists is most apparent in the case of the Scottish city of Glasgow and The Glasgow Institute of the Fine Arts. Although it was founded around 1840, the school, became an important resource for training young women in the field of design in the mid-1880s when "Fra" Newberry, the headmaster of the school actively recruited women. "Under his tutelage, there was consistent growth in the number of women students who were free to enroll in most classes and worked side by side with men in all the studios, except the life class."[19] The "Glasgow style," which achieved international prominence at the Eighth Vienna Secession Exhibition of 1900, was initially developed from

Fig. 14–4. Poster for the Glasgow Institute of the Fine Arts, c. 1896. *(Courtesy of the Library of Congress.)*

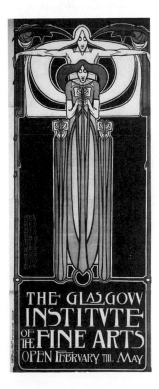

the interactions of "The Four," Charles Rennie Mackintosh, the sisters Margaret and Frances Macdonald, and Herbert MacNair.[20] Margaret (1864–1933) and Frances (1873–1921) were students at the Glasgow School of Art between 1890 and 1894. Newberry introduced them to Mackintosh and MacNair and they exhibited as "The Four," in November 1894. Their elegant, attenuated "Spook School" is visible in the poster for the school, created by the two sisters and MacNair.

The originality of the style would decisively influence Klimt and the artists of the Vienna Secession. Hoffmann, the organizer of the exhibition, had seen their work reproduced in the magazine *The Studio* and had invited them to exhibit. The importance of creative pairings is clearly seen in the marriages of Margaret to Mackintosh and Frances to MacNair.[21]

However, the number of important and original women artists active in this period in Glasgow was impressive. Newberry's wife, Jessie, as head of the embroidery department at the school, was another influential figure for the evolution of the Glasgow style. The exhibition catalog, edited by Jude Burkhauser, documents the presence of significant numbers of women as both fine artists, especially painters, and as designers in Glasgow from the 1880s to the 1920s. It is significant that the core of this great outpouring of creativity in all media can be traced, in large part, to the decisive impact of Newberry and the opportunities for art training provided by the Glasgow Institute of the Fine Arts.

The Education of Women Artists in Philadelphia

• Alice Barber Stephens, *The Women's Life Class*

This painting depicts the advanced class taught by Thomas Eakins at the Pennsylvania Academy of the Fine Arts. It was created to illustrate an article titled "The Art School of Philadelphia" scheduled to appear in the September 1879 issue of *Scribner's Monthly*. Its monochromatic palette surely was determined by the intended publication of the work as a black-and-white illustration in the popular press. Seated prominently in the left foreground is Susan Macdowell, a portrait painter who would marry Eakins in 1884. Alice Barber (1858–1932) went on to become "one of the most successful illustrators, male or female, of the late nineteenth century."[22]

It is no accident that the nude model is a woman. The male nude was outside the limits of even the supportive and liberated environment of Eakins's life class. Previously, women had studied the anatomy of a cow. The male nude was firmly excluded from the art production of women artists.

In 1873 Stephens enrolled in the Philadelphia School of Design for Women, founded by Sarah Worthington Peter in 1848 to train women for

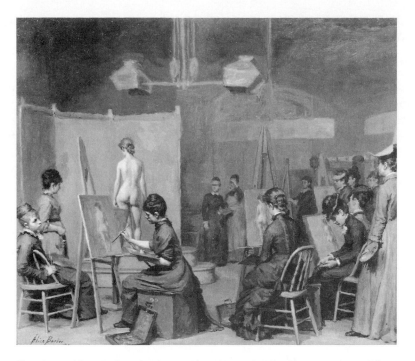

Fig. 14–5. Alice Barber Stephens, *The Women's Life Class.* c. 1879. Oil on cardboard, 12 × 14 in. *(Courtesy of the Philadelphia Academy of the Fine Arts, Philadelphia. Gift of the artist. 1879.2)*

acceptable forms of employment consistent with the "Cult of True Womanhood." Stephens transferred to the Pennsylvania Academy in 1876. Upon graduation, she supported herself through illustrations that appeared in many popular periodicals of the era such as *Harpers'*, *Colliers*, and *The Ladies Home Journal.* She illustrated books as well, including Louisa May Alcott's *Little Women.* She was a professor at the School of Design from 1883 to 1893 and continued to create illustrations until 1926.

The Pennsylvania Academy of Fine Arts was the first art school to permit women to draw from plaster casts, in 1844. By 1860, women were enrolled in the anatomy class and a separate life-drawing class was established in 1868. That this was still a curiosity over a decade later can be inferred by the interest of *Scribner's* in documenting the women's class.

The educational options for artistic training in the United States available to women remained limited and discriminatory throughout the nineteenth century. For the ambitious woman seeking professional artistic training, Paris was a magnet, since the courses of study back home were fewer and less extensive than those open to men.[23]

DOMESTIC IDEOLOGY: THE "CULT OF TRUE WOMANHOOD" AND AMERICAN PIECED QUILTS

• Harriet Powers, Pictorial Quilt, 1895–1898

Scholars have documented the central importance of quilt making and other forms of needlework in many aspects of the lives of women throughout the nineteenth century. Girls were taught to sew by age 5, and sewing occupied a central role in girls' education. Needlework created and used within the sphere of the home was "one area in which women were encouraged to give their imaginations free reign. . . ." [24] The ideology of the "Cult of True Womanhood" sustained a cultural context in which quilt making could flourish.[25] Sewing reinforced the dominant ideology of the "Cult," which defined white women's role as exclusively domestic and maternal. However, African-American women, both as slaves in the ante-bellum era and as freed women, such as Harriet Powers also embraced quilt making as a creative art form.

Quilts served many different purposes in the lives of women in this era. In practical terms, they covered beds and kept the sleeper warm.

Fig. 14–6. Harriet Powers, Pictorial Quilt, 1895–1898. *(Courtesy Boston Museum of Fine Arts, Bequest of Maxim Karolik.)*

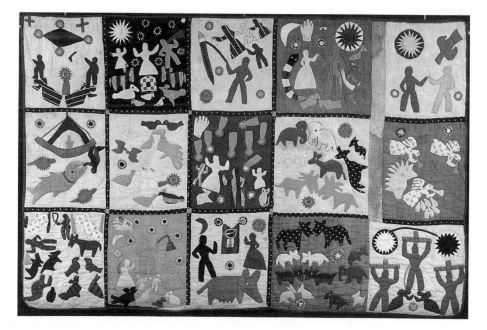

However, quilts were also a conspicuous demonstration of the skills of their creators. Pride, care, and effort were lavished on them. Long after the invention of the sewing machine, quilts were sewn by hand. Women made quilts as part of their dowry, and mothers made a quilt for each child. The creation of quilts was intertwined with the cycle of women's lives. Furthermore, quilts marked off major events in the lives of a family. Crib quilts were made for new babies, engagement and bridal quilts were created, as were widow's or mourner's quilts. Quilts traveled west with the pioneer migrations, protecting children and furniture and lining wagons for insulation. Sadly they were used as shrouds in which to bury the dead along the trail. Quilting parties in the newly opened frontier territories were essential opportunities for socializing for women living in great isolation. All in all, quilts played an important part in women's lives.

Women also used quilts for public and political purposes. "Women used their quilts to register their responses to and also their participation in the major social, economic, and political developments of their times."[26] The Women's Christian Temperance Union used quilts as fund-raising vehicles, for example.

The women artists selected for discussion in this book overcame a variety of cultural and institutional obstacles to acquire the skills necessary for a career in the "fine arts," that is, painting and sculpture. The vast majority of women did not have that opportunity. But like photographers, women have found outlets for their visual creativity in ways that did not require specialized training. Sewing was one skill that all women have learned since antiquity. In the nineteenth and early twentieth centuries, many American women designed and fabricated quilts pieced from scraps of cloth. Many of these quilts are remarkably beautiful and original creations, worthy of consideration as works of art. These mostly anonymous women created visual images in cloth that demonstrate a high level of sophistication, anticipating some of the developments in twentieth-century abstract painting.

Most quilts were made with geometric shapes because straight edges were the easiest to sew together. From scraps of fabric left over from clothing, square units of uniform size were stitched together. These individual squares were then arranged to form the overall design of the quilt. Some quilts used identical blocks creating a repeating pattern, while others, such as the example illustrated here, used differing blocks. The cutting of each piece to be fitted into the patchwork quilt had to be extremely accurate so the blocks would fit together precisely. Once the top layer of the quilt was stitched together, it was joined to a solid backing, and a filler of cotton or wool was sandwiched between. The three layers were joined by the quilting technique itself. This final quilting was often accomplished at a social gathering known as a "quilting bee." Quilting bees were a valid pretext for a party, breaking the often oppressive isolation of rural life.

This Bible quilt is created using the technique of appliqué. Its creator, Harriet Powers, was born into slavery in 1837 and died in 1911. In 1870, she was living in Georgia with her husband and three children. In the 1880s the family bought four acres of land, but by 1891 the family's fortunes began to decline and they were forced to sell the land in 1895. A white woman, Jennie Smith, saw one of Powers's quilts at a craft exhibit and eventually purchased it for five dollars. This quilt, now in the Smithsonian Institution, was sent to the Atlanta Exposition of 1895. The faculty ladies of Atlanta University were so impressed by the quilt that they commissioned a second narrative quilt to be made for the Reverend Charles Cuthbert Hall, president of the Union Theological Seminary in 1898. This quilt (Fig. 14–6) was sold to the art collector Maxim Karolik, who donated it to the Museum of Fine Arts in Boston in 1964.

One leading scholar of African-American folk art, Gladys-Marie Fry, connects this appliqué technique to tapestries made by the Fon people of West Africa. She relates this image to tapestries from the African region of Dahomey in "terms of design, construction technique, and the retention of stories associated with pictorial representations."[27] Frieda Tesfagiorgis regards this work as "canonical" for a black feminist aesthetic, since the technique "link(s) African-American quilting traditions to African textile traditions."[28] The imagery of this quilt may have been inspired by the sermons Powers heard in church. Other panels depict specific, unusual astronomical events such as a meteor storm or "Black Friday" of May 19, 1780, which survived as oral history.

Tesfagiorgis compares Powers with Edmonia Lewis, discussed in Chapter 12. She sees both figures as essential for an understanding of Black American women's art.

> "The form and meaning in the works of Powers and Lewis reveal that the artists intervened in their contexts with their own particular Black feminist or womanist voice and drew upon shared cultural and social attitudes not unrelated to their shared racial identities. Their chosen media is related to the opportunities available to each. . . . 'low' craft and 'high' fine art traditions in the history of African-American art interpenetrate each other and are both essential to the critical art history of Black women's art."[29]

From the perspective of the twentieth century, we are prepared to appreciate these quilts as works of art. Harriet Powers, like so many other quilt makers, black and white, did not possess the specialized training available to the painters discussed in this book. She used a readily available and economic technique, that is, and sewing, as the means to create a beautiful, narrative image that expresses an individual visual sensibility.

The outstanding achievements of America's quilt makers warns against maintaining any strict *a priori* value distinctions between the fine arts, that is, painting, sculpture, and architecture, and the "crafts," that is,

all other art forms. Craft objects were often made by women without access or ambition to develop the skills needed for the execution of paintings or sculpture. As we will see in Chapter 18, the art versus craft controversy has been reopened since 1970 with a modern, feminist-inspired appreciation of craft objects such as quilts. Contemporary artists have realized the expressive potential of china plate painting and needlework, for example, in Judy Chicago's monumental *Dinner Party* (Fig. 18–6), while the "pattern paintings" of Miriam Schapiro have led to a renewed appreciation for the decorative possibilities of fabric (Fig. 18–5).

THE PHILADELPHIA CENTENNIAL EXPOSITION (1876) AND THE DECORATIVE ARTS MOVEMENT

Led by a formidable organizer, Elizabeth Duane Gillespie, great-granddaughter of Benjamin Franklin, funds were raised to construct a Women's Pavilion for the Philadelphia Centennial Exposition. Six hundred exhibits organized by state and foreign women's committees were displayed in over an acre of enclosed space. Displays ranged from embroidery and other needlework, to paintings and other forms of "art," to a steam engine that powered six looms and a printing press. Some women artists were unwilling to exhibit their works in this unjuried and diverse display. Others, like Emily Sartain, showed works in both the official art exhibition and at the Women's Pavilion. Radical suffragist feminists like Elizabeth Cady Stanton objected to the absence of works by women in factories, while the building's organizers pointedly refused to participate in the most important feminist protest of the centennial, the reading of the Declaration of the Rights of Women on July 4.[30]

Sparked by interest in the decorative arts exhibits at the Philadelphia Centennial Exposition, Candace Wheeler spearheaded the decorative arts movement, "the first major artistic crusade created, managed, and promoted under female control."[31] The New York Society of Decorative Arts was founded in 1877. Wheeler attracted society leaders as well as artists and collectors to the organization. Its purpose was at least twofold. Wheeler sought to broaden women's career opportunities through the decorative arts. Therefore, one primary goal was to market the products of middle-class women so they could earn a viable living through their handicrafts. Another goal was to enlarge women's cultural authority. The establishment of several chapters witnessed the success of this venture across the country. Lending libraries helped upgrade the level of women's taste as decorators of the home environment. The Decorative Arts Movement employed a separatist strategy. Wheeler accepted women's general exclusion from the realm of the "fine" arts and concentrated women's efforts on the areas deemed more appropriate to women, the "minor" arts.

As laudable as these achievements were, there was a negative impact on women artists: ". . . the ambitions that inspired the decision to become

an artist often challenged the domestic ideologies that legitimized women's public, philanthropic roles. Women artists did not want charity, they wanted public recognition and acceptance on a par with men . . . ideas that often ran counter to the separatist dictum that women should cleave to their own distinctive cultural sphere."[32]

McCarthy notes that by the 1890s women began to play a more prominent role as collectors and connoisseurs.[33] Louisine Havemeyer, guided by her artist friend Mary Cassatt, is one obvious example, and Isabella Stewart Gardner, advised by Bernard Berenson, built an impressive collection, which she eventually turned into a museum bearing her name in Boston. But men largely ran urban museums, like orchestras and research universities. Women did not participate on the boards or make large financial contributions to the new museums. Only a handful of women secured jobs as curators, often in the field of the "decorative arts."

THE WOMAN'S BUILDING, WORLD'S COLUMBIAN EXPOSITION, CHICAGO, 1893

Seventeen years after the Philadelphia Centennial the World's Columbian Exposition in Chicago included an impressive "Woman's Building." Led by Bertha Palmer, wife of one of Chicago's wealthiest financiers, the Board of Lady Managers selected as the building's theme "The Progress of Women." When completed, vast arrays of displays from around the world, including a library of 7,000 volumes written by women, were housed in the structure. Unlike the Philadelphia Women's Pavilion of 1876, examples of work from the women's industrial labor force were shown and women's contributions to the fine arts also were highlighted. One hundred thirty-eight prints by women printmakers were exhibited. This was "probably the first woman's art survey of its type."[34] Designed by a woman architect, Sophia Hayden, the building was decorated with murals by Mary Cassatt and other noted women painters.

The Board of Lady Managers supervised construction of a women's dormitory that provided shelter for over 12,000 women during the four months of the fair. A children's building provided child care for fair visitors. Women speakers from around the world were invited to participate in the "congresses," which addressed a vast array of topics. The work of the Board of Lady Managers in Chicago in 1893 served to highlight the full range of women's achievements in a manner unprecedented in the history of world's fairs.[35]

Suggestions for Further Reading

Women Impressionists and Images of Women
GARB, TAMAR, *Bodies of Modernity: Figure and Flesh in Fin-de-Siècle France* (London: Thames and Hudson, 1998).

GARB, TAMAR, *Women Impressionists* (New York: Rizzoli, 1986).

POLLOCK, GRISELDA, "Modernity and the Spaces of Femininity" in *Vision and Difference: Femininity, Feminism and the Histories of Art* (London and New York: Routledge, 1988).

VAN HOOK, BAILEY, *Angels of Art: Women and Art in American Society: 1876–1914* (University Park: Pennsylvania State University Press, 1996).

Berthe Morisot

ADLER, KATHLEEN, and TAMAR GARB, *Berthe Morisot* (Ithaca, NY: Cornell University Press, 1987).

EDELSON, T. J. (ed.), *Perspectives on Morisot* (New York: Hudson Hills Press, 1990).

HIGONNET, ANNE, *Berthe Morisot* (New York: Harper and Row, 1990).

HIGONNET, ANNE, *Berthe Morisot's Images of Women* (Cambridge, MA: Harvard University Press, 1992).

ROUART, DENIS (ed.), *The Correspondence of Berthe Morisot* (London: Lund Humphries, 1957; republished 1986).

STUCKEY, CHARLES F., and WILLIAM P. SCOTT, *Berthe Morisot: Impressionist* (New York: Hudson Hills Press, Mount Holyoke College Art Museum in Association with the National Gallery of Art, 1987).

Mary Cassatt

BARTER, JUDITH A., *et al.*, *Mary Cassatt, Modern Woman* (New York, Art Institute of Chicago, in association with H. N. Abrams, 1998). Published to accompany a traveling exhibition.

BREESKIN, ADYLYN, *Mary Cassatt: A Catalogue Raisonné of the Oils, Pastels, Watercolors and Drawings* (Washington, DC: Smithsonian Institution Press, 1970).

HALE, NANCY, *Mary Cassatt* (Garden City, NY: Doubleday, 1975).

MATHEWS, NANCY MOWLL, *Cassatt and Her Circle: Selected Letters* (New York: Abbeville Press, 1984).

MATHEWS, NANCY MOWLL, *Cassatt, a Retrospective* (New York, H. Levin Associates, 1996).

MATHEWS, NANCY MOWLL, *Mary Cassatt* (New York: Abrams, in association with the National Museum of American Art, Smithsonian Institution, 1987).

MATHEWS, NANCY MOWLL, *Mary Cassatt: The Color Prints* (New York: Abrams, 1989).

POLLOCK, GRISELDA, *Mary Cassatt: Painter of Modern Women* (London: Thames and Hudson, 1998).

Marie Bashkirtseff

The Journal of Marie Bashkirtseff, trans. by Mathil de Blind, introduction by Roszika Parker and Griselda Pollock (London: Virago Press, 1985).

UFPS
GARB, TAMAR, *Sisters of the Brush: Women's Artistic Culture in Late Nineteenth-Century Paris* (New Haven, CT: Yale University Press, 1994).

"Glasgow Girls"
BURKHAUSER, JUDE (ed.), *Glasgow Girls: Women in Art and Design (1880–1920)*, revised ed. (Edinburgh: Canongate Press, 1993).

HELLAND, JANICE, *The Studios of Frances and Margaret Macdonald* (Manchester, UK: Manchester University Press, 1996).

Quilts
BENBERRY, CUESTA, *Always There: The African American Presence in American Quilts* (Louisville, KY: Kentucky Quilt Project, 1992).

ESKY, PATSY, and MYRON, *Quilts in America*, 2nd ed. (New York, Abbeville Press, 1992).

FERRERO, ELAINE HEDGES, and JULIE SILBER, *Hearts and Hands: The Influence of Women and Quilts on American Society* (San Francisco: Quilt Digest Press, 1987).

FREEMAN, ROLAND, *A Communion of the Spirits: African-American Quilters, Preservers and Their Stories* (Nashville, TN: Rutledge Hill Press, 1996).

FRY, GLADYS-MARIE, *Stitched from the Soul: Slave Quilts from the Ante-bellum South* (New York: Dutton, 1990).

HOLSTEIN, JONATHAN, *Abstract Design in American Quilts* (Published for an exhibition at the Whitney Museum of American Art, New York, 1971).

HOLSTEIN, JONATHAN, *The Pieced Quilt: An American Design Tradition* (Greenwich, CT: New York Graphic Society, 1973).

PERRY, REGINA, *Harriet Powers's Bible Quilts* (New York, Rizzoli International, 1994).

WAHLMAN, MAUDE, *Signs and Symbols: African Images in African-American Quilts* (New York, Studio Books, 1993).

The Women's Buildings, 1876 and 1893
CORN, WANDA M., "Women Building History" in Eleanor Tufts (ed.), *American Women Artists: 1830–1930* (Washington, DC: The National Museum of Women in the Arts, 1987).

WEIMANN, JEANNE MADELINE, *The Fair Women: The Story of the Women's Building, World's Columbian Exposition, Chicago, 1893* (Chicago: Academy Chicago, 1981).

15

The Early
Twentieth Century:
1900 – 1920

INTRODUCTION TO THE TWENTIETH CENTURY: WHOSE MODERNISM?

In the twentieth century (addressed in this and the following chapters), the major institutional obstacles to training were removed. Therefore, women became practicing artists in significant numbers. However, just as this was beginning to occur, a theoretical/art historical construction, known as "Modernism," developed to marginalize, and frequently erase completely, works of art created by women artists. A number of influential studies, published during the 1990s, have addressed the position of women in relationship to "Modernism." This is a key concern when evaluating the activities of twentieth-century women artists.

For recent art history, Alfred Barr in 1936 began to construct a lineage or heritage of Modernism prioritizing Picasso and Cubism and other movements practiced by male artists. In this genealogy, priority is given to abstraction and formalist experimentation. Women artists were frequently not as attracted to such types of art, since it displaced the subjective responses of the artist in favor of an impersonal, neutral formal language. Furthermore, men dominated avant-garde artists' groups of the early twentieth century. Women were permitted to exhibit most often as "wives" or "girlfriends." The ideology of Modernism prioritizes male activities and relegates women to the fringes as "followers" of male leaders. Male artists are the "heroes" propelling art forward. Women artists are of little significance to the "major" movements: Their presence is limited and trivialized. Katy Deepwell has defined the issue in the following manner:

> As twentieth-century museums and art history textbooks have defined and revised our ideas of modernism, the work of women artists has rarely

occupied more than 10–20 percent of illustrations in modern art books or of works in exhibitions of modern movements and in installations of permanent collections. This level of presentation . . . reinforces the ideas that women artists who worked in or around the modernist movements of the twentieth century were at best marginal or occasional presences in the art world, and therefore only of marginal interest in relation to defining avant-garde practice or its politics."[1]

Deepwell and others have cited Raymond Williams's model of culture in which a single "dominant" thread comes to stand for the entire field of art. Using Foucault's ideas, supported by an influential essay by Donna Haraway, we can characterize "Modernism" as a form of "situated knowledge" not an inevitably "true" or "correct" view of the "history of twentieth-century art."[2] In this constructed history, women artists only rarely make appearances. However, "Woman" is consistently present in representations. The nude female body dominates the canvases of the twentieth-century avant garde, a passive material on which the male artist exerts active control.

In an influential study, Bridget Elliott and Jo-Ann Wallace asked the question "Whose Modernism?," which is the subtitle of this discussion. These scholars wanted to explore the work of women creators in greater depth and detailed analysis than had been done previously, as well as open up a reexamination of the critical reception of artists such as Romaine Brooks and Marie Laurencin. They attempted to "de-naturalize" the history of twentieth-century art. "In calling 'modernism' a discursive or a cultural field and in placing the term within inverted commas, we want to suggest that there is no innate or unproblematic modernism whose history can simply be uncovered."[3]

Therefore, in addressing the issues of greatest relevance for women artists of the twentieth century, we must rethink the rather narrow string of avant-garde movements led by the handful of male "heroes" or "geniuses" that form the core of this "discourse." Women artists who created works of great originality and quality are present in significant numbers in every country and period under investigation.

The remainder of this text, addressing the twentieth century, has been subdivided into four chronological segments, with a separate chapter devoted to each period:

Chapter 15: 1900–1920
Chapter 16: 1920–1945
Chapter 17: 1945–1970
Chapter 18: 1970–present

Within the limits of this book a selection of artists has been included that reflects the diversity of the contributions of women, as well as the

interests of feminist scholars in this field. Because this text is only an intro-duction to this discourse of feminist art histories, generally the issues selected for discussion reflect the existing published scholarship in the field. For the most part, works of art included in these chapters have been the focus of detailed interpretation and analysis by scholars. In making these selections, many valuable and fascinating issues were necessarily, but unfortunately, omitted. The reader is encouraged to pursue her or his interests beyond the relatively narrow scope of the artists and movements that could be included here.

This chapter focuses on the first two decades of the twentieth century, which encompass the extremely rich pre–World War I era and the war years in which Russian Constructivism developed. Art historians, such as Gill Perry, have begun to excavate a more complete picture of the variety of works by French women active in Paris during this era whose names remain unfamiliar to most of us. Emilie Charmy (1878–1947) is one such artist whose works and critical appraisals are reconstructed in her important study, *Women Artists and the Parisian Avant-Garde.*"[4] During this period large numbers of women acquired professional skills, exhibited works of art in public venues, and pursued an active career as artists. Women created art in the most diverse range of styles imaginable, from the most conservative to the most radical. Because of the physical limitations of this text, the women artists in this chapter are restricted to three geographi-cally distinct avant-garde movements: German expressionist women active in the first decade of the twentieth century, Cubist-inspired experimental art as exemplified by the work of Sonia Delaunay, a Russian born émigré active in Paris, and the women who participated in Russian Constructivism, during and immediately after World War I.

GERMAN EXPRESSIONISTS: 1900–1910

German women who aspired to become artists acquired their training under highly discriminatory conditions. As late as the 1890s, women were still not permitted to study at the state-sponsored art academies in Germany or Austria. Women wishing to pursue a career in the visual arts could attend applied and decorative arts schools in Germany, but the official government schools for "fine arts" were closed to them. In response, the Verein der Künstlerinnen, the official women's art organization, ran independent schools in Berlin, Munich, and Karlsruhe, organized around a traditional academic curriculum.

This reflected the broader educational climate of Germany, because all German schools were sexually segregated. This situation differed from that of the women's art organizations of England and France, which sought to integrate women students into the male educational establishments, the Royal Academy in England or the Ecole des Beaux-Arts in France.

The Berlin school was opened sometime before 1885, when Käthe Kollwitz was enrolled. According to Diane Radycki, this school cost six times the tuition of the Prussian Academy and offered a shorter, less rigorous course of study.[5]

If the goal was to prepare women artists for the Prussian Academy of Fine Arts, the difficulties of achieving full status were virtually insurmountable. The Prussian Academy conveyed only honorary—not regular—membership to women artists, the same category of membership available to males who were not artists but helped promote the arts in some manner. It was only in 1919, after the collapse of the Wilhelmine government, that Kollwitz became the first woman member of the Prussian Academy. She held the directorship of the Graphic Arts Department from 1928 until her resignation under Nazi pressure in 1933.

Paula Modersohn-Becker, Käthe Kollwitz, and Gabriele Munter may all be characterized as Expressionists (as defined by Shulamith Behr) despite their highly diverse styles and themes. Behr rightly points out that any number of male Expressionist artists did not paint in a uniform group style.[6] The three women developed highly original and unique avant-garde personal styles independently.

- Paula Modersohn-Becker, *Kneeling Mother and Child*

Before her premature death at the age of 31, Paula Modersohn-Becker developed an innovative personal style based on a synthesis of French Post-Impressionism and native German art forms. Her mature paintings, which include some recognized masterpieces, reveal a talented and original artist whose works bear comparison with the best paintings of her European contemporaries in the Post-Impressionist era.

Paula Becker (1876–1907) was born in Dresden, Germany, into a cultured, upper-middle-class family. She first became interested in becoming an artist when, at age 16, she was given art lessons as part of her finishing school education. Visiting wealthy relatives in London, she attended St. John's Wood School of Art, which prepared students for admission to the Royal Academy.

As Radycki notes, when Becker studied at the St. John's Wood School in London, a private drawing school but one with the best reputation of preparing students for the Royal Academy, she was in a serious, coeducational environment aimed at conferring professional status and expertise.[7] This situation contrasted markedly with the Berlin school of the Verein der Künstlerinnen. In fact, it was only when Becker left school and began living and working in the artist's colony of Worpswede under Fritz Mackensen's supervision that her talents and personal style first emerged. And it was not until she arrived in Paris after 1900 and studied the works of Cézanne, Gauguin, and Van Gogh that her mature individual painting style developed. Becker studied at the Académie Julian and Académie Colarossi

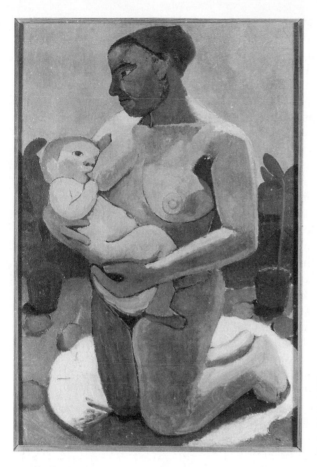

Fig. 15–1 Paula Modersohn-Becker, *Kneeling Mother and Child.* Oil on canvas, 113 × 74 cm. *(Staatliche Museen zu Berlin—Preussischer Kulturbesitz Nationalgalerie)*

and even took advantage of the anatomy course recently opened to women at the Ecole des Beaux-Arts.

By the time Becker arrived at the Berlin school of the Verein der Künstlerinnen in 1896, there were separate departments for drawing, painting, and graphics. Four of the six male teachers were affiliated with the Prussian Academy. A few women also taught there. Käthe Kollwitz joined the faculty and taught figure drawing and graphics from 1897 to 1902.

After two years of this traditional instruction, Becker moved to the artists' colony located in Worpswede, a small village in northern Germany. The Worpswede artists, such as Fritz Mackensen and Otto Modersohn, used the local peasants and the bleak landscape as subjects and painted with a dark earth-toned, naturalistic palette. Becker studied with Mackensen and at first adopted the realistic style of this painter.

On New Year's Eve, 1900, Becker left Worpswede for Paris. This was her first visit to the world's art capital. During the next seven years, Becker

spent long periods in Paris, where she acquired more art training and absorbed the latest developments in French avant-garde painting. Becker joined many other women artists who were studying art in Paris at the turn of the century. She worked at the Académie Colarossi where, for a small fee, an aspiring artist could paint or draw from a live model and receive some criticism from established masters. Becker also benefited from the recent opening of classes to women at the Ecole des Beaux-Arts.

Returning to Worpswede, Becker married the recently widowed Otto Modersohn in 1901. Even after marriage, Modersohn-Becker continued to make independent journeys to Paris. In 1903, 1905, and during a prolonged stay from February 1906 to April 1907, she abandoned the style of Worpswede naturalism for an avant-garde method that attained a greatly simplified monumentality.

In this painting Modersohn-Becker has created an image that is outside any historical framework, an impersonal archetype of fertility. As opposed to Cassatt's mothers and children, which are always portraits, or Kollwitz's mothers, who are forces for political change, Becker emphasizes the biology of creation. It is important to appreciate the different messages these images communicate. Women artists often approach the specifically female experience of maternity, as well as every other subject, in distinctive ways. Factors such as nationality, political views, and family background influence the outlook and philosophy of an artist at least as much as—and perhaps more than—the artist's sex. Becker's *Kneeling Mother and Child* is related more closely to Gauguin's paintings of Tahitians than to the works of Cassatt or Kollwitz.

As early as 1898 Modersohn-Becker was attracted to the theme of the nursing mother. She wrote in her journal:

> I sketched a young mother with her child at her breast, sitting in a smoky hut. If only I could someday paint what I felt then! A sweet woman, an image of charity. She was nursing her big, year-old bambino, when with defiant eyes her four-year-old daughter snatched for her breast until she was given it. And the woman gave her life and her youth and her power to the child in utter simplicity, unaware that she was a heroine.[8]

Rosemary Betterton has analyzed the maternal imagery of both Modersohn-Becker and Kollwitz in some depth. She is interested in the appearance of the highly unusual motif of the nude human mother, as seen in this painting. Both Betterton and Behr believe that Modersohn-Becker was familiar with maternalist discourses circulating in Germany in this period. In particular, the artist may have been inspired to paint such an image by the writings of Swedish writer Ellen Key, whose book *Lines of Life* (1903) "considered the positive and cultural implications of motherhood within the general advance of women's rights."[9] Betterton notes that "Key's

views helped to define the terms of debates about motherhood in the 1900s and were taken up by many German feminists."[10]

Of further interest to us, especially in light of the recurring fascination with the body in contemporary arts, discussed in Chapters 17 and 18, is Betterton's essay, which helps us to appreciate the range of meanings attached to the representation of the female nude for women artists of the era. As Betterton notes: "Study of the nude was of crucial interest to women artists in the early modernist period because it was the point of intersection for contemporary discourses on gender and art. Mastery of the female nude was central to the construction of artistic identity in the nineteenth century and the site of a specifically gendered relationship between the male artist and the female model."[11]

Otto Modersohn followed his wife to Paris in 1906. She became pregnant and returned with him to Worpswede in 1907. It is possible that Becker was already pregnant when she painted *Kneeling Mother and Child*. She died three weeks after giving birth to a daughter, tragically ending a career that had just reached maturity. Nevertheless, she had lived long enough to create a group of paintings of great artistic power and originality. As the first German artist to forge an original style that incorporated the innovations of French painting from the 1890s, her importance within the European Post-Impressionist avant garde is firmly established.

- Käthe Kollwitz, *Outbreak*

Käthe Kollwitz (1867–1945) shares a common nationality and generation with Paula Modersohn-Becker. While both women shared many of the same concerns, especially surrounding the depiction of the "maternal nude," their styles are quite distinct.

Unlike Modersohn-Becker who worked in paint and was attracted to the French avant garde of Gauguin and Cézanne, Kollwitz eschewed such influences. From the beginning of her career, Kollwitz chose to concentrate on drawings and prints in black and white. Her self-imposed restriction to the graphic media stems from both personal inclination and political conviction. While still an art student, Kollwitz was fascinated by the demands of the printmaking process. She did not feel the need for color to express her powerful political messages. A print is less expensive than a painting because a number of original copies can be made from one source. Therefore, Kollwitz's graphics could be bought if not by the destitute workers, whom she depicted so sympathetically, then at least by the middle-class people who shared her political beliefs.

Käthe Schmidt was born into an unusual family in the small Baltic seaport of Königsberg (now Kaliningrad). Her father was an ardent believer in socialism and an activist in the Social Democratic Worker's Party. Käthe absorbed these political beliefs, and throughout her lifetime her works

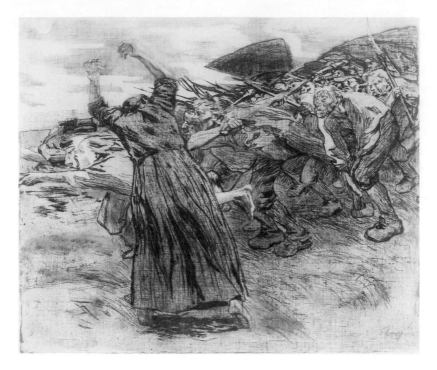

Fig. 15–2 Käthe Kollwitz, *Outbreak.* 1903. Mixed technique, 20 × 23¼ in. *(Courtesy of the Library of Congress)*

express her sympathies for the oppressed poor and her strongly anticapitalist convictions. Her family encouraged her artistic talents and gave her drawing lessons with a local artist. In 1885 she studied art in Berlin at the school for women established by the Verein der Kunstlerinnen. After a few years at home, in 1889 she entered the Verein's school in Munich where the cultural environment was more stimulating.

In 1884 she became engaged to Karl Kollwitz, who shared her family's political convictions. Fearful that marriage might interfere with her ambition to become an artist, she postponed the wedding until 1891, when Karl had completed his medical studies and was a practicing doctor in a working-class neighborhood in Berlin. During the 1890s she bore two sons and worked on her first major graphic series, *The Revolt of the Weavers,* completed in 1897. The work was inspired by a play that told the true story of the 1844 armed rebellion of a group of destitute linen weavers in the German province of Silesia. This subject contains many recurrent themes that Kollwitz was to illustrate throughout the rest of her life: the misery of the impoverished working classes, the omnipresence of death, and a sympathy with armed revolt to improve inhumane conditions. *The Revolt of*

the Weavers was greeted with great critical praise when it was displayed in 1898. The six prints that constitute this work established Kollwitz as one of Germany's leading graphic artists. Although she was nominated for a gold medal, the Kaiser denied her the award because of the radically leftist political content of the series.

Kollwitz's next major print cycle, *The Peasant War* (1902–1808), was inspired by an uprising of German peasants in the sixteenth century. Kollwitz believed that women could be a force for political change, and she was attracted to this particular event because the leader of the revolt was a woman, known as Black Anna. *Outbreak* (Fig. 15–2) depicts Black Anna inciting the men, who are armed with primitive weapons. In this extraordinarily powerful image, a peasant army races across the scene with a seemingly invincible force. Here Kollwitz retained enough descriptive details to characterize the individual features of the peasants, and there is an element of naturalism in the figure of Black Anna. The tension of the scene is intensified by presenting Black Anna with her back to the viewer. Kollwitz used her own body as a model for her great back. In this manner, emotion and energy are expressed through posture and gesture rather than mere facial expression. Technically, Kollwitz employed a mixture of etching techniques, aquatint, and soft ground to achieve the range of textures, shadings, and details of the finished work.

Kollwitz's humanitarianism is so self-evident in the themes of her work that it is also important to remember that she resisted specific political affiliations. As Elizabeth Prelinger notes, her pre–World War I work did not generally carry revolutionary or even specifically political overtones. While her compassion was sincere and universal, she remained indecisive in her political beliefs.[12] Like Modersohn-Becker, Kollwitz also employs the nude mother, most often paired with a theme of "maternal loss" or the death of a child. As Betterton notes: "For both artists, the 'maternal nude' was one means by which they could address issues of their own sexual and creative identity at a time when the roles of artist and mother were viewed as irreconcilable."[13]

Kollwitz's later works continue to explore the themes that had fascinated her in her youth. Many images focus on the horrors of sudden death, the pains and joys of motherhood, and the injustice of the economic exploitation and political oppression of one class by another. The experience of World War I was a great trauma for Kollwitz. In 1914 her son Peter was killed in Belgium. Kollwitz channeled her grief and fury into many prints in which she made statements against the futility of war and the destruction of young sons.

Kollwitz's compassion extended not only to the oppressed but also to her fellow women artists who were not as famous as herself. She was elected president of the Frauenkunstverband (Women's Art Union) in 1914. The main goal of this group was "securing the right of women to teach and

study in all public art schools."[14] In 1926 she helped found GEDOK (Society for Women Artists and Friends of Art), a feminist organization "dedicated to showing, sponsoring, and contributing to the work of women artists."[15]

Avoiding the abstraction and stylistic innovations of many avant-garde artists, Kollwitz maintained a somewhat naturalistic style throughout her career, although her works became more simplified and forms more generalized in the 1920s and 1930s. Her talents were widely recognized during her lifetime. In 1919 she became the first woman to be elected to the Prussian Academy of the Fine Arts. In 1928 she became director of graphic arts at this school. It was not until the Nazis assumed power in Germany that, like so many other artists, she experienced discrimination and was forced to resign from the academy in 1933.

Kollwitz continued working into her seventies. She witnessed the annihilation of yet another generation of German youth in World War II. Her grandson, Peter, named after the son who had perished in World War I, also died in battle. The works she left to posterity are loaded with the fullest possible range of human emotions. Her images express her convictions as a woman, a mother, and a political being. They are frequently painful and always emotionally stirring.

• Gabriele Münter, *Boating*

Gabriele Münter (1877–1962), like Kollwitz and Modersohn-Becker, studied at the school of the Verein der Kunstlerinnen. Dissatisfied with the level of instruction there, she enrolled in Wassily Kandinsky's class at the "alternative" Phalanx School in 1902. As Anne Mochon notes, Kandinsky "was the first teacher to offer her consistent and careful instruction which recognized and respected the intuitive nature of her ability."[16] From 1903 to 1914 Münter and Kandinsky lived, traveled, and worked together. In 1908 they settled in Murnau, a small village in the Bavarian Alps. *Boating* was painted during the summer of 1910 on the lake at Murnau, the Staffelsee.

In Murnau they were close friends with the Russian artist-couple Alexei Jawlensky and Marianne von Werefkin. Jawlensky had been in Matisse's studio in 1907 and was familiar with the Symbolist theories of Paul Sérusier. All four artists exhibited at the first show of the New Artists' Association in 1909.

Boating is one of three versions of the theme executed that summer. It is the largest one, and it may be the work exhibited at the Munich New Artists' Association show of 1910 and at the Salon des Independents of 1912 in Paris.

The painting is a record of the importance of Münter's relationships in this period. The little boy is Jawlensky and Werefkin's son, Andreas. The seated woman in the red hat is Werefkin, who was seventeen years older than Münter. Münter's admiration for her is documented in at least one portrait.[17]

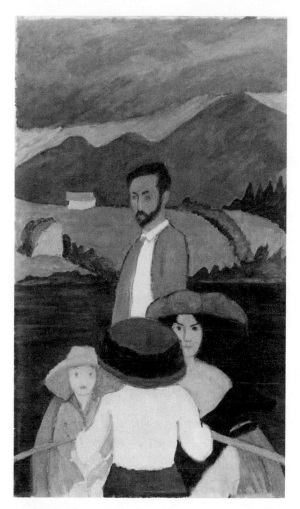

Fig. 15–3 Gabriele Münter,
Boating. 1910. Oil on canvas,
49¼ × 28⅞ in. (*Milwaukee Art
Museum, Gift of Mrs. Harry Lynde
Bradley)*

Dominating the composition at the apex of the triangle is the standing figure of Kandinsky, silhouetted against the green field and blue mountains of the background. However, one cannot ignore the fact that it is Münter herself who steers the boat. Positioned with her back to the viewer, she is looking at this scene, controlling both the viewpoint and the safety of her passengers. With the approaching storm, indicated by the dark gray sky, her role as oarsman is crucial and unique. The broad expanse of her back, painted in an unmodulated flesh tone, is centered in the composition and provides the zone of highest value attracting the viewer's eye to the lower half of the composition. This visually balances the shapes of the upper portion, that is, the figure of Kandinsky, the mountains, and the threatening gray sky.

In 1911 Münter participated in the activities surrounding the new avant-garde group, The Blue Rider. But World War I proved to be a time of great disruption for Münter. She moved to Stockholm in 1915 when Kandinsky returned to Russia. When Kandinsky married another woman in 1917, Münter's painting production tapered off dramatically. She never again found an avant-garde community in which her artistic practice could truly flourish.

WOMEN ARTISTS AND CUBISM

- Sonia Delaunay, *Electric Prisms*

A number of women artists adopted Cubist styles as early as 1912, following the public presentation of the movement in 1911. Thanks to Perry's important study we are more familiar with artists such as Emilie Charmy, Alice Halicka, Marie Vassiliev, Maria Blanchard, Suzanne Duchamp, and others who aggressively engaged in the new language of Cubism. Delaunay, then, is far from an isolated and exceptional women artist who developed a personal style based on the most radical avant-garde idiom of pre–World War I Paris.[18] She is perhaps the best known, however. Just before World War I, Sonia Delaunay, in collaboration with her husband, Robert Delaunay, created a painting system that employed brilliantly colored disks to create an effect of rhythmic movement. Her style, known as "Simultanism," is an important and influential contribution to twentieth-century avant-garde painting. Sonia Delaunay possessed a finely developed sensitivity to colors and their interrelationships.

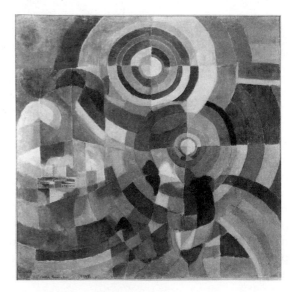

Fig. 15–4 Sonia Delaunay, *Electric Prisms.* 1914. Oil on canvas, 98½ × 98½ in. *(Musée National d'Art Moderne)*

Born in the Ukraine in 1885, at the age of 5, Sonia was adopted by her maternal uncle, Henry Terk, and raised in the wealthy, cultured environment of his home in St. Petersburg. Sonia Terk's artistic talents were encouraged, and from 1903 to 1905 she studied art in Germany. Her artistic training began in earnest when she arrived in Paris in 1905. Like Modersohn-Becker, who was also in Paris during these years, Terk absorbed the latest developments of French Post-Impressionism and Fauvism.

In 1908 she had her first one-woman exhibition in the gallery of Wilhelm Uhde, but she did not exhibit her works in public again until 1953. In 1909 she married Uhde, but she divorced him in 1910 to marry the painter Robert Delaunay (1885–1941). Each of their talents complemented the other's, and their lives became a team effort that enhanced their individual gifts. Both Sonia and Robert Delaunay acknowledged the influence the other exerted on his or her art, especially between 1910 and 1914 when they both were formulating their definitive styles.

A major turning point in Sonia Delaunay's development was triggered by the creation of a quilt for her infant son in 1911. Unlike the American quilt makers discussed in Chapter 14, Delaunay was prepared to appreciate the possibilities of this abstract language for painting. The results of this breakthrough were soon visible in her work.

Electric Prisms (Fig. 15–4) is one of her most important pre–World War I paintings. This large canvas (almost 8 feet square) was inspired by the electric lamps that had recently replaced gas lights on the Parisian boulevards. Using concentric circles divided into quadrants, the alternating and repeating colors create an optical effect of pulsating, brilliant light. These colored sections are arranged in a complex pattern of disks and are divided by straight lines and waving arched sections.

The exploration and depiction of "colored rhythms" or "rhythms of color" (both frequent titles of her works) was to be Delaunay's lifelong obsession. Her paintings, gouaches, and other two-dimensional works show a ceaseless inventiveness in the arrangement of colors to express movement and syncopation. Musical analogies seem unavoidable in the description of her pictorial language because she uses colored units like notes in a musical scale. Delaunay employs only the most basic elements of painting to construct her works. She defined her aesthetic system in the following way:

> The pure colors becoming planes and opposing each other by simultaneous contrasts create, for the first time, new constructed forms, not through chiaroscuro but through the depth of color itself.[19]

The term "simultaneous contrasts" refers to Chevreul's law, which states that when two complementary colors, such as red and green, are juxtaposed, their contrast is intensified. Delaunay once explained her devotion

to abstraction by stating: "Beauty refuses to submit to the constraint of meaning or description."[20]

Delaunay lost her personal income during the Russian Revolution, so after World War I she turned increasingly to commercial, income-producing activities. She became a successful and highly innovative fashion designer. In 1925, at the famous and influential International Exhibition of Decorative Arts, she displayed her fashions and fabrics at a "Boutique simultanée." Vivid colors and geometric patterns characterize her textile designs, which were shown as loose-fitting full skirts and tunics. Such styles, which liberated the wearer from the confines of the wasp-waisted, corseted, pre-war silhouette, were very popular in the new culture of the 1920s. The Depression of 1929 put her out of business. Sonia Delaunay's activity in the decorative arts industry demonstrated her unorthodox, independent attitude toward the conventional hierarchies of fine versus applied art and male versus female realms.[21] She did not perceive her activities outside of easel painting as inherently less important or intellectually demanding.

The fact that Sonia Delaunay did not exhibit her paintings between 1908 and 1953 has affected the public's knowledge of her artistic achievement. However, since the 1950s her works are more widely known. Major retrospective exhibitions of her works were held in Paris in 1967 and in the United States in 1980. Sonia Delaunay has escaped the fate of many a woman artist married to another artist. Both Sonia and Robert Delaunay have received full recognition, individually and as a team, for their contributions to the history of art.

RUSSIAN CONSTRUCTIVISM

In Russia, as in other countries of Europe, aristocratic women were often enthusiastic amateur painters. In 1842 the St. Petersburg Drawing School was opened to women. Later on there was a group of successful, if conservative, women artists active in the 1870s and 1880s, among whom Marie Bashkirtseff was perhaps the most famous. Such precedents established a base that at least partially explains the number of women artists in the pre- and post-Revolutionary Russian avant garde.[22]

As opposed to the Berlin Dada circle in which Höch only grudgingly gained admittance via her relationship with Hausmann, the situation in Russia presents a concentration of women creators. After the revolution, a group of artists emerged who were politically engaged and eager to redefine and expand the role of the artist in the creation of "The Great Utopia" (the title of a major show at the Guggenheim Museum in 1993).

As one historian of the movement, Christine Lodder, notes, "the term Constructivism arose in Russia during the winter of 1920–21 as a term specifically formulated to meet the needs of these new attitudes toward the

culture of the future classless society."[23] The identification with the new political and social order was at the core of the Constructivist enterprise, as was the call for the artist to go into the factory to move beyond art object and easel painting to transform life. This radical political agenda was formulated with women, as Nochlin notes, "participating in the art process as equals or near-equals as never before or since, in such numbers and with such impact"[24] In the landmark exhibition "5X5=25," three of the five artists participating, Popova, Stepanova, and Exter, were women.

Furthermore, according to Lodder, it was Popova and Stepanova who, with their male colleague, Tatlin, were the only members of this group who actually implemented the move into the factories and put their theoretical concepts of the artist-constructor into practical effect. Only the two women "entered mass production and formulated a constructivist approach and methodology to work in the area that correlated two design processes," textile design and clothing design.[25]

• Lyubov Popova, *Architectonic Painting*

Lodder identifies Lyubov Popova (1889–1924) as "the most important" artist working prior to 1920 in two dimensions. The artist traveled to Paris in 1912 to study Cubism, and in the next years she painted in an abstract Cubo-Futurist style. In 1916 Popova worked with Kasimir Malevich on the publication of the Suprematist journal *Supremus.* This encouraged her break from a Cubo-Futurist monochromatic palette and tonal modeling. Her theoretical writing clarifies her approach to the creation of a work to be involved with the invention of a whole new pictorial language that concentrated on unmodulated color and the intersection of planes.

A typical example of the Constructivist style is *Architectonic Painting* (Fig. 15–5). This work consists of intersecting multicolored planes without any reference to objects in nature. Despite a certain amount of overlapping, it is impossible to say that these forms exist in a three-dimensional space. The traditional technique of modeling is employed nontraditionally because one cannot perceive these planes as rounded objects. Colors are also selected arbitrarily. This work is constructed with the most basic elements of painting, manipulated in a totally new way, overturning the Western tradition of painting since the Renaissance.

Popova, Stepanova, and other women artists who painted in a Constructivist style became active in "production art," which included theater sets and costumes, as well as industrial, graphic, and textile designs. As early as 1918, despite the political upheavals in Russia, the Visual Arts Section of the People's Commissariat for Enlightenment opened a special Subsection for Art-Industry, organized and directed by Olga Rosanova (1886–1918). The purpose of this group was to restructure the industrial

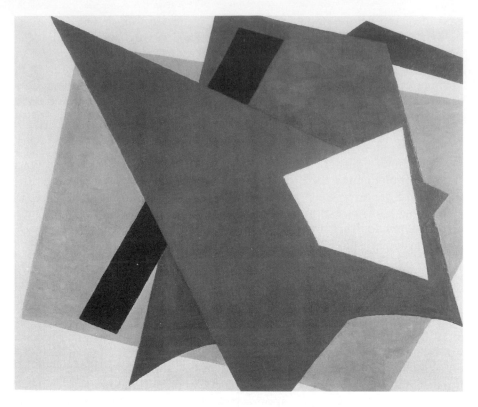

Fig. 15–5 Lyubov Sergeievna Popova, *Architectonic Painting.* 1917. Oil on canvas, 31½ × 38⅝ in. *(The Museum of Modern Art, New York. Philip Johnson Fund. Photograph © 1995 The Museum of Modern Art, New York)*

design of the country. Rosanova encouraged many existing schools to join this organization.[26] She also devised a plan to reorganize the museums of industrial art in Moscow, which was eventually implemented. Many of her ideas were incorporated into the manifestos of Constructivism in the 1920s.

• Varvara Stepanova, *Designs for Sports Clothing*

Varvara Stepanova (1894–1958) was a key member of the Constructivist group. Since 1916 she had been living in Moscow with Alexander Rodchenko, another member of this avant-garde circle. As with Modersohn-Becker, Delaunay, Münter, Höch, and others, romantic liaisons with male members of avant-garde groups did not overwhelm the unique creativity of these women, but provided a liberating base in which that creativity could flourish.

In collaboration with Popova, Stepanova identified the area of textile and clothing design as essential for the Constructivist utopian vision. In an

article titled "Present Day Dress—Production Clothing," Stepanova formulated the concept that clothing had to be designed in a way that was consistent with its intended use. The freedom of movement and energy of these designs for sports clothing is a clear example of this philosophy. Stepanova wrote:

> Fashion which psychologically reflects a way of life, customs and esthetic taste, give[s] way to clothing organized for work in different fields as defined by social movements, clothing which can prove itself only in the process of working in it, not presenting itself as having an independent value outside real life, as a special type of "work of art."[27]

These designs for sports clothing, *sportodezhda*, are characterized by a minimum of clothing, ease of putting on and wearing, and the special significance of color effects to distinguish individual sports and sports groups.[28] Between 1924 and 1925, Stepanova designed more than 150 fabrics at the First Textile Printing Factory.

Fig. 15–6 Varvara Stepanova, *Sportodezhda* (Designs for Sports Clothing). *(Photo courtesy of Christina Lodder)*

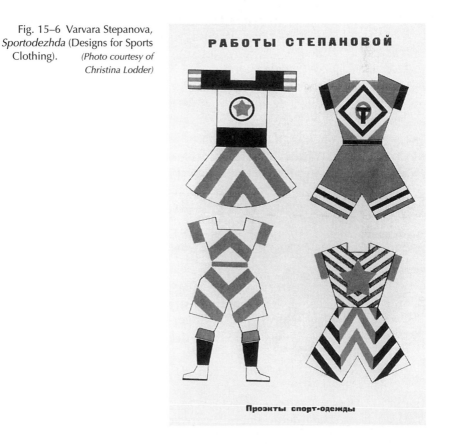

РАБОТЫ СТЕПАНОВОЙ

Проэкты спорт-одежды

Popova also designed highly innovative fabrics and clothing and worked on the overalls for the actors in Meierkhold's production of *The Magnanimous Cuckold* of 1922. The overalls were actually prototypes for workers' clothing, and designed to allow complete freedom of movement. Like those of Stepanova, Popova's clothing designs were simple, uncomplicated, and revolutionary. Both Stepanova and Popova "saw the replacement of traditional Russian plant and flower patterns by geometrically based designs as an essential aspect of the design process of cloth production."[29] Each design was composed of one or two geometric shapes with black, white, and a maximum of two other colors.

Both Stepanova and Popova actively pursued the revolutionary program of liberating avant-garde design from the aesthetic sphere of the art object to directly impact the lives of the working classes.

Suggestions for Further Reading

Modernism and Women Artists

DEEPWELL, KATY, *Women Artists and Modernism* (Manchester and New York: Manchester University Press, 1998).

ELLIOTT, BRIDGET, and JO-ANN WALLACE, *Women Artists and Writers: Modernist (Im)positionings* (London and New York: Routledge, 1994).

PERRY, GILL, *Women Artists and the Parisian Avant-Garde: Modernism and 'Feminine' Art, 1900 to the Late 1920s* (Manchester and New York: Manchester University Press, 1995).

German Expressionist Women

BEHR, SHULAMITH, *Women Expressionists* (New York: Rizzoli, 1988).

BETTERTON, ROSEMARY, "Mother Figures: The Maternal Nude in the Work of Käthe Kollwitz and Paula Modersohn-Becker," in Griselda Pollock (ed.), *Generations and Geographies in the Visual Arts: Feminist Reading* (London and New York: Routledge, 1996). The essay also appears in Rosemary Betterton, *An Intimate Distance: Women, Artists and the Body* (London and New York: Routledge, 1996).

Paula Modersohn-Becker

BUSCH, GUNTER, and LISELOTTE VON REINKEN (eds.), *Paula Modersohn-Becker: The Letters and Journals,* trans. by Arthur S. Wensinger and Carole Clew Hoey (New York: Taplinger Publishing, 1983).

Paula Modersohn-Becker: zum hundertsten Geburtsdag (Bremen Kunsthalle, 1976). (German)

PERRY, GILLIAN, *Paula Modersohn-Becker: Her Life and Work* (London: The Woman's Press, 1979).

RADYCKI, J. DIANE (trans. and ed.), *The Letters and Journals of Paula Modersohn-Becker* (Metuchen, NJ: Scarecrow Press, 1980).

Käthe Kollwitz

HINZ, RENATE (ed.), *Käthe Kollwitz, Graphics, Posters, Drawings*, trans. by Rita and Robert Kimber (New York: Pantheon Books, 1981).

KEARNS, MARTHA, *Käthe Kollwitz: Woman and Artist* (Old Westbury, NY: Feminist Press, 1976).

KOLLWITZ, HANS (ed.), *The Diary and Letters of Kaethe Kollwitz*, trans. by Richard and Clara Winston (Evanston, IL: Northwestern University Press, 1988).

PRELINGER, ELIZABETH, *et al.*, *Käthe Kollwitz* (Washington, DC: National Gallery of Art, 1992).

ZIGROSSER, CARL, *Prints and Drawings of Käthe Kollwitz* (New York: Dover Press, 1951; reprinted 1969).

Sonia Delaunay

BARON, STANLEY, *Sonia Delaunay: The Life of an Artist* (New York: Abrams, 1995).

BUCKBERROUGH, SHERRY A., *Sonia Delaunay: A Retrospective* (Buffalo, NY: Albright-Knox Gallery, 1980).

COHEN, ARTHUR A., *Sonia Delaunay* (New York: Abrams, 1975).

DAMASE, JACQUE, *Sonia Delaunay: Fashion and Fabrics* (New York: Abrams, 1991).

Russian Constructivism

GRAY, CAMILLA, *The Russian Experiment in Art: 1863–1922* (New York: Abrams, 1972).

IABLONSKAIA, MIUDA, *Women Artists of Russia's New Age, 1900–1935* (New York: Rizzoli, 1990).

LODDER, CHRISTINA, *Russian Constructivism* (New Haven, CT: Yale University Press, 1983).

WOOD, PAUL E., *et al.*, *The Great Utopia: The Russian and Soviet Avant Garde: 1915–1932* (New York: Guggenheim Museum, 1992).

Lyubov Popova

DABROWSKI, MAGDALELNA, *Liubov Popova* (New York: Museum of Modern Art, 1991).

SARABIANOV, DMITRI V., and NATALIA L. ADASKINA, *Popova*, trans. by Marian Schwartz (New York: Abrams, 1990).

Varvara Stepanova

LAVRENTIEV, ALEXANDER, in John E. Bowlt (ed.), *Varvara Stepanova: The Complete Work* (Cambridge, MA: The MIT Press, 1988).

16

Europe and the United States: 1920 – 1945

Despite the political upheavals and trauma of this historical period, we find that women artists continue to explore a wide range of styles, themes, and media. Although continually marginalized by modernist discourses, women artists created remarkable works of art in every European country as well as in the United States. As we will see, New York and Paris, in the 1920s, provided a nurturing environment for women artists who were exploring issues of gendered identity and creativity. Also, this is the era in which many women photographers were active, especially in the field of documentary photography.

WOMEN ARTISTS IN WEIMAR GERMANY, THE 1920S

Marsha Meskimmon and other scholars have enlarged our understanding of the contribution of women creators to their visual culture during the Weimar era, in Germany. These scholars have explored a number of issues that broaden our knowledge of the cultural matrix related to politics and gender in this era. These feminist scholars have investigated the roles of women as dealers, as sculptors, as wives of artists, the "Kunstlerehepaar," as well as the role of images of women in mass media and film. Taken collectively these studies form a much more complete and varied picture of the ways in which women artists negotiated their positions.[1]

Like Perry, Meskimmon does not isolate individual artists in a mono-graphic manner but organizes her study, "We Weren't Modern Enough," into categories or "tropes," which were in wide circulation during the era, such as "the Prostitute," "the Mother," and the "Neue Frau" or "New Woman." The ways in which specific women creators imaged these tropes

194

reveals the different positioning of women relative to male avant-garde practice.[2] Nowhere is this different position more evident than within avant-garde movements such as Dada and the Bauhaus, during this era, in Germany

Women in Dada

A recently published collection of essays has added to our knowledge of the ways in which women both as creative artists and as image impacted this diverse movement. As Naomi Sawelson-Gorse notes in the introduction to this volume: "For all their avant-gardism in shedding aesthetic precepts and bourgeois tenets, male Dadaists maintained the status quo of the patriarchal, socio-cultural judgements and codifications regarding gender of the late nineteenth-century bourgeois society in which they were born, and, in most instances, of Catholic upbringings."[3] These attitudes were obstacles for women artists who engaged directly with Dadaist practices as creators. Despite this, a number of talented women did engage in an artistic practice, informed by the principles of Dada. Today, there are a range of strategies in which scholars have explored this diverse art movement, not only in terms of intensive investigations of works by women artists, but also in iconographical analyses of images of women from a feminist perspective. Such studies lead to new insights into the movement, and help us to better understand the attitudes toward gender that underlay the radical ruptures of the Dadaists, for which they are remembered in histories of twentieth-century art.

• Berlin Dada: Hannah Höch, *Cut with the Kitchen Knife*

This extraordinary photomontage was exhibited quite prominently at the First International Dada-Messe (Dada Fair) of 1920, held in Berlin. It was shown with works by other members of the Dada group such as George Grosz, John Heartfield, and Raoul Hausmann, with whom Höch had been living since 1915. Höch occupied a marginal position in the group as the only woman and was connected to the others mainly via her relationship with Hausmann. However, she did participate in all the major Berlin Dada exhibitions.

Höch was born in 1889 into a bourgeois family with no artistic inclinations. Her high school education was interrupted when she was 15, and at age 22, she left home to pursue an artist's education. Between 1912 and 1916 she studied at several applied arts schools in Berlin. From 1916 to 1926 Höch worked for Ullstein Verlag as a pattern designer in the handicrafts department, which produced instructions for knitting, crocheting, and embroidery. Her relationship with Hausmann was quite volatile since he was married and had a daughter. The definitive break with him occurred in 1922.

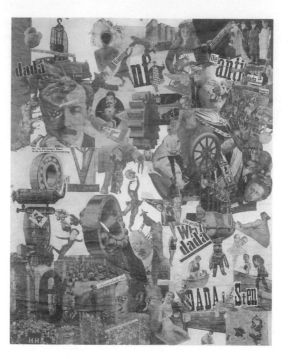

Fig. 16–1 Hannah Höch,
Cut with the Kitchen Knife.
1919. Collage,
114 × 90 cm.
(Staatliche Museen zu Berlin—
Preussischer Kulturbesitz
Nationalgalerie)

Maud Lavin has provided a fascinating reading of this large-scale, highly complex, and satirical image which "functions as a Dadaist manifesto on the politics of Weimar society."[4] The upper-right quadrant, labeled "anti-dadaistische Bewegung" or "anti-Dada movement," is dominated by the image of Kaiser Wilhelm II, recently deposed as ruler of Germany. Four army officers are in the extreme upper-right corner. Just below them is an image of people waiting on line at an employment office. In the lower-right quadrant, labeled "Die grosse Welt dada/Dadaisaten" (The Great Dada World/Dadaists), the small figure of Hausmann in a diver's suit looks out at the viewer. From his head is a mass of machinery symbolizing the world of technology. At the extreme lower-right corner is a map of Europe in which the countries where women could vote are indicated in lighter tones.

A photo of Albert Einstein, from whose head springs the word "DADA," dominates the upper-left quadrant. Five large wheels are also included, another reference to technology. The modernism of the entire image is made explicit by the use of photos from a specific newspaper, the *Berliner Illustrierte Zeitung,* the newspaper of widest circulation in Weimar Germany and published by Ullstein Verlag, the company where Höch worked during this time.

In these images, men disseminate Dada through words. However, there are a number of images of women, who, as Lavin argues, "occupy the

principal revolutionary roles."[5] Female dancers and athletes move with physical freedom and liberation across the surface of the work. The body of a dancer is placed at the pivotal center of the composition. Just above the dancer's body floats the head of Käthe Kollwitz, who had just been appointed as the first woman professor of the Berlin Art Academy. Although Kollwitz's art was quite different from the Dadaists, Lavin notes that Höch and Kollwitz shared anti-Weimar political positions. Lavin concludes that the presence of Kollwitz is "an inter-generational attribute, a sign of both admiration and difference."[6]

This work may be interpreted as a celebration of modernity and the "New Woman," a stereotype promoted by the mass print media that defined a new social role for women. In sum, this image is optimistic and utopian, projecting a new freedom and empowerment for both women and artists of the era in the wake of the overthrow of the Kaiser's government.

Women of the Bauhaus

- Gunta Stölzl, *5 Choirs*

Sigrid Weltge has supplied a much more complete understanding of the experiences and contributions of women to the avant-garde art school known as the Bauhaus. The pioneering spirit of the male leaders of this enterprise, such as Walter Gropius, did not prevent the implementation of the most conservative gender ideology for women who enrolled at this school. Stölzl, like almost all the women who presented themselves to the Bauhaus as students, had previous art training. They were all "passionately interested in painting What attracted them to the Bauhaus in the first place was the lure of the painters,"[7] especially Klee and Kandinsky. What they encountered was the exclusion of women from all workshops by 1922, with the exception of the Weaving Workshop. As Weltge reports, "Instead of being fully integrated into the Bauhaus, they were segregated and given their own workshop—The Weaving Workshop—regardless of talent or inclination."[8]

Weltge identifies three categories of students in the Weaving Workshop: those who left without committing to a professional career, those who pursued artistic careers outside of the textile world, and those who embraced weaving as a career. Of this latter group, Gunta Stölzl and Anni Albers are the best known.

Products of the Weaving Workshop received very positive critical attention when shown to the public in two Bauhaus exhibitions. In 1925, a report of a delegation of the Dessau Trade Union noted that "The Weaving Workshop seems to be better than others. Its products clearly demand recognition, which cannot be said of the Carpentry Workshop."[9]

Gunta Stölzl was "the dominant presence in the Weaving Workshop."[10] She had been one of the first students to enroll in 1919, arriving at the Bauhaus with several years of training at the School of Applied Arts in

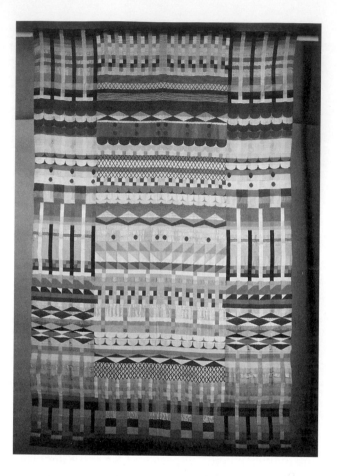

Fig. 16–2 Gunta Stölzl,
5 Choirs. *(Photograph
by Herbert Jäger)*

Munich. By 1920 she was already playing a leading role in the Weaving Workshop. She had a natural affinity for materials and helped organize the workshop so works could be shown in the first official Bauhaus Exhibition in 1923. Textile designs incorporated the most sophisticated design principles and vocabulary articulated by the avant-garde painting masters, Kandinsky, Klee, van Doesburg, and Itten.

By 1928, when Stölzl created this hanging, she was able to incorporate Paul Klee's compositional ideas into "the most sophisticated Jacquard weaving produced at the Bauhaus . . . this work . . . shows her supreme mastery of this demanding medium. Her complex color scheme use of abstract pattern and shape shows the complexity and beauty of which her finest works are capable."[11]

Despite Stölzl's brilliance, the number of students in the Weaving Workshop steadily decreased during the 1920s. Weltge believes this to be due in part to the growing emphasis on industrial textile design and the

inability of some women to perceive themselves as integrated into a world of industry. However, by 1930, Stölzl, Albers, and the other women of the Bauhaus Weaving Workshop accepted the responsibilities of designing textiles for practical industrial production, aimed at all classes of society. Like the Russian Constructivists, they participated in the utopian avant-garde attitudes of the post–World War I period. The startling creativity and originality of the Weaving Workshop is impressive. As Weltge points out, "What has now become commonplace—geometrical designs in stacked units, light/dark juxtapositions and transposed elements in a multiplicity of variations—was explored for the first time by Bauhaus weavers in the twenties."[12]

With the closing of the school and the dispersal of the members of the Weaving Workshop, some of these women eventually exerted a direct impact on American textile design in the post–World War II era.

WOMEN OF THE LEFT BANK: PARIS BETWEEN THE WARS

Several excellent and detailed studies have been published documenting the network of women artists, publishers, and patrons that developed in Paris in the 1920s. It is hardly coincidental that both Romaine Brooks and Claude Cahun created a body of works of visual art—paintings for Brooks; photographs in the case of Cahun—which explore issues of gender identity. Both women were lesbians, living openly in Paris, who found the freedom to explore issues of masculinity and femininity that challenged existing gender discourses as well as the contemporary attitudes toward lesbianism.

- Romaine Brooks, *Una, Lady Troubridge*

Romaine Brooks (1894–1970) was born in Rome and lived a highly unusual existence in her early life, moving frequently between Europe and the United States. She attended private schools in New Jersey, Italy, and Geneva, Switzerland, prior to her study of painting at the Scuola Nazionale in Rome. In 1898 Brooks was the only female student at the Scuola. Sandra Langer tells us that "From the beginning, Romaine Brooks was in revolt against family obligations, society and, to a lesser extent, her youthful indecision."[13]

The most productive period for Brooks's art was in the post–World War I environment of Paris and in the lesbian community which flourished there, described by Shari Benstock in her study, *Women of the Left Bank*. Brooks became the lover of author Natalie Barney and a key member of the group of talented women drawn to this writer and *Salonnière*. Lesbianism was a courageous and self-conscious rejection of patriarchal gender constructions for this circle. Chadwick notes that medical models in this epoch "constructed lesbianism around notions of perversion, illness inversion and paranoia."[14]

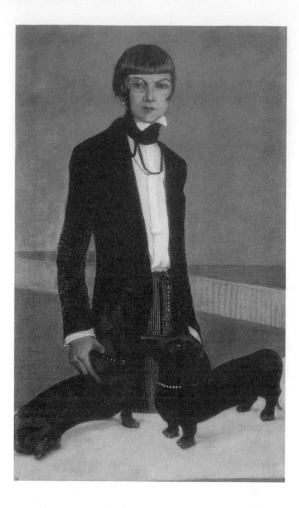

Fig. 16–3 Romaine Brooks,
Una, Lady Troubridge. 1924.
Oil on canvas, 51⅛ × 30⅛ in.
*(National Museum of American Art,
Washington DC/Art Resource, NY)*

"Brooks's choice of style was a symbol of personal emancipation from the structures of feminine roles."[15]

In 1924 Brooks painted this portrait of Una Vincenzo, who became the second wife of Admiral Sir Ernest Charles Thomas Troubridge in 1908, then left her husband in 1915 to live with the author Radclyffe Hall until the latter's death in 1943. Hall described their relationship and the life of this group of artists in a novel, *The Well of Loneliness.* The dachshunds were a gift to the sitter from Hall.[16] According to Secrest, Brooks's biographer, Una usually dressed in male clothes and sported a monocle. Langer identifies her costume as "a little Lord Fauntleroy suit, the epitome of what a well-dressed lesbian of fashion might wear at home or for intimate evenings among friends."[17] Langer argues for an interpretation of this and other

portraits of lesbians in the circle "as positive visions of emancipated lesbians. . . . Her work . . . is . . . a visual expression of deeply held social, political and esthetic beliefs."[18] This reading is much more sensitive to the choices and lifestyle of Brooks than Adelyn Breeskin's simple dismissal of the image as a "caricature."

The shallow space and monochromatic palette are typical of Brooks's works in this decade and relate to her personal creation of a coloristic system derived from Whistler's closely toned symbolist technique.

WOMEN ARTISTS OF SURREALISM

Whitney Chadwick and other scholars have expanded our understanding of Surrealism in many valuable ways. Scholars of this movement have positioned a range of women creators in the movement and have also provided analyses of images of women by male artists. There is an irony inherent in the Surrealist position on the nature of women, the "other" sex. André Breton, the leading theorist of the Surrealist movement, valued woman as a primal force that he viewed with respect and awe. He advanced definitions of woman as catalytic muse, visionary goddess, evil seductress, and, most significantly, as *femme-enfant*, the woman-child whose naive and spontaneous innocence, uncorrupted by logic or reason, brings her into closer contact with the intuitive realm of the unconscious so crucial to Surrealism. Breton exalted woman as the primary source of artistic creativity, saying, "The time will come when the ideas of woman will be asserted at the expense of those of man."[19] However, Breton expected men to translate this intuitive woman's realm, viewed as closer to natural forces, into the culture as art. As flattering as his adulation of woman might seem, his theories relegated the "other" sex to the status of male-defined object, leaving little place for real women or women artists to develop independent identities. Thus, the women of Surrealism, as Gloria Orenstein has suggested in a landmark article, had to struggle against limitations placed on them by the very concepts of Surrealism itself.[20]

Yet Surrealism, as a movement that sought to explore altered states of consciousness, to penetrate the realm of dreams, and to make the imaginary real, includes a number of women who produced significant works that have exerted a strong influence on contemporary women artists, active since the 1970s. Scholars, in a series of recently published volumes, have begun to recognize and evaluate the contributions of these artists. Surrealism, a movement that exalted Woman as the creative force, may also be understood and valued for the women creators within it. Only a few works by Surrealist women artists can be included here; however, there is an extensive literature on artists such as Tanning, Sage, Maar, Varo, and other important creators. The art by Cahun, Oppenheim, and Kahlo illustrated

here has been selected, rather arbitrarily, to represent an extensive and varied body of works created by the "Women of Surrealism."

• Claude Cahun, *Self-Portrait*

A series of recently published essays has brought the artistic practice of Claude Cahun (1893–1954) into focus. Cahun was an important participant in the Parisian cultural scene which we have been describing in relation to Romaine Brooks. Cahun's artistic practice incorporated "surrealist-inspired objects, collages, photographs, and critical writings."[21] One of these photographs is illustrated in this text Fig. 16–4.

Fig. 16–4 Claude Cahun, *Self-Portrait,* c. 1928. *(Courtesy of San Francisco Museum of Modern Art.)*

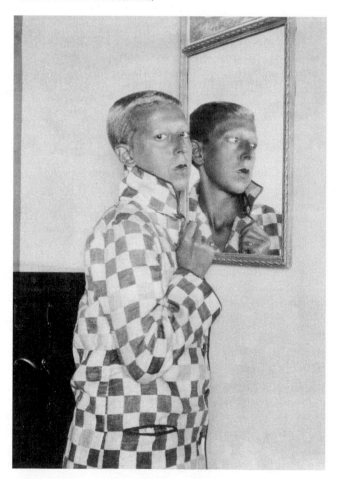

Cahun was born into a prominent French-Jewish family as Lucy Schwob. In 1918 she changed her name to the androgynous or sexually ambiguous "Claude." "Cahun," as Rosalind Krauss has noted, was the French form of "Cohen" her mother's maiden name and identified the bearer as a descendent of the biblical priestly or rabbinical class. "The act of defiance attached to leaving 'Schwob' to affect 'Cahun' can thus only be seen as one of flaunting one's Jewishness in the face of the heightened anti-Semitism of post war France, a kind of provocation every bit as dangerous as parading one's lesbianism."[22]

In a fascinating series of photographs, anticipating some of the issues raised by the *Film Stills* of Cindy Sherman, 50 years later, Cahun created a series of "self-portraits," which "aggressively militates against the normative ideals of femininity, and more broadly exposes the viewer's expectation of intelligible identity as grounded, specifically in gender."[23] While Cahun openly lived with her lover, Suzanne Malherbe, her photographic project goes beyond the asserting of a lesbian identity. Given the wide range of "faces" she assumes, the viewer could reasonably become bewildered. "Is there a 'real' Claude Cahun?" or "Who is this person?" Laurie Monahan notes that it is precisely the idea of a unified coherent identity that Cahun's practice seeks to destabilize. "Cahun's constantly shifting and transforming self sought to make gender itself ambiguous."[24] It is a logical step to then relate this project to the frequently quoted essay by Joan Riviere, a psychoanalyst, written in 1929: "Womanliness as Masquerade."[25] Contemporary scholars of Surrealism are fascinated with Riviere's text because it makes explicit the concept of gender as a construction rather than part of a "natural" or biologically determined inevitability. Riviere proposed that the attributes of "womanliness" could be adopted as a "mask" to hide the qualities that might make women successful in masculine-dominated activities. Furthermore, Riviere asserts that the aspects of the masquerade and the "woman" who acts it out are not two distinct aspects of a unified identity, but are merged together so that these elements of masquerade cannot be distinguished from an "essential" identity.[26]

• Meret Oppenheim, *Object*

Raised in Switzerland and southern Germany, Meret Oppenheim (1913–1985) went to Paris at the age of 18 to become an artist. She became the subject of some of Man Ray's most beautiful and provocative photographs, and in 1933 she was invited by Alberto Giacometti and Jean Arp to exhibit with the Surrealists. She continued to participate in their exhibitions until 1937 and again after World War II until 1960.

In the catalog of Surrealist imagery, one piece stands out as the paradigm of the disturbing object: the fur-lined teacup of Meret Oppenheim.

Fig. 16–5 Meret Oppenheim, *Object (Le Déjeuner en fourrure)*. 1936. Fur-covered cup, saucer, and spoon. Cup 4⅜ in. diameter; saucer 9⅜ in. diameter; spoon 8 in. long; overall height 2⅞ in. (7.3 cm). *(The Museum of Modern Art, New York. Purchase. Photograph © 1995 The Museum of Modern Art, New York)*

Although this work, alternately titled *Object* and *Fur Breakfast* (Fig. 16–5), is frequently reproduced in standard texts, there is "a truly stunning absence of critical curiosity about Meret Oppenheim herself."[27] Her fur-lined teacup remains a most potent example of the Surrealist goal to transform the familiar into the strange. Here, a mundane household object is rendered useless, while evoking the viewer's response to the sensation of drinking from wet fur. In another clever Surrealist object, Oppenheim trussed up a pair of women's high-heeled shoes like a holiday bird served on a silver platter, complete with paper frills. She also transformed a mirror by silk-screening onto the surface a face in the process of metamorphosis. She maintained a commitment to the ideas that formed the basis of Surrealism: "Artists, poets, keep the passage to the unconscious open. . . . The unconscious is the only place from which help and advice can come to us."[28]

- Frida Kahlo, *The Two Fridas*

Of all the women artists active in the twentieth century prior to 1950, Frida Kahlo (1910–1954) is today one of the most famous. Her life and her art are more closely interlocked than any other artist in this book. Her

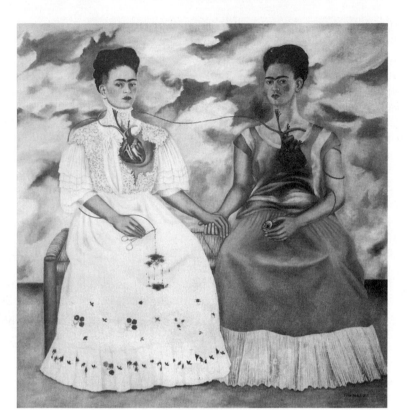

Fig. 16–6 Frida Kahlo, *The Two Fridas.* 1939. Oil on canvas, 67 × 67 in.
(Collection of the Museo de Arte Moderno, Mexico City; photo by Jorge Contreras Chacel)

recurrent, even obsessive, focus on self-portraiture as her main subject generated an *oeuvre* of great honesty, power, and originality.

Kahlo married the noted Mexican mural painter Diego Rivera in 1929. Their stormy and passionate relationship was an important component of Kahlo's life. This work was painted during the period, lasting over a year, in which they were divorced. In *The Two Fridas,* Kahlo explores the dualities of her Mexican heritage and identity. On the left she wears a European-styled white lace dress, while on the right she presents herself in a Tehuana dress. This is the traditional costume of Zapotec women from the Isthmus of Tehuantepec. Helland states that Zapotec women "represent[ed] an ideal of freedom and economic independence."[29] Kahlo's commitment to Aztec imagery and native dress can be connected to the nationalistic political movement of her youth, "Mexicanidad."

The two figures are united by their clasped hands and an artery that stretches between their two hearts. The extracted heart was a device used

by Kahlo to show pain in love.[30] The artery emerges from the miniature painting of Rivera as a boy held by the Frida on the right. It reappears on the white dress and is clamped with a hemostat, dripping red blood. Helland notes that "Aztecs often represent the 'heart,' which they perceived as the life center of a human being, as drops of (or spurting) blood."[31] A phrase from a love poem by Elias Nandino that Kahlo had copied in her journal states "My blood is the miracle that travels in the veins of the air from my heart to yours."[32] Herrera refers to this work as a "dramatization of loneliness."[33] Kahlo has only herself, with all her complexity of identity, to accompany herself in the world.

Solomon Grimberg has recently interpreted this image as "two opposing forces: living and dying."[34] For Kahlo, separation from Rivera was a form of death, symbolized by the Frida on the left, in white. Grimberg proposed a painting by Theodore Chasseriau hanging in the Louvre as a source for the image. Kahlo had only recently returned from Paris when Rivera asked for the divorce.[35]

Kahlo's position in Surrealism is highly tenuous. Her works came to the attention of Julian Levy, who ran a small gallery oriented toward Surrealism in New York. Kahlo had met André Breton, the theoretician of the Surrealists, and had entertained him as her houseguest in Mexico City. In 1939 she went to Paris, since Breton had promised to organize a show of her works. Her frustration and anger toward Breton and the French artists in his circle are clear in her letters from Paris. In 1952 Kahlo made the following statement concerning her relationship to Surrealism:

> Some critics have tried to classify me as a Surrealist; but I do not consider myself to be a Surrealist. . . . Really I do not know whether my paintings are Surrealist or not, but I do know that they are the frankest expression of myself. . . . I detest Surrealism. To me it seems to be a decadent manifestation of bourgeois art. A deviation from the true art that the people hope for from the artist. . . . I wish to be worthy, with my painting, of the people to whom I belong and to the ideas that strengthen me. . . . I want my work to be a contribution to the struggle of the people for peace and liberty.[36]

• Charlotte Salomon, *Leben? Oder Theater? (Life? Or Theater?)*

The tragic life and dramatic circumstances in which Salomon created her magnum opus *Life? Or Theater?* have provided a fascinating focus for scholars. Salomon was born in 1917 into an upper-middle-class Jewish family in Berlin. In 1926, Charlotte's mother committed suicide, which the family disguised to avoid the social stigmas attached to suicide. Her death was presented to the world as a natural one. In the midst of Nazi efforts to eliminate Jews from state schools, Salomon managed to be admitted to the State Art Academy in Berlin in 1935. In January 1939, Salomon separated

from her family, left Germany, and went to the south of France to live in a small town with her grandparents. Sadly, her grandmother also committed suicide, in 1940.

Toward the end of 1941, Salomon set herself up in a little hotel in the resort town of St. Jean Cap Ferrat and produced her amazing and unprecedented *Life? Or Theater?* This highly creative work consists of 769 compositions and an additional thirteen pages of text. It was created in watercolor, using only the three primary colors, red, yellow, and blue. Salomon called it a "song play" and meaning here is communicated both in text as lyrics, and images juxtaposed in very powerful ways. *Life? Or Theater?* is subdivided into acts and scenes like an operetta.

The circumstances in which *Life? Or Theater?* was created have sometimes overshadowed the analysis of the work itself. However, it should not be forgotten that *Life? Or Theater?* is a work of art and so should be interpreted in an art historical context, separated from the "real" biography of its creator. The style of the drawings is broadly "expressionist," but its format and reliance on text prevents the work from fitting comfortably within the framework of German Expressionism. Because *Life? Or Theater?* is a life history with a narrator, we must be careful of compressing too neatly the "real" historical person of Charlotte Salomon and the "Charlotte" imaged in the work or yet a third entity, the "narrator." One important concern for an understanding of this work is the issue of "resistance." In the text, Salomon writes: "My grandfather was for me the symbol of all the people I had to fight against." Ernst van Alphen has isolated at least three modes of resistance focused on the figure of her grandfather. "Charlotte resists the family traditions that led to suicide for both her mother and her grandmother and denied her full artistic identity. She resists in the very creation of *Life? Or Theater?* And perhaps her resistance to her grandfather is a way of resisting the Nazis."[37] Van Alphen believes that this is why the Nazis are not explicitly figured in the pages of *Life? Or Theater?* In the final image of this work, the artist is pictured, with her back to the viewer, facing out to sea. She is holding a transparent and, as yet blank, page framed in black, with her brush poised diagonally across the "page." Across her back, the title *"Leben? oder Theater? that is Life? Or Theater?"* is emblazoned. The style of the work is direct, assured, and confident. Perhaps it was only in the creation of art that Salomon could feel such confidence, living in hiding from the Nazis, in the south of France. The over 700 different pages reveal a wide range of stylistic techniques and compositional strategies, demonstrating the talent and versatility of this artist. The entire work deserves to be studied and any one single image cannot convey the prodigious talent evident in the complete project. This extraordinary project, which survived intact, is the tangible record of the creative power of one individual.

Salomon married Alexander Nagler, another Jewish refugee, in June 1943. By September, she and Nagler were captured and interned at the camp of Drancy, which was a key loading zone for Jews of France to be exported to the concentration camps of Eastern Europe. Eventually, they were sent to Auschwitz. While Nagler's name is listed on the records, Charlotte's name does not appear, indicating that she was immediately executed on her arrival. Mary Lowenthal Felstiner has written a compelling biography of Salomon detailing the facts of her life and death and placing her situation within the genocide, which was especially effective for women of the Holocaust.

The pages of *Life? Or Theater?* were preserved by Mrs. Moore who owned the villa in which Salomon's grandparents lived, and who had befriended Salomon. Mrs. Moore gave the drawings that comprise *Life? Or Theater?* to Salomon's parents in 1947, who had survived the war by living underground, in Holland. Like Anne Frank, Salomon summoned up a powerful creative energy from the center of the Holocaust. *Life? Or Theater?* is an incredibly rich and layered project, which is an autobiography detailing her coming into her complex identity as a woman, as an artist, and as a woman artist.

THE UNITED STATES

Painting

* Florine Stettheimer, *Cathedrals of Fifth Avenue*, 1931

Like Cahun and Salomon, Stettheimer is another Jewish woman who created an impressive oeuvre by defying gender expectations for her race and class. Born into a wealthy family in 1871, Stettheimer spent much of her formative artistic years in Europe. Abandoned by her father, she and her three sisters lived with their mother in Manhattan after 1914. There, Stettheimer was integrated into the most avant-garde artistic circles of the city. She was friendly with Marcel Duchamp, O'Keeffe, and Stieglitz. Between 1914 and her death in 1944, she produced about 150 paintings during her "middle-aged" years in which she invents an original artistic vocabulary.

One outstanding example of her art is *The Cathedrals of Fifth Avenue*, one of a series of works in which she satirizes her contemporary culture. According to Barbara Bloemink, the leading scholar on this artist, this painting "attests to her view of marriage as a suffocating, conventional, and commercial undertaking that benefits the man, not the woman: . . . the plump bride . . . is a characterless mass of diffused white light, her features nearly invisible."[38] Stettheimer paints herself into the work at the far right. She is wearing an artist's beret and peers at the procession over her sisters' shoulders.

Fig. 16–7 Florine Stettheimer, *The Cathedrals of Fifth Avenue.* (Courtesy of Metropolitan Muesum of Art, New York.)

Stettheimer's society wedding has no reference to romantic love. The image is bedecked with symbols of the ostentatious display and commercialized components of the wedding. The names of Tiffany's and Altman's, an upscale department store, light up the sky. On the right, expensive roses, chocolates, bottles of champagne, a car with a dollar symbol waiting at the curb, all refer to the costs of courtship and marriage in this society. The canopy adapted from Giotto's *Enthroned Madonna* in the Uffizi references the Christian rituals of marriage. An archbishop and monk preside over the couple. Like Stettheimer's other paintings, this work is densely layered symbolically. An additional layer of meaning is supplied by the vignette

documenting Charles Lindbergh's flight across the Atlantic. By framing the anonymous "bride" with Lindbergh, herself, and her sisters, Stettheimer is creating an "ironic comment of the value of individualized achievement and idiosyncratic choice versus conventional actions."[39]

- Georgia O'Keeffe, *Black Iris*

Georgia O'Keeffe (1887–1986) is widely recognized as one of the foremost American painters of the twentieth century. A highly individual artist, she cannot be easily classified with any movement or school of painters. Although she sometimes has been related to precisionists such as Charles Sheeler, her largely organic abstractions and her painterly style separate her from the machine aesthetic of that group. O'Keeffe was truly an "original"—an independent American who remained uninfluenced by the contemporary European abstract movements. O'Keeffe's period of greatest fame and productivity coincides with that of Stettheimer, with whom she had a close friendship.

Born on a farm in Wisconsin, O'Keeffe acquired some academic training at the Art Institute of Chicago and then at the Art Students League in New York. In 1912 she was exposed to the teachings of Arthur Wesley Dow, one of the few art educators in America who rejected academic realism in favor of the simplifications and flat patterning of Oriental art.

Between 1912 and 1916, O'Keeffe spent winters teaching art in Amarillo, Texas. Inspired by the vast expanse of the plains and responsive to Dow's concepts, she began drawing abstract shapes that came from her internal visual imagination. In 1916 she sent a friend some of these drawings. Her friend took them to Alfred Stieglitz, the noted photographer, who ran a gallery in New York that showed avant-garde European and American works. The following year O'Keeffe had the first in a series of annual one-woman shows at Stieglitz's 291 Gallery. In 1924 she and Stieglitz were married, and they lived mostly in New York City until his death in 1946.

O'Keeffe's ability to distill abstract shapes from natural phenomena is never more apparent than in her famous paintings of flowers. In *Black Iris* (Fig. 16–8), the flower is presented in a strictly frontal position, revealing its form to the viewer. From the mysterious mauve darkness of its center, one's eye moves outward to the violet-gray veil-like shapes at the peak. The black-gray lower section forms a base on which the upper half of the flower is supported.

The interpretation of O'Keeffe's flower paintings is a complex issue. As Barbara Buhler Lynes and others have noted, it was Stieglitz who first promoted the interpretation of her art,[40] even prior to the series of flower paintings of the 1920s, as a correlative of female sexual experience. This concept dominated the reviews of O'Keeffe's first major exhibition of 1923

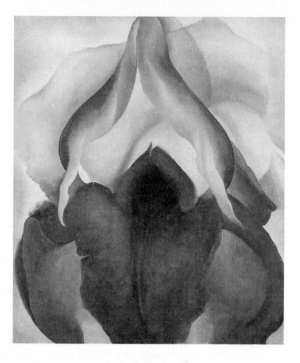

Fig. 16–8 Georgia O'Keeffe,
Black Iris. 1926. Oil on canvas,
36 × 29⅞ in. *(The Metropolitan
Museum of Art, Alfred Stieglitz
Collection, 1949. All rights reserved,
The Metropolitan Museum of Art,
69.278.1)*

and continued throughout the decade. However, O'Keeffe herself consistently sought to distinguish her work from the label of "woman artist" and to deny all associations of her flowers with female anatomy.

Lynes documents O'Keeffe's participation in the National Women's Party (NWP) campaign for the Equal Rights Amendment.[41] O'Keeffe believed in equality between the sexes. She began her large-format flower paintings in 1924, the year after her abstractions had received so much comment in the press and, as Lynes proposes, perhaps wished to make more specific imagery that would not be open to interpretations of sexuality. The paintings sold well, and she continued to make them. In her published statement of 1939, she explicitly repudiates connections between this imagery and female genitalia:

> Everyone has many associations with a flower. . . . Still, in a way, nobody sees a flower—really—it is so small—we haven't time—and to see takes time, like to have a friend takes time. If I could paint the flower exactly as I see it, no one would see what I see because I would paint it small like the flower is small.
>
> So I said to myself—I'll paint what I see—what the flower is to me but I'll paint it big and they will be surprised into taking time to look at it—I will make even busy New Yorkers take time to see what I see of flowers.

> Well I made you take time to look at what I saw and when you took time to really notice my flower you hung all your own associations with flowers on my flower and you write about my flower as if I think and see what you think and see of the flower—and I don't.[42]

The "associations" from which O'Keeffe separates herself refer to the connections often drawn between images such as *Black Iris* and a woman's sexual anatomy.

However, in an interesting article, Anna Chave characterizes O'Keeffe's art in the following terms: "O'Keeffe portrayed abstractly, but unmistakably, her experience of her own body, not what it looked like to others. The parts of the body she engaged were mainly invisible (and unrepresented) due to interiority, but she offered viewers an ever-expanding catalogue of visual metaphors for those areas, and for the experience of space and penetrability generally."[43] Chave connects this awareness with the political campaign for reproductive freedom through access to contraception, and one might add the feminist euphoria in the aftermath of the successful battle for female suffrage in the 1920s.

It is a tribute to the power of O'Keeffe's works that they can evoke a broad range of associations that vary from viewer to viewer. The relationship of this image to the female body is but one layer of metaphorical meaning that may be taken from it. Another interpretation might view it as fantasy architecture, an elaborate construction, or as a metaphor for a shelter, enclosure, or protection of a special being or sacred object. As Lloyd Goodrich has written, "The flower became a world in itself, a microcosm. Magnification was another kind of abstraction, of separating the object from ordinary reality, and endowing it with a life of its own."[44] The sheer formal power and brilliance of O'Keeffe's flower paintings secure their place among the most important American paintings of the twentieth century.

Beginning in 1929, O'Keeffe spent summers in New Mexico, where she felt a strong attraction to the stark beauties of the desert landscape. In addition to the geography of the desert, O'Keeffe repeatedly painted the bleached animal bones she found in the parched wilderness.

In 1949, after settling Stieglitz's estate, she moved permanently to the remote town of Abiquiu, New Mexico. O'Keeffe's art—spare, clear, and powerful—forces us to see that portion of nature she explored in a new and more profound way.

PHOTOGRAPHY

Whether to consider photography an art and photographers artists, rather than technicians or craftsmen, has been the subject of debate since the invention of photography in the nineteenth century. As was discussed in relation to the practice of Cameron, in Chapter 13, most nineteenth-century

authorities thought of photography more as a science or craft than as an art. Today, there is a consensus that photography is indeed an art form. Photographs are collected, displayed in museums and galleries, and subjected to critical evaluation. Major photographers are the subjects of scholarly monographs. Photography has its own history, with recognized masters, which parallels the history of painting and sculpture. Therefore, it is appropriate that a select group of outstanding women photographers be included in this study.

- Imogen Cunningham, *Portrait of Martha Graham*

Along with Edward Weston and Ansel Adams, Imogen Cunningham (1883–1975) is known for her sharply focused images of natural phenomena. Reacting against the style of "pictorial photography" favored by Alfred Stieglitz and Gertrude Käsebier, these San Francisco photographers formed a rather unstructured organization known as Group f. 64. An f. 64 setting on a camera is a very small lens opening that gives a sharply focused, finely detailed image along with a greater depth of field. Through the 1930s, Group f. 64 was the most influential photography society in the country. Among Cunningham's most famous photos are very close-up studies of flowers and plants with strong light–dark contrast. O'Keeffe also favored this type of subject.

Cunningham met the dancer Martha Graham (Fig. 16–9) during the summer of 1931, when both women were living in Santa Barbara, Cali-

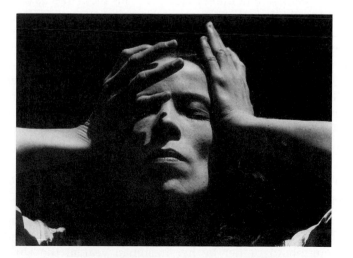

Fig. 16–9 Imogen Cunningham, *Martha Graham, Dancer.* 1931.
(© 1970 The Imogen Cunningham Trust)

fornia. Graham was visiting her mother, and Cunningham isolated her against the dark interior of the barn to achieve the dramatic light–dark contrasts of this image.[45] The expressive positioning of the hands is made even more exaggerated by the close-up focus and severe cropping of the image. Cunningham seems to have been inspired by the beauty, power, and intensity of Graham's choreography to create a photographic portrait worthy of this giant of modern dance. Cunningham's original vision established her reputation as one of the foremost women photographers of the twentieth century.

- Dorothea Lange, *Migrant Mother*

Born of German immigrants in Hoboken, New Jersey, Dorothea Lange (1895–1965) had decided to become a photographer by the time she was 17 years old. While attending courses to become an elementary school teacher, she worked in several photographers' studios in New York learning her craft. Leaving home with a girlfriend, Lange settled in San Francisco in 1918, where she established herself as a professional portrait photographer.

Lange's contribution to the history of photography dates from the 1930s, when she was hired by the Farm Security Administration both to document the plight of the migrant workers and to arouse sympathy for federal relief programs to aid them. *Migrant Mother* (Fig. 16–10) is the most famous photograph from this program. The circumstances surrounding the encounter with the subject of *Migrant Mother* have an almost eerie quality of intuitive recognition. Lange said, "I drove into that wet and soggy camp and parked my car like a homing pigeon."[46] This woman was only 32 years old. She and her children had been surviving on frozen vegetables gleaned from the fields and birds caught by the children. There was no more work since the pea crop had frozen. They could not move on because the car tires had just been sold to buy food. We do not really need to know this background saga of desperation. The anguish on this woman's face, her children who hide their faces from the photographer—these are immediately recognizable symbols of extreme poverty and social endurance. In fact, the image conveys this information so directly and eloquently that it has become one of the most memorable pictures of the last fifty years.

- Margaret Bourke-White, *At the Time of the Louisville Flood, 1937*

Like Dorothea Lange, Margaret Bourke-White (1904–1971) was a documentary photographer. She is remembered as one of the most famous and prolific American photojournalists. Born in New York, she was an active amateur photographer by her freshman year at the University of Michigan in 1921. Her professional career began in Cleveland in 1927,

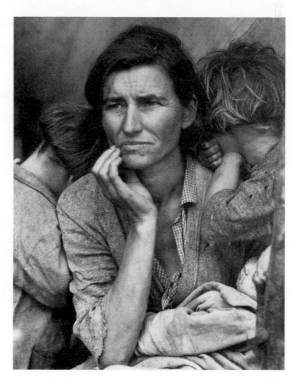

Fig. 16–10 Dorothea Lange, *Migrant Mother, Nipomo, California.* 1936. Gelatin-silver print, 12½ × 9⅞ in. *(Copyright the Dorothea Lange Collection, The Oakland Museum of California, The City of Oakland. Gift of Paul S. Taylor.)*

following the collapse of a two-year marriage. In 1929 she was hired as a staff photographer for a new magazine, *Fortune,* published by Henry Luce. When Luce founded the magazine *Life* in 1936, Bourke-White was hired as one of its four original staff photographers. She continued to work for the immensely popular *Life* until 1956, when the debilitating effects of Parkinson's disease forced her into retirement.

Bourke-White was an aggressive, fearless documentary photographer. She traveled the globe in pursuit of images to inform the American people of the major world events of the epoch. Her courage and determination to get the right photo are legendary. She understood her pictures to be historical documents and, in fact, her images shaped the consciousness of millions.

Bourke-White traveled through the dustbowl of America's Midwest in the 1930s, recording the daily lives and the effects of poverty on the people of small-town America. Like the works of Lange, Bourke-White's images forced the readers of *Life* magazine to empathize with the plight of the unfortunate and destitute people captured in her photographs. *At the Time of the Louisville Flood, 1937* (Fig. 16–11), one of her most famous photographs, depicts homeless refugees lining up for emergency supplies. The

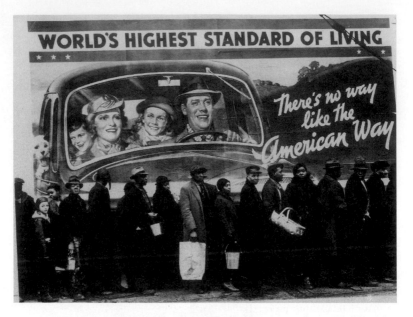

Fig. 16–11 Margaret Bourke-White, *At the Time of the Louisville Flood, 1937.*
(Life Magazine © 1937 Time Inc.)

juxtaposition of these impoverished blacks and the billboard behind them proclaiming the prosperity of the "typical" American family is ironic social commentary.

Bourke-White was a courageous war photojournalist. At the end of World War II she arrived with General Patton to record the liberation of Buchenwald, one of the Nazi concentration camps. Her photograph of the emaciated and expressionless survivors, *The Living Dead of Buchenwald, 1945,* became an unforgettable image of the Holocaust. Bourke-White recorded her reactions to this experience in her book, *Dear Fatherland, Rest Quietly:*

> I kept telling myself that I would believe the indescribably horrible sight in the courtyard before me only when I had a chance to look at my own photographs. Using the camera was almost a relief; it interposed a slight barrier between myself and the white horror in front of me. . . it made me ashamed to be a member of the human race.[47]

Despite stylistic differences, each photographer possessed great force of personality—a combination of determination, persistence, and energy that accounts, in part, for success in this medium.

ARCHITECTURE

- Julia Morgan, *San Simeon*

During a forty-seven-year career as a practicing professional architect, Julia Morgan (1872–1957) designed more than 700 buildings, mainly in California. Her professional practice was based in San Francisco. Morgan worked in a broad range of styles and building materials and suited her designs to the tastes and needs of her patrons. Sara Boutelle has noted that light and color were a consistent preoccupation in her work, whether she used a Beaux-Arts, Arts and Crafts, or Mediterranean architectural vocabulary.[48]

Morgan was raised in the San Francisco Bay area and in 1890 enrolled at the University of California, Berkeley. Because there was no architecture school then, she became the only woman in the engineering program. In October 1897, Morgan took the entrance examination for the Ecole des Beaux-Arts in Paris. Although she placed forty-second out of 376 applicants, that score was not good enough to secure her admission. However, on her third try, in October 1898, she became the first woman in architecture to be accepted to this prestigious art academy. Morgan spent six years in Paris, returning to San Francisco in 1902. In 1904 she passed the state examination and was certified for architecture.

According to Boutelle, Morgan's career should be understood in the context of a women's network of philanthropy and public activities. She built a large number of structures designed for women's use, from buildings on the campus of Mills College to a sorority house at Berkeley. In addition, the Young Women's Christian Association (YWCA) was a very important client for Morgan. She designed several YWCA structures, for example, in Asilomar, Oakland, and Riverside (now the home of the Riverside Art Museum). Phoebe Apperson Hearst was a major patron of the YWCA, and Morgan had been working on additions to Mrs. Hearst's ranch in Pleasanton, "The Hacienda," since 1903. When the concept for a YWCA conference center was developed, Mrs. Hearst recommended Morgan for the job. Asilomar, which means "refuge by the sea," is "perhaps the largest institutional complex ever built in the Arts and Crafts style."[49]

The project for which Morgan is most famous is the elaborate structure built for William Randolph Hearst, San Simeon. In April 1919, Hearst met with Morgan for the first time to discuss the construction of a home at "The Ranch" at San Simeon, 200 miles south of San Francisco on the Pacific Coast. This project would occupy much of Morgan's efforts for the next eighteen years. She traveled to the site nearly every weekend from 1920 through 1938. Hearst and Morgan worked in a close and cooperative collaboration on the construction of three guest houses or "cottages" and the main building.

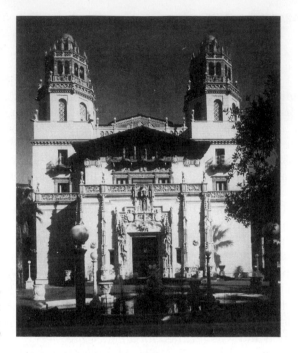

Fig. 16–12 Julia Morgan, *San Simeon.* 1922–1926. Front entrance, Main Building. *(Courtesy of Sara H. Boutelle)*

Construction of the main building began in 1922. The reinforced concrete structure was designed with earthquake-proof standards in mind. The white facade was built of reinforced concrete and faced with stone. Initially, inspiration for the towers came from the church at Ronda in southern Spain, one of Hearst's favorites. The assembly room was two stories tall and measured about 80 × 30 feet, extending across the entire front of the building. The equally enormous refectory, with a 28-foot stone mantel, provided the inspiration for *Citizen Kane*'s Xanadu sets. Morgan also designed a movie theater, two elaborate pools, the Neptune pool and the Roman pool, and a zoo for San Simeon. Boutelle records that the correspondence between Morgan and Hearst indicates that securing adequate funds to keep the building construction going was a constant problem.

Morgan closed her office in 1951, six years before her death, in 1957. Her career was eclipsed by the predominance of the International Style in architecture in the post–World War II period.

Suggestions for Further Reading

Weimar Artists
Ankum, Katharina von, *Women in the Metropolis: Gender and Modernity in Weimar Culture* (Berkeley: University of California Press, 1997).

MESKIMMON, MARSHA, *We Weren't Modern Enough: Women Artists and the Limits of German Modernism* (Berkeley and Los Angeles: University of California Press, 1999).

MESKIMMON, MARSHA, and SHERER WEST (eds.), *Visions of the "Neue Frau": Women and the Visual Arts in Weimar Germany* (Aldershot, England: Ashgate Publishing, 1995).

NOUN, LOUISE R., *Three Berlin Artists of the Weimar Era: Hannah Höch, Käthe Kollwitz, Jeanne Mammer,* with essays by contributing authors (Des Moines, IA: Des Moines Art Center, 1994).

Hannah Höch

BOSWELL, PETER, et al., *The Photomontages of Hannah Höch* (Minneapolis: Walker Art Center, 1996).

LAVIN, MAUD, *Cut with the Kitchen Knife: The Weimar Photomontages of Hannah Höch* (New Haven, CT: Yale University Press, 1993).

Dada

SAWELSON-GORSE, NAOMI, *Women in Dada: Essays on Sex, Gender and Identity* (Cambridge, MA: The MIT Press, 1998).

Bauhaus Women

WELTGE, SIGRID W., *Women's Work: Textile Art from the Bahaus* (San Francisco: Chronicle Books, 1993).

Parisian Avant Garde

BENSTOCK, *Women of the Left Bank, Paris, 1900–1940* (Austin: University of Texas Press, 1986).

WEISS, ANDREA, *Paris Was a Woman: Portraits from the Left Bank* (San Francisco, Harper, 1995).

Romaine Brooks

BREESKIN, ADELYN, *Romaine Brooks, "Thief of Souls"* (Washington, DC: National Collection of Fine Arts, Smithsonian Institution Press, 1971).

LANGER, CASSANDRA L., "Fashion, Character and Sexual Politics in Some of Romaine Brooks' Lesbian Portraits," *Art Criticism,* 1 (1981).

SECREST, MERYLE, *Between Me and Life: A Biography of Romaine Brooks* (Garden City, NY: Doubleday, 1974).

Surrealism

CAWS, MARY ANN, RUDOLF KUENZLI, and GWEN RAABERG (eds.), *Surrealism and Women* (Cambridge, MA: The MIT Press, 1991).

CHADWICK, WHITNEY (ed.), *Mirror Images: Women, Surrealism and Self-Representation* (Cambridge, MA: The MIT Press, 1998).

CHADWICK, WHITNEY, *Women Artists and the Surrealist Movement* (Boston: Little, Brown, 1985).

CHADWICK, WHITNEY, and ISABELLE DE COURTIVRON (eds.), *Significant Others: Creativity and Intimate Partnership* (London and New York: Thames and Hudson, 1993).

HUBERT, RENEE R. *Magnifying Mirrors: Women, Surrealism and Partnership* (Lincoln: University of Nebraska Press, 1994).

Claude Cahun

KRAUSS, ROSALIND E., *Bachelors* (Cambridge, MA: The MIT Press, 1999).

MONAHAN, LAURIE J., "Radical Transformations: Claude Cahun and the Masquerade of Womanliness," in M. Catherine de Zegher (ed.), *Inside the Visible: An Elliptical Traverse of Twentieth Century Art in, of, and from the Feminine* (Cambridge, MA: The MIT Press, 1996).

Meret Oppenheim

OPPENHEIM, MERET, and DOMINIQUE BURGI, *Meret Oppenheim* (Cambridge, MA: The MIT Press, 1989).

Frida Kahlo

HERRERA, HAYDEN, *Frida: A Biography of Frida Kahlo* (New York: Harper and Row, 1983).

HERRERA, HAYDEN, *Frida Kahlo . . . The Paintings* (New York: HarperCollins, 1991).

KAHLO, FRIDA, *A Diary of Frida Kahlo: An Intimate Self-Portrait,* intro. by Carlos Fuentes, essay by Sara M. Lowe (New York: Harry N. Abrams, 1995).

Charlotte Salomon

Charlotte Salomon: Life? Or Theater? Intro. by Judith Belinfante (Zwolle, Netherlands: Jewish Historical Museum, 1998). (Facsimile edition)

FELSTINER, MARY L. *To Paint Her Life: Charlotte Salomon in the Nazi Era* (New York, HarperCollins, 1994).

VAN ALPHEN, ERNST, "Charlotte Salomon: Autobiography as a Resistance to History," in M. Catherine de Zegher (ed.), *Inside the Visible: An Elliptical Traverse of Twentieth Century Art in, of, and from the Feminine* (Cambridge, MA: The MIT Press, 1996).

Florine Stettheimer

BLOEMINK, BARBARA J., "Florine Stettheimer: Hiding in Plain Sight," in Naomi Sawelson-Gorse (ed.), *Women in Dada: Essays on Sex, Gender and Identity* (Cambridge, MA: The MIT Press, 1998).

BLOEMINK, BARBARA J., *The Life and Art of Florine Stettheimer* (New Haven, CT: Yale University Press, 1995).

PRESSMAN, ELISABETH, and BARBARA J. BLOEMINK, *Florine Stettheimer: Manhattan Fantastica* (New York: Whitney Museum of Americn Art, 1995).

Georgia O'Keeffe

CHAVE, ANNA, "O'Keeffe and the Masculine Gaze," *Art in America*, 78 (January 1990).

COWART, JACK, and JUAN HAMILTON, *Georgia O'Keeffe, Art and Letters.* Letters selected and annotated by Sarah Greenough (Washington, DC: National Gallery of Art; and Boston: New York Graphic Society, 1987).

HOFFMAN, KATHERINE, *An Enduring Spirit: The Art of Georgia O'Keeffe* (Metuchen, NJ: Scarecrow Press, 1984).

LISLE, LAURIE, *Portrait of an Artist: A Biography of Georgia O'Keeffe* (Albuquerque: University of New Mexico, 1986; and New York: Pocketbooks, 1987).

LYNES, BARBARA BUHLER, *Georgia O'Keeffe: The Catalogue Raisonné* (New Haven, CT, Yale University Press, 1999).

LYNES, BARBARA BUHLER, *O'Keeffe, Stieglitz and the Critics, 1916–1927* (Ann Arbor, MI: UMI Research Press, 1989).

MESSINGER, LISA M. *Georgia O'Keeffe* (New York: Thames and Hudson and the Metropolitan Museum of Art, 1988).

O'KEEFFE, GEORGIA, *Georgia O'Keeffe* (New York: Viking, 1976).

PETERS, SARAH WHITAKER, *Becoming O'Keeffe: The Early Years* (New York, Abbeville Press, 1991).

Photography

KREISEL, MARTHA, *American Women Photographers: A Selected and Annotated Bibliography* (Westport, CT: Greenwood Press, 1999).

ROSENBLUM, NAOMI, *A History of Women Photographers* (New York: Abbeville Press, 1994).

SULLIVAN, CONSTANCE (ed.), *Women Photographers* (New York: Abrams, 1990).

Imogen Cunningham

DATER, JUDY. *Imogen Cunningham: A Portrait* (Boston: New York Graphic Society, 1979).

Imogen Cunningham (Seattle: University of Washington Press, 1970).

Dorothea Lange

HEYMAN, THERESE THAU, et al., *Dorothea Lange: American Photographs* (San Francisco: Museum of Modern Art, 1994).

MELTZER, MILTON, *Dorothea Lange: A Photographer's Life* (New York: Farrar, Straus and Giroux, 1978).

OHRN, KARIN BECKER, *Dorothea Lange and the Documentary Tradition* (Baton Rouge: Louisiana State University Press, 1980).

PARTRIDGE, ELIZABETH, *Dorothea Lange, A Visual Life* (Washington, DC: Smithsonian Institution Press, 1994).

TSUJIMOTO, KAREN, *Dorotha Lange: Archive of an Artist* (Oakland, CA: Museum of California, 1995).

Margaret Bourke-White
STOMBERG, JOHN R., *Maragaret Bourke-White, Modernity and the Documentary Mode* (Boston: Boston University Art Gallery, 1998).

Julia Morgan
BOUTELLE, SARA, *Julia Morgan, Architect* (New York: Abbeville, 1988).

17

The Post–World War II Era: 1945 – 1970

Women artists have been increasingly influential and active as equal participants in the full range of developments in painting and sculpture since World War II. A cursory overview of works by women artists during more recent times indicates that sex alone is not a strong enough factor to determine any particular predisposition toward a specific style of art. The large numbers of women artists, of whom only a handful of the most outstanding have been selected for discussion in this chapter, have worked in a wide variety of styles in the most diverse media imaginable. In the absence of institutional barriers and with the increased equality of women in all phases of the postwar culture, women artists have demonstrated that they are capable of originality and can achieve the highest levels of creativity in the visual arts.

As Ellen Laudau has noted, women as art teachers and art patrons were already prominent in the 1920s.[1] By the 1930s, women comprised a significant percentage of the population of artists. The 1930 census identifies 40 percent of all practicing American art professionals as women. Women were also prominent as administrators of federally funded arts projects during the Depression. These programs were notably free of sex bias; 40 percent of those receiving assistance were women.[2] These statistics indicate that women artists were no longer interesting oddities or exceptions in a male-dominated profession. From that time to the present, the percentage of art students and artists who are women has steadily grown.

During the 1930s, especially in New York, many of the administrators of the local WPA Fine Arts Projects were women.[3] However, in the postwar period, women artists struggled in isolation from one another for recognition and success. Landau concluded that influential male support was

crucial for "even a modicum of mainstream success. . . . Romantic entanglements with prominent artists, dealers, and critics had a key impact on the careers of a majority of artists . . . the entrée into the art world offered by these men proved critical to the women's success."[4] Landau also discusses the difficulty women experienced in combining the bearing and raising of children and having a professional career. Some women chose not to have children. "Women artists often had to play double roles and to prove themselves in ways not demanded of men, who could more easily integrate their personal and professional lives."[5] Women artists were subject to ridicule and condescension from critics, especially in the popular press. "Typically overshadowed in the history books by their husbands, lovers, and male colleagues, women artists have also had their works incorrectly labeled as derivative."[6]

Many of these women were uncertain about the role of their gender in the creation and formation of their art. Alice Neel stated: "When I was in my studio, I didn't give a damn what sex I was. . . . I thought art is art."[7]

Women artists are often reluctant to accept the label "woman artist," which they perceive as a way of isolating them or placing them in a "ghetto" with a corresponding diminution of their talents. They have lacked the experience of institutional structures for mutual support, "doomed to work in relative isolation and to have their work belittled or ignored."[8]

Despite such attitudes, however, we can see that in all trends of the mainstream art world women artists have been active and original contributors. Their achievements are a crucial part of the historical account of avant-garde artistic practices between 1945 and 1970. However, this is also the period in which the critical system of "Modernism" formulated by New York critic Clement Greenberg was most influential. As discussed in the introduction to Part IV, women artists, with the exception perhaps of Helen Frankenthaler, were pushed to the margins of Modernism, simply because they were women. Therefore, the works of virtually every woman artist became invisible not because of the relatively small numbers of women in the profession, characteristic of preceding centuries, but because of the critical discourse that eliminated all but a few male creators from the "canon" of greatness of the era.

ABSTRACT EXPRESSIONISM

- Lee Krasner, *Gaea*

Lee Krasner (1908–1984) is the only woman in the first generation of Abstract Expressionist artists. Until recently, her role in the movement has been overshadowed by her position as the widow of Jackson Pollack. A reevaluation of her contribution was undertaken only a year before her

death with a major retrospective exhibition at the Museum of Modern Art in New York.[9]

Born into a Russian Jewish family with absolutely no predisposition to the arts, Krasner was determined to become a painter by her teens. After studying on scholarship at Cooper Union in New York, she received very traditional academic training at the National Academy of Design. However, it was her years in the classes of Hans Hoffman that opened her art experience to the European masters Matisse, Picasso, and, of crucial importance, Mondrian.

From this grounding in the formal options of European Modernism, she, like the other Abstract Expressionists, eventually rejected the cool, intellectual distance of that art in favor of the immediacy and spontaneity urged by Surrealism. Between 1942 and 1945 she shared Pollock's studio. These years mark a time of doubt and lack of direction for Krasner.

Anne Wagner has discussed the difficulties that Krasner experienced as "Mrs. Jackson Pollock." In that role, she stuffed envelopes with announcements for Pollock's shows and kept track of details like the titles of his paintings. Of a joint exhibition titled "Artists: Man and Wife" at the Sidney Janis Gallery in 1949, an *Art News* critic wrote, "There is also a tendency among some of these wives to 'tidy up' the husbands' styles. Lee Krasner (Mrs. Jackson Pollock) takes her husband's paints and enamels and changes his unrestrained, sweeping lines into neat little squares and triangles."[10]

To combat the negative stereotyping of women artists' works, Leonore Krasner was known by the more gender-neutral name "Lee." She often used the initials "L.K." to sign her work. Wagner refers to these practices as "strategems . . . a resistance to her art being identified and thus seen 'as that of a woman,' a reluctance that went hand in hand with her refusal in 1945 to take part . . . in a group show of artists who were women."[11]

After meeting Pollock, Krasner stopped painting for a year and then endured a frustrating three-year period of "grey slabs," her term for the thickly encrusted paint and lack of image in work of the early 1940s.

In the spring of 1945, after Krasner and Pollock married, the couple moved out of New York City to East Hampton, Long Island. The following year both artists became preoccupied with all-over compositions. Between 1946 and 1949 Krasner created the "Little Image" paintings, which may be divided into three series. These works, created simultaneously with Pollock's drip paintings, are executed on a smaller scale and with a greater degree of precision and control.

Barbara Rose maintains that the original source for the all-over image was Mondrian's "ocean and pier" (or plus or minus drawings). She believes that it was Krasner who first drew Pollock's attention to the possibilities of this composition.[12] Pollock, in turn, encouraged Krasner to abandon her tenuous Cubist ties to physical nature.

Figure 17–1 Lee Krasner, *Gaea*. 1966. Oil on canvas, 69 in. × 10 ft. 5½ in. *(The Museum of Modern Art, New York. Kay Sage Tanguy Fund. Photography © 1995 The Museum of Modern Art, New York)*

In 1951 Krasner showed her paintings for the first time after the 1949 "Artists: Man and Wife" show. Although she subsequently destroyed most of these paintings, the surviving works indicate a strategy to distinguish her art from that of Pollock. The paintings somewhat resemble early Rothkos, composed of bands or rectangles of colors in delicate ranges of related tones. Krasner would not show again until 1955. "In this instance negating Pollock ended up as a kind of neutrality too easily equated with the condition and mental habits of womanhood."[13]

Krasner's works after 1955, such as *Gaea*, reveal a great energy and self-confidence. From the aggressive, Dionysiac frenzy of *Celebration* (1959–1960) to the precision and linear majesty of the "Majuscule" series (1971), Krasner's painting never settled into a signature style. Exploring the range of coloristic possibilities or restricting her palette to earth tones, using forms from nature or rejecting any organic illusionism, Krasner's art springs from sincerity, dedication to craft, and the strength of purpose found in the survivors of personal tragedy.

A painting such as *Gaea* (Fig. 17–1) illustrates one pole of Krasner's art. Active, visible, and seemingly spontaneous brush strokes define the moving, energetic forms. The palette is characteristically restricted, in this case to black, white, rose pink, and a fleshy-toned, higher valued pink. *Gaea* is the Greek name for the Earth Mother of the primordial past, a reference that underscores the sense of a prehuman, prehistoric life force pulsing through undifferentiated nature. Almost 7 feet tall and over

12 feet across, the sheer scale of the work overwhelms the viewer with its power and energy.

Krasner's restoration into the pantheon of Abstract Expressionists began in 1978 with her inclusion in an exhibition curated by Gail Levin and Robert Hobbs for the Whitney Museum's *Abstract Expressionism: The Formative Years* (1978). Her reputation, so consistently overshadowed by her position as the wife of Jackson Pollock, began to emerge independently when the artist was over 70. Feminist revisionism has helped us reevaluate the art of this major creator.

SCULPTURE

- Louise Nevelson, *Sky Cathedral*

Louise Nevelson (1889–1988) is generally recognized as one of the major innovators in the history of twentieth-century sculpture. By the late 1950s she was making large-scale works that were technically and formally without art historical precedents.

Louise Berliawsky was born in Russia to Jewish parents. When she was 6 years old, the family emigrated to the United States, settling in Rockland, Maine. Louise's affinity for wood dates from her childhood, spent in the proximity of her father's lumber yard. In 1920 she married Charles Nevelson, whose family owned a cargo-shipping business. Two years later her son Myron was born. During the 1920s Nevelson studied voice, drama, and dance, as well as the visual arts. In 1931 she separated from her husband and began to focus her energies on her painting classes at the Art Students League. She continued her painting studies through the 1940s, but it was only when she began to make sculpture from pieces of wood, nailed together and painted a uniform color, that Nevelson found her identity as an artist. Her reputation rests on a series of environmental structures that she began building in the 1950s.

These large-scale works are constructed from fragments of wood, arranged in compositions within boxlike enclosures. They are always painted a uniform color. During the 1950s, the color was black, but later the color changed to white, then gold. However, the black sculptures are the best known and most characteristic of her works.

Sky Cathedral (Fig. 17–2) is one wall of an environmental installation typical of her style. The work is over 8 feet tall and 11 feet wide. By its sheer scale, it dominates the viewer and commands attention. The title evokes a sense of the sculpture as mysterious, awe-inspiring architecture. It is not a unified, coherently designed work. In this sense, Nevelson's aesthetic is diametrically opposed to the sculptures of contemporary Minimalism. *Sky Cathedral* is divided into boxlike enclosures so that the work operates on two levels: an overall impression and the compositions of each individual box.

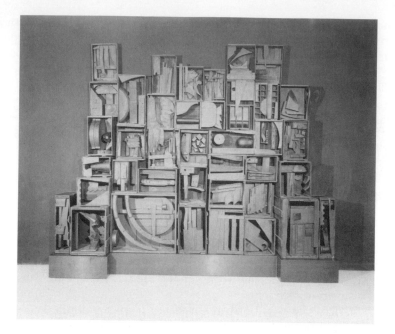

Figure 17–2 Louise Nevelson, *Sky Cathedral.* 1958. Wood, 102½ × 133½ in. *(Albright-Knox Art Gallery, Buffalo, New York. George B. and Jenny R. Mathews Fund, 1970)*

Nevelson began to enclose her sculpture in boxes in 1956 for emotional reasons:

> I wanted to be more secretive about the work and I began working in the enclosures. . . . There's something more private about it for me and gives me a better sense of security.[14]

From the confined limits of the box, Nevelson found the freedom to develop the fullest range of expressive potential in the interior compositions. However, she wanted to maintain a monumental scale for her sculpture, so she began piling these boxes on top of one another to create larger scaled works:

> I attribute the walls to this: I had loads of energy. I mean, energy and energy and loads of creative energy. . . . So I began to stack my sculptures into an environment. It was natural. It was a flowing energy. I think there is something in the consciousness of the creative person that adds up, and the multiple image that I give, say, in an enormous wall gives me so much satisfaction. There is great satisfaction in seeing a splendid, big, enormous work of art.[15]

Part of the distinction of Nevelson's sculpture is that it operates very effectively on the microcosmic scale of the individual enclosures and the macrocosmic scale of a mural or piece of architecture.

Sky Cathedral contains great variety and diversity within its overall unity. Each of the enclosures has a distinctive composition, balanced and complete within its own confines. For example, the third box from the left, on the floor, is a study in curving versus straight elements. Two sweeping arcs are counterbalanced by four horizontal units. The circular shape is then repeated with a disk set on a third spatial level. It is very carefully arranged so that the abstract elements contain their own tensions. Unity is maintained by the overall black color and the consistency of the use of wood fragments. Black is traditionally associated with death in our society. Yet Nevelson has said,

> . . . it's only an assumption of the western world that it means death; for me it may mean finish, completeness, maybe eternity.[16]

Nevelson's art, as has been noted, had variety and unity, complexity and a certain awesome simplicity. It is both very small and intimate in the box compositions and very large in overall impact. Nevelson believes that her work reflects her identity as a woman:

> I feel that my works are definitely feminine. . . . A man simply couldn't use the means of, say, fingerwork to produce my small pieces. They are like needlework. . . . My work is delicate; it may look strong, but it is delicate. . . . My whole life is in it, and my whole life is feminine. . . . Women through all ages could have had physical strength and mental creativity and still have been feminine. The fact that these things have been suppressed is the fault of society.[17]

It may be surprising at first to hear Nevelson relate her work—which uses nails, saws, and other tools—to needlework. But she has indeed taken bits and pieces of material, the debris of society, and transformed them, like a patchwork quilt, into a series of uniquely beautiful and impressive works of sculptural art.

Nevelson, who recognized her own isolation from the contemporary movement of Abstract Expressionism, made the following statement:

> Through personal choice and necessity, I never became involved with a group of artists. I don't belong to any movement. Of course, there is no mistake that the times I was living in had influence on me. We pool our energies with other creative people. I feel that, say, if some of our people weren't around where sparks fly, maybe I would not have come to this. That *must* be. My work is bound to be related to that of others. . . .
>
> But you know . . . I wouldn't feel in the right place if I was in the stream of Abstract Expressionism. Now I think they are marvelous. I love their art, and I love their energy. Nevertheless I had to go my own way. Yes, I believe artists reflect their time, but they have to stand on their own two feet . . . not on someone else's. I chose at quite an early age to be a soloist. Because I realized

that the rhythms of people are different. Consequently, I wouldn't assume to impose that on somebody else. And by the same token, I had to make my decisions, I had to make my moves. Everything came back to *me*.[18]

- Claire Falkenstein, *U as a Set*

Over the course of a lengthy and prolific career, Claire Falkenstein (1908–1997) created an enormously diverse oeuvre of highly innovative abstract sculpture. While her materials range from massive cedar logs of the *Forum, Memorial to A. Quincy Jones* to delicate welded wire, her works illustrate universal forces and processes as understood by twentieth-century science and philosophy.

Falkenstein was born in 1908 in a small rural community in Oregon, but her family moved to the San Francisco Bay area early in her life. She graduated from the University of California at Berkeley, where she studied anthropology and philosophy. These early intellectual interests would persist throughout her career and serve as sources for her aesthetic systems.

Alexander Archipenko was the first famous sculptor with whom Falkenstein studied. Archipenko's interest in the expressive possibilities of negative spaces, although still tied to the human form, was influential for Falkenstein, who would pursue her exploration of sculptural form freed from enclosing volumes throughout her career. In the late 1940s she taught sculpture at the California School of Fine Arts with such noted Abstract Expressionist painters as Clyfford Still.

A significant turning point occurred in her career when she moved to Paris in 1950. She lived and worked in Europe until 1962. Like the experiences a century earlier of sculptors such as Harriet Hosmer, Falkenstein matured as an artist during these years abroad, creating a significant body of works of great originality. Like Sam Francis, Joan Mitchell, and Ellsworth Kelly, Falkenstein found Paris inspirational. Direct contact with European masters such as Brancusi, Arp, and Giacometti, coupled with access to works of the School of Paris and the freedom of movement far from the competitive environment of New York, made Paris a liberating and fruitful environment. In the welded wire sculptures known as the "Sun Series," Falkenstein created work that demonstrated her rejection of the closed, defined, and measurable world of Euclidean geometry in favor of an active curved space illustrative of her understanding of topology. The flowing and continuously expanding forms of topological space are related directly to Falkenstein's understanding of Einstein's theory of relativity:

> So when I'm talking about expanding space, I'm thinking in terms actually Einsteinian, the Einstein attitude of the expanding universe. I'm thinking about total space, that you do not make something to displace space but whatever you do is part of space. It's a through thing. It's not something that pushes space away from it, but space goes through it.[19]

Thus, one underlying principle of Falkenstein's art is never to create objects or images that imply that one can entrap or separate space from the unity of the natural world.

To illustrate this concept sculpturally, Falkenstein often employs "the sign of the U," a curved, open linear shape flattened at both ends. In the monumental *U as a Set* (Fig. 17–3) a mass of U signs made of copper tubing have been welded into a gigantic shape, which is also a "U" over 20 feet long. It is placed against a "wall" of fountain jets and isolated in its own reflecting pool on the campus of California State University in Long Beach. The interaction of active linear forms in the sculpture and the shooting sprays of water provide two parallel references to the motion of natural forces.

Falkenstein's works constantly surprise and confound programmed expectations of sculpture, painting, or architecture. Although she came to maturity in the era of second-generation Abstract Expressionism and her works can be seen in that historical context, they do not fit easily or securely within a specific period, movement, or group. Emerging from a firm philosophical base, their quality resides in a high level of distinctive, individual expression.

Figure 17–3 Claire Falkenstein, *U as a Set—A Fountain.* 1966. California State University, Long Beach, CA. Copper tubing, 14 × 20 × 10 ft. *(Courtesy estate of Claire Falkenstein)*

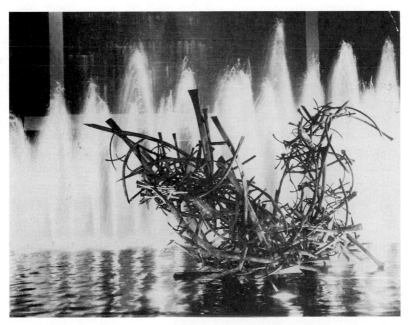

THE FEMALE BODY IN PAINTING AND SCULPTURE

Other artists in the 1960s eschewed the dominant modernist forms of abstraction and instead opted to focus on works that direct attention to the female body. Artists who focused on the body were largely marginalized and worked to a great degree without public recognition until the feminism of the 1970s directed attention to their works, which then appeared to anticipate the concerns of the next generation of women artists.

- Alice Neel, *Pregnant Maria*

With total indifference to the trends in the art world since World War II, ignoring fluctuations of taste and the pervasive abstraction of the 1950s and 1960s, Alice Neel (1900–1984) created a body of works, almost all portraits, of supreme individuality and psychological intensity. After forty years of painting, it was only in 1974 with a major retrospective at the Whitney Museum in New York that her oeuvre became recognized outside of a small circle of cognoscenti. Neel's gifts spring from her unique ability to pierce the "protective strategies" which people assume, revealing the soul beneath the surface.[20] With deceptive modesty, Neel has said, "I usually know why people look the way they look."[21] Pamela Allara's detailed study[22] of this artist provides us with a much more detailed picture of the cultural matrix in which Neel's art was created.

Born in a suburb of Philadelphia, Neel recalls always knowing she would become a painter. Avoiding the Impressionist-dominated Pennsylvania Academy of Fine Arts, she received her training in the more traditional academic curriculum of the Philadelphia School of Design for Women between 1921 and 1925. That year she married an artist from a wealthy Cuban family, Carlos Enriquez. The death of her first daughter, the disintegration of her marriage, and the impoverishment of the Depression led to a suicide attempt and total nervous breakdown in the early 1930s. From these painful experiences, Neel emerged to settle in New York City and eventually receive a small stipend from the WPA. Neel only began to receive some recognition in the art world when she won a prize for one of her portraits in 1962.

As Ann Sutherland Harris has observed, Neel has turned the conventions of portraiture inside out by operating outside of the confines of the commissioned work.[23] Without catering to the tastes or desires of her patrons, the artist selects her sitters, positioning them in her own studio rather than integrating them into their own environment. This absence of conventional portrait patronage has permitted Neel to paint some segments of humanity rarely, if ever, recorded in paint. Neel's sitters are drawn from the broadest range of social and economic classes. They include art world celebrities, such as Andy Warhol, members of the intelligensia, such as Linda Nochlin, and ordinary working-class minority persons, such as her

Haitian housekeeper, Carmen, portrayed nursing her developmentally damaged child.

Between 1930 and 1978 Neel executed a series of nude portraits of pregnant women, sometimes reclining as in *Pregnant Maria,* at other times upright. Neel has justified her attention to pregnancy by noting its importance in life and its neglect by other artists.[24]

One of the most marked characteristics of Neel's images is their specificity. They never descend into stereotypes or generalizations. Even in the subcategory of nude pregnant portraiture, which Neel practiced sporadically throughout her career, the individual retains her own unique identity. This is clearly apparent in *Pregnant Maria.*

Like Manet's *Olympia, Pregnant Maria* presents an image of a whole person, unashamed of her nudity or obvious pregnancy, confronting the viewer with dignity and apparent lack of self-consciousness. No female fertility goddess or archetypal earth mother, this very real individual does not symbolize "Maternity," but embodies the physical human fact of childbearing.

Characteristically, Maria is positioned very close to the viewer in the extreme foreground, with little depth indicated. This forces a direct interaction between portrait subject and viewer. Also in a typical fashion, some portions of the canvas are treated with a great deal more detail and modeling than others. Maria's face, breasts, and distended belly are fully modeled, giving them a tangible presence, while the receding foot and

Figure 17–4 Alice Neel, *Pregnant Maria.* 1964. Oil on canvas, 32 × 47 in. *(Courtesy Robert Miller Gallery, New York. © Estate of Alice Neel)*

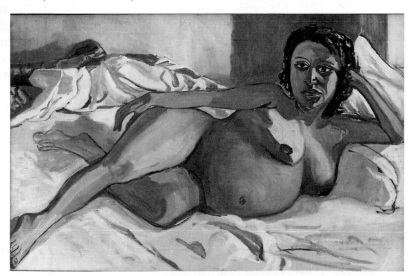

background are undetailed and unmodeled. Clearly defined contour lines and visible brushwork also characterize the style of the painting.

Neel's talent lies in her unique ability to present the essence of her sitter, not merely his or her surface ornamentation. She calls this "telling the truth":

> I do not know if the truth that I have told will benefit the world in any way. I managed to do it at great cost to myself and perhaps to others. It is hard to go against the tide of one's time, milieu, and position. But at least I tried to reflect innocently the twentieth century and my feelings and perceptions as a girl and a woman. Not that I felt they were all that different from men's.
>
> I did this at the expense of untold humiliations, but at least after my fashion I told the truth as I perceived it, and, considering the way one is bombarded by reality, did the best and most honest art of which I was capable.[25]

Linda Nochlin identifies this ability to tell the truth about an individual's personality as a characteristic most appropriate to the socialization processes of women:

> In the field of portraiture, women have been active among the subverters of the natural laws of modernism. This hardly seems accidental: women have, after all, been encouraged if not coerced, into making responsiveness to the moods, attentiveness to the character-traits . . . of others into a lifetime's occupation. What is more natural than that they should put their subtle talents as seismographic recorders of social position, as quivering reactors to the most minimal subsurface psychological tremors to good use in their art.[26]

Alice Neel, more than any other contemporary artist, has exploited this female trait of insight to generate a large body of extraordinarily powerful images.

- Niki de Saint-Phalle, *Hon (She)*

Born in 1930, Saint-Phalle spent her youth in New York, but her life as an artist began with her return to Europe in 1952. She had her first one-person show in 1956 in Switzerland, and she was given a retrospective exhibition at the Pompidou Center, Paris, in 1980 and at the Nassau Museum, Long Island, in 1988.

Living with the artist Jean Tinguely, known for his late Dada-inspired performance art, Saint-Phalle's early work incorporated found objects. In works such as *Bride* and *Accouchment,* dolls and other small-scale toys are affixed to a figural image and then painted for uniformity. The immediate precedent for *Hon* was the series of giant *Nanas* she created beginning in

1965. Brightly painted, massive, and awesome, the *Nanas* took back the primordial power of the female body.

Hon (She) was created in 1966 as a temporary installation for Stockholm's Modern Museum. This work stretched 82 feet in length. Viewers entered the figure through a door in the vagina. A milk bar was installed in one breast and a film was projected in a different portion of the interior. Chadwick states that this work "reclaimed woman's body as a site of tactile pleasure rather than an object of voyeuristic viewing; the figure was both a playful and colorful homage to woman as nurturer and a potent demythologizer of male romantic notions of the female body as a 'dark continent' and unknowable reality."[27]

* Louise Bourgeois, *Cumul I*

Bourgeois was born in 1911 into a French family in which her artistic talents were not only recognized but put to use. Her parents restored Aubusson tapestries, and her job as a child was to draw in the missing parts to guide the weavers. She received a classical education at the Sorbonne, where she studied philosophy and geometry. She also studied art history at the Ecole du Louvre and acquired academic training in the fine arts at the Ecole des Beaux-Arts, which she attended from 1936 to 1938. She moved to New York in 1938 and has lived there ever since.

Since the late 1940s Louise Bourgeois has created works of sculpture that express a highly personal symbolic system. Unaffected by the successive art movements that have dominated the art world since World War II, she has pursued personal goals, tenaciously seeking formal equivalents for the constants underlying the human condition. Working in a wide variety of media, ranging from traditional sculptural materials, such as marble, wood, and bronze, to impermanent latex, Bourgeois's works explore the relationship between man and woman and the concept of androgyny, as well as seeking equivalents for emotional states.

In the late 1940s Bourgeois created simple wooden structures that convey a powerful and eerie presence. *The Blind Leading the Blind*, for example, consists of a double row of upright wooden posts that taper to pointed "feet." An irregularly shaped lintel connects the posts. The almost uniform uprights are easily interpreted as anonymous, unindividualized persons. The lintel binds them together, turning the separate posts into an architectural structure. Painted black, like Nevelson's later constructions, the work conveys a sense of monotonous menace. It is interesting and relevant that this work was created during the McCarthy era, around the time when Bourgeois, Duchamp, and other artists were being investigated by the House Committee on Un-American Activities. This work, then, may be interpreted as a reflection of the paranoia about

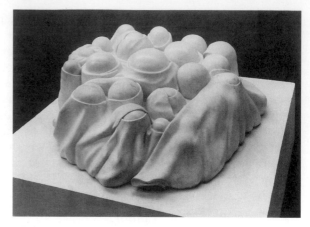

Figure 17–5 Louise Bourgeois, *Cumul I.* 1969. Marble, 22⅜ × 50 × 48 in. *(Photo courtesy of the artist and the Musée National d'Art Moderne, Centre Georges Pompidou, Paris)*

communism that had temporarily seized the government machinery of the United States.

The use of a group of regular units is also seen in Bourgeois's "Cumul" series from the late 1960s (Fig. 17–5). In these works, most of which are carved in marble, rounded forms seem to be bursting through or growing out of undifferentiated matter. Like spores emerging from a sac, or a penis becoming erect, these rounded forms, which also could be interpreted as breast shapes, are symbols of a life force. They evoke a sense of eclosion and androgynous generation.

Bourgeois's works do not fit within a stylistic movement or a neatly defined category. She has worked in a wide variety of media and in a range of different styles, adjusting her formal means to fit her expressive intent. She deals with the most fascinating questions of the human spirit—the relationship between the sexes and the relationship between the individual and the society in which he or she lives.

Although Bourgeois often uses carved marble, that most traditional of all sculptural materials, her imagery is unique, and there is little point in trying to relate her works to other famous carvers such as Michelangelo or Rodin. Two major exhibitions, spaced about a decade apart in 1982 and 1993, indicate that Bourgeois's position in the history of contemporary art is finally secured.

PROCESS ART

• Eva Hesse, *Untitled*

Eva Hesse's (1936–1970) mature and significant career as an artist is concentrated within the brief span of five years, 1966 through 1970, the year

she died from a brain tumor at the age of 34. During this time, she created a number of sculptures that differ in many ways from the prevailing contemporary aesthetic of Minimalism. As a post-Minimalist, Hesse's works were formally, technically, and conceptually innovative and influential for the direction of sculpture during the 1970s. Her oeuvre is well documented, and her contribution to the history of contemporary art is significant.

Born in Hamburg into a German Jewish family, she and her sister escaped extermination in the Holocaust by leaving Germany on a children's train bound for neutral Holland. Her parents rejoined them several months later, and the family settled in New York City in 1939. New traumas came when her parents were divorced and when, the following year, her mother committed suicide. By age 16, Hesse had decided to become an artist. She studied at several New York art schools: Pratt Institute, the Art Students League, and Cooper Union. From 1957 to 1959 Hesse attended Yale University's School of Art and Architecture. Returning to New York City, she integrated herself into the avant-garde art community. In 1961 she married the artist Tom Doyle, and in 1964 the couple spent a year in Germany. During this stay abroad, Hesse abandoned painting and started making three-dimensional, biomorphic reliefs, related in form and spirit to Surrealism.

In 1966 two emotionally traumatic events occurred in Hesse's life: Her marriage ended and her father died. She emerged from these crises a mature sculptor with a personal style and direction. That same year she participated, along with Louise Bourgeois, in a group show called "Eccentric Abstraction," curated by Lucy Lippard. This exhibition first defined the post-Minimal process-oriented attitude of a group of contemporary sculptors.

Hesse shared with Claes Oldenburg, Robert Smithson, Lucas Samaras, and Louise Bourgeois an aversion to the ponderous, architectural ambitions of Minimalist sculpture. Hesse was one of the first artists to use a wide range of nontraditional materials to make her objects. Her earliest works were made from limp and pliable materials, such as cord, rubber tubing, or wire, emerging from boards mounted on a wall. Hesse's works often employed the repetition of similar units. She was very aware and deliberate about her intentions. In the last year of her life she told an interviewer:

> If something is meaningful, maybe it's more meaningful said ten times. It's not just an esthetic choice. If something is absurd, it's much more absurd if it's repeated . . . repetition does enlarge or increase or exaggerate an idea or purpose in a statement.[28]

In 1967 Hesse made *Repetition Nineteen,* in which nineteen nearly identical buckets are scattered about the floor. That same year she discovered latex rubber, a sensuous and flexible but impermanent material. The following year she also began working with fiberglass.

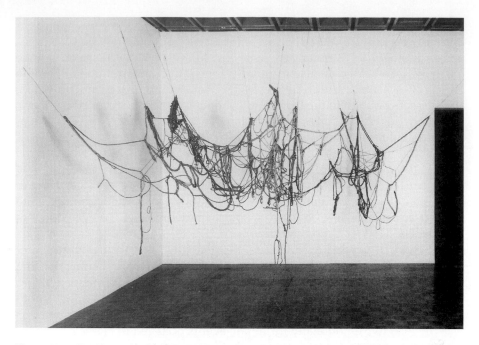

Figure 17–6 Eva Hesse, *Untitled (Rope Piece)*. 1969–1970. Latex over rope, string, and wire. Two strands: dimensions variable. *(Collection of Whitney Museum of American Art. Purchase, with funds from Eli and Edythe L. Broad, the Mrs. Percy Uris Purchase Fund, and the Painting and Sculpture Committee 88.17a–b. Copyright © 1995: Whitney Museum of American Art. Photo by Geoffrey Clements)*

Anna Chave has analyzed Hesse's search for new and original ways "to articulate a feminine sexual subjectivity. . . . Rather than use her art to refuse the socio-historically invisible position of being a woman, Hesse worked to attest to that very sense of vacancy or absence and the pain it entails."[29] Chave finds the body imagery in Hesse's work to be "a body in pain . . . mutilated, dismembered or flayed."[30] Chave identifies the work illustrated (Fig. 17–6) as an example of what Hesse was trying to achieve in a series of negations. Hesse wrote in 1969, "I wanted to get to non art, non connotive, non anthropomorphic, non geometric, non, nothing."[31] Chave builds a case to understand Hesse as "more or less seriously ill throughout her life, and that she almost always viewed herself as sick."[32]

Hesse suffered from depression and anticipated her own death as a suicide, like that of her mother. She experienced severe pains in her legs in Germany, so severe that she could barely stand. Her materials, malleable, fragile, and soft, relate to spinning, weaving, sewing, knitting, wrapping, and bandaging—all associated with women's work. "But in becoming a professional sculptor— . . . one who courageously refused both academic

and avant-garde orthodoxies— . . . Hesse effectively declined such stulti-
fying roles, while inverting the means and material of women's art into a
mode of self empowerment."[33] Chave characterizes our fascination with
Hesse's art in the following way:

> "The noisome scent of decay which seems to emanate from Hesse's sculpture
> helps explain its chilling effect on viewers, as it plays on our fears of contami-
> nation and dissolution, on our gnawing sense of our own mortality. . . . She
> made her art out of her illnesses, which substantially defined her identity as a
> woman and (to a lesser degree) as a Jew, as one of the disempowered and
> despised."[34]

The sculpture of Eva Hesse challenges many traditional attitudes
concerning our expectations of the appearance of a piece of sculpture and
the materials used in its construction. In a witty and understated way,
Hesse's works are revolutionary, transforming the medium and the intellec-
tual approach to the creation of a work of "art." Her sculptural oeuvre has
been quite influential and her formative position within the history of
contemporary art is widely acknowledged today.

Suggestions for Further Reading

BETTERTON, ROSEMARY, *An Intimate Distance: Women, Artists, and the Body*
(London and New York: Routledge, 1996).

MESKIMMON, MARSHA, *The Art of Reflection: Women Artists' Self-Portraiture
in the Twentieth Century* (New York: Columbia University Press, 1996).

MUNRO, ELEANOR, *Originals: American Women Artists* (New York: Simon
and Schuster, 1979).

NEMSER, CINDY, *Art Talk: Conversations with Twelve Women Artists* (New
York: Scribner's, 1975).

PUNIELLO, FRANCOISE, *Abstract Expressionist Women Painters: An Annotated
Bibliography* (Lanham, MD: Scarecrow Press, 1996).

SWENSON, LYNN F., and SALLY SWENSON, *Lives and Work: Talks with Women
Artists* (Metuchen, NJ: Scarecrow Press, 1981).

Lee Krasner

HOBBS, ROBERT, *Krasner* (New York: Abbeville Modern Masters, 1993).

LANDAU, ELLEN, *Lee Krasner: A Catalogue Raisonné* (New York: Abrams,
1995).

ROSE, BARBARA, *Lee Krasner: A Retrospective* (New York: Museum of Modern
Art, 1983).

WAGNER, ANNE, *Three Artists (Three Women): Modernism and the Art of Hesse,
Krasner and O'Keeffe* (Berkeley: University of California Press, 1996).

Louise Nevelson

GLIMCHER, ARNOLD, *Louise Nevelson* (New York: Praeger, 1972).

NEVELSON, LOUISE, *Atmospheres and Environments* (New York: Clarkson N. Potter in association with the Whitney Museum of American Art, 1980).

NEVELSON, LOUISE, *Dawns and Dusks* (New York: Scribner's, 1976).

WILSON, LAURIE, "Bride of the Black Moon: An Iconographic Study of the Work of Louise Nevelson," *ARTS Magazine*, 54 (May 1980), pp. 140–148.

Alice Neel

ALLARA, PAMELA, *Pictures of People: Alice Neel's American Portrait Gallery* (Hanover, NH: Brandeis University Press, 1998).

HARRIS, ANN SUTHERLAND, *Alice Neel: 1930–1980* (Los Angeles: Loyola Marymount University, 1983).

HILLS, PATRICIA, *Alice Neel* (New York: Abrams, 1983).

Louise Bourgeois

BERNA, MARIE-LAURE, *Louise Bourgeois*, trans. by Deke Dusinberre (New York and Paris: Flammarion, 1996).

BERNADAC, MARIE-LAURE, and HANS-ULRICH OBRIST, *Louise Bourgeois, Destruction of the Father, Reconstruction of the Father; Writings and Interviews, 1923–1997* (Cambridge, MA: The MIT Press in association with Violette Editions, London, 1998).

MEYER-THOSS, CHRISTIANE, *Louise Bourgeois: Konstruktionen fur den freien Fall (Designing for Free Fall)* (Zurich: Ammann, 1992). (English and German).

KOTIK, CHARLOTTA, *et al.*, *Louise Bourgeois: The Locus of Memory, Works 1982–1993* (New York: The Brooklyn Museum and Abrams, 1994).

WYE, DEBORAH, *Louise Bourgeois* (New York: Museum of Modern Art, 1982).

Eva Hesse

BARRETTE, BILL, *Eva Hesse: Sculpture: Catalogue Raisonné* (New York: Timken Publishers, 1989).

COOPER, HELEN, *et al.*, *Eva Hesse: A Retrospective* (New Haven, CT: Yale University Press, 1992).

LIPPARD, LUCY, *Eva Hesse* (New York: New York University Press, 1976).

18

Contemporary Art: 1970 – Present

During the past thirty years, women artists have created a vast, varied, and original quantity of works of art. No longer bound by the confining and limiting gender stereotypes of earlier periods, contemporary women artists have created art in a broad range of techniques and formal idioms. Clearly, for this chapter, our selections become much more arbitrary and difficult to make.

The energy and force of the women's liberation movement in America, in the early 1970s, generated new subjects, techniques, and inspiration for women artists. Largely bypassed by the coolly rational and ironic aesthetics of Pop Art and Minimalism, women artists began impacting very directly on the art world as a whole. In 1980, one critic looking back on the decade confidently proclaimed "For the first time women are leading, not following."[1] That leadership role occurred in a number of different media and directions, exemplified by the artists included in this chapter.

Women artists first began incorporating subject matter derived from personal experience into the work of art. This inaugurated a shift from Minimalism to the era known as "Pluralism" or "Postmodernism." Frequently subjects were autobiographical and focused on the specific experiences of being female. In an effort to integrate the private realm with the public activity of the art work, women artists adopted the feminist slogan "The personal is the political." As one male artist succinctly observed: "Women have made subject matter legitimate again."[2] Women artists employed a wide range of media for the expression of content. Whether it appeared in the traditional forms of painting or sculpture or in the rituals of performance art, the validity of using material summoned from the artist's life as a woman had immense consequences for the entire art world.

241

In *The Power of Feminist Art*, published in 1994, and edited by Norma Broude and Mary Garrard, the full extent and impact of women artists' creativity in the visual arts in this decade is given more complete discussion than is possible within the scope of this book. The selected examples of works by a few artists active in the movement indicate the range and scale of this explosion of women's creativity in the 1970s. This period offers a marked contrast to the isolation often experienced by women artists in earlier times.[3] Women's political organizations and alternative exhibition systems were an important factor in building networks of support that encouraged this art to flourish.

While critical consensus identifies the 1970s as an extremely active and fruitful epoch for women artists, this situation began to change in the early 1980s. Coinciding with the political rise of Reagan and the Moral Majority, coupled with the defeat of the ERA amendment, the cultural backlash against women artists was in full force by 1984, the year of the inaugural exhibition of the newly refurbished Museum of Modern Art in New York City. In that international survey of trends in the arts, only 14 of 150 works were by women. The underrepresentation of women in that major show stimulated the formation of the "Guerrilla Girls," an anonymous activist group who appear in public wearing gorilla masks. They are the self-proclaimed "conscience of the art world." The Guerrilla Girls remain quite active in the struggle of women artists for recognition and equality in the most prestigious institutions of the art community. The abysmal record of the Whitney Museum in showcasing women artists has been a specific target of their attacks.

The declining fortunes of women artists in the 1980s could be measured economically. Funding by the National Endowment for the Arts for women artists' organizations such as cooperative galleries declined 35 percent between 1982 and 1985.[4] According to an NEA report, women artists made an average annual income of less than half that of men. While 38 percent of practicing artists were women, only a very tiny minority was able to maintain public careers as artists. In the spring of 1987, the National Museum of Women in the Arts opened to the public in Washington, D.C., with a major historical exhibition of works by American women artists.[5] The establishment of this institution reopened the debate over the role of women artists and feminism in the art world.[6] Some people believed that the "ghettoization" of work by women in a separate museum was not a positive move. Others felt that the concept was valid if the museum functioned on a feminist agenda, working to improve the situation of living artists. The politically conservative founder, Mrs. Wilhelmina Cole Holladay, whose private collection forms the core of the museum's permanent collection, has publicly refused to use the museum as a feminist forum. Since its "birth" this institution has hosted a series of historically significant shows, published with scholarly catalogs, that have expanded the literature on women artists.

Some talented women artists have produced original and exciting art that may be defined quite loosely as "Postmodernism." These works do not specifically reference issues of concern to feminists. Since it is important to recognize the diversity of interests of contemporary women artists, this chapter begins with a selection of works in painting and three-dimensional media selected for their high quality and originality as well as their influential role in the art world. However, in our text, which is focused on women artists, it is appropriate to recognize and emphasize the works of those artists directly impacted by the cultural and theoretical discourses of feminism. The second half of this chapter traces the variety of artistic projects that reflect feminist theoretical concerns in some manner. The overwhelming importance of the female body for a wide group of artists has encouraged me to focus on this theme to clarify some of the issues of representation for contemporary artists. I conclude with a discussion of the identity politics of Africana artists. The special theoretical concerns of black women artists seemed to be best addressed in a subcategory of this topic.

PAINTING: EXTENDING THE BOUNDARIES OF ABSTRACTION

• Elizabeth Murray, *Sail Baby*

Elizabeth Murray's witty, inventive paintings of the 1980s demonstrate the survival of abstraction as a viable mode in contemporary painting. However, Murray's style of abstraction is filled with organic forms, references to content, narrative, and synthetic Cubist still life objects and could not be further removed from the reductivist geometry of 1960s Minimalism or other formalist aesthetic systems.

Murray was born in Chicago in 1940 but received her masters in fine arts in 1964 from Mills College, in the San Francisco Bay area. Moving to New York in 1967, her development proceeded slowly through the 1970s. From an early interest in narrative and cartooning, Murray spent much of the 1970s experimenting with the formal possibilities of oil paint, enlarged scale, shaped canvases, and highly saturated color. Only in the early 1980s did Murray acquire the self-assurance and control of her formal means to create fascinating and unique paintings that can generate multiple and ambiguous associations while avoiding programmed or specific narrative content.

Sail Baby (Fig. 18–1) is characteristic of Murray's mature paintings on a number of levels. First, it is composed of three individual canvases. Murray's 1980s paintings most frequently employ multiple canvases, which echo or contradict the forms depicted on them. Often, as in this example, painted shapes are continued from one canvas to the other, generating an obvious tension between the physical facts of the painting, that is, the

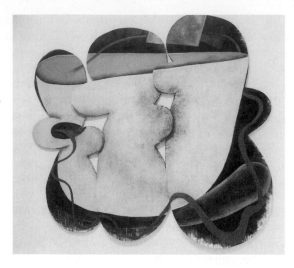

separate canvases and the painted illusion that unifies those physically distinct canvases. Another characteristic of Murray's art is the presence of large areas of highly saturated colors. The frequently depicted coffee cup, here in a brilliantly saturated yellow with a sky-blue interior edge, is "supported" by a magenta saucer shape underneath.

Also, *Sail Baby* has a narrative meaning. Murray notes that this painting is "about my family. It's about myself and my brother and my sister, and I think, it's also about my own three children, even though Daisy wasn't born yet."[7] This painting expresses the tension between individual identity and the emotional bonding within families. In fact, every form in this painting helps to unify this image and work against the physical separation of the three canvases. The shape of the cup and saucer most obviously bridges the canvases. A serpentine emerald-green linear element weaves about in a continuous counterclockwise motion from the "hole" in the handle of the cup to its disappearance into the sky-blue interior of the cup. The whole form is set against a wine-red ground, which on its lower edges reveals a dripped paint surface of yellows and blue. Therefore, in terms of method of paint application, *Sail Baby* contains a range from gestural definition to hard edge, from evenly painted surfaces to dripping, residually Abstract Expressionist spontaneity.

The green serpentine is the most obvious element in *Sail Baby* that reveals Murray's obsession with movement. "Elizabeth Murray's art has always been in motion and about motion. . . . Everything is in flux, is undergoing a process of change and distortion that is visually strange and abstract, but also psychologically real. . . ."[8]

It is exciting to see an artist find ways of using the traditional medium of oil painting in a very innovative and also very personal way. Murray's

paintings are full of formal surprises that remain engrossing because they resonate with human implications.

THREE-DIMENSIONAL WORKS: FIBER ART, SITE-SPECIFIC SCULPTURE AND INSTALLATIONS

Women artists have been important participants in every movement and all phases of art in three dimensions. Although historically, sculpture was outside of the accepted genres for women, we have seen, especially in the last chapter, the emergence of women as sculptors of the highest level of creativity.

- Magdalena Abakanowicz, *Embryology*

The work of Magdalena Abakanowicz is one of the most persuasive reasons to abandon any inherent devaluation of craft from the "fine art" of sculpture. The Polish artist is today widely recognized as the foremost artist working with fiber. She has built an international reputation since the 1960s, moving from her initial medium of weaving, to sculpture in fiber and wood, to other more permanent materials.

Born in 1930 into an aristocratic family of the Polish landed gentry, Abakanowicz's youth was spent in the upheavals of World War II and its aftermath in Poland. She studied from 1950 to 1954 at the Academy of Fine Arts of Warsaw without finding a clear direction as an artist. It was only in the early 1960s, on a borrowed loom, that her original vision found its means of expression. Exhibiting regularly in the Lausanne Biennial of Tapestry from 1962 through 1979, she began to receive international recognition for her extraordinary creations.

Her first major works were the huge woven structures known as *Abakans*. These enormous, freely hanging objects, full of slits and negative spaces, exist in three dimensions and transform the medium of tapestry into the realm of monumental sculpture. They signaled a new set of possibilities for the use of fiber. Beginning in 1973, Abakanowicz abandoned the loom and the weaving process while maintaining the use of natural organic fibers, now pressed into molds. The "Seated Figures" and "Backs" series are evocative symbols of community and anonymity, individuality and similarity.

Mary Jane Jacobs, curator of the major retrospective exhibition that traveled about the United States and Montreal from 1982 to 1984, identifies *Embryology*, created in 1978 to 1980 (Fig. 18–2), as Abakanowicz's masterpiece.[9] Composed of hundreds of rounded forms of various sizes, the shapes are cut and stitched. Some are closed opaque shapes covered in rough burlap. Others are semitransparent, gauze-covered forms that reveal their interior stuffing. Composed of hand-made thread that the artist soaked, dyed, rinsed, and dried in a complex process, "the cycle is about

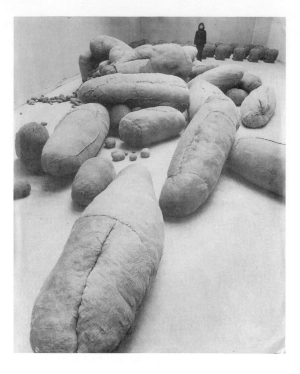

Fig. 18–2 Magdalena
Abakanowicz, *Embryology.*
1978–1980. *(Photo by Jan
Nordahl, Sodertalje,
Sweden/©Magdalena Abakanowicz;
licensed by VAGA/Courtesy
Marlborough Gallery, NYC.)*

the process of birth and growth in human beings and in nature and the changes that bodies or earth undergo when cut or altered."[10]

In the 1980s, Abakanowicz shifted from soft materials to the use of a full range of permanent materials for her sculpture, including aluminum and bronze casting. As documented in a monograph by Barbara Rose, it is clear that this artist no longer fits into the niche of "fiber art." More recent work reveals a shift from "environmental installation to contextually sited sculpture"[11] most vividly with the seven upright 12-ton disks of stone quarried in the Negev desert for *Negev,* commissioned for the sculpture garden of the Israel Museum in Jerusalem (1987).

- Maya Lin, *The Vietnam Veterans Memorial*

By far, the most famous and important site-specific monument of our contemporary world is the extraordinary Vietnam Veterans Memorial (VVM). It is hard to conceive of a greater challenge to America's artists than the invention of a design for a memorial to those who died in Vietnam.[12] For a war in which winning and losing lost their significance, a war in which there were no heroes but only survivors, the task of finding a form that would honor and commemorate the dead without glorifying this inglorious war might seem an impossible task. The achievement of Maya Lin, then an

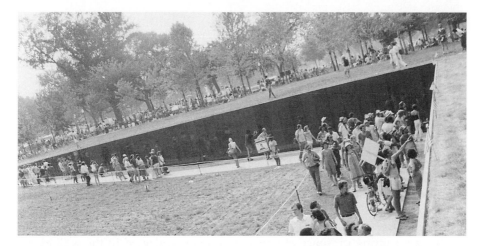

Fig. 18–3 Maya Lin, *The Vietnam Veterans Memorial.* *(Pearson Education/Prentice Hall College.)*

undergraduate architecture student at Yale, in inventing the design of the memorial seems all the more remarkable.

The Vietnam Veterans Memorial owes its existence to the Vietnam Veterans Memorial Fund founded by Jan C. Scruggs in 1979. This group lobbied for a site in Washington and succeeded in this goal in 1980, when President Carter authorized the establishment of the monument on two acres of the Mall of the U.S. Capitol. With the securing of the site, an enormous open competition took place in which over 1,400 final entries were submitted. Lin's winning design was announced on May 1, 1981. The memorial was finished in 1983.

This powerfully simple work is neither sculpture nor architecture, but a hybrid form derived in its essential, utterly simple formal vocabulary from the tenets of Minimalism. The memorial consists of two triangular walls that form an arc, meeting at about 125 degrees. The viewer moves along a 247-foot-long path on either end, constantly descending into the earth, to a depth of over 10 feet at the point of intersection. The visitor then makes his or her ascent. The walls create a structure without enclosing space. The descent into the earth is an extremely powerful aspect of the experience of the memorial and one with an ancient history in funerary monuments. From the buried tombs of the Pharaohs to the tholos tombs of Mycenae, burial in the life-giving body of Mother Earth has provided solace for survivors and signified respect for the dead.

The cool simplicity of a Minimalist vocabulary seen in the identical triangular walls appears as a necessary form of intellectual control given the immense emotional power of the experience. As our national "wailing wall" with the ability to evoke such depths of mourning, the need for a spare language with an intellectually or rationally clear form seems appropriate.

The material for the walls, a very highly polished granite, was another important component of the overall design of the memorial. A total of seventy granite slabs compose the two walls. Engraved into the slabs are the individual names of every person killed in Vietnam, listed chronologically by date of death. The years encompassing the conflict, 1959 and 1975, are inscribed in the center angle. This most modern war memorial turns upside down the concept of the "tomb of the unknown soldier." One dead body does not abstractly symbolize all casualties. Every individual who died is evoked, one by one, by name. No trite generalizations are permitted to relieve the awareness of individual sacrifice.

The granite surface both contains the names of the dead and functions as a mirror reflecting the image of each visitor. Thus, no matter how aggressively one might wish to distance oneself from the consciousness of the human cost of Vietnam, every visitor is by definition a part of the memorial by the unremitting presence of one's own image reflected in the wall every step of the way. There is no way to remain "outside" the experience of the monument once one has initiated the descent. Lin has referred to the VVM as a "scar." She said "Take a knife and cut open the earth, and with time the grass would heal it."[13] Lin also intended the memorial to serve as "a cathartic healing process."[14] Charles Griswold believes that the "main purpose of the memorial is therapeutic, a point absolutely essential for an adequate understanding of the VVM."[15]

In the *New York Times*, on Veterans Day, November 11, 1994, Gustav Neibuhr described the memorial as "something like a sacred shrine, where pilgrims come and devotions are paid."[16] The memorial regularly attracts more visitors than either the Washington Monument or the Lincoln Memorial. Over 30,000 items have been left at the site, and these, coupled with the reverence and the emotions visitors often display, encourage authorities on religion to relate the visitors' experience to that of pilgrims at religious sites such as Lourdes, Buddhist holy shrines, or the "Wailing Wall" in Jerusalem.

Despite the controversies at the beginning of the project and the addition of highly realistic statues, the power of this memorial seems to grow stronger through the years. The beauty, power, and immense originality of the VVM has penetrated into America's consciousness. This great work has redefined the form of a fitting monument to the dead and proven to be a magnet for an entire nation that lived and suffered through those terrible years. The VVM exists for everyone, not only the comrades and families of the slain.

• Jenny Holzer, Untitled, Installation in Guggenheim Museum, 1989

Jenny Holzer (born 1950) is one of the most important artists to have generated highly original ways of communicating through words. Her verbal messages are exhibited in inventive ways not anticipated by any other artist. She has imprinted her words on a wide range of media such as

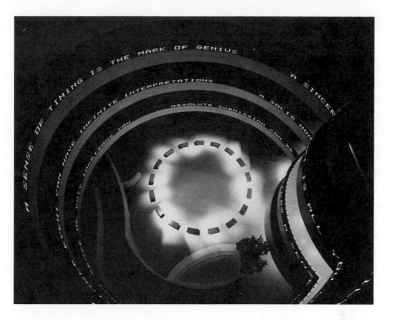

Fig. 18–4 Jenny Holzer, Untitled, installation in Guggenheim in Wilkins.
(Courtesy of Solomon R. Guggenheim Foundation, New York.)

metal plaques, stone benches, as well as on the Times Square Spectacolor board in New York City and on electronic LED (light-emitting diode) boards of various sizes.

Born into a middle-class and nonartistic family in Ohio in 1950, Holzer studied art formally at the University of Chicago, Ohio University, and the Rhode Island School of Design in Providence. She spent these years mostly painting abstract works.

In 1977, Holzer created her first mature series, *The Truisms*. In pithy one-liners, such as "Abuse of power comes as no surprise," she first committed herself to language as her primary medium. However, even in her first works, Holzer was highly sensitive to the ways in which language communicates in a visual sense. *The Truisms* became posters, plastered in public on buildings in lower Manhattan, T-shirts, and billboards.

Beginning in 1982, she began using LED machines, which first displayed *The Truisms*. In 1989, Holzer took over the space of the Guggenheim Museum. By means of large LED boards her messages zapped around and across Frank Lloyd Wright's central void, finding yet another way in which the medium and the message could be reinvented. According to Diane Waldman, "Holzer's signs, benches and sarcophagi seem permanent and totemic no matter how swiftly her messages flash on and off the boards. The message is the medium and then some."[17]

Holzer's art proceeds from a conceptual base. Her creative input is in the writing of the texts and control of their dissemination. Her interest in language is not unusual in the context of Postmodernism. As in the work of Mary Kelly and Barbara Kruger, words are simply too important, too powerful a means of communication to be banished from the work of art.

THE FEMINIST ART MOVEMENT OF THE 1970S

The history of a contemporary feminist art movement is generally traced back to 1970, the year Judy Chicago founded the first feminist studio art course at Fresno State College in northern California.[18] It is also the year that Judy Gerowitz abandoned the patriarchal association of her father's name and selected the surname "Chicago" from the city of her birth and initial formal education at the Chicago Art Institute. That same year she showed the first images characterized by the centrality of vaginal imagery, which would dominate her art for the next decade. The following year, in 1971, she teamed up with Miriam Schapiro, who had been living in California since 1967. Together they developed a feminist art program at the California Institute of the Arts in Valencia.

The energy generated from these pedagogical experiments led to the communal art installation known as *Womanhouse*.[19] Working with a team of students, Schapiro and Chicago supervised the renovation of a run-down building in Hollywood, designing installation works in each of the rooms. The walls and ceiling of the "Kitchen" (by Robin Weltsch) were covered in breast-shaped eggs. Schapiro, in collaboration with Sherry Brody, created a dollhouse whose forms and fabric elements would influence the course of her art for the next few years, while Chicago created the more aggressive "Menstruation Bathroom." Set into the sterile white environment of the typical American bathroom, a garbage can revealed the evidence of female menstruation cycles.

These artists' distinct contributions to *Womanhouse* are illustrative of the diverse directions their feminist art would take during the 1970s. *Womanhouse* was a catalytic force for Los Angeles's women artists' community and led directly to the founding in 1973 of the Los Angeles Woman's Building.

PATTERN AND DECORATION

• Miriam Schapiro, *Barcelona Fan*

Miriam Schapiro's contributions to the feminist art movement and the entire school of painting known as "pattern painting" or "decorative art" are well established. Her monumental compositions, which deal directly

with the objects and life experiences of women, have received regular and consistently positive critical appraisals. Her ability to generate symbols based on historically grounded artifacts of women's life experiences provides a convincing case for the existence of a woman's culture that has survived and flourished through the centuries of patriarchy.

Born in 1923 and formally trained at Hunter College, Schapiro received her M.A. in fine arts from the University of Iowa in the early 1950s. Throughout that decade, she worked in an Abstract Expressionist style that contained veiled references to the human figure. Despite the execution in 1960 and 1961 of a large series of paintings that incorporated the personal symbol of the egg and the house as confining structure, by 1965 the artist had succeeded in erasing all personal metaphor and iconography from her abstractions.[20]

A turning point in her development occurred with the creation of the mural-scaled *Big OX #1* in 1968. The painting is dominated by an orange structure, hexagonal in shape, whose orifice is edged in pink. Four orange arms stretch to the corners of the composition, forming the "X" to the hexagon's "O" of the title. Despite the hard-edged style, the coloration and central imagery identify this transitional work as one loaded with female body imagery.

Her collaboration with Judy Chicago was a catalyst for Schapiro. After executing in 1972 (with Sherry Brody) the dollhouse, which was exhibited in *Womanhouse*, Schapiro began to explore and exploit the potential of patterned fabric to carry beauty and significance in a high-art context. By 1973–1974 she had developed a style that combined fabric collage and painting, structured within an architectural framework. She named her new formal interest "Femmage": collages developed from materials and themes of concern to the lives of women. Bridging her return to New York in 1976, Schapiro worked on a series known as "Collaborations," which incorporated reproductions of works of art by women artists of the past.

Between 1976 and 1979 Schapiro exhibited a series of monumental works based on the form of the kimono, the fan, and the robe (the "Vestiture" series). These magnificent, impressive, and monumentally scaled works break down any meaningful distinction between the concerns of abstraction and the "merely" decorative use of patterning in craft objects or fabric design. Like the nineteenth-century American quilts, these works set new standards as complex abstract statements. Schapiro was now one of the leading figures in the Postmodernist movement known as "pattern painting," defined by John Perrault in the following way:

> Pattern painting is non-Minimalist, non-sexist, historically conscious, sensuous, romantic, rational, decorative. Its methods, motifs, and referents cross cultural and class lines. Virtually everyone takes some delight in patterning, the modernist taboo against the decorative notwithstanding. As a new painting style, pattern painting, like patterning itself, is two dimensional,

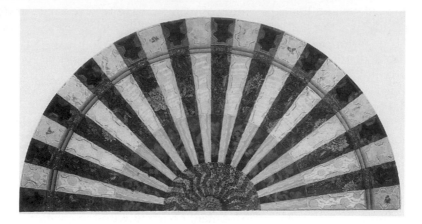

Fig. 18–5 Miriam Schapiro, *Barcelona Fan*. 1979. Fabric and acrylic on canvas, 6 × 12 ft.　*(Courtesy Miriam Schapiro and The Metropolitan Museum of Art, Gift of Steven M. Jacobson and Howard A. Kalka, 1993. All rights reserved, The Metropolitan Museum of Art, 1993.408)*

non hierarchical, all over, a-centric, and aniconic. It has its roots in modernist art, but contradicts some of the basic tenets of the faith, attempting to assimilate aspects of Western and non-Western culture not previously allowed into the realms of high art.[21]

Schapiro's role as a key generator of this new interest in pattern, which became widespread among a number of artists in the second half of the 1970s, cannot be overestimated.

An outstanding example of a fully developed "pattern painting" is the *Barcelona Fan* (Fig. 18–5). Stretching 12 feet across and 6 feet high, this enormous work is composed of alternating light and dark bands, which generate a continuous and rhythmic movement across the surface. The semicircular shape is divided into four major sections, each composed of alternating strips of fabric. Unity from the core to the outer edges is maintained by the continuity of linear elements from the "handle" to the edge. *Barcelona Fan* is dazzling in its red and gold richness of flowered brocade. The form of the fan metaphorically reveals the unfolding of woman's consciousness. It was exhibited with the "Vestiture" series, which presents "ceremonial robes to celebrate the new meaning of womanhood."[22] These works presented the art world with a new use of fabric and a new definition of the "decorative" and its inescapable significance as "high art," as well as symbolic images suffused with feminist relevance.

In the 1980s Schapiro frequently employed the human figure in her art, often creating dancers. A dancing couple, *Anna and David* (1987), enlarged to 35 feet, was installed in a public space in Roslyn, Virginia, a suburb of Washington, D.C.

In 1988 Schapiro created *Conservatory (Portrait of Frida Kahlo)*, a monumentally scaled painting and fabric collage, stretching nearly 13 feet across. In this work, the figure of Frida Kahlo sits regally in the center, bearing a close resemblance to the features of Schapiro herself. It is hard to imagine an image that more directly testifies to the importance of the role models of women artists of the past, an image that addresses most directly the purpose of this book.

• Judy Chicago, *The Dinner Party*

Chicago's feminist activism culminated in the design and execution of the single most monumental and well-publicized individual work to emerge out of the women's movement in southern California. *The Dinner Party* (Fig. 18–6) was conceived in 1974–1975, exhibited at the San Francisco Museum in 1978, and traveled around the country, finally arriving at the Brooklyn Museum in New York in 1980.

This major installation work is composed of a large triangular table, stretching 48 feet on each side. The monumental table is set on a raised

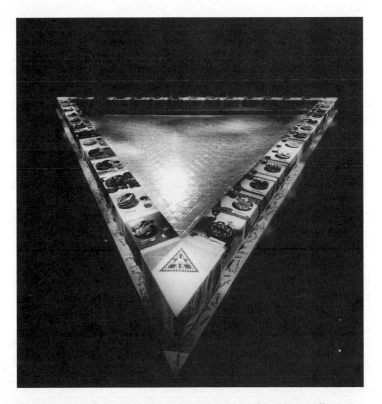

Fig. 18–6 Judy Chicago, *The Dinner Party.* 1979. Multimedia installation, 48 × 48 × 48 ft. *(© Judy Chicago, 1979; photo by Michael Alexander)*

platform, covered with 2,300 hand-cast tiles, on which are written the names of 999 significant women in history. The triangle was selected as the earliest symbol of female power and the sign of the goddess. Each arm of the equilateral triangle supports thirteen place settings. The thirty-nine women selected for this homage range from early goddesses, through Eleanor of Aquitaine, Christine de Pisan, the noted feminist of the early fifteenth century, Artemisia Gentileschi, and Sojourner Truth, to the diverse achievements in the twentieth century of Margaret Sanger and Georgia O'Keeffe. Each of these place settings consists of a porcelain plate, 14 inches in diameter, designed by Chicago to reflect the specific achievements and experiences of these historic figures. The designs of all the plates are based on the central, vaginal imagery so critical to Chicago's aesthetic.

One of the most remarkable aspects of *The Dinner Party* was the complex and beautiful needlework runners that form a major part of the ensemble. More than 100 skilled needle workers executed these. The use of china plate painting and needlework as the key components of this piece form a self-conscious reevaluation of "craft" media, most often practiced by women and barred from consideration as "fine art."

Chicago's ambitious goals for this work were didactic and, in turn, political. By educating women about their unique contributions to history, she hoped to spark social change in today's world.

Whatever reservations one might have concerning the obsessive repetition of vaginal imagery and difficulties in viewing the needlework runners caused by the closed triangular form of the table, *The Dinner Party* fulfilled Chicago's expectations. Shown around the country, it impacted on a very large number of viewers, demonstrating the potential of a work of art, if it was large and clear and strong in its message, to touch the lives of many people in a very direct, immediate way.

However, this work has had a deeply ambivalent reception within the art world. Even feminist art critics have distanced themselves from the imagery labeled in the 1980s as "essentialist." As Josephine Withers so accurately observed, "It seems unrealistic to expect *The Dinner Party*—a late seventies embodiment of feminist polemics—to also reflect the evolution of feminist critical thinking during the intervening years."[24]

The Dinner Party still lacks a permanent home. It was presented to the University of the District of Columbia in 1990, a black, urban land-grant institution. However, a heated debate in the House of Representatives, fueled by ultraconservatives, resulted in the withdrawal of the gift. It was again shown in Los Angeles in 1996, with an exhibition, curated by Amelia Jones, which sought to provide an historical context for the work. This time, *The Dinner Party* was the focus of a scholarly series of essays.[25] However, the work still managed to provoke controversy when it was characterized by Christopher Knight, art critic for the *Los Angeles Times*, as "a failed work." Despite the negative criticism, *The Dinner Party* has proved to be a durable and inspiring work of art to generations of viewers. One can only

hope that some permanent home for this historically significant work will be found in the future.

Since the late 1970s, Chicago has created two major ensembles, *The Birth Project* and *The Holocaust Project*, both dealing with themes of overwhelming human significance.

• Mary Kelly, *Post Partum Document*

Although she was born in Minneapolis, in 1941, Mary Kelly spent the formative years of her artistic career in London, from 1968 through the 1970s. Her *Post Partum Document*, first exhibited in 1979, is contemporary with Chicago's *The Dinner Party*. A comparison between these two works reveals the very different nature of contemporary American and British feminism. Kelly was part of the consciousness-raising group that included psychoanalyst Juliet Mitchell and filmmaker-critic Laura Mulvey. In this environment, Kelly became conversant with the post-Freudian psychoanalytic theories of

Fig. 18–7 Mary Kelly, *Post Partum Document.* *(Courtesy of Arts Council Collection, London.)*

Jacques Lacan and with Michel Foucault's theories on sexuality as embedded in the society's discourses and institutions. Begun in 1973, the *Post Partum Document* was exhibited at the Institute of Contemporary Art in London in 1979. It is a six-section, 135-part work that deals with the artist's relationship with her son from his birth until he entered school at the age of 6. Kelly focused on such developmental milestones as weaning from the breast, learning to speak, starting school, and writing. The whole is presented with pseudoscientific objectivity "documented" with memorabilia such as soiled diapers, clothing, and the child's markings, which are exhibited as museum objects or in Kelly's word "fetishes." The records of these "events" are infused with awareness of Freud's and Lacan's psychoanalytical systems. What is resolutely and obviously avoided are visual images of the mother. As Kelly states:

> . . . I have tried to cut across the predominant representation of woman as the object of the look in order to question the notion of femininity as a pre-given entity and to foreground instead its social construction as a representation of sexual difference within specific discourses.[26]

In Kelly's view, imagery of women as object of the male gaze is suspect to essentialism and the oppression of women under patriarchy. In the form and the content of this original opus, Kelly moved to the core of the issues of Postmodernist feminist analysis.

The *Post Partum Document* has been reproduced in book form (published in 1985). Sections of the original have been acquired by a number of museums, including the Tate Gallery in London. In this particular segment of the work, her son's early efforts at writing are reproduced with the artist's journal entries and interpretations of his development and efforts to locate appropriate day care. Kelly's work seems especially prescient when one views the subsequent works by artists such as Carrie Mae Weems and Renee Cox who also deal with the issues of identity confronting women who are both artists and mothers.

FEMINIST PERFORMANCE ART OF THE 1970S

During the 1970s, women artists interested in both exploring their gender-defined identities and in changing society's attitudes and behavior toward women turned to a totally new art form known as "performance art." As Moira Roth, a historian of this movement, defines it, performance art is "a hybrid form which combines visual art, theater, dance, music, poetry and ritual."[27] The presence of one or more performers, an audience, and the execution of the work in real time and space provides the performance artist with an immediacy and concrete reality appropriate for the communication of feelings, beliefs, and concepts that would receive much more highly abstracted representation in the traditional media of painting or sculpture.

Roth has identified three major trends in performance art of the 1970s. This "Amazing Decade" for women saw performance artists exploring autobiographical sources as valid material for a work of art. The belief that the "personal is the political" lent a broadened significance to these performance pieces. Carolee Schneeman and Hannah Wilke are artists whose performances illustrate this component of the movement. A second trend focused on the developing interest in prehistoric matriarchies, goddess worship, and other forms of women's spirituality through the staging of rituals. Ana Mendieta exemplifies this interest. The third trend involved highly structured events with a well-defined feminist political intent. Such events are intended in Labowitz and Lacy's term to serve as "models for feminist action." By 1972 there were active centers of performance art on both the East and West Coasts.

- Leslie Labowitz and Suzanne Lacy, *In Mourning and In Rage*

Leslie Labowitz and Suzanne Lacy pioneered a trend in performance art most closely associated with Southern California. These performances are activist, interventionist, and political. Labowitz spent five years in Germany during the 1970s, studying with Joseph Beuys and developing a consciousness and experience in the possibilities of carefully staged events to force political, media, and popular attention on issues of key concern to women. Lacy had been involved in Judy Chicago's feminist art program in Fresno in 1970 and also brought many years of involvement with feminist issues to their collaboration. Spurred by the crimes of the Hillside Strangler and the climate of fear being generated by the news media, Lacy and Labowitz staged *In Mourning and In Rage* on the steps of Los Angeles City Hall in 1977. A funeral procession first circled City Hall. Then, nine 7-foot-tall women, veiled in black, emerged from the hearse. Each of the nine black mourners read a statement that explicitly connected the murders of the Hillside Strangler with the entire range of crimes against women perpetrated by our society. As each mourner read her statement, a tenth figure, clothed in red, draped a red scarf around the black figures. The surrounding chorus chanted, "In memory of our sisters, we fight back!" The press was given a statement of the purpose of the event, and a list of demands for women's self-defense was presented to members of the City Council. In their written explanation of the event, Labowitz and Lacy express their concern about the images as well as the condition of women in our culture.[28] They state three primary reasons for *In Mourning and In Rage:* first, to provide a public ritual for women to share their grief and rage over the recent tragedies; second, to provide a means for women's organizations and city government to share in a collective expression against this violence; and third, to create a media event controlled by the artists to permit a wider audience to learn of their concerns. The political artists here harnessed the power of television, radio, and written news media to communicate their viewpoint.

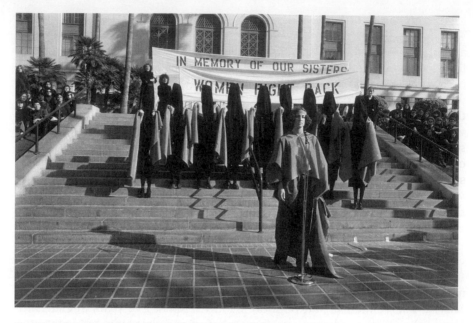

Fig. 18–8 Suzanne Lacy and Leslie Labowitz, *In Mourning and In Rage*. Los Angeles, California, 1977. *(Courtesy Suzanne Lacy; photo by Susan Mogul)*

Breaking out of the confines and limitations of the traditional forms of the visual arts, performance artists invented a new genre of art, one that focused on the specific experience of women and spoke to those needs in a very direct form of politicized communication.

TOWARD A POLITICS OF THE BODY

Since the 1970s, a significant group of works both in performance and in representations, that is, paintings and photographs, has been focused around issues crucial to the female body. Because the female nude has been so ubiquitous in the history of the visual arts of the past 500 years, women artists have confronted the "problem" of the body in order to reclaim this subject for women. No longer content to view the female nude as the territory of the male artist, women artists have struggled and grappled with ways in which the female body can be employed actively in performance and as a representational strategy without becoming the passive receptacle of the active male gaze. As discussed in the introduction and in other chapters, representations of women play an important role in reinforcing dominant gender ideologies of the culture. If those gender ideologies are going to be subject to change, then women artists can play an important role in providing new ways of "seeing" the female body. Here is precisely

the point at which women artists addressing the body "always already" in representation can effect social change. By altering the conventions and ideals that are dominant in works of art by male artists, women creators can provide alternative imagery that can in turn impact the viewer's bodily identity.

In a study of self-portraiture by women artists of the twentieth century, Marsha Meskimmon also underscores the centrality of the body for women artists. She notes: "the body is the site at which the social and biological/psychological meet. It is not just a natural 'given', but a constructed web of meaning and subject positions."[29] Meskimmon underscores the radical potential of self-representations: "Representation, in visual, verbal and political terms, constructs the experiences of women, and their voice in the discursive arena is necessary if these forms are to change."[30]

As Joanna Frueh notes, "seeing the body through women's eyes was a crucial aspect of women's self-determination and self-actualization,"[31] since the 1970s. Works of art by women to be discussed reflect the ideas of two influential French theoreticians, Luce Irigaray and Julia Kristeva. In a fascinating essay, "The Bodily Encounter with the Mother," psychoanalyst Irigaray argues for the importance of finding positive symbols of the maternal body:

> We must also find, find anew, invent the words, the sentences that speak the most archaic and most contemporary relationship with the body of the mother, with our bodies, the sentences that translate the bond between her body, ours and that of our daughters. We have to discover a language which does not replace the bodily encounter, as paternal language attempts to do, but which can go along with it, words which do not bar the corporeal, but which speak corporeal. . . . Neither little girl nor woman must give up love for their mother. Doing so uproots them from their identity, their subjectivity.[32]

Julia Kristeva considers the representations of motherhood in the visual arts, in her essay "Motherhood According to Bellini." She, too, is concerned about the role of the mother in psychoanalytical theories. In this essay, she analyzes the appearance of motherhood in representations, especially in a series of *Madonna and Child* paintings by Giovanni Bellini: "Craftsmen of Western art reveal better than anyone else the artist's debt to the maternal body and/or motherhood's entry into symbolic existence."[33] Both Irigaray and Kristeva "problematize" the body of women and define it as the site of deeply rooted attitudes of patriarchy. Irigaray goes so far as to state ". . . the whole of our western culture is based upon the murder of the mother."[34]

This section is divided into two main parts: the role of the body in performance art, as "the explicit body" in Rebecca Schneider's term, and then the body in representations, in which artists use the two-dimensional

media of either painting or photography to explore the ways in which the female body can be configured for the contemporary world.

In 1992, Lynda Nead published her influential essay in which she theorizes that "one of the principal goals of the female nude has been the containment and regulation of the female sexual body. . . ."[35] "If the female body is defined as lacking containment and issuing filth and pollution from its faltering outlines and broken surface, then the classical forms of art perform a kind of magical regulation of the female, containing it and momentarily repairing the orifices and tears."[36] For Nead the importance of examining the attitudes toward representation of the female body is crucial. Nead views the power of representations as pervasive and inescapable since "the body is always already in representation. And since there is no recourse to a semiotically innocent and unmediated body, we must be content to investigate the diverse ways in which women's bodies are represented and to promote new bodily images and identities."[37] Lynda Nead observed that "some of the most exciting and radical women's art in recent years has drawn on the representation of the female body and has explored subjectivity in relation to a politics of the body."[38]

The Body in Performance

Many women performance artists have focused on the expression of personal feelings and experiences about their lives as women. Such works have no equivalent in the aggressive "Body Art" of male artists such as Vito Acconci or Chris Burden. As precedents to concerns later explored by Cindy Sherman, "Women performers made attempts to study, expose, mock, and challenge stereotyped images of women."[39] Historically, the earliest most self-evident manifestation of the body, "the explicit body," occurred in the performances of women artists. Carolee Schneeman, a filmmaker, and Eleanor Antin have been among the leading performance artists in this trend. Eleanor Antin's art has involved the development of a series of alter-ego personae, including a nurse and Eleanora Antinova, a black ballerina in Diaghilev's Ballet Russes. Primarily through the medium of performance, Antin explores aspects of herself by playing out the lives of these fictional people.

- Carolee Schneeman, *Interior Scroll*

In performance art, Carolee Schneeman is historically significant as one of the first artists who utilized her own body in a series of performances, beginning in the early 1960s. Schneeman first became involved in the subculture of happenings in New York City and participated in the Fluxus movement. *Eye/Body,* performed in late 1963, and *Meat Joy* of 1964 marked the first time that a woman was both physically the object and, simultaneously, the creator of a performance. Schneider describes *Eye/Body* in the following way:

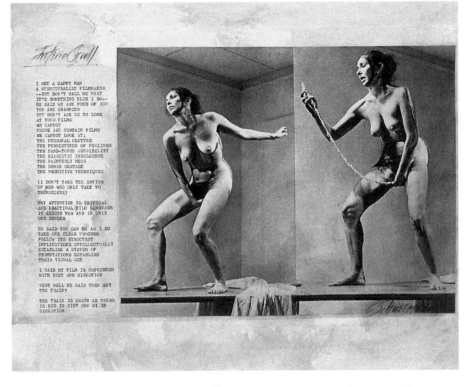

Fig. 18–9 Carolee Schneeman, *Interior Scroll.* *(Photo by Anthony McCall, courtesy of the artist.)*

The environment (of her studio) consisted of 4 × 9-foot panels, broken glass and shards of mirrors, photographs, and lights and motorized umbrellas. Schneeman stepped into her work, and, in what she calls a "kind of shamanic ritual," she incorporated her naked body into her construction by painting, greasing and chalking herself.[40]

Amidst the growing recognition of performance in the art world of the 1960s, works such as Schneeman's remained marginalized and dismissed by the art establishment. Schneeman's work seems so prophetic today, because, by the following decade of the 1970s feminist performance had exploded on both the East and West Coasts among many practitioners. This is the period its first historian, Moira Roth, calls "the amazing decade." Schneeman continued to be a leader of performance in the 1970s and one performance in particular "Interior Scroll" performed in 1975 and 1977 is frequently cited as an exemplar of the ways in which women artists asserted their own identities in this new art form. In this piece, Schneeman appeared undressed, painted her body in a ritualistic manner, and then pulled a text from her vagina. This text is often quoted since it characterizes

so well the lack of comprehension of male artists of the phenomenon of the feminist performance mode. This text defended and explained the need for the exposure of the personal in art. Schneeman's text adopted the "voice" of such an uncomprehending male colleague:

> We cannot look at
> the personal clutter
> the persistence of feeling
> the hand-touch sensibility
> the diaristic indulgent
> the painterly mess
> the dense gestalt
> the primitive techniques[41]

The importance of the autobiographical, "the personal clutter" was precisely what women believed was essential for the creation of art in this period.

- Hannah Wilke, *S.O.S. Starification Object Series*

Hannah Wilke (1940–1993) occupies a significant position in the history of feminist body art and performance. In her latex works of the late 1960s and early 1970s she was among the first artists to use vaginal imagery, which would become the subject of works by many women artists in the 1970s.

For Amelia Jones, in her recently published book *Body Art: Performing the Subject*, Hannah Wilke's performances and body art works of the mid-1970s, contemporary with Schneeman's "Interior Scroll," are exemplary of a feminist critique of the politics of gender differences:

> Through the very performance of their bodies through the feminizing rhetoric of the pose, feminist body artists begin to complicate and subvert the dualistic, simplistic logic of these scenarios of gender difference by which women are consigned to a pose that is understood to be unself-reflective, passively pinioned to the center of a "male gaze."[42]

Basing her concepts on the philosophy of Merleau Ponty, known as "Phenomenology," Jones analyzes Wilke's art practice as a radical destabilization of gender hierarchies in the art world.

Wilke made vulvas out of a wide range of nontraditional materials, such as kneaded erasers and chewing gum. The use of gum is visible in this series of photographs documenting her performance piece, *S.O.S. Starification Object Series* of 1974. Wilke uses her nude body as a sort of "canvas" on which the gum "vulvas" are attached. Her work sought to "valorize female form and to criticize the cultural devaluation of the feminine."[43] As Wilke herself stated: "I chose gum because it's the perfect metaphor for the

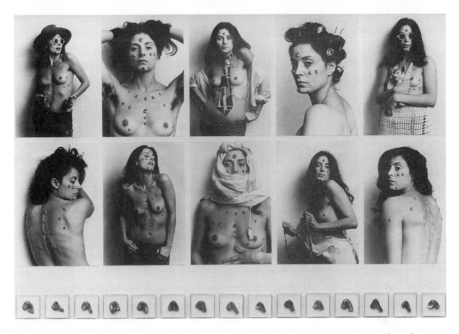

Fig. 18–10 Hannah Wilke, *S.O.S. Starification Object Series.* 1974–1982. Mixed media, 40½ × 58 in. framed. *(Courtesy Ronald Feldman Fine Arts, New York; photo by D. James Dee)*

American woman—chew her up, get what you want out of her, throw her out and pop in a new piece."[44]

Wilke was awarded her B.F.A. degree from the Tyler School of Art in Philadelphia, but her professional life was based in New York. She taught sculpture at the School of Visual Arts in Manhattan for many years and was represented by the Ronald Feldman Gallery, beginning in 1972.

Wilke's persistent use of her own body should not be interpreted as self-absorption or hedonistic narcissism. Her sense of collective identity was highly developed. She told an interviewer that from the very beginning of her career, her art making carried a sense of communal identity and social responsibility:

> I felt it would interest me to create an iconography about a woman by a woman. I could be representative of every woman.[45]

She connected this awareness directly to her identity as a Jew impacted by the Holocaust:

> I realized, the only universal is womanhood, which regenerates life. I was conscious of the destruction of so many people for all of man's ideals. I had to

create something that was almost a new religion that was a universal symbol for all humankind.[46]

Wilke used photographs to document her mother's battle with cancer. Between 1978 and 1982 she took thousands of photos of her mother.

I felt if I could get her [Wilke's mother] to have the same energy that I had when I made the art, possibly she would lose her cancer.[47]

The memorial exhibition, held in 1984, included a selection of life-sized photographs, sculpture, poems, and performances.

The enlarged photograph became Wilke's own medium a decade later in a series of thirteen over-life-sized prints which served as a powerful document of her own unsuccessful battle with lymphoma. Roberta Smith wrote that these self-portraits "seared the psyche."[48] The images that form the "Intra-Venus" series were selected from slides taken by her husband, Donald Goddard, during the last five years of her life. In these images, she confronts the viewer through strands of hair, thinned by chemotherapy, or totally bald, and hooked to an IV (intravenous) tube. The enlarged scale and direct, uncompromising gaze make these images powerful, indeed unforgettable, and somewhat "unbearable."[49]

Wilke's imagery forces the viewer to confront the artist, even as the creator is encased in a body ravaged by disease. In this project, Wilke's faith in the power of art as both witness and document ultimately affirms both her personal courage and integrity and the life force of every single human being.

Jones maintains that Intra-Venus was fully consistent with Wilke's project: "up to the end of her life she performs herself obsessively in relation to femininity through the rhetoric of the pose. . . ."[50] Jones notes that "Intra-Venus forces the viewer to confront his or her expectations about the appearance of the female body in visual representation and the link between this appearance and the understanding of the female subject so rendered."[51]

- Ana Mendieta, The Silhueta Series, 1973–1980

The work of Ana Mendieta brings together most of the concerns of women artists in the 1970s. We are indebted to Jane Blockner's detailed study to better understand this complex, original artist. Mendieta created "over 200 works in which she used the earth as a sculptural medium. She molded it, burned it, and lay down on it. It was her source for rich artistic materials . . . it is a womb, both sexual and maternal, the fundamental source of life."[52] Her most famous series of images are photographs that document a performance known as the Silhueta Series. Mendieta used a wide range of

strategies to image the outline of her own body. "Sometimes she molded mud, sand, and stones alongside a creek bed to register a thick and wet outline of her 5-foot figure. Sometimes she gathered flowers to decorate her body or to follow its contours. Sometimes she imprinted barely visible silhouettes of herself onto grassy meadows. Sometimes she "drew" the perimeter of her body with an arrangement of burning candles. Sometimes, in a more explosive gesture she burned gunpowder to create ash pits the size and shape of a human being or ignited fireworks whose blazing form in the night sky echoes the artist's upright, open-armed stance."[53] The photograph is a trace, a record of an event in the past. The camera records an absent body. The medium in which the performances are preserved echoes the nostalgia for an irretrievable past implicit in the project. Mendieta herself described these works in a statement written in 1981:

> My art is a return to the maternal source. Through my earth/body sculptures I become one with the earth. I become an extension of nature and nature becomes an extension of my body. This obsessive act of reasserting my ties with the earth is really the reactivation of primeval beliefs . . . [in] an omnipresent female force, the after-image of being encompassed with the womb, in a manifestation of my thirst for being.[54]

Mendieta was clearly involved with the feminist desire for prehistorical powers embodied in the myths of the "Great Goddess" or "Earth Mother," which were widely discussed among feminists at this time. She was a member of the A.I.R. collective gallery with Mary Beth Edelson and others, and worked actively to raise awareness within this group of middle-class white women of the existing discrimination toward minorities.

The special circumstances of her life made Mendieta especially sensitive to issues of difference. Ana Mendieta was born in Cuba, in 1948. Her father was a highly placed lawyer who became an FBI informant, who openly opposed Castro and was sentenced to a twenty-year prison term for aiding the CIA in the Bay of Pigs invasion. Ana and her sister were sent to the United States in 1961 with other Cuban children and without her mother. The girls were sent to live in Iowa and were cared for in foster homes, orphanages, and juvenile correction facilities. She remained in Iowa for her formal education, receiving both a B.A. and M.A. from the University of Iowa.

Mendieta established herself in the New York art world and was awarded a series of grants from the New York State Council for the Arts, the National Endowment for the Arts, and a Guggenheim Fellowship. In January 1985, she married the minimalist sculptor Carl Andre and on September 8, 1985, she fell from their apartment and died a very tragic and untimely death. Andre was brought to trial for her death, but was acquitted in February 1988. These few biographical facts do not help us very much in

trying to understand Mendieta. As Jane Blockner notes, "Ana Mendieta's short life, aesthetic choices, gender, ethnicity, and politics have contributed to her absence from a variety of discursive sites."[55]

The Body in Representation

* Cindy Sherman, *Untitled Film Still #2*

Using the medium of photography paired with the life-sized or larger scale and color of painting, Cindy Sherman employs carefully staged pictures to expose the artifices of imagery and the power of that constructed imagery to manipulate the reality of women's lives. Since she began her career in 1977, her works have received consistent critical appreciation, culminating in a retrospective exhibition organized by the Akron Art Museum and shown at the Whitney Museum in New York in 1987. Part of the second generation of feminists, her true subject is a deconstruction of film, magazine, and all forms of popular imagery. As Lisa Phillips observed: "For Sherman the camera is a tool with which to explore the condition of representation and the myth that the photograph is an index of reality."[56] More recent works explore the appearances of a loss of sanity and the deterioration of the human into first animal then vegetable decay, rot, and defilement.

Fig. 18–11 Cindy Sherman, *Untitled*. 1977. Black and white photo, 10 × 8 in. *(Courtesy Metro Pictures)*

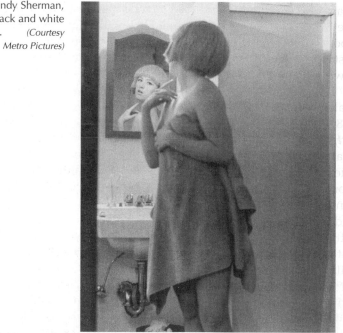

Born in New Jersey and raised on Long Island, Sherman emerged in the art world in the late 1970s with a series of "film stills." In these black-and-white, 8- by 10-inch photos, carefully staged, and using herself as actress, Sherman changes her own appearance to create a frozen moment out of a fictitious, but implied, continuous film narrative. Borrowing from the imagery of *film noir* movies of the late 1950s and early 1960s, these works aggressively appropriate content and imagery in a Postmodernist stance. Her art is meant to engage the viewer, forcing him or her into an involvement with the self-consciously ambiguous scenario only hinted at in the single image. Laura Mulvey, one of the leading voices in feminist film criticism, has characterized the complexities of the film stills in the following statement: "But just as she is artist and model, voyeur and looked-at, active and passive, subject and object, the photographs set up a comparable variety of positions and responses for the viewer. There is no stable subject position in her work, no resting point that does not quickly shift into something else."[57]

Thus, while male critics such as Arthur Danto perceive the persona in the film stills as "The Girl,"[58] an object of male desire, women critics such as Mulvey and Abigail Solomon-Godeau can read the images more as a critique of such stereotypes from *film noir.*[59]

In this particular film still, Sherman explores the theme of the self-consciousness of the gaze mediated by the mirror, echoing the concerns of Morisot in *Woman at Her Toilet* (Fig. 13–5). Krauss notes the pronounced graininess of the image, a signifier in photographic terms of distance, as if the image is captured via a telephoto lens.[60] The black bar on the left of the doorframe positions the viewer as "voyeur" peeping in on the scene from a distance, intruding on the self-conscious gazing of the figure draped in a towel and standing in a bathroom.

In 1980 Sherman began to use color, simultaneously enlarging the scale of the image. Her first fully mature series, the horizontal works of 1981, was inspired by pornographic centerfolds. Sparked by a request from *Artforum* to design a portfolio, these life-sized figures are "psychologically charged, unsettling, and disturbing."[61] Following the highly theatrical and idiosyncratically colored scenes of the 1983 "Costume Dramas," Sherman's work began a descent into a hellish world of madness and loss of rational control. Her images, still using herself as actress, are bizarre, distressing, and at times veering into the animal world. Her works from 1987 present a rotting landscape of death, decay, and waste, in which her presence has all but disappeared. If Ken Johnson is accurate, Sherman's work "therapeutically releases the contents of psychic disturbance through the clarifying sanity of a prolifically inventive and witty theatrical, photographic and artistic practice."[62]

Sherman would attack the entire history of art in her series based on famous and instantly recognizable "masterpieces." In using the icons of art

history as raw material, Sherman includes the "high" art of painting with all the other media in a destabilizing project that questions the impact of imagery in gender construction of identity.

- Barbara Kruger, *Untitled (Your body is a battleground)*

Like Cindy Sherman, Barbara Kruger deals in her work with the power, sexual politics, and hidden meanings of images inherited from the popular media of films, television, and magazines. Unlike Sherman, Kruger does not assume the role of actress in constructed scenarios, but manipulates "found" imagery. She combines these pictures with brief, pithy texts that she has written. This appropriation of images is an important trend in works by second-generation, Postmodernist artists who had internalized feminist concepts.

Born in Newark, New Jersey, in 1945, Kruger studied with the photographer Diane Arbus for a short time at the Parsons School of Design. Encouraged by Marvin Israels, another teacher at Parsons, she secured a job as a graphic designer at Condé Nast publications, working on *Mademoiselle* magazine, which she designed between 1968 and 1972. This crucial experience gave Kruger the familiarity with media layout formulas that she employs directly in her characteristic photomontages.

Inspired by a massive wall hanging by Magdalena Abakanowicz, Kruger began making works in the late 1960s that incorporated yarn and cloth. When she began combining her own photos with short written texts, she discovered a new, very personal direction in her art.

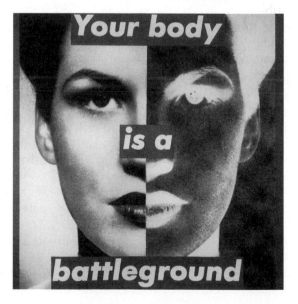

Fig. 18–12 Barbara Kruger, *Untitled (Your body is a battleground)*. 1989. Photographic silkscreen/vinyl, 112 × 112 in. *(Courtesy Mary Boone Gallery)*

In 1981 she developed the form she uses today. An image appropriated from a source in popular culture is manipulated through enlargement or cropping and juxtaposed with a text, set in boldface type. Her large-scale works, often 4 feet tall and 6 feet wide, are fitted into bright red frames for exhibition. They announce their identity as art objects, commodities on the market.[63]

Kruger works with the specific intent of including women in her audience. She recognizes the distinct experiences women have in the culture. "I want to address difference that leads to gender distinctions. I'm not a separatist, I'm not a utopian."[64] Her art has received wide recognition in the art world since its first appearance in the early 1980s. Considered among the most important Post-Modernists, Kruger creates work that is "contentious, aggressive, and explosive."[65] Similarly, Kate Linker defines Kruger's work as "assertive, aggressive and argumentative."[66] In its power to communicate concepts directly and expose manipulative meanings of imagery, it points in the direction of a widened role for art to effect significant social change.

Kruger's artistic practice is rooted in the belief that gender is not essential and biologically determined but constructed in culture. Kruger is very intent on including women in her audience and developing an "active viewer" capable of deconstructing words and text.[67] Linker articulates the ways in which Kruger's work was impacted by a number of theoretical discourses. Like Foucault, Kruger views power as decentralized and anonymous, dispersed over a multitude of sites.[68] Her mission, then, is "to erode the impassivity engendered by the imposition of social norms." She wants her male and female viewers to critique cultural "stereotypes," perceived as prime instruments in the production of docile and submissive subjects.[69]

Your body is a battleground is an enormous image, over 9 feet square. The severely cropped face is divided vertically into a positive image and its photographic negative. "Your body is a battleground" was a political slogan from the 1960s and, in this context, alerts the viewer to the rootedness of gender politics in the actual bodies of real women. This image was used as a poster, supporting the issue of abortion rights. As a poster it was disseminated for the march on Washington in 1992 to encourage the Supreme Court to uphold the right to legalized abortions, symbolized by the landmark decision of *Roe v. Wade*. This was, in fact, the largest demonstration ever held in Washington, when over 750,000 people marched. In this image, Kruger demonstrates her political commitment to issues directly affecting women's health and survival. Whether in the gallery or on a poster or T-shirt, this image is direct and unequivocal, designed to galvanize the often depoliticized groups in the post-Reagan era. At the same time, she addresses the issue of the corporeal body. In addressing immediate political issues, Kruger's art is capable of direct engagement in issues of power. Here Kruger goes beyond much of Post-Modernism's theo-

retical meditations on the nature of subjectivity, authorship, and gender formation to more direct action.

- Jenny Saville, *Branded*, 1992

The youngest artist in this book, Jenny Saville, born in 1970, received her formal education at the Glasgow School of Art discussed in Part III for its championing of women at the end of the nineteenth century. She created this painting in 1992 toward the end of her four years of study at the school. *Branded* was one of a series of enormous canvases, in this case 7 feet by 6 feet, in which a huge woman both literally and in terms of our culture's definitions of beauty confronts the view. This large body is surmounted by a self-portrait of Saville herself. Words such as "Support," "decorative," "delicate," and "petite" are incised into the paint, which is transformed into flesh. As Alison Rowley has noted, *Branded* evokes the powerful image by Jo Spence, *Exiled*, in which her body, scarred by breast cancer, carries the word "monster" across her chest.[70] Another work in Saville's series of

Fig. 18–13 Jenny Saville, *Branded.* *(Courtesy of Saatchi Collection, London.)*

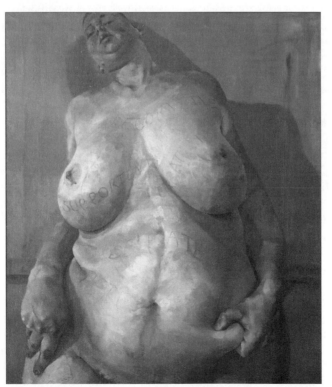

paintings, *Plans,* is even larger than *Branded* (9 feet by 7 feet) and has markings similar to those used by plastic surgeons. Saville has openly acknowledged the influence of Lucien Freud whose paintings of the human body are well-respected prototypes for these works.

Saville has stated: "I am not painting disgusting, big women. I'm painting women who've been made to think they're big and disgusting, who imagine their thighs go on forever. . . ."[71] Observers of these images seem to agree on the fact that Saville is skillfully using paint to simulate flesh and then removing paint in a ritual act of "scarification."[72] Her paintings force the viewer to confront his/her visceral attitudes toward the maternal body in its large scale as well as the gap between perceptions of the body and the actual physical dimensions of a body. As a member of a new generation of painters, Saville demonstrates that the body is indeed the key site for representation by contemporary women artists.

IDENTITY POLITICS OF AFRICANA ARTISTS

Contemporary women artists of African descent have contributed significantly to the richness of women's creative output in the past decades. Although sometimes marginalized, even from discussions of contemporary women artists' activities, the power, beauty, and variety of works created by Africana women is remarkable. Artists in the United States and in Europe of African heritage occupy a different place from artists discussed in this chapter, due to the politics of racial discrimination. This is most evident when Africana artists incorporate self-representations into their works. The term "Africana" was used by the organizers of an exhibition of six artists to connote "the complexity of the African experience and its global Diaspora dimension."[73] "We find 'Africana' to be an all encompassing term for the multiple experiences of Africans and people of African descent in the Diaspora, as well as for their complex creative expressions."[74] The term "Africana" is an extremely appropriate term for the five artists discussed in this section. Although Sonia Boyce is the only non-African-American artist it is important to acknowledge the wide diversity of "Africana" women's creativity in the last thirty years, outside of the United States.

However, it would be inaccurate to assume that African heritage alone is sufficient to unify these creative talents. As Leslie King-Hammond, in an introduction to a compilation of biographical entries on over 150 African-American women artists, describes: "There is not one voice. It is a collection of voices, which, through their combined synergy, vibrantly explore, challenge, invent, remember, reconfigure, innovate, improvise, act out, act up, cut up, piece, and perform their responses to the American experience in a complex 'exchange and re-exchange of ideas between groups'."[75] While acknowledging the diversity and individuality of artists of African heritage or from the African Diaspora, one scholar, Freida Hugh W. Tesfagiorgis,

believes that there is place for a discourse that centers on black women artists, issues, and concerns, which she terms "Black Feminism." Such a construct is appropriate since it would "take into account the simultaneity-multiplicative construct of race, class, gender, and sexuality fundamental to understanding the lives, thought, production and interventions of Black women artists."[76] All artists discussed in this section have addressed quite directly the role of imagery in the construction of negative stereotypes and the power of their own artistic practice to deconstruct those stereotypes.

- Bettye Saar, *The Liberation of Aunt Jemima*

Bettye Saar is a noted African-American artist who developed a personal style to convey her distinctive vision outside the realm of the "fine arts" and the traditions of Western art. Born in Los Angeles in 1926, she studied art at Pasadena City College, graduating in 1949. During the 1950s she raised a family, but in the 1960s she began making constructions in boxes. Inspired by the works of Joseph Cornell, Saar gathered objects, fabrics, and other bits and pieces with which she composed her imaginative

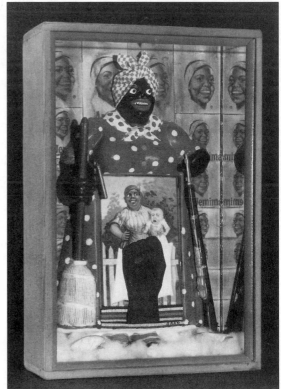

Fig. 18–14 Bettye Saar, *The Liberation of Aunt Jemima.* 1972. Mixed media, 11¾ × 8 × 2¾ in. *(University Art Museum, University of California at Berkeley. Purchased with the aid of funds from the National Endowment for the Arts; photo by Colin McRae)*

tableaux. Using this assemblage technique, Saar discovered the formal means by which she could best express a personal content. In the mid-1960s and early 1970s Saar focused on the ready-made stereotypes of black people promoted by white society to make her political statements, using images such as "Uncle Tom" or "Little Black Sambo." In *The Liberation of Aunt Jemima* (Fig. 18–14), Saar explodes the myth of the "good house nigger."[77] Aunt Jemima holds a broom in one hand and a rifle in the other. The anger and violence of the black revolution is here given a forceful symbol.

Bettye Saar's creative process is one of self-described ritual. She haunts junk shops and markets around the globe, searching for the materials that she will transform into her works of art. Her works then acquire layered, multiple meanings in the recontextualization from found object to "art." The pyramid, or tiered altar, moving from the lower, more tangible levels to the more metaphysical or esoteric symbolism at the top is a recurring element in her art, as are the symbols of the four elements: earth, air, fire, and water.[78]

Saar's daughter, Alison, is also an artist, one whose work is strongly influenced by African-American folk art and African sculpture.

- Faith Ringgold, *Tar Beach*

Faith Ringgold is an artist of impressive talents who also developed her personal style outside the Western Renaissance tradition. Born in Harlem in 1930, Ringgold studied art at the City College of New York. Like Saar, Ringgold's education was acquired through subsidized public schools for higher education. In the mid-1960s, inspired by the political upheavals of the civil rights movement, Ringgold painted a 12-foot-wide mural entitled *Die*. Using flat, unmodulated colors, Ringgold achieves a decorative and original style for a vision of interracial violence. While black and white adults attack each other, two children huddle together in the center of the composition hoping to survive the massacre.

Ringgold recalls that she became a feminist in 1970 when she launched a protest against an all-male exhibition at the School of Visual Arts in New York, in itself designed to protest war, racism, and sexism. Ringgold's feminism became incorporated into her art in 1973, when she abandoned oil painting and began making soft sculpture using sewing and other craft techniques. Her mother had been a fashion designer, and Ringgold recalls that when she was young her mother was always sewing. However, it was the feminist movement that sanctioned her use of these techniques for the creation of art:

> If I'd been left alone, I'd have done my own kind of thing earlier, based on sewing. As it was, it wasn't until the Women's Movement that I got the go-ahead to do that kind of work.[79]

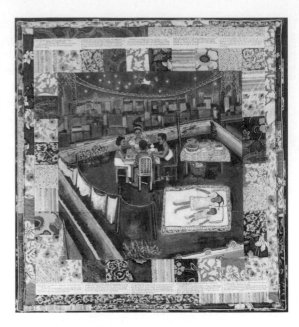

Fig. 18–15 Faith Ringgold, *Tar Beach (Woman on a Beach Series #1).* 1988. Acrylic paint on canvas bordered with printed and painted quilted and pieced cloth, 74⅝× 68½ in. *(The Solomon R. Guggenheim Museum, New York. Gift of Mr. and Mrs. Gus and Judith Lieber, 1998. Photograph by David Heald © The Solomon R. Guggenheim Foundation, New York. FN 88.3620)*

During this time she had been teaching African crafts, such as beadwork, appliqué, and mask-making, at the Bank Street College in New York. Combining her interest in African crafts with her feminist consciousness of traditional women's art, she decided to make soft sculptures based on her memory images of black people. The results are the group of works known collectively as the "Family of Women." Using a variety of techniques, needlepoint, braided ribbon, beading, and sewn fabric, these images are imaginative presences with foam bodies. They are dressed in African-inspired clothing, and the sewn faces are derived from African masks.

Ringgold's works, formed with nontraditional materials, focus insistently on her identity as an African-American woman of the twentieth century:

> After I decided to be an artist, the first thing that I had to believe was that I, a black woman, could penetrate the art scene and that I could do so without sacrificing one iota of my blackness, or my femaleness, or my humanity.[80]

From this strong and focused sense of communal and individual identity, Ringgold has created a highly personal body of works of formal, technical, and iconographical originality. Her mature works are consistently outside of neatly defined categories of painting or sculpture, utilizing fabric, quilting techniques, and literary narrative in highly original ways.

In the 1980s Ringgold produced a remarkable series of works that combine narrative stories with quilting techniques. *Tar Beach* is the best

known in this series and reveals her imaginative and fantastic visions. Ringgold's works remain firmly rooted in her personal identity. Ringgold expressed her attitudes toward success and recognition in the art world with characteristic honesty:

> As far as the art world is concerned, I have not had to think about that, because I'm not a member of those groups that would profit from being on the cutting edge. I'm not a man and I'm not white. So I can do what I want to do and that has been my greatest gift. It's kind of a backhanded gift but it sets me free. I do what I want to do because I'm not lined up for those things anyway. I may get those things but I'm not in the lineup. I'm over here, you see, and that's fine. I believe that what you do in this world is figure out where you are and go ahead and do what you can do, and that's what I'm doing.[81]

By any standards of success in the art world, Faith Ringgold measures up to a level of creative excellence shared by only a small group of African-American women artists of her generation. In 1990, a major retrospective exhibition of her works began to tour the country, exhibited not only on both coasts but in selected sites throughout the Midwest and the South.

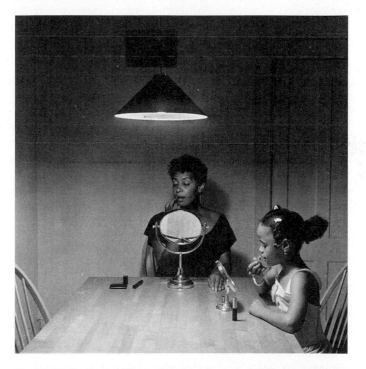

Fig. 18–16 Carrie Mae Weems, *Untitled* (From the Kitchen Table Series).
(Courtesy of the artist and P.P.O.W., New York.)

- Carrie Mae Weems, *Untitled* (From the Kitchen Table Series), 1990

Born in 1953, Weems received her formal art education in California in what bell hooks defines as "mainstream art schools where there was little or no awareness of the way in which the politics of white supremacy shaped and informed academic pedagogies or photographic practice."[82] From the start of her mature career, Weems has used the black subject for all her photographic projects. Beginning with Family Pictures and Stories (1978–1984) Weems has avoided any tendency to essentialize her subjects. She creates photographic images of black individuals. Therefore, she has engaged in a "politics of anticolonialism"[83] as defined by hooks. Her photographs engage in a deconstructive practice where identity is fluid and changing.

In the *Kitchen Table Series*, Weems explores the range of ways in which identity is constructed. In this image Weems photographs herself with a young girl (her daughter?) in which the mirrors are references to the mirroring of women in images of the culture and the ways in which identity constructions are passed from one generation to the next. More recently, Weems's works led her to explore her "spiritual" home. In the series of photographs, *Went Looking for Africa,* she "problematized this dream of exile and return, of homecoming."[84] As hooks describes her project, "Weems positions her work on Africa as a counterhegemonic response to the Western cultural imperialism that systematically erases that connection—that diasporic bond—which links all black people."[85]

- Renee Cox, *Yo Mama,* 1993

Renee Cox was born in Colgate, Jamaica, in the West Indies in 1958. She was formally educated at Syracuse University in upstate New York. Cox graduated in 1979 with a degree in communications and photography and worked as a fashion photographer for ten years. When Cox became pregnant, in 1993, she was forced to confront, as were most other women artists, the problems inherent in assuming the identity of "mother" while maintaining the already established "artist." Out of this very personal issue emerged the powerful series, *Yo Mama.* In this image an over-life-sized nude image of the artist holds her baby son in a manner immediately reminiscent of Renaissance Madonna imagery. The simplicity of the image, combined with its scale (8 inches × 63 inches) confronts the viewer unapologetically.

B. E. Myers proposes that Cox's work should be understood in the context of the ethnographic imagery of colonialism, which produced the notoriously disfigured "Hottentot Venus" (c. 1815):

These images are aggressive in that they demand the reclamation of public spaces which women have been denied, and in order to be understood fully,

Fig. 18–17 Renee Cox, *Yo Mama,* 1993.
(Courtesy of Collection of the Artist.)

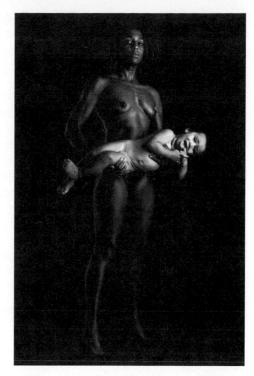

viewers must look at and bear witness to the elements of the female body that enable her to be understood as a "woman."[86]

Myers proposes the term "autocartography" to help interpret Cox's projects. "Autocartography is an incorporation of the ways a subject resists, redraws and reconstitutes the very lines of limitation placed on his or her subjectivity. . . . Through ambiguity and play, autocartographers context the overdetermined constraints and limitations placed on subjectivity."[87] Cox presents us with herself, but she is represented in an over-life-sized image of beauty that is not predictable or expected in our culture and that continues to privilege whiteness as standards of beauty. It is one body, which can force the viewer to think about all black women, maternity, and internal registers of beauty.

CONCLUSION

The artists discussed in this chapter, as in many previous epochs, are not the only women creators to make important contributions to contemporary art. They have been selected for detailed discussion because each figure is

an outstanding representative of a major avant-garde movement or trend in contemporary art history. The achievements of these few artists, however, do not represent the total contribution of women to the visual arts. There are many other productive women artists whose works are also worthy of attention and recognition.

I encourage the reader to use the list of suggested references at the end of this chapter to explore in greater depth than is possible in this text a fuller range of works of art created by women artists, since 1970.

Without minimizing current concerns over the increasingly conservative nature of government funding or the political vulnerability of the National Endowment for the Arts, the future for women artists is filled with the possibilities of further achievements. The canon has been exploded, at least to the extent that the history of art can never again be retold without including the contributions of women in the story.

Suggestions for Further Reading

General Works on Contemporary Women Artists
Bad Girls (London: Institute of Contemporary Arts, 1993), exhibition catalog.

BECKETT, WENDY, *Contemporary Women Artists* (New York: Universe Books, 1988).

BROUDE, NORMA, and MARY D. GARRARD (eds.), *The Power of Feminist Art: The American Movement of the 1970s, History and Impact* (New York: Abrams, 1994).

DE ZEGHER, M. CATHERINE, *Inside the Visible: An Elliptical Traverse of Twentieth Century Art In, Of, and From the Feminine* (Cambridge, MA: The MIT Press, 1996).

DEEPWELL, KATY (ed.), *New Feminist Art Criticism: Critical Strategies* (Manchester and New York: Manchester University Press, 1995).

KRAUSS, ROSALIND E., *Bachelors* (Cambridge, MA: The MIT Press, 1999).

LINKER, KATE, and JANE WEINSTOCK, *Difference: On Representation and Sexuality* (New York: New Museum of Contemporary Art, 1984).

LIPPARD, LUCY R., *From the Center: Feminist Essays on Women's Art* (New York: E. P. Dutton, 1976).

LIPPARD, LUCY R., *Overlay: Contemporary Art and the Art of Prehistory* (New York: Pantheon Books, 1983).

MILLER, LYNN, and SALLY SWENSON, *Lives and Works, Talks with Women Artists* (Metuchen, NJ: Scarecrow Press, 1981).

POLLOCK, GRISELDA, *Framing Feminism: Art and the Women's Movement, 1970–1985* (London and New York: Pandora, 1987).

RAVEN, ARLENE, CASSANDRA L. LANGER, and JOANNA FRUEH (eds.), *Feminist Art Criticism: An Anthology* (Ann Arbor, MI: UMI Research

Press, 1988), and *New Feminist Criticism: Art, Identity, Action* (New York: HarperCollins, 1994).

ROBINS, CORINNE, *The Pluralist Era: American Art, 1968–1981* (New York: Harper and Row, Icon Editions, 1984).

ROBINSON, HILARY (ed.), *Visibly Female: Feminism and Art Today* (New York: Universe Books, 1988).

ROSEN, RANDY, *et al., Making Their Mark: Women Artists Move into the Mainstream, 1970–1985* (New York: Abbeville Press, 1989).

SMAGULA, HOWARD, *Currents: Contemporary Directions in the Visual Arts* (Englewood Cliffs, NJ: Prentice-Hall, 1983).

Elizabeth Murray

GRAZE, SUE, and KATHY HALBRIECH, *Elizabeth Murray: Paintings and Drawings* (New York: Abrams, in association with the Dallas Museum of Art and the MIT Committee on the Visual Arts, 1987).

Magdalena Abakanowicz

JACOBS, MARY JANE, *Magdalena Abakanowicz* (New York: Abbeville Press, 1982).

ROSE, BARBARA, *Magdalena Abakanowicz* (New York: Abrams, 1994).

Jenny Holzer

AUPING, MICHAEL, *Jenny Holzer* (New York, Universe Press, 1992).

WALDMAN, DIANE, *Jenny Holzer* (New York: Guggenheim and Abrams, 1989).

Maya Lin

BLUM, SHIRLEY NEILSEN, "The National Vietnam War Memorial," *ARTS Magazine,* 59 (December 1984), pp. 124–128.

MITCHELL, W. J. T. (ed.), *Art and the Public Sphere* (Chicago: University of Chicago Press, 1990).

Miriam Schapiro

GOUMA-PETERSON, THALIA, *Miriam Schapiro: A Retrospective: 1953–1980* (Wooster, OH: The College of Wooster, 1980).

GOUMA-PETERSON, THALIA, *Miriam Schapiro: Shaping the Fragments of Art and Life* (New York: Abrams, 1999).

Judy Chicago

CHICAGO, JUDY, *The Dinner Party: A Symbol of Our Heritage* (New York: Doubleday; and Garden City, NY: Anchor Books, 1979).

CHICAGO, JUDY, *Through the Flower: My Struggle as a Woman Artist* (New York: Doubleday; and Garden City, NY: Anchor Books, 1975).

JONES, AMELIA (ed.), *Sexual Politics: Judy Chicago's* Dinner Party *in Feminist Art History* (Berkeley and Los Angeles: University of California Press, 1996).

Mary Kelly

IVERSON, MARGARET et al. *Mary Kelly* (London: Phaidon, 1997).

KELLY, MARY, *The Postpartum Document* (London: Routledge, 1985).

Performance Art

EDELSON, MARY BETH, *Seven Cycles: Public Rituals* (New York: A. I. R., 1980).

GOLDBERG, ROSELEE, *Performance Art: From Futurism to the Present* (New York: Abrams, 1988).

JONES, AMELIA, *Body Art: Performing the Subject* (Minneapolis: University of Minnesota Press, 1998).

ROTH, MOIRA (ed.), *The Amazing Decade: Women and Performance Art in America: 1970–1980; A Source Book* (Los Angeles: Astro Artz, 1983).

Carolee Schneeman

SCHNEEMAN, CAROLEE, *More than Meat Joy* (New Paltz, NY: Documentext, 1979).

SCHNEIDER, REBECCA, *The Explicit Body in Performance* (London and New York: Routledge, 1997).

Ana Mendieta

BLOCKNER, JANE, *Where Is Ana Mendieta?: Identity, Performativity and Exile* (Durham and London: Duke University Press, 1999).

KATZ, ROBERT, *Naked by the Window: The Fatal Marriage of Carl Andre and Ana Mendieta* (New York: Atlantic Monthly Press, 1990).

KWON, MIWON, "Bloody Valentines: Afterimages by Ana Mendieta" in Catherine de Zegher (ed.), *Inside the Visible: An Elliptical Traverse of Twentieth Century Art In, Of, and From the Feminine* (Cambridge, MA: The MIT Press, 1996).

NEW MUSEUM OF CONTEMPORARY ART, *Ana Mendieta: A Retrospective* (New York, New Museum of Contemporary Art, 1987) Petra Barreras de Rio and John Perreault, guest curators.

Cindy Sherman

KRAUSS, ROSALIND, *Cindy Sherman* (New York: Rizzoli, 1993).

SHERMAN, CINDY, *Cindy Sherman* (New York: Whitney Museum of Art, 1987).

Cindy Sherman History Portraits, essay by Arthur C. Danto (New York: Rizzoli, 1991).

Barbara Kruger

GOLDSTEIN, ANN (ed.), *Barbara Kruger* (Cambridge, MA: The MIT Press, 1999), exhibition catalog.

LINKER, KATE, *Love for Sale: The Words and Pictures of Barbara Kruger* (New York: Abrams, 1990).

SQUIERS, CAROL, "Diversionary (Syn)tactics: Barbara Kruger Has Her Way with Words," *Art News,* 86 (February 1987), pp. 74–85.

African-American Artists

FARRIS, PHOEBE, *Women Artists of Color: A Bio-Critical Sourcebook to 20th Century Artists in the Americas* (Westport, CT: Greenwood Press, 1999).

Gumbo Ya Ya: Anthology of Contemporary African-American Women Artists (New York: MidMarch, 1995).

HALL, ROBERT, *Gathered Visions: Selected Works by African American Women Artists* (Washington, DC: Smithsonian Institution, 1992).

HASSAN, SALAH M. (ed.), *Gendered Visions: The Art of Contemporary Africana Women Artists* (Trenton, NJ: Africa World Press, 1997).

HENKES, ROBERT, *The Art of Black American Women: Works of Twenty-Four Artists of the Twentieth Century* (Jefferson, NC: McFarland, 1993).

HOOKS, BELL, *Art on My Mind: Visual Politics* (New York: The New Press, 1995).

KING-HAMMOND, LESLIE, *et al.* (eds.), *3 Generations of African American Women Sculptors: A Study in Paradox* (Philadelphia: Afro-American Historical and Cultural Museum, 1996).

LA DUKE, BETTY, *Women Artists: Multi-Cultural Visions* (Trenton, NJ: The Red Sea Press, 1992).

ROBINSON, JONTYLE THERESA, *Bearing Witness: Contemporary Works by African American Women Artists* (New York: Spelman College and Rizzoli, 1996).

Carrie Mae Weems

JACOBS, MARY JANE, *Carrie Mae Weems* (Philadelphia: Fabric Workshop Museum, 1994).

Faith Ringgold

CAMERON, DAN, *et al.*, *Dancing at the Louvre: Faith Ringgold's French Collection and Other Story Quilts* (New York: New Museum of Contemporary Art; and Berkeley: University of California Press, 1998).

FARRINGTON, LISA, *Art on Fire: The Politics of Race and Sex in the Paintings of Faith Ringgold* (New York: Millennium Fine Arts, 1999).

RINGGOLD, FAITH, *We Flew Over the Bridge: The Memoirs of Faith Ringgold* (Boston, Little, Brown, 1995).

19

Global Issues for Women Artists: Past, Present, and Future

This book is Eurocentric in its focus. The women artists discussed in the text were active in western Europe and the United States. It is an unfortunate, but unavoidable emphasis. There are several reasons for this bias. One is the always present limitations on space to which a textbook, such as this one, is confined. It is simply not possible to present a truly global perspective for women artists in a depth equal to the treatment of European and American creators. However, there is an additional reason for the Eurocentric bias. The published literature, in English, concerning women artists active on other continents does not have the range and complexity of treatments similar to those on which we have relied to build this book. Most texts concerning women artists in other regions are focused on a reconstruction of the activity of women creators. The ways in which these works relate to dominant discourses on gender and related political issues of feminism are not yet fully understood. With few exceptions, texts focused on women artists, especially those active after World War II, are engaged in recuperation, a historical rediscovery of the creators of the present and their predecessors of the nineteenth century. There are a few notable texts concerning Asian women painters of the traditional periods of Japan and China. However, the literature in this area is still quite limited.

Based on existing works, it is possible to state with confidence that women artists have been fully active creators in all styles, media, and periods wherever scholars have looked to find them. It is unthinkable to assume that women will not continue to be active participants in their visual cultures in the future.

The new millennium presents a unique opportunity to look back on the progressive range of activity and the broadening base of knowledge about

women artists of the past. I eagerly anticipate the next decades and I feel confident that the literature will expand to document, in more critical depth the works of women artists around the globe. I hope that the inclusion of the following bibliography on women of different continents will, partially, make up for the omission of individual chapters on all of these regions. I strongly encourage the reader to view this text as a beginning point, a jumping off place to pursue the topics in the scale and complexity which they deserve.

Suggestions for Further Reading

Latin American Women Artists
AGOSIN, MARJORIE (ed.), *A Woman's Gaze: Latin American Women Artists* (Fredonia, NY: White Pine Press, 1998).

AMARAL, ARACY, *Ultramodern: The Art of Contemporary Brazil* (Washington, DC: National Museum of Women in the Arts, 1993).

BILLER, GERALDINE, curator, *Latin American Women Artists/Artistas Latinoamericanas: 1915–1995* (Milwaukee, WI: Milwaukee Art Museum, 1995).

GOLDMAN, SHIFRA, *Dimensions of the Americas: Art and Social Change in Latin America and the United States* (Chicago: University of Chicago Press, 1994).

GOLDMAN, SHIFRA, *Latin American Art* (Chicago: University of Chicago Press, 1995).

HENKES, ROBERT, *Latin American Women Artists of the United States: The Works of 33 Twentieth-Century Women* (Jefferson, NC: McFarland, 1999).

PUERTO, CECILIA, *Latin American Women Artists, Kahlo and Look Who Else: A Selective Annotated Bibliography* (Westport, CT: Greenwood Press, 1996).

Asian Women Artists (Traditional)
FISTER, PAT, *Japanese Women Artists, 1600–1900* (Lawrence: Spencer Museum of Art, University of Kansas, 1988).

WEIDNER, MARSHA (ed.), *Flowering in the Shadows: Women in the History of Chinese and Japanese Painting* (Honolulu: University of Hawaii Press, 1990).

WEIDENER, MARSHA (ed.), *Views from Jade Terrace: Chinese Women Artists, 1300–1912* (Indianapolis: Indianapolis Museum of Art, 1988).

Asian Women Artists (Contemporary)
DYSART, DINAH, and HANNAH FINK (eds.), *Asian Women Artists* (Roseville East, NSW, Australia: Craftsman House, 1996).

LEE, CANDACE, *A Gathering Place: Artmaking by Asian/Pacific Women in Traditional and Contemporary Directions* (Pasadena, CA: Pacific Asia Museum, 1995).

LIM, LUCY, *Six Contemporary Chinese Women Artists* (San Francisco: Chinese Cultural Foundation of San Francisco, 1991).

Australia and New Zealand

GERMAINE, MAX, *A Dictionary of Women Artists of Australia* (Australia: Craftsman House, 1991).

HAMMOND, VICTORIA, and JULIET PEERS, *Completing the Picture: Women Artists and the Heidelberg Era* (Melbourne, Australia: Artmoves, 1992).

HORN, JEANETTE (ed.), *Strange Women: Essays in Art and Gender* (Melbourne: Melbourne University Press, 1994).

KIRBY, SANDY, *Sight Lines: Women's Art and Feminist Perspectives in Australia* (Australia: Craftsman House, 1992).

KIRKER, ANNE, *New Zealand Women Artists: A Survey of 150 Years*, 2nd ed. (Tortola, BVI: Craftsman House, 1993).

TOPLISS, HELEN, *Modernism and Feminism: Australian Women Artists, 1900–1940* (Roseville East, NSW: Australia, Craftsman House, 1996).

Israel

GINTON, ELLEN, *et al.*, *Feminine Presence: Israeli Women Artists in the Seventies and Eighties* (Tel Aviv: Museum of Art, 1990).

GINTON, ELLEN, *et al.*, *Jennifer bar Lev* (Tel Aviv: Museum of Art, 1992).

LEVINGER, ESTHER, "Women and War Memorials in Israel," *Woman's Art Journal*, 16(1) (Spring/Summer 1995). pp. 40–46.

Africa

ARNOLD, MARION, *Women and Art in South Africa* (New York: St. Martin's Press, 1997).

HASHIMI, SALIM, and NIMA POOVAYA-SMITH, *An Intelligent Rebellion: Women Artists of Pakistan* (Bradford, England: City of Bradford Metropolitan Council Arts, Museums and Libraries, 1994).

LA DUKE, BETTY, *Africa: Women's Art, Women's Lives* (Trenton, NJ: Africa World Press, 1997).

Arab World

NASHASHIBI, SALVA MIKDADI, *Forces of Change, Artists of the Arab World* (Washington, DC: National Museum of Women in the Arts, 1994).

Canada and the Pacific Northwest

BRUNSMAN, LAURA, and RUTH ASKEY (eds.), *Modernism and Beyond: Women Artists of the Pacific Northwest* (New York: Midmarch Arts, 1993).

LEROUX, ODETTE, MARION E. JACKSON, and MINNIE AODLA FREEMAN (eds.), *Inuit Women Artists: Voices from Cape Dorset* (Vancouver: Dougland and McIntyper, 1994).

TIPPETT, MARIA, *By a Lady: Celebrating Three Centuries of Art by Canadian Women* (New York: Viking/Penguin, 1992).

ZEMANS, JOYCE, *et al.*, *New Perspectives on Modernism in Canada: Kathleen Munn and Edna Tacon* (Toronto: Editions du GREF, 1988).

Notes

Preface
1. Griselda Pollock, "Feminist Interventions in the History of Art: An Introduction" in *Vision and Difference: Femininity, Feminism and the Histories of Art* (London: Routledge, 1988), pp. 1ff.

Introduction
1. Reprinted in Thomas B. Hess and Elizabeth C. Baker (eds.), *Art and Sexual Politics: Women's Liberation, Women Artists and Art History* (New York and London: Collier, 1973).
2. Pollock, *Vision and Difference*, pp. 1ff.
3. Michael Ann Holly, "Past Looking," *Critical Inquiry*, 16 (Winter 1990), p. 395.
4. Denise Riley, " *Am I That Name?": Feminism and the Category of "Women in History"* (Minneapolis: University of Minnesota Press, 1988), p. 2.
5. Judith Butler, *Gender Trouble: Feminism and the Subversion of Identity* (New York and London: Routledge, 1990), p. 14.
6. Judith Butler, *Bodies that Matter: On the Discursive Limits of "Sex"* (New York and London: Routledge, 1993), p. 10.
7. Natalie Boymel Kampen, "Gender Theory in Roman Art" in Diana E. E. Kleiner and Susan B. Matheson (eds.), *I Claudia: Women in Ancient Rome* (New Haven, CT: Yale University Art Gallery, 1996), p. 14.
8. Simone de Beauvoir, *The Second Sex*, trans. H. M. Parshley (New York, 1953), p. 249 quoted in Ibid, p. 14.
9. Mary D. Sheriff, *The Exceptional Woman: Elisabeth Vigée-Lebrun and the Cultural Politics of Art* (Chicago and London: University of Chicago Press, 1996), p. 9.
10. Butler, *Gender Trouble*, p. 25.
11. Kampen, in *I Claudia*, p. 17.
12. Ibid., p. 14.
13. Mieke Bal and Normal Bryson, "Semiotics and Art History," *Art Bulletin*, 73 (1991), pp. 174–208.
14. Pollock, *Vision and Difference*, p. 11.
15. Amy Richlin, in Richlin (ed.), *Pornography and Representation in Greece and Rome* (New York: Oxford University Press, 1992), p. 179.
16. Bal and Bryson, "Semiotics in Art History," p. 177.
17. Griselda Pollock, *Differencing the Canon: Feminist Desire and Writing of Art's Histories* (London and New York: Routledge, 1999), p. 9.
18. Sheriff, *The Exceptional Woman*, p. 9.
19. Christine Battersby, *Gender and Genius: Towards a Feminist Aesthetics* (London and Bloomington: Indiana University Press, 1989), p. 14.
20. Ibid., p. 23.

Chapter 1
1. Margaret Ehrenberg, *Women in Prehistory* (Norman: University of Oklahoma Press, 1989), p. 66.
2. Ibid.

3. Stephanie Coontz and Peta Henderson (eds.), *Women's Work, Men's Property: The Origins of Gender and Class* (London: Verso, 1986), p. 37.
4. Elizabeth Barber, *Prehistoric Textiles: The Development of Cloth in the Neolithic and Bronze Ages* (Princeton, NJ: Princeton University Press, 1991), p. 284.
5. Ibid., p. 290.
6. Paula Webster, "Matriarchy: A Vision of Power," in Rayna R. Reiter, *Toward an Anthropology of Women* (New York: Monthly Review Press, 1975), p. 143.
7. Ann Oakley, *Sex, Gender and Society* (New York: Harper and Row, 1972), p. 165.

Chapter 2
1. Julia Asher Grève, *Frauen in Altsumerscher Zeit*, Biblioteca Mesopotamica 18 (Malibu: Udena Publications, 1985).
2. For the following discussion I am indebted to the detailed, excellent study by Gerda Lerner, *The Creation of Patriarchy* (New York: Oxford University Press, 1986) and the briefer essay by Ilse Seibert, *Women in the Ancient Near East*, trans. Marianne Herzfeld (New York: Abner Schram, 1974).
3. Asher Grève, *Frauen*, pp. 181ff.
4. Irene J. Winter, "Women in Public: *The Disk of Enheduanna*, the Beginning of the Office of En-Priestess and the Weight of Visual Evidence," in J. M. Durand, *La Femme dans le Proche-Orient Antique* (Paris: Editions Recherche sur les civilisations, 1987).
5. Asher Grève, *Frauen*, p. 182.
6. The seal is reproduced in Seibert, *Women in the Ancient Near East*, p. 22.
7. Asher Grève, *Frauen*, p. 182.
8. Winter, "Women in Public," p. 200.

Chapter 3
1. Gay Robins, *Women in Ancient Egypt* (Cambridge, MA: Harvard University Press, 1993), p. 180.
2. Ibid.
3. Ibid., p. 55.
4. Ibid., p. 53.
5. Ibid., p. 189.
6. Ibid.
7. Gay Robins, "Dress, Undress, and the Representation of Fertility and Potency in New Kingdom Egyptian Art" in Natalie Boymel Kampen (ed.), *Sexuality in Ancient Art* (New York: Cambridge University Press, 1996), p. 39.

Chapter 4
1. Scully, *The Earth, the Temple, and the Gods: Greek Sacred Architecture*, rev. ed. (New Haven: Yale University Press, 1979), pp. 11–24. Sections of this discussion are reprinted in Broude and Garrard (eds.), *Feminism and Art History: Questioning the Litany* (New York: Harper and Row, 1982), pp. 33–43.
2. Ehrenberg, *Women in Prehistory*, p. 116.

Chapter 5
1. Jenifer Neils (ed.), *Goddess and Polis, The Panathenaia Festival in Ancient Athens* (Hanover, NJ and Princeton, NJ: Princeton University Press, 1992), p. 23.
2. Sarah B. Pomeroy, *Goddesses, Whores, Wives and Slaves: Women in Classical Antiquity* (New York: Schocken Books, 1975), pp. 64–78.
3. Eve Cantarella, *Pandora's Daughters: The Role and Status of Women in Greece and Roman Antiquity* (Baltimore, MD: Johns Hopkins University Press, 1987), p. 51.
4. Pomeroy, *Goddesses*, p. 227.
5. See E. J. W. Barber, "The Peplos of Athena" in Neils, *Goddess and Polis*, pp. 106–10.
6. Robert F. Sutton, Jr., "Pornography and Persuasion on Attic Pottery," in Amy Richlin (ed.), *Pornography and Representation in Greece and Rome* (New York: Oxford University Press, 1992), p. 24.
7. Dyfri Williams, "Women on Athenian Vases: Problems of Interpretation," in Averil Cameron and Amelie Kuhrt (eds.), *Images of Women in Antiquity* (London: Croom Helm, 1983), p. 94.
8. Kate McK. Elderkin, "The Contribution of Women to Ornament in Antiquity," in *Classical Studies Presented to Edward Capps on His Seventieth Birthday* (Princeton, NJ: Princeton University Press, 1936), p. 125.
9. Barber, *Prehistoric Textiles*, pp. 365ff.
10. Neils, *Goddess and Polis*, p. 14.
11. Ibid., p. 23.
12. Ibid., pp. 23–24.
13. Barber, "The Peplos of Athena" in Neils, Ibid., p. 117.
14. Robin Osborne, "Democracy and Imperialism in the Panathenaic Procession: The Parthenon Frieze in Its Context" in W. D. E. Coulson, et al., eds., *The Archeology of Athens and Attica Under the Democracy* (Oxford: Oxbow Monograph 37, 1994), pp. 143–50.
15. Eva Stehle and Amy Day, "Women Looking at Women: Women's Ritual and Temple Sculpture" in Kampen (ed.), *Sexuality in Ancient Art*, p. 110.

16. Osborn, "Democracy and Imperialism," p. 143.
17. Jeffrey Henderson in David Halperin, John J. Winkler, and Froma Zeitlin (eds.), *Before Sexuality: The Construction of Erotic Experience in Ancient Greece* (Princeton, NJ: Princeton University Press, 1990), p. 3.
18. Michel Foucault, *The Use of Pleasure: The History of Sexuality*, vol. 2, trans. Robert Hurley (New York: Random House, 1985), pp. 217–25.
19. Ibid., p. 213.
20. Sutton, "Pornography and Persuasion," pp. 21–22.
21. Elderkin, "The Contribution of Women to Ornament," pp. 125–26.
22. Giovanni Boccaccio, *Concerning Famous Women*, trans. with an introduction by Guido A. Guarino (New Brunswick, NJ: Rutgers University Press, 1963), p. 131.
23. Robert Rosenblum, "The Origin of Painting: A Problem in the Iconography of Romantic Classicism," *Art Bulletin*, 39 (1957), pp. 279–82.
24. These histories include: Ernest Guhl, *Die Frauen in der Kunstgeschichte* (Berlin, 1858); Elizabeth Fries Lummis Ellet, *Women Artists in All Ages and Countries* (New York, 1859); Octave Fidière, *Les Femmes artistes à l'Académie royale de peinture et de sculpture* (Paris, 1885); Walter Sparrow, *Women Painters of the World* (London, 1905).

Chapter 6
1. Diana E. Kleiner, "Imperial Women as Patrons of the Arts in the Early Empire" in Kleiner and Matheson (eds.), *I Claudia*, p. 28.
2. Natalie Boymel Kampen, "Social Status and Gender in Roman Art: The Case of the Saleswoman," in Eve d'Ambra (ed.), *Roman Art in Context: An Anthology* (Englewood Cliffs, NJ: Prentice Hall, 1993), pp. 220ff.
3. Ibid., p. 220.
4. Pomeroy, *Goddesses*, pp. 199–200.
5. Diana E. E. Kleiner, "The Great Friezes of the Ara Pacis Augustae. Greek Sources, Roman Derivatives, and Augustan Social Policy," in d'Ambra (ed.), *Roman Art in Context*, pp. 27ff.
6. Verena Zinserling, *Women in Greece and Rome*, trans. L. A. Jones (New York: Abner Schram, 1973), p. 64.
7. Natalie Boymel Kampen, "Between Public and Private: Women as Historical Subjects in Roman Art," in Sarah B. Pomeroy (ed.), *Women's History and Ancient History* (Chapel Hill: University of North Carolina Press, 1991), p. 243.
8. Ibid.
9. Kleiner in Kleiner and Matheson (eds.), *I Claudia*, p. 35.
10. Mary T. Boatwright, "The City Gate of Plancia Magna in Perge," in d'Ambra (ed.), *Roman Art in Context*, p. 200.
11. Ramsay Macmullen, "Women in Public in the Roman Empire," *Historia*, XXIX/2 (1980), p. 212.
12. Eve d'Ambra, "The Calculus of Venus: Nude Portraits of Roman Matrons" in Kampen (ed.), *Sexuality in Ancient Art*, pp. 229–30.
13. Ibid., p. 222.
14. Elaine K. Gazda, "Introduction," in *Roman Art in the Private Sphere: New Perspectives on the Architecture and Decor of the Domus, Villa, and Insula* (Ann Arbor: University of Michigan Press, 1991), pp. 6–7.
15. Yvon Thébert, "Private and Public Spaces: The Components of the Domus," in d'Ambra (ed.), *Roman Art in Context*, p. 229.
16. Andrew Wallace-Hadrill, "Engendering the Roman House" in Kleiner and Matheson (eds.), *I Claudia*, p. 109.
17. Molly Myerowitz, "The Domestication of Desire: Ovid's *Parva Tabella* and the Theater of Love," in Amy Richlin (ed.), *Pornography and Representation in Greece and Rome* (New York: Oxford University Press, 1992), pp. 131ff.
18. Michel Foucault, "The Care of the Self," in *The History of Sexuality*, vol. 3, trans. Robert Hurley (New York: Random House, 1986), pp. 79–80.
19. Herlihy notes that there were fewer girls reaching adulthood than boys, but he does not attribute this directly to female infanticide. David Herlihy, "Life Expectancies for Women in Medieval Society," in Rosemarie Thee Morewedge (ed.), *The Role of Women in the Middle Ages* (Albany: State University of New York Press, 1975), pp. 4–5.
20. JoAnn McNamara and Suzanne Wemple, "The Power of Women Through the Family in Medieval Europe: 500–1100," in Mary Hartman and Louise Banner (eds.), *Clio's Consciousness Raised* (New York: Harper Colophon Books, 1974), pp. 103–4.
21. Averil Cameron, *Procopius* (Berkeley: University of California Press, 1985), p. 67.
22. Ibid., pp. 53–54.
23. Ibid., chapters 4 and 5.
24. Ibid., p. 74.
25. Ibid., p. 68.
26. Ibid., p. 81.

Chapter 7

1. Annemarie Weyl Carr, "Women Artists in the Middle Ages," *Feminist Art Journal*, V (1976), p. 6.
2. Caroline Bynum, *Holy Feast and Holy Fast: The Religious Significance of Food to Medieval Women* (Berkeley: University of California Press, 1987), pp. 264–65.
3. Quoted in Bynum, ibid., p. 260.
4. Jeryldene M. Wood, *Women, Art and Spirituality: The Poor Clares of Early Modern Italy* (New York: Cambridge University Press, 1996), p. 23.
5. Ibid., pp. 73–85.
6. Ibid., p. 85.
7. Ibid., p. 137.
8. Ibid., p. 144.
9. Jeffrey F. Hamburger, *Nuns as Artists: the Visual Culture of a Medieval Convent* (Berkeley: University of California Press, 1997), pp. 214–15.
10. Ibid., p. 137.
11. Ibid.
12. Ibid., p. 145.
13. Bynum, *Holy Feast*, p. 270.
14. Ibid., p. 274.
15. Kathleen Casey, "The Cheshire Cat: Reconstructing the Experience of Medieval Women," in Berenice A. Carroll (ed.), *Liberating Women's History* (Urbana: University of Illinois Press, 1976), p. 247, note 7.
16. Susan Groag Bell, "Medieval Women Book Owners: Arbiters of Lay Piety and Ambassadors of Culture," in Mary Erler and Maryann Kowalski (eds.), *Women and Power in the Middle Ages* (Athens: University of Georgia Press, 1988).
17. Joan Kelly, "Early Feminist Theory and the *Querelle des Femmes*, 1400–1789," *Signs*, VIII (Autumn 1982), pp. 4–28.
18. Gerda Lerner, *The Creation of Feminist Consciousness: From the Middle Ages to Eighteen-Seventy* (New York: Oxford University Press, 1993), p. 139.
19. Millard Meiss, *French Painting in the Time of Jean de Berry* (London: Phaidon, 1967–1968), I, p. 3.
20. Dorothy Miner believes that Le Noir is identical with the artist identified by Meiss as the "Passion Master" (see Dorothy Miner, *Anastaise and Her Sisters* (Baltimore, MD: Walters Art Gallery, 1974), p. 19. While Meiss accepts the possibility that Le Noir might be the name of the artist whose works form a stylistic group, he uses the name "Passion Master" for this figure, stopping short of attributing these works to Jean Le Noir (*French Painting*, pp. 167–68).
21. Miner, *Anastaise and Her Sisters*, pp. 18–19.
22. Ann Sutherland Harris and Linda Nochlin, *Women Artists: 1550–1950* (New York: Knopf, and Los Angeles County Museum of Art, 1977), p. 26.
23. A. G. I. Christie, *English Medieval Embroidery* (Oxford: Clarendon Press, 1938), Appendix I.
24. Roszika Parker, *The Subversive Stitch: Embroidery and the Making of the Feminine* (London: Women's Press, 1984), p. 27.
25. Ibid., p. 29.
26. Harris and Nochlin, *Women Artists: 1550–1950*, pp. 16–17.
27. For a detailed description of the Syon Cope, see Christie, *English Medieval Embroidery*, pp. 142–48.
28. Martha Howell, *Women, Production and Patriarchy in Late Medieval Cities* (New Brunswick, NJ: Rutgers University Press, 1986), pp. 9ff.
29. Eileen Power, *Medieval Women*, ed. M. M. Postan (London: Cambridge University Press, 1975), p. 38.
30. Ibid., pp. 87–88.
31. Maryanne Kowalski and Judith M. Bennett, "Crafts, Guilds, and Women in the Middle Ages: Fifty Years after Marian K. Dale," *Signs*, 14 (1989), p. 480.
32. Ibid., p. 483.
33. Howell, *Women, Production and Patriarchy, in Late Medieval Cities*, p. 179.
34. Merry E. Wiesner, *Working Women in Renaissance Germany* (New Brunswick, NJ: Rutgers University Press, 1986), pp. 157ff.
35. Ibid., pp. 163ff.
36. Ibid., p. 172.
37. Natalie Zemon Davis, "Women in the Crafts in Sixteenth-Century Lyon," in Barbara A. Hanawalt (ed.), *Women and Work in Preindustrial Europe* (Bloomington: Indiana University Press, 1986), p. 187.
38. Ibid., p. 189.
39. Sibylle Harksen, *Women in the Middle Ages*, trans. Marianne Herzfeld (New York: Abner Schram, 1975), p. 28.

Chapter 8

1. Judith Brown, "A Woman's Place Was in the Home: Women's Work in Renaissance Tuscany," in Margaret W. Ferguson et al. (eds.), *Rewriting the Renaissance: The Discourse of Difference in Early Modern Europe* (Chicago: University of Chicago Press, 1986), p. 209.
2. Ibid., p. 215.

3. Patricia Simons, "Women in Frames: The Gaze, the Eye, the Profile in Renaissance Portraiture," in Norma Broude and Mary D. Garrard (eds.), *The Expanding Discourse: Feminism and Art History* (New York: HarperCollins, 1992), pp. 39ff.
4. Joan Kelly-Gadol, "Did Women Have a Renaissance?" In Renate Bridenthal and Claudia Koonz (eds.), *Becoming Visible: Women in European History* (Boston: Houghton Mifflin, 1972), pp. 160–61.
5. J. O'Faolain and L. Martines, *Not in God's Image* (New York: Harper and Row, 1973), p. 145.
6. Hannelore Sachs, *The Renaissance Woman,* trans. Marianne Herzfeld (New York: McGraw-Hill, 1971), p. 9.
7. Ruth Kelso, *Doctrine for the Lady of the Renaissance* (Urbana: University of Illinois Press, 1956), pp. 59, 77.
8. Simons, op. cit., p. 41.
9. Ibid., p. 45.
10. Richard Goldthwaite, *The Building of Renaissance Florence: An Economic and Social History* (Baltimore, MD: Johns Hopkins University Press, 1980), pp. 77ff.
11. Ibid., pp. 13–14.
12. Ibid., p. 108 (emphasis added).
13. Lilian Zirpolo, "Botticelli's *Primavera:* A Lesson for the Bride," in Broude and Garrard (eds.), *The Expanding Discourse,* pp. 101ff.
14. Howell, *Women, Production and Patriarchy in Late Medieval Cities,* p. 16.
15. Fredrika Jacobs, *Defining the Renaissance Virtuosa: Women Artists and the Language of Art History and Criticism* (New York: Cambridge University Press, 1997), p. 66.
16. Nancy Finlay, "The Female Gaze: Women's Interpretations of the Life and Work of Properzia De' Rossi, Renaissance Sculptor," in Natalie Harris Bluestone (ed.), *Double Vision: Perspectives on Gender and the Visual Arts* (London and Cranbury, NJ: Associated University Presses, 1995), p. 43.
17. Harris and Nochlin, in *Women Artists: 1550–1950,* p. 106.
18. Margaret L. King, "Book Lined Cells: Women and Humanism in the Early Italian Renaissance," in Patricia Labalme (ed.), *Beyond Their Sex: Learned Women of the European Past* (New York: New York University Press, 1984).
19. Quoted in Harris and Nochlin, *Women Artists: 1550–1950,* p. 107.
20. Jacobs, *Defining the Renaissance Virtuosa,* pp. 154–55.
21. Ibid., p. 158.
22. Ibid., p. 159.
23. Sondra Ilya Perlinghieri, *Sofonisba Anguissola: The First Great Woman Artist of the Renaissance* (New York: Rizzoli, 1992), pp. 65ff.
24. Eleanor Tufts, *Our Hidden Heritage: Five Centuries of Women Artists* (New York: Paddington Press, 1974), p. 21.
25. Mario Praz, *Conversation Pieces: A Survey of the Informal Group Portrait in Europe and America* (University Park: Pennsylvania State University Press, 1971), p. 149.
26. Harris and Nochlin, *Women Artists: 1550–1950,* p. 111.
27. *The Age of Correggio and the Carracci: Emilian Painting of the 16th and 17th Centuries* (Washington, DC: National Gallery of Art, 1986), p. 132.
28. Tufts, op. cit., p. 32.
29. Cynthia Lawrence (ed.), *Women and Art in Early Modern Europe: Patrons, Collectors, and Connoisseurs* (University Park, PA: Pennsylvania State University Press, 1997), p. 16.
30. See Lawrence, *Women and Art in Early Modern Europe.*
31. Clifford M. Brown "A Ferrarese Lady: A Mantuan Marchesa: the art and antiquities collection of Isabella d'Este Gonzaga (1474–1539)" in Lawrence (ed.), *Women and Art in Early Modern Europe,* p. 63.
32. Sheila ffolliott, "The ideal queenly patron of the Renaissance: Catherine de Medici, defining herself or defined by others?" in Lawrence (ed.), *Women and Art in Early Modern Europe.*

Chapter 9
1. R. Ward Bissell, *Artemisia Gentileschi and the Authority of Art* (University Park, PA: Pennsylvania State University Press, 1999), p. 15.
2. Ibid., p. 16.
3. Ibid., p. 18. A complete transcript, translated into English, is published in Mary D. Garrard, *Artemisia Gentileschi: The Image of the Female Hero in Italian Baroque Art* (Princeton, NJ: Princeton University Press, 1989).
4. Bissell, *Artemisia Gentileschi,* p. 125.
5. All Artemisia Gentileschi's letters are reprinted in Garrard, *Artemisia Gentileschi.*
6. Pamela Hibbs Decateau, *Clara Peeters (1594–c.1640) and the Development of Still-Life Painting in Northern Europe* (Luca Verlag, 1992), p. 118.
7. E. de Jongh, *Still Life in the Age of Rembrandt* (Auckland, New Zealand: Auckland City Art Gallery, 1982), p. 65.
8. Decateau, *Clara Peeters,* p. 120.
9. Ibid., p. 108.
10. de Jongh, *Still Life,* p. 179.

11. Wayne E. Franits, *Paragons of Virtue: Women and Domesticity in Seventeenth Century Dutch Art* (Cambridge and New York: Cambridge University Press, 1993), p. 196.
12. Ibid., p. 31.
13. Ibid., p. 33.
14. Frima Fox Hofrichter, *Judith Leyster: A Woman Painter in Holland's Golden Age* (Doornspijk, The Netherlands: Davaco, 1989), p. 52.
15. James A. Welu and Pieter Biesboer, *Judith Leyster: A Dutch Master and Her World* (Worcester Art Museum and New Haven, CT: Yale University Press, 1993), p. 168.
16. Ibid., pp. 47–48.
17. Laurinda S. Dixon, *Women and Illness in Pre-Enlightenment Art and Medicine* (Ithaca and London: Cornell University Press, 1995), p. 159.
18. Ibid., p. 161.
19. Ibid., p. 194.
20. Ibid., p. 209.
21. Katlijne van der Stighelen, "Et ses artistes mains . . . ": the Art of Anna Maria van Schurman" in Mirjam De Baar (ed.), *Choosing the Better Part: Anna Maria van Schurman* (1607–1678), trans. by Lynne Richards (Dordrecht and Boston: Kluwer Academic Publishers, 1996), p. 58.
22. Dixon, *Women and Illness*, p. 210.
23. Simon Schama, *The Embarrassment of Riches: An Interpretation of Dutch Culture in the Golden Age* (Berkeley: University of California Press, 1988), p. 407.

Chapter 10

1. Harris and Nochlin, *Women Artists: 1550–1950*, p. 161.
2. For a discussion of the Crozat Circle, see Thomas Crow, *Painters and Public Life in Eighteenth Century France* (New Haven, CT: Yale University Press, 1985).
3. Tufts, *Our Hidden Heritage*, p. 110.
4. For a translation of this text, see Wendy Slatkin, *The Voices of Women Artists* (Englewood Cliffs, NJ: Prentice Hall, 1993), pp. 18–19.
5. Patricia Labalme, "Women's Roles in Early Modern Venice: An Exceptional Case," in Labalme (ed.), *Beyond Their Sex: Learned Women of the European Past* (New York: New York University Press, 1980), pp. 129–152.
6. Ibid.
7. Wendy Wassyng Roworth, *Angelica Kauffman: A Continental Artist in Georgian England* (Brighton: The Royal Pavilion Art Gallery and Museums, and London: Reaktion Books, 1992), pp. 15–17.
8. Ibid., p. 21.
9. Ibid., p. 91.
10. Ibid., pp. 92–93.
11. Marcia Pointon, *Strategies for Showing: Women, Possession and Representation in English Visual Culture, 1665–1800* (Oxford and New York: Oxford University Press, 1997), pp. 145–46.
12. Ibid., pp. 150ff.
13. Mary Sheriff, *The Exceptional Woman: Elisabeth Vigée-Lebrun and the Cultural Politics of Art* (Chicago and London: University of Chicago Press, 1996), p. 78.
14. Ibid., p. 79.
15. For a thorough discussion of this painting, in French see Joseph Baillio, "*Marie-Antoinette et ses enfants* par Mme. Vigée-Lebrun," *L'Oeil* (March–April 1981).
16. Lynn Hunt, "The Many Bodies of Marie Antoinette: Political Pornography and the Problem of the Feminine in the French Revolution," in Lynn Hunt (ed.), *Eroticism and the Body Politic* (Baltimore, MD: Johns Hopkins University Press, 1991), pp. 108ff.
17. For a discussion of the new issues of motherhood, see Carol Duncan, "Happy Mothers and Other New Ideas in Eighteenth-Century French Art," in Broude and Garrard (eds.), *Feminism and Art History*, pp. 201ff.
18. Sheriff, *The Exceptional Woman*, p. 2.
19. The discussion of Labille-Guiard is based on the detailed, authoritative study of the artist by Anne-Marie Passez, *Biographie et Catalogue raisonné des oeuvres de Mme. Labille-Guiard* (Paris: Arts et Metiers Graphiques, 1973).
20. Roseanne Runte, "Women as Muse," in Samia I. Spencer (ed.), *French Women and the Age of Enlightenment* (Bloomington: Indiana University Press, 1984), p. 144.

Chapter 11

1. Marilyn J. Boxer and Jean H. Quataert (eds.), *Connecting Spheres: Women in the Western World, 1500 to the Present* (New York: Oxford University Press, 1987), pp. 102–9.
2. Gen Doy, *Women and Visual Culture in 19th Century France: 1800–1852* (London and New York: Leicester University Press, 1998), p. 32.
3. Ibid., p. 41.
4. Ibid., p. 9.
5. Ibid., p. 120.

6. Carol Ockham, *Ingres's Eroticized Bodies: Retracing the Serpentine Line* (New Haven, CT: Yale University Press, 1995).
7. Ibid., Chapter 2.
8. Janis Bergman-Carton, *The Woman of Ideas in French Art, 1830–1848* (New Haven, CT: Yale University Press, 1995), p. 36.
9. Ibid., p. 221.
10. Theodore Stanton (ed.), *Reminiscences of Rosa Bonheur* (London, 1910; reprinted New York: Hacker Art Books, 1976), p. 72.
11. Anna Elizabeth Klumpke, *Rosa Bonheur, sa vie, son oeuvre* (Paris: Flammarion, 1908), pp. 311–12 (author's translation).
12. For the discussion of Bonheur, I am strongly indebted to the excellent essay by Albert Boime, "The Case of Rosa Bonheur: Why Should a Woman Want to Be More Like a Man?" *Art History*, 4 (December 1981), p. 384.
13. James M. Salsow, "Disagreeably Hidden: Construction and Constriction of the Lesbian Body in Rosa Bonheur's *Horse Fair*," in Broude and Garrard (eds.), *The Expanding Discourse*, p. 190.
14. Ibid., Fig. 8.
15. Whitney Chadwick, *Women, Art, and Society* (London: Thames and Hudson, 1991), p. 185.
16. Coral Landsbury, *The Old Brown Dog: Women, Workers and Vivisection* (Madison: University of Wisconsin Press, 1985).
17. Chadwick, *Women Art, and Society*, pp. 180ff.

Chapter 12
1. Kathleen D. McCarthy, *Women's Culture: American Philanthropy and Art, 1830–1930* (Chicago: University of Chicago Press, 1991), p. 28.
2. Ibid., p. 8.
3. Ibid., p. 20.
4. Eleanor Tufts (ed.), *American Women Artists: 1830–1930* (Washington, DC: The National Museum of Women in the Arts, 1987), catalogue entry number 5.
5. Robin Bolton-Smith and William H. Truettner, *Lilly Martin Spencer: The Joys of Sentiment* (Washington, DC: Smithsonian Institution Press for the National Collection of Fine Arts, 1973), p. 11.
6. Ibid., p. 69.
7. McCarthy, *Women's Culture*, p. 18.
8. Jane Mayo Roos, "Another Look at Henry James and the 'White Marmorean Flock'," *Woman's Art Journal*, 4 (Summer 1983), p. 32.
9. Harriet Hosmer, quoted in Slatkin, *The Voices of Women Artists*, p. 121.
10. Susan Waller, "The Artist, the Writer, and the Queen: Hosmer, Jameson, and Zenobia," *Woman's Art Journal*, 4 (Summer 1983), pp. 21–28.
11. For a complete discussion of this work, see Tufts, *American Women Artists: 1830–1930*, catalogue entry number 107.

Chapter 13
1. Cherry, *Painting Women: Victorian Women Artists* (London: Routledge, 1993) p. 78.
2. Morris and Nochlin, in *Women Artists: 1550–1950*, p. 55.
3. Cherry, *Painting Women*, p. 50.
4. Pamela Gerrish Nunn and Jan Marsh, *Women Artists of the Pre-Raphaelite Movement* (London: Virago, 1989).
5. Jan Marsh and Pamela Gerrish Nunn, *Pre-Raphaelite Women Artists* (London: Thames and Hudson, 1998), p. 11.
6. Reprinted in Pollock, *Vision and Difference*, pp. 91ff.
7. Ibid., p. 105.
8. Ibid., p. 97.
9. Marsh and Gerrish Nunn, *Pre-Raphaelite Women Artists*, p. 115.
10. Gerrish Nunn and Marsh, *Women Artists*, p. 70.
11. Ibid., p. 72.
12. Ibid., p. 73.
13. Marsh and Gerrish Nunn, *Pre-Raphaelite Women Artists*, p. 72.
14. Violet Hamilton, *Annals of My Glass House* (Seattle and London: Scripps College in association with University of Washington Press, 1996), p. 54.
15. For a thorough discussion of *The Roll Call*, see Paul Usherwood and Jenny Spencer-Smith, *Lady Butler (1846–1933): Battle Artist* (London: National Army Museum, 1987), pp. 31ff, catalogue number 18. For the influence of French military painting, see pp. 163ff.
16. Matthew Lalumia, "Lady Elizabeth Thompson Butler in the 1870s," *Woman's Art Journal*, 4 (Spring/Summer, 1983), pp. 9ff.
17. Paul Usherwood, "A Case of Tokenism," *Woman's Art Journal*, 11 (Fall 1990/Winter 1991), pp. 14ff.
18. Paul Usherwood, "Elizabeth Thompson Butler: The Consequences of Marriage," in *Woman's Art Journal* (Spring/Summer, 1988), pp. 30ff.

Chapter 14

1. Harris and Nochlin, *Women Artists: 1550–1950*, p. 46.
2. Denis Rouart, *The Correspondence of Berthe Morisot* (London: Lund Humphries, 1957), p. 14.
3. Charles F. Stuckey and William P. Scott, *Berthe Morisot: Impressionist* (New York: Hudson Hills Press, Mount Holyoke College Art Museum in Association with the National Gallery of Art, 1987). See color-plate 2 in the volume.
4. Ibid., pp. 88ff.
5. Anne Higonnet, *Berthe Morisot's Images of Women* (Cambridge, MA: Harvard University Press, 1992), p. 187.
6. Ibid., p. 173.
7. Tamar Garb, *Bodies of Modernity: Figure and Flesh in Fin-de-Siecle France* (London: Thames and Hudson, 1998), p. 130.
8. Griselda Pollock, "Modernity and the Spaces of Femininity," in *Vision and Difference*, p. 88.
9. Bailey van Hook, *Angels of Art: Women and Art in American Society: 1876–1914* (University Park, PA: Pennsylvania State University Press, 1996), p. 183.
10. Pollock, *Vision and Difference*, p. 78.
11. Harris and Nochlin, *Women Artists: 1550–1950*, p. 257.
12. Roszika Parker and Griselda Pollock, Introduction to *The Journal of Marie Bashkirtseff*, translated by Mathilde Blind (London: Virago Press, 1985), first published in English in 1890.
13. Ibid., Jan. 2, 1879, quoted in Slatkin, *Voices of Women Artists*, p. 71.
14. Ibid., p. vi.
15. Tamar Garb, *Sisters of the Brush: Women's Artistic Culture in Late Nineteenth-Century Paris* (New Haven, CT: Yale University Press, 1994).
16. Ibid., p. 111.
17. Ibid., p. 129.
18. Ibid., p. 165.
19. Jude Burkhauser (ed.), *Glasgow Girls: Women in Art and Design (1880–1920)* (Edinburgh: Canongate Press, 1993), p. 66.
20. Ibid., p. 81.
21. For a series of essays on a number of creative couples, see Whitney Chadwick and Isabelle de Courtivron (eds.), *Significant Others: Creativity and Intimate Partnership* (London and New York: Thames and Hudson, 1993).
22. Tufts, *American Women Artists*, p. 43.
23. Jo Ann Wein, "The Parisian Training of American Women Artists," *Woman's Art Journal*, 2 (Spring/Summer 1981), pp. 41ff.
24. McCarthy, *Women's Culture*, p. 14.
25. Pat Ferrero, Elaine Hedges, and Julie Silber, *Hearts and Hands: The Influence of Women and Quilts on American Society* (San Francisco: Quilt Digest Press, 1987), p. 28.
26. Ibid., p. 11.
27. Gladys-Marie Fry, "Harriet Powers" in Salah M. Hassan, *Gendered Visions: The Art of Contemporary Africana Women Artists* (Trenton, NJ: Africa World Press, 1997), p. 85.
28. Frieda High W. Tesfagiorgis, "In search of discourse and critique(s) that center the art of black women artists" in Hassan (ed.) *Gendered Visions*, p. 87.
29. Ibid.
30. Wanda M. Corn, "Women Building History," in Tufts, *American Women Artists: 1830–1930*, pp. 26–29.
31. McCarthy, *Women's Culture*, p. 37.
32. Ibid., p. 84.
33. Ibid., p. 112.
34. Corn, "Women Building History," p. 31.
35. For a complete discussion, see Jeanne Madeline Weimann, *The Fair Women: The Story of the Women's Building, World's Columbian Exposition, Chicago, 1893* (Chicago: Academy Chicago, 1981).

Chapter 15

1. Katy Deepwell, *Women Artists and Modernism* (Manchester and New York: Manchester University Press, 1998), p. 2.
2. Donna J. Haraway, "Situated Knowledges: The Science Question in Feminism and the Privilege of Partial Perspective" in *Simians, Cyborgs and Women* (New York, Routledge, 1991), pp. 183–202.
3. Bridget Elliott and Jo-Ann Wallace, *Women Artists and Writers: Modernist (Im)positionings* (London and New York: Routledge, 1994), p. 2.
4. Gill Perry, *Women Artists and the Parisian: Avant-Garde: Modernism and "feminine" art, 1900 to late 1920s* (Manchester and New York: Manchester University Press, 1995).
5. J. Diane Radycki, "The Life of Lady Art Students: Changing Art Education at the Turn of the Century," *Art Journal*, 42 (Spring 1982), pp. 9–13.
6. Shulamith Behr, *Women Expressionists* (New York: Rizzoli, 1988).
7. Radycki, "The Life of Lady Art Students."
8. Gunter Busch and Liselotte von Reinken (eds.), trans. by Arthur S. Wensinger and Carole Clew Hoes (Evanston, IL: Northwestern University Press, 1990), p. 112.

9. Rosemary Betterton, "Mother Figures: the Maternal Nude in the Work of Käthe Kollwitz and Paula Modersohn-Becker" in Griselda Pollock (ed.), *Generations and Geographies in the Visual Arts: Feminist Readings* (London and New York: Routledge, 1996), p. 169.
10. Ibid.
11. Ibid., p. 162.
12. Elizabeth Prelinger et al., *Käthe Kollwitz* (Washington, DC: National Gallery of Art, 1992), pp. 75ff.
13. Betterton, "Mother Figures," p. 175.
14. Radycki, op. cit., p. 11.
15. Martha Kearns, *Käthe Kollwitz: Woman and Artist* (Old Westbury, NY: The Feminist Press, 1976), p. 192.
16. Anne Mochon, *Gabriele Munter: Between Munich and Murnau* (Cambridge, MA: Busch-Reisinger Museum, Harvard University, 1980), p. 16.
17. See catalogue entry no. 34 in Mochon.
18. Perry, *Women Artists and the Parisian Avant-Garde*, pp. 60ff.
19. Arthur A. Cohen, *Sonia Delaunay* (New York: Abrams, 1975), p. 61.
20. Ibid., p. 83.
21. For a discussion of this issue, see Clare Rendell, "Sonia Delaunay and the Expanding Definition of Art," *Woman's Art Journal*, 4 (Summer 1983), pp. 35–38.
22. Harris and Nochlin, in *Women Artists: 1550–1950*, p. 62.
23. Christina Lodder, *Russian Constructivism* (New Haven, CT: Yale University Press, 1983), p. 3.
24. Linda Nochlin, "Matisse and Its Other," *Art in America* (May 1993), p. 94.
25. Lodder, *Russian Constructivism*, p. 146.
26. Camilla Gray, *The Russian Experiment in Art: 1863–1922* (New York: Abrams, 1972), p. 224.
27. Quoted in Lodder, *Russian Constructivism*, p. 148.
28. Ibid., p. 151.
29. Ibid.

Chapter 16
1. Marsha Meskimmon and Shere West (eds.), *Visions of the "Neue frau": Women and the Visual Arts in Weimar Germany* (Aldershot, England: Ashgate Publishing, 1995).
2. Marsha Meskimmon, *"We Weren't Modern Enough": Women Artists and the Limits of German Modernism* (Berkeley and Los Angeles University of California Press, 1999).
3. Naomi Sawelson-Gorse, *Women in Dada: Essays on Sex, Gender and Identity* (Cambridge, MA: The MIT Press, 1998), p. xii.
4. Maud Lavid, *Cut with the Kitchen Knife: The Weimar Photomontages of Hannah Höch* (New Haven, CT: Yale University Press, 1993), p. 19.
5. Ibid., p. 23.
6. Ibid., p. 31.
7. Sigrid Weltge, *Women's Work: Textile Art from the Bauhaus* (San Francisco: Chronicle Books, 1993), p. 47.
8. Ibid., pp. 9–10.
9. Ibid., p. 89.
10. Ibid., p. 46.
11. Ibid., p. 104.
12. Ibid., p. 187.
13. Cassandra L. Langer, "Fashion, Character and Sexual Politics in Some Romain Brooks' Lesbian Portraits," *Art Criticism*, 1 (1981), p. 29.
14. Chadwick, *Women, Art, and Society*, p. 261.
15. Langer, "Fashion, Character and Sexual Politics," p. 30.
16. Adylyn Breeskin, *Romaine Brooks, "Thief of Souls"* (Washington, DC: National Collection of Fine Arts, Smithsonian Institution Press, 1971), p. 35.
17. Langer, Fashion, Character and Sexual Politics," p. 34.
18. Ibid., p. 36.
19. Andre Breton, *Arcane 17*, quoted in Whitney Chadwick, "Eros or Thanatos—The Surrealist Cult of Love Reexamined," *Artforum*, 14 (November 1975), p. 50.
20. Gloria F. Orenstein, "Art History and the Case for the Women of Surrealism," *The Journal of General Education*, XXVII (Spring 1975); reprinted in *Feminist Collage: Educating Women in the Visual Arts*, Judy Loeb (ed.) (New York: Teacher's College Press, Columbia University, 1979), pp. 35–59. This situation receives expanded treatment in Whitney Chadwick, *Women Artists and the Surrealist Movement* (Boston: Little, Brown, 1985).
21. Laurie J. Monahan, "Radical Transformations: Claude Cahun and the Masquerade of Womanliness" in M. Catherine de Zegher (ed.), *Inside the Visible: An Elliptical Traverse of Twentieth Century Art In, Of, and From the Feminine* (Cambridge, MA: the MIT Press, 1996), p. 125.
22. Rosalind Krauss, *Bachelors* (Cambridge, MA: The MIT Press, 1999), p. 42.
23. Monahan "Radical Transformations," p. 128.
24. Ibid.
25. Ibid., note 11.
26. Ibid., p. 128.

27. Josephine Withers, "The Famous Fur-Lined Teacup and the Anonymous Meret Oppenheim," *ARTS Magazine*, 52 (November 1977), p. 88.
28. From *Chronicle* (1958), quoted in Ibid., p. 93.
29. Janice Helland, "Culture, Politics and Identity in the Paintings of Frida Kahlo," in *The Expanding Discourse*, pp. 399–400.
30. Hayden Herrera, *Frida Kahlo: The Paintings* (New York: HarperCollins, 1991), p. 135.
31. Helland, "Culture, Politics and Identity," p. 401.
32. Herrera, *Frida Kahlo*, p. 135.
33. Ibid., p. 139.
34. Whitney Chadwick (ed.), *Mirror Images: Women, Surrealism and Self-Representation* (Cambridge, MA: The MIT Press, 1998), p. 97.
35. Ibid., p. 98.
36. Quoted in Slatkin, *Voices of Women Artists*, p. 236.
37. Ernst Van Alphen, "Charlotte Salomon: Autobiography as a Resistence to History" in de Zegher (ed.), *Inside the Visible*, p. 230.
38. Barbara Bloemink, *The Life and Art of Florine Stettheimer* (New Haven, CT: Yale University Press, 1995), pp. 180–82.
39. Ibid., pp. 180–83.
40. Barbara Buhler Lynes, "Georgia O'Keeffe and Feminism: A Problem of Position," in *The Expanding Discourse*, p. 439.
41. Ibid., p. 442.
42. Georgia O'Keeffe exhibition catalogue, *An American Place, 1939*, reprinted in *Georgia O'Keeffe* (New York: Viking Press, 1976).
43. Anna C. Chave, "O'Keeffe and the Masculine Gaze," in *Art in America*, 78 (January, 1990), p. 119.
44. Lloyd Goodrich and Doris Bry, *Georgia O'Keeffe* (New York: Whitney Museum of American Art, 1970), p. 18.
45. *Imogen Cunningham: Photographs*, with an introduction by Margery Mann (Seattle: University of Washington Press, 1970).
46. Karin Becker Ohrn, *Dorothea Lange and the Documentary Tradition* (Baton Rouge: Louisiana State University Press, 1980), p. 79.
47. Margaret Bourke-White, *Dear Fatherland, Rest Quietly* (New York: Simon and Schuster, 1946), p. 73.
48. Sara Boutelle, *Julia Morgan, Architect* (New York: Abbeville Press, 1988), pp. 16–17.
49. Ibid., p. 95.

Chapter 17

1. Ellen Landau, "Tough Choices: Becoming a Woman Artist, 1900–1970," in Randy Rosen et al. (eds.), *Making Their Mark: Women Artists Move into the Mainstream, 1970–85* (New York: Abbeville Press, 1989), p. 29.
2. "Introduction" in *Seven American Women: The Depression Decade* (Vassar College Art Gallery, 1976), p. 7.
3. Landau, op. cit., p. 29.
4. Ibid., p. 39.
5. Ibid.
6. Ibid., p. 40.
7. Ibid., p. 39.
8. Ibid., p. 40.
9. Barbara Rose, *Lee Krasner: A Retrospective* (New York: Museum of Modern Art, 1983). My discussion is indebted to Rose's excellent, detailed essay.
10. Anne M. Wagner, "Lee Krasner as L. K.," in *The Expanding Discourse*, pp. 426–27.
11. Ibid., p. 429.
12. Rose, op. cit., p. 54.
13. Wagner, op. cit., p. 434.
14. Quoted in Laurie Wilson, "Bride of the Black Moon: An Iconographic Study of the Work of Louise Nevelson," *ARTS Magazine*, 54 (May 1980), p. 144.
15. Louise Nevelson, *Louise Nevelson: Atmospheres and Environments* (New York: C. N. Potter in association with the Whitney Museum of American Art, 1980), p. 77.
16. Wilson, op. cit., p. 145.
17. Arnold B. Glimcher, *Louise Nevelson* (New York: Praeger, 1972), pp. 22–23.
18. Louise Nevelson, *Dawns and Dusks* (New York: Scribner's, 1976), quoted in Slatkin, *The Voices of Women Artists*, p. 254.
19. Claire Falkenstein, transcript from recorded conversation in *Los Angeles Art Community Group Portrait* (University of California, Los Angeles Oral History Program, 1982), p. 189.
20. Linda Nochlin, "Some Women Realists: Painters of the Figure," *ARTS Magazine*, 48 (May 1974), p. 30.
21. Ann Sutherland Harris, *Alice Neel: 1930–1980* exhibition catalogue (Los Angeles: Loyola Marymount University, 1983), p. 3.
22. Pamela Allara, *Pictures of People: Alice Neel's American Portrait Gallery* (Hanover, NH: Brandeis University Press, 1998).

23. Harris, *Alice Neel*, p. 6.
24. Patricia Hills, *Alice Neel* (New York: Abrams, 1983), p. 162.
25. Ibid., p. 185.
26. Nochlin, "Some Women Realists," p. 29.
27. Chadwick, *Women, Art, and Society*, p. 312.
28. Cindy Nemser, "An Interview with Eva Hesse," *Artforum* (May 1970), p. 62.
29. Anna Chave, "Eva Hesse: A Girl Being a Sculpture," in Helen Cooper et al. (eds.), *Eva Hesse: A Retrospective* (New Haven, CT: Yale University Press, 1992), pp. 100–101.
30. Quoted in Ibid., p. 102.
31. Ibid., p. 103.
32. Ibid., p. 108.
33. Ibid., p. 112.
34. Ibid.

Chapter 18
1. Kay Larson, "For the First Time Women Are Leading, Not Following," *Art News*, 79 (October 1980), pp. 64–72.
2. Ibid., p. 68.
3. Mary D. Garrard, "Feminist Politics: Networks and Organizations," in Norma Broude and Mary D. Garrard (eds.), *The Power of Feminist Art: The American Movement of the 1970s, History and Impact* (New York: Abrams, 1994), pp. 88ff.
4. Eleanor Heartney, "How Wide Is the Gender Gap?" *Art News*, 86 (Summer 1987), p. 141.
5. Tufts, *American Women Artists* with essays by Gail Levin, Alessandra Comini, and Wanda M. Corn.
6. John Loughery, "Mrs. Holladay and the Guerrilla Girls," *ARTS Magazine*, 62 (October 1987), pp. 61–65.
7. *Elizabeth Murray: Paintings and Drawings*, exhibition catalogue organized by Sue Graze and Kathy Halbreich, essay by Roberta Smith (New York: Abrams, in association with the Dallas Museum of Art and the MIT Committee on the Visual Arts, 1987), p. 64.
8. Ibid., p. 8.
9. *Magdalena Abakanowicz*, intro. by Mary Jane Jacobs (New York: Abbeville Press, 1982), catalogue organized by the Museum of Contemporary Art, Chicago, for traveling exhibition, p. 14.
10. Ibid., p. 15.
11. Ibid., p. 94.
12. For this discussion of the Vietnam War Memorial, I am indebted to Shirley Neilsen Blum, "The National Vietnam War Memorial," *ARTS Magazine*, 59 (December 1984), pp. 124–28.
13. Charles L. Griswold, "The Vietnam Veteran's Memorial and the Washington Mall: Philosophical Thoughts on Political Iconography," in W. J. T. Mitchell (ed.), *Art and the Public Sphere* (Chicago: University of Chicago Press, 1990), p. 106.
14. Ibid., p. 101.
15. Charles Griswold, Ibid., p. 109.
16. Gustave Neibuhr, "More Than a Monument: The Spiritual Dimension of These Hallowed Walls," *The New York Times*, Nov. 11, 1994, p. A12.
17. Diane Waldman, *Jenny Holzer* (New York: Guggenheim Museum and Abrams, 1989), p. 13.
18. Faith Wilding, "The Feminist Art Programs at Fresno and CalArts, 1970–75," in *The Power of Feminist Art*, pp. 32ff.
19. Arlene Raven, "Womanhouse," in *The Power of Feminist Art*, pp. 48ff.
20. The most detailed discussion of Schapiro's work before 1980 is Thalia Gouma-Peterson, *Miriam Schapiro: A Retrospective: 1953–1980* exhibition catalogue (Wooster, OH: The College of Wooster, 1980). This catalogue was prepared for a major traveling exhibition of Schapiro's works.
21. John Perrault, "Issues in Pattern Painting," *Artforum* (December 1977), reprinted in Richard Hertz, *Theories of Contemporary Art* (Englewood Cliffs, NJ: Prentice-Hall, 1985).
22. Paula Bradley, "Placing Women in History: Miriam Schapiro's Fan and Vestiture Series," *ARTS Magazine*, 56 (February 1979), p. 148.
23. See Judy Chicago, text in *The Dinner Party: A Symbol of Our Heritage* (Garden City, NY: Anchor Books, 1979).
24. Josephine Withers, "Judy Chicago's Dinner Party: A Personal Vision of Women's History," in *The Expanding Discourse*, p. 462.
25. Amelia Jones (ed.), *Sexual Politics: Judy Chicago's Dinner Party in Feminist Art History* (Berkeley and Los Angeles: University of California Press, 1996).
26. Mary Kelly, *The Postpartum Document* (London: Routledge, 1985), pp. xvii–xviii.
27. Moira Roth (ed.), *The Amazing Decade: Women and Performance Art in America: 1970–1980* (Los Angeles: Astro Artz, 1983), p. 8. For the following discussion of performance art, I am indebted to Roth's excellent essay.
28. Leslie Labowitz-Starus and Suzanne Lacy, "In Mourning and In Rage . . ." *Frontiers: A Journal of Women's Studies*, 1 (Spring 1978), pp. 52–55.
29. Marsha Meskimmon, *The Art of Reflection: Women Artists' Self-Portraiture in the Twentieth Century* (New York: Columbia University Press, 1996), p. 201.

30. Ibid.
31. Joanna Frueh, "The Body through Women's Eyes," in *The Power of Feminist Art*, p. 192.
32. Margaret Whitford (ed.), *The Irigaray Reader* (Oxford and Cambridge, MA: Blackwell, 1992), pp. 43–44.
33. Julia Kristeva, Leon S. Roudiez, ed. *Desire in Language: A Semiotic Approach to Literature and Art* (New York: Columbia University Press, 1980), p. 243.
34. Whitford (ed.), *The Irigary Reader*, p. 47.
35. Lynda Nead, *The Female Nude: Art Obscenity and Sexuality* (London and New York: Routledge, 1992), p. 56.
36. Ibid., p. 7.
37. Ibid., p. 16.
38. Ibid., p. 6.
39. Roth, *The Amazing Decade*, p. 20.
40. Rebecca Schneider, *The Explicit Body in Performance* (London and New York: Routledge, 1997), p. 33.
41. Ibid., p. 132.
42. Amelia Jones, *Body Art: Performing the Subject* (Minneapolis: University of Minnesota Press, 1998), p. 155.
43. Arlene Raven, "Hannah Wilke, 1940–1993," *The Village Voice* (Feb. 23, 1993), p. 81.
44. Jones, *Body Art*, p. 184.
45. Garry Noland, "Art's Impact Depends on Feminist Content," *Forum*, 14 (Nov./Dec. 1989), p. 9.
46. Ibid., p. 10.
47. Cassandra Langer, "The Art of Healing," *Ms.* (Jan./Feb. 1989), p. 132.
48. Roberta Smith, "The Year in the Arts," *The New York Times* (Arts and Leisure Section), Dec. 25, 1994, p. 41.
49. Roberta Smith, "An Artist's Chronicle of a Death Foretold," *The New York Times* (Section 2), Jan. 30, 1994, p. 37.
50. Jones, *Body Art*, p. 186.
51. Ibid., pp. 186–87.
52. Jane Blockner, *Where Is Ana Mendieta?: Identity, Performativity and Exile* (Durham and London: Duke University Press, 1999), pp. 45–46.
53. Miwon Kwon, "Bloody Valentines: Afterimages by Ana Mendieta in de Zegher (ed.), *Inside the Visible*, p. 167.
54. Ibid.
55. Blockner, *Where is Ana Mendieta?*, p. 3.
56. *Cindy Sherman*, essays by Peter Schjeldahl and Lisa Phillips (New York: Whitney Museum of Art, 1987), p. 13.
57. Laura Mulvey, "A Phantasmagoria of the Female Body: The Work of Cindy Sherman," *New Left Review*, 188 (July/August 1991), p. 142.
58. Arthur C. Danto in Cindy Sherman, *Untitled Film Stills* (New York: Rizzoli, 1990), p. 10.
59. Abigail Solomon-Godeau, "Suitable for Framing: The Critical Recasting of Cindy Sherman," *Parkett*, 29 (1991), pp. 112ff.
60. Rosalind Krauss, *Cindy Sherman* (New York: Rizzoli, 1993), p. 56.
61. Phillips, op. cit., p. 15.
62. Ken Johnson, "Cindy Sherman and the Anti-Self: An Interpretation of Her Imagery," *ARTS Magazine*, 62 (November 1987), p. 53.
63. Carol Squiers, "Diversionary (Syn)tactics: Barbara Kruger Has Her Way with Words," *Art News*, 86 (February 1987), p. 84.
64. Ibid., p. 80.
65. Ibid., p. 75.
66. Kate Linker, *Love for Sale: The Words and Pictures of Barbara Kruger* (New York: Abrams, 1990), p. 12.
67. Ibid., p. 62.
68. Ibid., p. 27.
69. Ibid., p. 28.
70. Alison Rowley, "On Viewing Three Paintings by Jenny Saville: Rethinking a Feminist Practice of Painting" in Pollock (ed.), *Generations and Geographies*, pp. 90–91.
71. Ibid., p. 95.
72. Ibid., p. 106.
73. Salah M. Hassan (ed.), *Gendered Visions*, p. 5.
74. Ibid.
75. *Gumbo Ya Ya: Anthology of Contemporary African-American Women Artists* (New York: Mid-March, 1995), p. vii.
76. Tesfagiorgis, in *Gendered Visions*, p. 73.
77. Elaine Hedges and Ingrid Wendt, *In Her Own Image: Women Working in the Arts* (Old Westbury, NY: The Feminist Press, 1980), p. 289.
78. Lucy Lippard, entry for Alison and Bettye Saar, in *Gumbo Ya Ya*, op. cit., pp. 239ff.
79. Eleanor Munro, *The Originals: American Women Artists* (New York: Simon and Schuster, 1979), p. 410.

80. Thalia Gouma-Peterson, "Modern Dilemma Tales: Faith Ringgold's Story Quilts," in Eleanor Flomen-haft (ed.), *Faith Ringgold: A 25 Year Survey* (Hempstead, NY: The Fine Arts Museum of Long Island, 1990), p. 23.
81. Quoted in Ibid., pp. 14–15.
82. bell hooks, "Diasporic Landscapes of Longing" in *Art on My Mind* (New York: The New Press, 1995), p. 66.
83. Ibid., p. 71.
84. Ibid.
85. Ibid.
86. B. E. Myers, in *Gendered Visions*, p. 32.
87. Ibid.

Annotated Bibliography

Reference Books/ Dictionaries/Bibliographies

ANDERSON, JANET A., *Women in the Fine Arts: A Bibliography and Illustration Guide* (Jefferson, NC: McFarland, 1991).

BACHMANN, D., and S. PILAND (eds.), *Women Artists: An Historical, Contemporary and Feminist Bibliography* (Metuchen, NJ: Scarecrow Press, 1978, revised edition, 1994, by Sherry Piland).

CHIARMONTE, PAULA, *Women Artists in the United States: A Selective Bibliography and Resource Guide on the Fine and Decorative Arts, 1750–1986* (Boston: G. K. Hall, 1990).

DUNFORD, PENNY, *Biographical Dictionary of Women Artists in Europe and America Since 1850* (Philadelphia: University of Pennsylvania Press, 1990).

GAZE, DELIA (ed.), *Dictionary of Women Artists* (London and Chicago: Fitzroy Dearborn Publishers, 1997).

HELLER, JULES, and NANCY G. HELLER, *North American Women Artists of the Twentieth Century: A Biographical Dictionary* (New York: Garland, 1995).

HILLSTROM, LAURIE COLLIER, and KEVIN HILLSTROM (eds.), *Contemporary Women Artists* (Detroit: St. James Press, 1999).

KOVINICK, PHIL, and MARIAN YOSHIKI-KOVINICK, *An Encyclopedia of Women Artists of the American West* (Austin: University of Texas Press, 1998).

LANGER, CASSANDRA L. *Feminist Art Criticism: An Annotated Bibliography* (New York: G. K. Hall, 1993).

PETTYS, CHRIS, *Dictionary of Women Artists: An International Dictionary of Women Artists Born Before 1900* (Boston: G. K. Hall, 1985).

General Works on the History of Women Artists

BORZELLO, FRANCES, *Seeing Ourselves: Women's Self-Portraits* (New York: Abrams, 1998). A good historical overview of the topic, with excellent plates.

BROUDE, NORMA, and MARY D. GARRARD (eds.), *Feminism and Art History: Questioning the Litany* (New York: Harper and Row, 1982). A collection of scholarly articles that employs various methodological approaches, including analyses of works by women artists, to correct male-biased views of mainstream art history.

BROUDE, NORMA, and MARY D. GARRARD (eds.), *The Expanding Discourse: Feminism and Art History* (New York: HarperCollins, 1992). A recent volume which reprints twenty-nine key scholarly essays in feminist interpretations and re-evaluations of art, ranging from the late Middle Ages to the present.

CHADWICK, WHITNEY, *Women, Art, and Society* (New York: Thames and Hudson, 1990). Authoritative, concise overview of the history of women artists since the Middle Ages, which is integrated into a reframing of the discipline.

CLEMENT, CLARA ERSKINE, *Women in Fine Arts from the Seventh Century B.C. to the Twentieth Century* (Boston: Houghton Mifflin, 1904; reissued by Hacker Art Books, 1974). Provides interesting historical perspective.

ELLET, ELIZABETH FRIES LUMMIS, *Women Artists in All Ages and Countries* (New York: Harper and Co., 1859). An important early treatment of the subject.

FINE, ELSA HONIG, *Women and Art: A History of Women Painters and Sculptors from the Renaissance to the 20th Century* (Montclair, NJ: Abner Schram, 1978). Includes brief, interesting discussions of many artists. Each chapter is introduced with a concise, useful summary of women's social history. Useful bibliography.

298

GREER, GERMAINE, *The Obstacle Race: The Fortunes of Women Painters and Their Work* (New York: Farrar, Straus, Giroux, 1979). Contains useful information mixed with some distorted conclusions about a vast number of women artists. More important, Greer arranges the factors that prevented more women from achieving greater success in the visual arts into a series of obstacles and supports them with specific examples.

HARRIS, ANN SUTHERLAND, and LINDA NOCHLIN, *Women Artists: 1550–1950* (New York: Alfred A. Knopf, 1976). Still a fundamental reference work. Written as a catalogue for a traveling exhibition, the introductory essays provide informative overviews, and the catalogue entries contain pertinent data on individual creators. Useful bibliography.

HELLER, NANCY G., *Women Artists: An Illustrated History* (New York: Abbeville Press, 1987). An adequate nonpolemic survey text loaded with quality illustrations and details.

LOEB, JUDY (ed.), *Feminist Collage: Educating Women in the Visual Arts* (New York: Columbia University Press, 1982). Collection of essays on both specific women artists and broader feminist topics.

NOCHLIN, LINDA, *Women, Art, and Power and Other Essays* (New York: Harper and Row, 1988). A collection of seven key essays, including the author's seminal discussion of the issue "Why Have There Been No Great Women Artists?"

PARKER, ROSZIKA, and GRISELDA POLLACK, *Old Mistresses: Women, Art and Ideology* (New York: Pantheon Books, 1981). A thorough discussion of the stereotyping of women's art, ideological preconceptions of the discipline of art history, and women's relation to artistic and social structures. Avoiding biographical discussions, these English feminists present the first serious analysis of the relationship between the historical evaluation of women's art and the underlying criteria of the academic discipline of art history.

POLLOCK, GRISELDA, *Vision and Difference: Femininity, Feminism and the Histories of Art* (London: Routledge, 1988). A collection of seven essays, including the major theoretical discussion on "Feminist Interventions in the Histories of Art: An Introduction."

SLATKIN, WENDY (ed.), *The Voices of Women Artists* (Englewood Cliffs, NJ: Prentice Hall, 1993). Sourcebook of edited autobiographical texts by women artists from Gentileschi to the present. Primary sources are introduced with contextual information on the artists and the institutional structures in which they worked.

SPARROW, WALTER, *Women Painters of the World* (London: Hodder and Stoughton, 1905). Contemporary with Clement's volume, Sparrow's work is equally extensive.

TUFTS, ELEANOR, *Our Hidden Heritage: Five Centuries of Women Artists* (New York: Paddington Press, 1974). Lively biographical essays of twenty-two major women artists.

WALLER, SUSAN, *Women Artists in the Modern Era: A Documentary History* (Metuchen, NJ: Scarecrow Press, 1991). Sourcebook which includes the writings of women artists, critical reviews of women's work in exhibitions, discussion of women's abilities as artists, and institutional records concerning women artists, societies, and schools. Texts date from the 1760s to the 1950s.

General Works on Women's History

The literature in this discourse has expanded dramatically in recent years. The following selected volumes should prove useful to the student reader as an introduction to the field.

BOXER, MARILYN J., and JEAN H. QUATAERT (eds.), *Connecting Spheres: Women in the Western World, 1500 to the Present* (New York: Oxford University Press, 1987). The editors' introductory remarks to the more specific essays provide a useful overview of women's history since the Renaissance.

BRIDENTHAL, RENATE, and CLAUDIA KOONZ (eds.), *Becoming Visible: Women in European History* (Boston: Houghton Mifflin, 1977). An interesting collection of early essays.

BRIDENTHAL, RENATE, CLAUDIA KOONZ, and SUSAN M. STUARD, *Becoming Visible: Women in European History*, 2nd ed. (Boston: Houghton Mifflin, 1987). Published a decade later than the first volume, this book adopts a more integrated, textbook approach. Individual chapters on selected topics from prehistory to the twentieth century are written by leading scholars in each field.

CARROLL, BERENICE A., *Liberating Women's History* (Urbana: University of Illinois Press, 1976). An informative and reliable collection of essays on a range of topics in women's history.

DAVIS, NATALIE ZEMON, and ARLETTE FARGE (eds.), *A History of Women in the West* (Cambridge, Harvard University Press, MA: 1993). Multi volume history with up-to-date methodolgy by various contributors.

HARTMAN, MARY, and LOUISE BANNER (eds.), *Clio's Consciousness Raised* (New York: Harper, 1974). Authoritative collection of essays.

HELLY, DOROTHY O., and SUSAN M. REVERBY (eds.), *Gendered Domains: Rethinking Public and Private in Women's History* (Ithaca, NY: Cornell University Press, 1992). These essays originated in a session held at the Seventh Berkshire Conference on the History of Women. Useful revision of former dichotomies in "Introduction." Groups of interesting case studies.

OFFEN, KAREN, RUTH ROACH PEIRSON, and JANE RENDALL (eds.), *Writing Women's History: International Perspectives* (Bloomington: Indiana University Press, 1991). Essay by scholars in twenty-two countries documenting the "state of the art" of women's history in a wide range of historiographical contexts.

SCOTT, JOAN W., *Gender and the Politics of History* (New York: 1988). Key theoretical essays by one of the leading figures in women's history, including "Gender: A Useful Category of Historical Analysis."

SMITH, BONNIE G., *Changing Lives: Women in European History Since 1700* (Lexington, MA: D. C. Heath, 1989). Well-written textbook on the topic with useful bibliography.

CREDITS

1.1 *Venus of Willendorf.* c. 30,000-25,000 B.C. Limestone. Height 4⅜ in. Naturhistorisches Museum, Vienna. **1.2** Cycladic Figure from Amorgos. c. 3000 B.C. Marble, 2 ft 6¼ in. Ashmolean Museum, University of Oxford. **2.1** *Calcite Disk of Enheduanna, Daughter of Sargon the Great.* University of Pennsylvania Museum, Philadelphia. **3.1** *Pair Statue of Menkaure and His Queen,* Egypt, Giza Valley Temple of Mycerinus, Old Kingdom, Dynasty 4, reign of Mycerinus, 2532–2510. Greywacke; H: 54½ in. (1.39 m) Base: 57.0 × 54.0. Harvard Museum Expedition–Museum of Fine Arts Expedition. Courtesy of Museum of Fine Arts, Boston. 11.1738. **3.2** Funerary Temple of Queen Hatshepsut, Dier el-Bahri. Foto Marburg/Art Resource, NY. **3.3** Stele, Altar at Amarna, Nefertiti and Ahknaten. © Staatliche Museen zu Berlin. Preu'βischer Kulturbesitz, Ägyptisches Museum. **3.4** *Menna with Family Fishing and Fowling,* Tomb of Menna. The Metropolitan Museum of Art. All Rights Reserved, The Metropolitan Museum of Art. 30.4.48. **3.5** Wall painting, Tomb of Nebanum. Copyright The British Museum, London. **4.1** Snake Goddess from the Palace at Knossos. c. 1600 B.C. Height 13½ in. Archaeological Museum, Heraklion, Crete. Courtesy of Hirmer Verlag München. **5.1** Attributed to The Amasis Painter, *Lekythos,* Women Working Wool, Attic Vase. c. 560 B.C. Height: 6¾ in. The Metropolitan Museum of Art, Fletcher Fund, 1931. All rights reserved, The Metropolitan Museum of Art. 31.11.10. **5.2** Athenian Red Figure Vase Paintings: *Bridal Procession,* and *Father and Son Bidding Farewell* c. 430 B.C. Height 0.753 m. Diameter (of body): 0.18 m. Courtesy, Museum of Fine Arts Boston; Francis Bartlett Fund. **5.3** Painter of the Polygnotan Circle, Domestic Scene. c. 430 B.C. Ceramic, 34.6 × 24.6 cm. Courtesy of the Arthur M. Sackler Museum, Harvard University Art Museums, bequest of David M. Robinson. **5.4** *Folding of the Peplos.* Panel from East Frieze of The Parthenon. British Museum, London, Great Britain. **5.5** *Aphrodite of Knidos.* Roman copy after an original of c. 330 B.C. by Praxiteles. Marble. Height 6 ft. 8 in. Vatican Museums, Vatican State; Alinari/Art Resource, NY. **6.1** Marcus Agrippa with imperial family (south frieze). 13–9 BCE, Museum of the Ara Pacis. Rome, Italy. **6.2** Relief on Column at Trajan, Provincial Town, Courtesy Deutsches Archäologisches Institute, Rome. **6.3** Marcia Furnilla, *Roman Matron as Venus.* Courtesy of Ny Carlsberg Glyptotek, Copenhagen. Photo: Jo Selsing. **6.4** Mosaic of Empress Theodora, San Vitale, Ravenna. 6th Century. Alinari/Art Resource, NY. **7.1** Illumination from St. Hildegarde of Bingen, *Scivias.* © 1978 Brepols Publishers Corpus Christianorum Continuatio Mediaevalis 43–43A: Hildegardis, Scivias. **7.2** *Tree of Life* c. 1310. Pacino di Bonaguida. L'Albero Della Vita. Alinari. 67243. Firenze: Accademia P. Di Bona Guida. **7.3** *The Heart as a House,* Staatsbibliothek zu Berlin. Courtesy of Staatsbibliotek zu Berlin–PreuBischer Kulturbesitz, Handschriftenabfeilung 417. **7.4** *Marcia, Self-Portrait from a Mirror.* From Boccaccio, *Concerning Famous Women.* Bibliothèque Nationale de France. **7.5** *Bayeux Tapestry,* detail, c. 1073–1083. Wool embroidery on linen. Height 20 in. Town Hall, Bayeux, France. **7.6** *The Syon Cope,* Gold, silver, and silk thread on linen, © The Trustees of the Victoria and Albert Museum, London. **8.1** Domenico Ghirlandaio, *Portrait of Giovanna Tornabuoni, née Albizzi.* 1488. Mixed media on panel, 77 × 49 cm. Fundación Coleccion Thyssen-Bornemisza, Madrid. **8.2** Sandro Botticelli. *La Primavera.* Galleria degli Uffizi, Firenze, Italy; Alinari/Art Resource, NY. **8.3** Properzia dé Rossi, *The Chastity of Joseph* (or *The Temptation of Joseph by the Wife of Potiphar*), c. 1526. Bologna, Basilica. Photograph di S. Petronio. Formella di Marmo. **8.4** Anguissoia, Sofonisba (1535–1625). A game of chess, involving the painter's three sisters and a servant, 1555. Canvas, 72 × 97 cm. ©Photograph by Erich Lessing. **8.5** Lavinia Fontana, *The Visit of the Queen of Sheba.* c. 1600. Courtesy of the National Gallery of Ireland. **9.1** Artemisia Gentileschi, *Judith Decapitating Holofernes.* 1615–20. Oil on canvas, 46¾ × 37¼ in. Pitti Palace, Florence. **9.2** Caravaggio, *Judith and Holofernes.* c. 1598. 144 × 195 cm. Galleria Nazionale D'Arte Antica, Palazzo Barberini, Rome. **9.3** Clara Peeters, *Still Life with Flowers, a Goblet, Dried Fruit and Pretzels.* 1611. Oil on panel, 19¹¹⁄₁₆ × 25⁵⁄₁₆ in. Prado Museum, Madrid. **9.4** Rachel Ruysch, Dutch, 1664–1750, *Flower Still Life* (1956.57). The Toledo Museum of Art, Toledo, Ohio; Purchased with funds from the Libbey Endowment, Gift of Edward Drummond Libbey. **9.5** Judith Leyster, *The Proposition.* 1631. Oil on panel, 11¹³⁄₁₆ × 9½ in. Mauritshuis—The Hague. **9.6** Jan Steen (Dutch 1626–1679), *The Doctor's Visit* 1663–'65. 18⅛" × 14½". Oil on panel. Philadelphia Museum of Art: The John G. Johnson Collection. **10.1** Rosalba Giovanna Carriera, *Louis XV as a Boy.* 1720. Pastel on paper, 47×35.6cm. (19 × 14 in.) Courtesy, Museum of Fine Arts, Boston. Reproduced with permission. ©1999 Museum of Fine Arts, Boston. All Rights Reserved. Gift of Joseph W., William B., and Edward H.R. Revere. Courtesy, Museum of Fine Arts, Boston. **10.2** Angelica Kauffman (1741–1807) *Cornelia Pointing to Her Children as Her Treasures.* Oil on canvas. 40 × 50 in. Virginia Museum of Fine Arts, Richmond, VA. Purchase: Williams Fund 1975. **10.3** Anne Vallayer-Coster, *The White Soup Bowl.* 1771. Oil on canvas, 19¹¹⁄₁₆ × 24½ in. Courtesy of the Library of Congress. **10.4** Vigée-LeBrun, Louise Elizabeth. *Marie Antoinette and Her Children,* 1787. Oil on canvas, 275 × 215 cm. Inv. MV 4520. Chateau, Versailles, France. **10.5** Adélaïde Labille-Guiard (1749–1803), *Self-Portrait with Two Pupils, Mademoiselle Marie Gabrielle Capet* (1761–1818) *and Mademoiselle Garreaux de Rosemond.* Oil on canvas, 83 × 59½ in. (210.8 × 151.1 cm.) The Metropolitan Museum of Art, Gift of Julia A. Berwind, 1953. All rights reserved. (53.225.5). **11.1** Mme. Angelique Mongez, *The Oath of the Seven Against Thebes.* Courtesy of Musee des Beaux-Arts, Angers. **11.2** Rosa Bonheur, *The Horse Fair.* Oil on canvas, 96¼ × 199½ in. (244.5 × 406.8 cm) The Metropolitan Museum of Art; Gift of Cornelius Vanderbilt, 1887. All Rights Reserved, The Metropolitan Museum of Art, 87.25. **12.1** Sarah Miriam Peale, *Portrait of Henry A. Wise.* Oil on canvas, 29½ × 24½ in. Virginia Museum of Fine Arts, Richmond, VA. Gift of the Duchess of Richelieu in memory of James W. Wise and Julia Wise. Photograph copyright Virginia Museum of Fine Arts. **12.2** Lilly Martin Spencer (1822–1902), *War Spirit at Home* (Celebrating the Victory at Vicksburg) 1866. Oil on canvas, 30 × 32¾ in. Collection of the Newark Museum, Purchase 1944 Wallace M. Scudder Bequest Fund.

12.3 Hariet Hosmer, *Zenobia in Chains*. 1859. Marble. Height 49 in. Wadsworth Atheneum, Hartford. Gift of Mrs. Josephine M. J. Dodge. **12.4** Hiram Powers, *The Greek Slave*. 1847. Marble. Height 65½ in. Collection of the Newark Museum. Gift of Franklin Murphy, Jr., 1926. Photo by Armen, Feb. 1972. **12.5** Edmonia Lewis, *Old Indian Arrowmaker and His Daughter*, 1872. George Washington Carver Museum, Tuskegee Institute. **13.1** Emily Mary Osborn, *Nameless and Friendless*, Courtauld Institute of Art, Photographic Survey of Private Collections. Private Collection. Photograph: Photographic Survey, Courtauld Institute of Art. **13.2** Elizabeth Siddall, *Pippa Passes*. Courtesy of the Visitors of the Ashmolean Museum, Oxford. **13.3** The J. Paul Getty Museum, Los Angeles, Julia Margaret Cameron (British b. India, 1815–1879) *The Whisper of the Muse*/Portrait of G. F. Watts. Freshwater, Isle of Wright, England. April 1865. 10¼ × 8⅟₁₆ in. 26.1 × 21.5 cm. **13.4** Lady Elizabeth Thompson Butler, *The Roll Call: Calling the Roll after an Engagement*, Crimea. The Royal Collection © 1995 Her Majesty Queen Elizabeth II. **14.1** Berthe Morisot, French, 1841–1895, *Lady at Her Toilette*, c. 1875. Oil on canvas, 60.3 × 80.4 cm. Stickney Fund, Photograph © 1995, The Art Institute of Chicago. All Rights Reserved. **14.2** Cassatt, Mary (American, 1844–1926), *Woman and Child Driving*. Oil on canvas, 35¼ × 51½ in., W'21-1-1. Philadelphia Museum of Art: W. P. Wilstach Collection. Photo by: Graydon Wood, 1993. **14.3** Marie Bashkirtseff, *The Meeting*. Musée d'Orsay, photo R.M.N. **14.4** Poster for the Glasgow Institute of the Fine Arts, c. 1896. Courtesy of the Library of Congress. **14.5** Alice Barber Stephens, *The Women's Life Class*. c. 1879. Oil on cardboard, 12 × 14 in. Courtesy of the Philadelphia Academy of Fine Arts, Philadelphia. Gift of the artist. 1879.2. **14.6** Harriet Powers, Pictorial Quilt, 1895–1988. Courtesy Boston Museum of Fine Arts, Bequest of Maxim Karolik. © 2000 Museum of Fine Arts, Boston. All rights reserved. **15.1** Paula Modersohn-Becker, *Kneeling Mother and Child*. 1907. Oil on canvas, 113 × 74 cm. Staatliche Museen zu Berlin—Preussisher Kulturbesitz Nationalgalerie. **15.2** Käthe Kollwitz, *Outbreak*. 1903. Mixed techniques, 20 × 23¾ in. Courtesy of the Library of Congress. **15.3** Gabriele Münter, *Boating*. 1910. Oil on canvas, 49¼ × 28¾ in. Milwaukee Art Museum, Gift of Mrs. Harry Lynde Bradley. **15.4** Sonia Delaunay, *Electric Prisms*. 12914. Oil on canvas, 98½ × 98½ in. Musee National d'Art Moderne. **15.5** Lyubov Sergeievna Popova, Architectonic Painting. 1917. Oil on canvas, 31½ × 38⅝ in. The Museum of Modern Art, New York. Philip Johnson Fund. Photograph copyright 1995 The Museum of Modern Art, New York. **16.1** Hannah Höch, *Cut with the Kitchen Knife*. 1919. Collage, 114 × 90 cm. Staatliche Museen zu Berlin—Preussischer Kulturbesitz Nationalgalerie. **16.2** Gunta Stölzl, *5 Choirs*. Photography by Herbert Jager. **16.3** *Una, Lady Troubridge*. 1924. Romaine Brooks (1874–1970). National Museum of American Art, Smithsonian Institution, Washington, DC/Art Resource, NY. **16.4** Claude Cahun, *Self-Portrait* (Figure in checked robe), c. 1928. Gelatin silver print. (9.2 × 6.7 cm.). San Francisco Museum of Modern Art. Gift of Robert Shapazian. **16.5** Meret Oppenheim, *Object (Le Déjeuner en fourrure)*. 1936. diameter; spoon, 8 in. (20.2 cm.) long; overall height 2⅞ in. (7.3 cm.). The Museum of Modern Art, New York. Purchase. Photograph copyright 1995 The Museum of Modern Art, New York. © 1998 Artists Rights Society (ARS), New York/Pro Litteris, Zurich. **16.6** Frida Kahlo, *The Two Fridas*. 1939. Oil on canvas, 67 × 67 in. Collection of the Museo de Arte Moderno, Mexico City; photo by Jorge Contreras Chacel. **16.8** Florine Stettheimer, *The Cathedrals of Fifth Avenue*, Oil on canvas, 60 × 50 in. Signed and dated lower right: N.Y. -31- Florine Stettheimer. The Metropolitan Museum of Art, Gift of Ettie Stettheimer, 1953. **16.9** Georgia O'Keeffe (American, 1887–1986), *Black Iris*, 1926. Oil on canvas, 36 × 29⅞ in. The Metropolitan Museum of Art, Alfred Stieglitz Collection, 1949. All rights reserved, The Metropolitan Museum of Art, 69.278.1. © 1998 The Georgia O'Keeffe Foundation/Artists Rights Society (ARS), New York. **16.10** Imogen Cunningham, *Martha Graham, Dancer*. 1931. © 1970 The Imogen Cunningham Trust. **16.11** Dorothea Lange, *Migrant Mother, Nipomo, California*. 1936. Gelatin-silver print, 12½ × 9⅞ in. Copyright the Dorothea Lange Collection, The Oakland Museum of California, The City of Oakland. Gift of Paul S. Taylor. **16.12** Margaret Bourke-White, *Al the Time of the Louisville Flood*, 1937. Life Magazine © 1937 Time Inc. **16.13** Julia Morgan, *San Simeon 1922–1926*. Front entrance, Main Building. Courtesy Sara H. Boutelle. **17.1** Lee Krasner, *Gaea*. 1966. Oil on canvas, 69 in. × 10 ft. 5½ in. The Museum of Modern Art, New York. Kay Sage Tanguy Fund. Photograph copyright 1995 The Museum of Modern Art, New York. © 1998 Pollock-Krasner Foundation/Artists Rights Society (ARS), New York. **17.2** Louise Nevelson, *Sky Cathedral*. 1958. Wood, 102½ × 133½ in. Albright-Knox Art Gallery, Buffalo, NY, George B. And Jenny R. Mathews Fund, 1970. **17.3** Claire Falkenstein, *U As a Set—A Fountain*. 1966. California State University, Long Beach, CA. Copper tubing, 14 × 20 × 10 ft. Courtesy estate of Claire Falkenstein. **17.4** Alice Neel, *Pregnant Maria*. 1964. Oil on canvas, 32 × 47 in. Courtesy Robert Miller Gallery, New York. Copyright Estate of Alice Neel. **17.5** Louise Bourgeois, *Cumul I*. 1969. Marble, 22⅜ × 50 × 48 in. Photo courtesy of the artist and The Musé National d'Art Moderne, Centre Georges Pompidou, Paris. **17.6** Eva Hesse (1936–1970), *Untitled (Rope Piece)*. 1970. Collection of Whitney Museum of American Art, New York. Purchased with funds from Eli and Edythe L. Broad, the Mrs. Percy Uris Purchase Fund, and the Painting and Sculpture Committee. Copyright © 1995 Whitney Museum of American Art. Photo by Geoffrey Clements. **18.1** Elizabeth Murray, *Sail Baby*. 1983. Oil on canvas, 26 × 135 in. Walker Art Center, Minneapolis. Walker Special Purchase Fund, 1984. **18.2** Magdalena Abakanowicz, *Embryology*, 1978–1980. Photo by Jan Nordahl, Sodertalje, Sweden/© Magdalena Abakanowicz/Licensed by VAGA/Courtesy Marlborough Gallery, NYC. **18.3** Maya Lin, *The Vietnam Veterans Memorial*. Vietnam War Memorial, Washington, DC. Pearson Education/Prentice Hall College. **18.4** Jenny Holzer. Untitled (Selections from Truisms, Inflammatory Essays, The Living Series, The Survival Series, Under a Rock, Laments, and Child Text), 1989. Extended helical tricolor L.E.D. electronic-display signboard. Site specific dimensions: 41.9 cm × 49 m × 37.8 cm × 15.2 cm (16½ inches × 162 feet × 6 inches). Solomon R. Guggenheim Museum, New York. Partial gift of the artist, 1989. 89.3626. Photography by Davis Heald © The Solomon R. Guggenheim Foundation, New York.

Index